golf courses of the world 365 DAYS

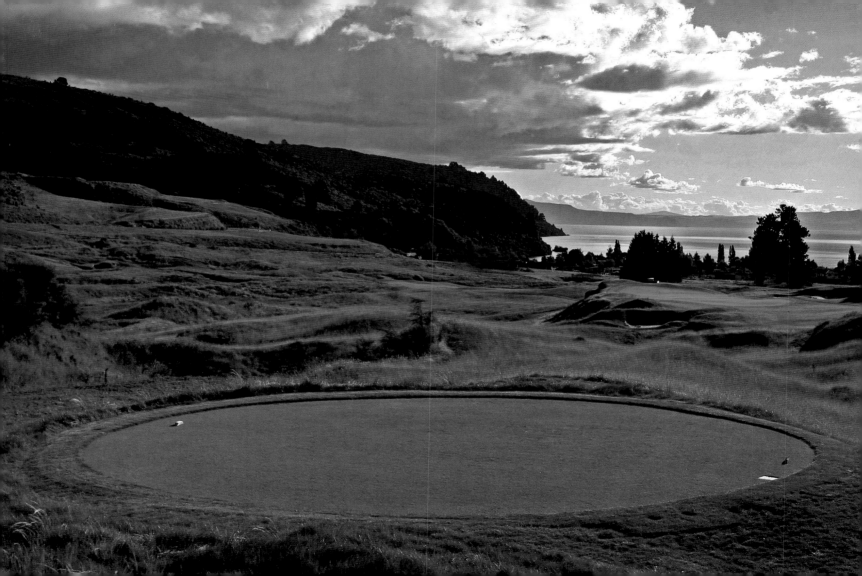

revised & updated edition

golf courses of the world

365 DAYS

ROBERT SIDORSKY

ABRAMS, NEW YORK

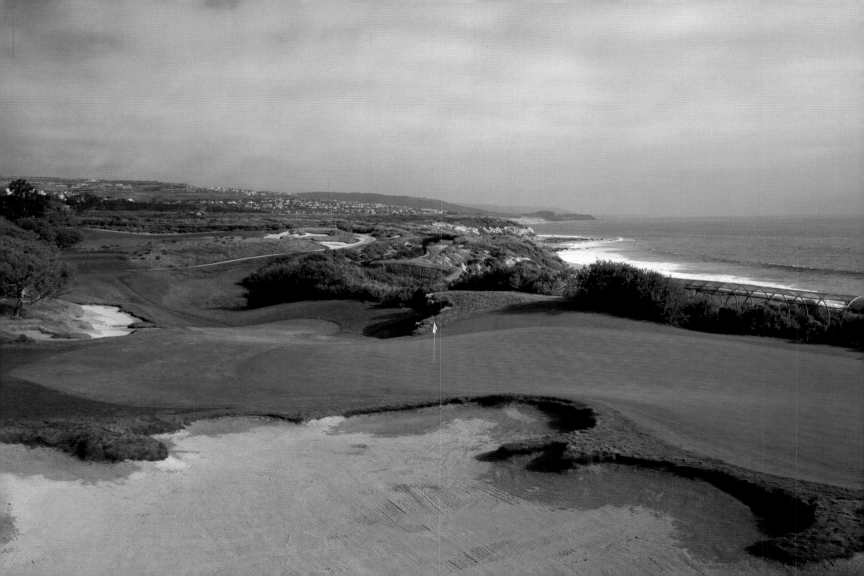

INTRODUCTION

Golf, more than any other sport, lends itself to journeys of discovery, and this book is in many respects the ultimate golfing journey. Here is every true golfer's most fervent fantasy—365 days of golf played on the most sensational courses, in blissfully balmy climes, circumnavigating the world of golf to visit a new site each day. It is a journey that I hope the reader will find both entertaining and educational, coming away with a newfound appreciation for the artistry and sheer beauty of golf courses around the world.

This completely revised edition of *Golf Courses of the World 365 Days* features over 200 new courses, many of them opened during the past five years, as well as several old gems that have recently been restored to their original luster. There are also many new images of courses that appeared in the prior edition.

This edition reflects the continued global expansion of this royal and ancient game. The golf boom in Asia is represented by pictures of courses in China, Thailand, Hong Kong, South Korea, Malaysia, Indonesia, Vietnam, and Cambodia.

The continued spread of the game to the distant corners of the world is also captured in photographs of new courses ranging from Fuego Maya, which lies under the volcano in Guatemala, to desert courses that beckon golfers to modern day oases in Dubai and Bahrain. The Caribbean has been a hot spot for new courses in recent years, and included here are such alluring seaside links as the Abaco Club on Winding Bay in the Bahamas, Roco Ki in the Dominican Republic, and Trump International at Canouan in St. Vincent and the Grenadines.

From the United States, there are almost 100 new course entries, from Stone Eagle in Southern California to Sunday River in northern Maine. The courses selected are a mix of resort, public access, and private clubs. The resort destinations range from Circling Raven at the Coeur d'Alene Resort in Idaho to May River Golf Club at South Carolina's Inn at Palmetto Bluff. New public access courses run the gamut from North Dakota's Bully Pulpit to Butterfield Trail in Texas. The new private clubs vary from the high-profile Sebonack in the Hamptons on Long Island to Michigan's low-key Kingsley Club.

PAGE 1: Taiheiyo Club, Gotemba Course, Japan

PAGE 2: Kinloch Golf Club, New Zealand

OPPOSITE: The Resort at Pelican Hill, South Course, California, U.S.A.

An effort was also made to include new venues that are hosting major tournaments in the near future, such as Chambers Bay in Washington State, Celtic Manor in Wales, the Hills Course, which hosts the New Zealand Open, and Sweden's new Bro Hof Slott Stadium Course.

The game's birthplace has not been overlooked, with a bevy of new courses in Scotland, from Askernish in the far-away Hebrides to Machrihanish Dunes on the Mull of Kintyre, to the Castle Course at St. Andrews—the seventh and latest course at the home of golf, but hopefully not the last. There is also a mix of old and new in Ireland, including Tralee, Carton House, and Dun Laoghaire, while on the other side of the Irish Sea in England, new additions range from West Lancashire to Royal Ashdown Forest and from Saunton to Rye.

As with the original edition, these images were selected to illustrate how golf has been creatively adapted and flourishes in every type of terrain and ecosystem. The golf courses featured span over 60 countries around the world and 49 states, ranging from the antipodes of Paltamo near the Arctic Circle to Arelauquen in Patagonia. The result is a dazzling variety of courses adapted to their natural surroundings—from the alpine splendor of Austria's Eichenheim and Canada's Grey Wolf to the swaying palms and sand-encircled fairways of Punta Espada in the Dominican Republic; from Querencia in Mexico's cactus-cluttered Baja Desert to the jungle greenery of Mount Kinabalu in the Borneo rainforest; from Ballyneal Hunt & Golf Club in the grassland dunes of northeastern Colorado to the seaside links of Barnbougle Dunes in Tasmania. For the island wayfarer, there are subtropical layouts from Santo da Serra on Madeira to Corsica and Crete as we sail across the Mediterranean, to Le Touessrok on Mauritius in the Indian Ocean.

My approach to selecting the 365 courses that comprise this grand global tour has been admittedly and intentionally subjective. The goal is to present the pageantry and poetry of golf around the globe rather than ranking courses by a set of criteria. Each of the courses has been selected because it has something of unique interest to offer through a combination of design, history, geographic setting, and plain old charm. No one could deny that Augusta National is a great course. Yet the true golfer will also find much to enjoy playing a round at the Fajara Club in Gambia, with its palm trees, exotic birds, and greens made of oily brown sand. Ballybunion in southwest Ireland, which may be the greatest of the world's seaside links, begins with a fairway that runs around a graveyard. The Delhi Golf Club in India might not provide the same test, but how many courses can claim that they play through the sandstone tombs of Mughal emperors?

Golfers revel in finding and playing new courses around the world. While we can all fantasize about playing 365 courses

in a year, the true aim of this book is to inspire more golfing adventures over many years. Any golfer who can play and then enjoy the lingering memories of a fair number of these 365 courses over a lifetime can consider him or herself fortunate indeed.

In an undertaking of this scope, I owe a debt of gratitude to many persons. I would like to thank Margaret L. Kaplan, editor-at-large at Abrams, for her unerring editing of the new text, constant attention to both content and presentation of the material, and her unwavering support of the Golf 365 series. I am also particularly grateful to Esther de Hollander at Abrams for going beyond the call of duty in organizing the text and photographs; to design supervisor Darilyn Carnes for her help with the layout; and to Kathryn Devanel for her support in collecting the many images. Kris Tobiassen pulled together the entire design in very short order and made both the text and photography flow together seamlessly. I would also like to thank Marc Wolfe for his invaluable assistance in sourcing the photographs and Emily Kronenberg for looking at them all and helping with the selections.

The sumptuous photographs of courses around the world are the essence of this book and I am truly grateful to each of the talented globetrotting photographers who supplied images, including Phil Arnold, Aidan Bradley, Tom Breazeale, Jordan Coonrad, Joann Dost, Dick Durrance, William fforde, Jorgé Gamboa, Tria Giovan, John and Jeannine Henebry, Bob Huxtable, Eric Hepworth, Paul Hundley, Taliaferro Jones, Russell Kirk, Mike Klemme, Larry Lambrecht, Jean-François Lefèvre, Patrick Lim, Iain Lowe, Ken May, Taku Miyamoto, Kevin Murray, Rob Perry, Wood Sabold, David Scaletti, Phil Sheldon, and Helen Shippey. I am also very grateful to *Golfweek* senior writer and golf course architecture maven Bradley Klein for his advice and sound counsel.

Last but not least, I would like to thank my wife, Hilary, and my children, Alexander and Julia, who are now old enough to walk into bookstores and let whoever happens to be nearby know with a certain degree of pride that this is their dad's book.

ROBERT SIDORSKY
New York City, September 2009

JANUARY 1 | PRINCEVILLE RESORT (PRINCE COURSE)—HAWAII, U.S.A.

The Prince Course at the Princeville Resort is Hawaii's ultimate combination of the dramatic, exotic, and punishing. The nearby ocean cliffs and bosky green mountains of the island of Kauai are favorite settings for Hollywood forays into the jungle, including *South Pacific*, *Raiders of the Lost Ark*, and *King Kong*, with Mount Makana serving as the Bali Hai of *South Pacific*. Designed by Robert Trent Jones, Jr., the Prince's fairways are terraced through a lush jungle of mango trees, laced with ravines, and bisected by Anini Stream, which cascades from the red-ore rockwalls on the 13th hole. Princeville is named after the Hawaiian prince, Albert Edward Kauikeaouli Leiopapa A. Kamehameha, the only child of Queen Emma and King Kamehameha IV, who died at age four. In 1860, when the Prince was two years old, his parents took him on their holiday at the ranch plantation of their foreign minister, a Scot named Robert Crichton Wyllie. Wyllie was so charmed by the little Prince that he named his 11,000-acre plantation Princeville.

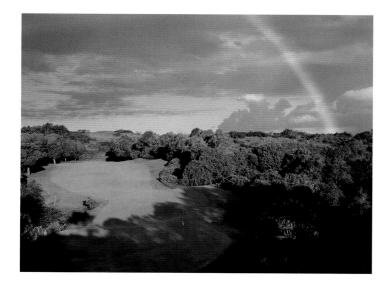

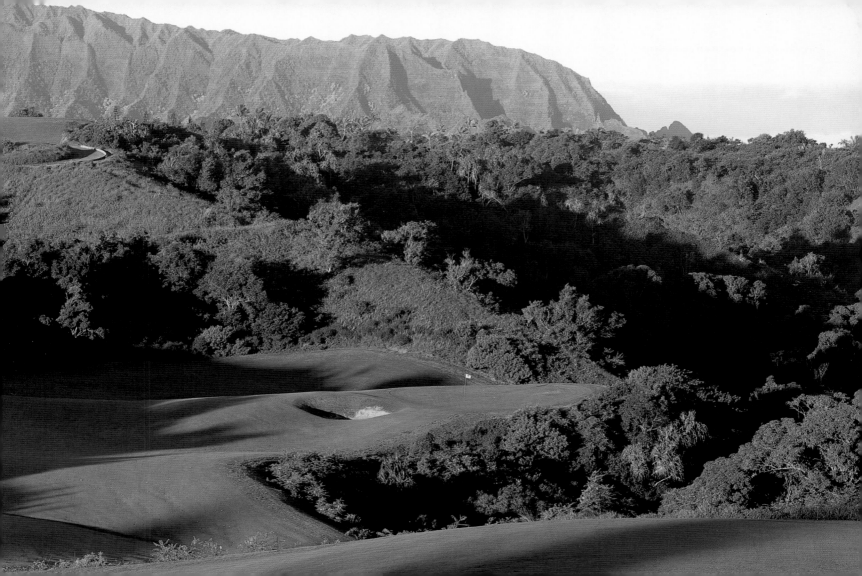

JANUARY 2 | MAUNA LANI RESORT—HAWAII, U.S.A.

The renowned Mauna Lani Resort on the Kohala Coast of Hawaii's Big Island, with its Francis H. I'i Brown North and South Courses, is quintessential Hawaiian golf. The fairways of the South Course are striped with the jet-black a'a lava of the ancient kaniku lava flow. The South Course hosted the Senior Skins game from 1990 to 2000, showing off its spectacular cape hole 15th that dares the golfer to bite off as much as he can chew for the tee shot over the foaming breakers. The North Course, which is roamed by herds of feral goats, rolls through more jagged terrain over beds of brown pahoehoe lava, with copses of bent kiawe or mesquite trees along the fairways. Designed by Homer Flint, Raymond Cain, and Robin Nelson in 1981, the 17th is a par-three to a green set in a natural lava amphitheater. The resort acquired the property in 1972 from Francis H. I'i Brown, who had served as Hawaii's territorial representative and was a legendary sportsman and golfer. He often competed in the Bing Crosby Pro-Am at Pebble Beach and shot a 62 in a practice round on the Old Course at St. Andrews before the start of the 1924 British Amateur. At one point, he was simultaneously the reigning amateur champion of Hawaii, Japan, and California.

RIGHT: North Course

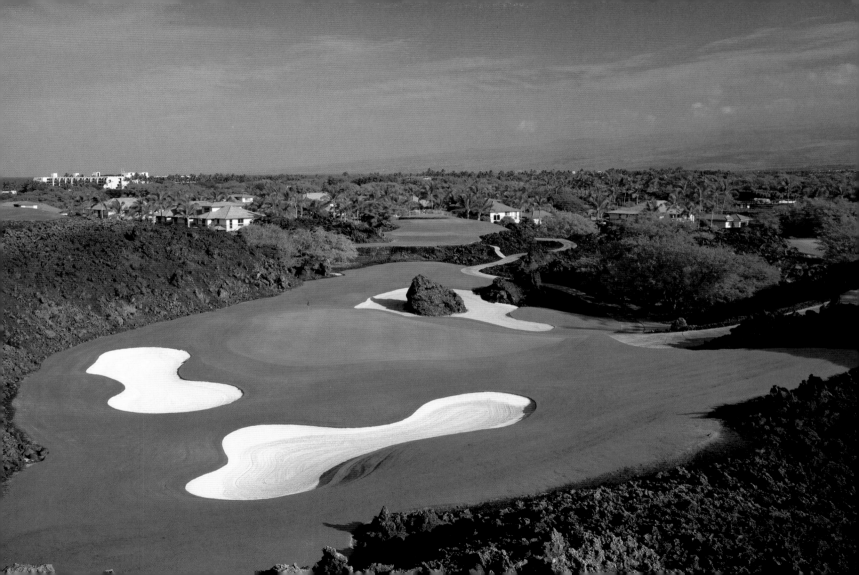

JANUARY 3 | KUKI'O GOLF CLUB—HAWAII, U.S.A.

Kuki'o Golf Club is a private golf and beach club on Hawaii's Big Island, adjacent to Kikaua Point Beach Park, which offers sumptuous views of the Kohala Coast along Uluweauweu and Kua Bays. Designed by Tom Fazio, and his only course in Hawaii, the fairways portage through streams of dark auburn lava sprigged with wild grasses, with 400 feet of elevation change throughout the design. In addition to the 18-hole course, Fazio also created a 10-hole short course. Kuki'o lies beneath the shoulder of Hualalai, a volcano that last erupted in 1801, when King Kamehameha, attended by a procession of chiefs and priests, sought to stem the lava flow that threatened the coastal villages by cutting off a portion of his hair—considered sacred—and tossing it into the fiery torrent.

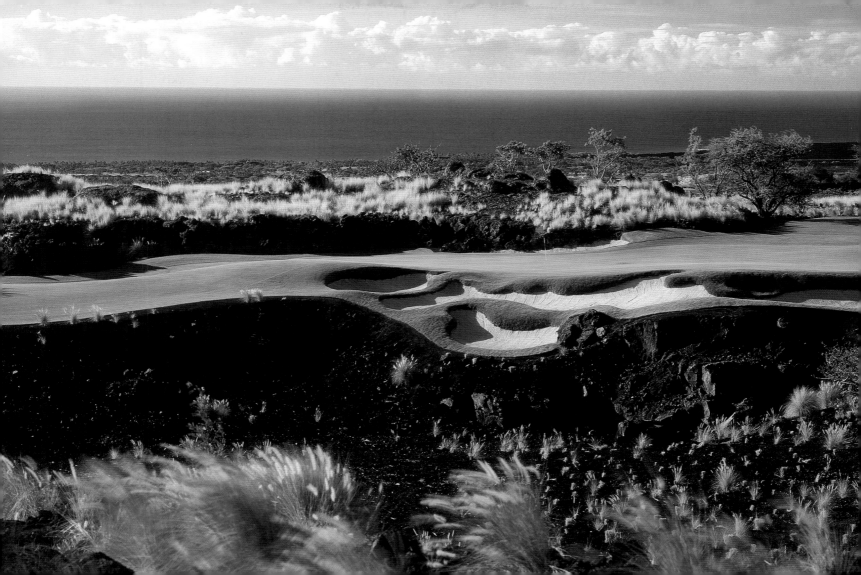

JANUARY 4 | KAPALUA RESORT (PLANTATION COURSE)—HAWAII, U.S.A.

The Plantation Course is part of the 1,650-acre Kapalua Resort on Maui. Opened in 1989, the Plantation Course put Maui on the world golf map and now hosts the Mercedes-Benz Championships, the season-opening event on the PGA Tour. *Kapalua* means arms embracing the sea, and the course sits on a spectacular promontory high above the Pacific, where humpback whales can be seen breaching in the winter and spring. In designing the layout, Ben Crenshaw and Bill Coore had to take into account the fierce trade winds and steep pitch of the land. The result is a brawny, sweeping course with immense fairways and forced carries over jungly ravines. The 18th is a 633-yard par five that plunges downhill, where Tiger Woods and Ernie Els both made eagle in the final round of the 2000 Mercedes to go into a sudden-death playoff won by Woods. The Kapalua Resort also has two older courses, the Bay and the Village, which run through stands of Cook pines, ironwood, plumeria, and coconut palms. Kapalua was part of the vast surrounding pineapple plantation, which continues to be operated by the descendants of Dwight Baldwin, a missionary doctor who arrived in Maui in 1819.

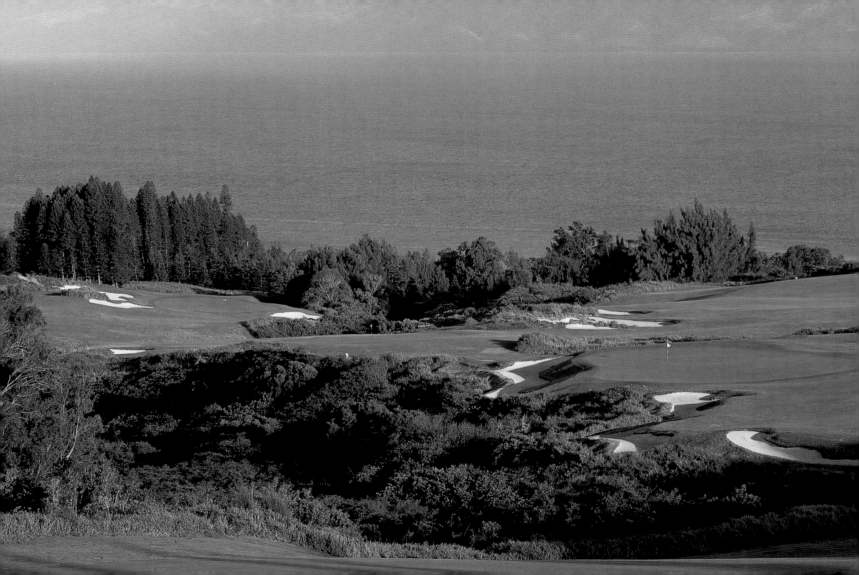

JANUARY 5 | THE CHALLENGE AT MANELE—HAWAII, U.S.A.

Lana'i was the Hawaiian Island known for its pineapples, but since 1991 it has been the home of two world-class resort courses, the Challenge at Manele and the Experience at Koele. Often referred to as Pineapple Island, Lana'i is owned by Castle & Cooke's Dole Pineapple Company, a subsidiary which developed both the elegant Manele Bay Hotel, on the western shore of the island, and the Lodge at Koele in the central highlands of Norfolk and Scotch pine near Lanai City. The Challenge at Manele, designed by Jack Nicklaus, cascades across the bluffs on top of sheer rock cliffs that rise 150 feet above the Pacific. The 12th hole is one of the most dramatic par-threes in the world, with a carry across the chasm that rises above the Pacific to the cliff-top green. The hole was the site of Bill Gates's wedding to his wife, Melinda, in 1994.

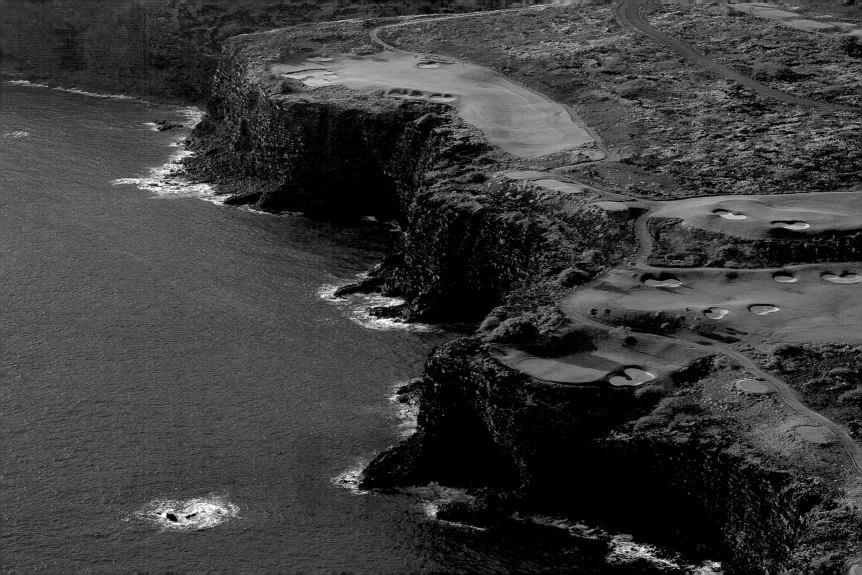

JANUARY 6 | LUANA HILLS COUNTRY CLUB—HAWAII, U.S.A.

Luana Hills is laid out through the extravagantly lush greenery of the Hawaiian rain forest in the Maunawili Valley, ringed by the verdant walls of Mount Olomana and the other Ko'olau Mountains, on the island of Oahu. A semiprivate country club, the course was designed by Pete Dye and his son Perry in 1994. While the course measures only 6,595 yards from the back tees, the danger of lost balls lurks at every turn—in the form of numerous ravines, the dense canopy of royal palms and koa trees that shelter the Aku'u, or black crowned night heron, and other rare native Hawaiian birds, and the Maunawili stream that runs through the course. The front nine offers views of the mountains and requires forced carries from the elevated tees to the humped fairways, while the back nine lies lower in the hidden valley of the flowering jungle.

JANUARY 7 | OLYMPIC CLUB (LAKESIDE COURSE)—CALIFORNIA, U.S.A.

The Olympic Club's Lakeside Course is known as the most claustrophobic in championship golf. The narrow, sloped fairways are overarched by an elaborate lattice of cypress, pine, and eucalyptus that must be negotiated from tee to green, demanding pinpoint driving accuracy and the ability to play a high fade through the narrow corridors. The Olympic Club actually acquired the course from the struggling Lakeside Country Club in 1922. The course is on the western edge of San Francisco, on the inland side of the ridges separating Lake Merced from the Pacific, while the club's other course, the Ocean Course, lies on the other side of the ridges. Olympic is known for producing underdog champions. In the 1955 U.S. Open, the unknown Jack Fleck defeated Ben Hogan in a playoff. In 1966, Arnold Palmer blew a big lead coming down the stretch and lost to Billy Casper in a playoff. In 1987, Tom Watson made his final hurrah in the U.S. Open but came up one stroke short of winner Scott Simpson. Lee Janzen won his second U.S. Open at Olympic in 1998, beating out Payne Stewart.

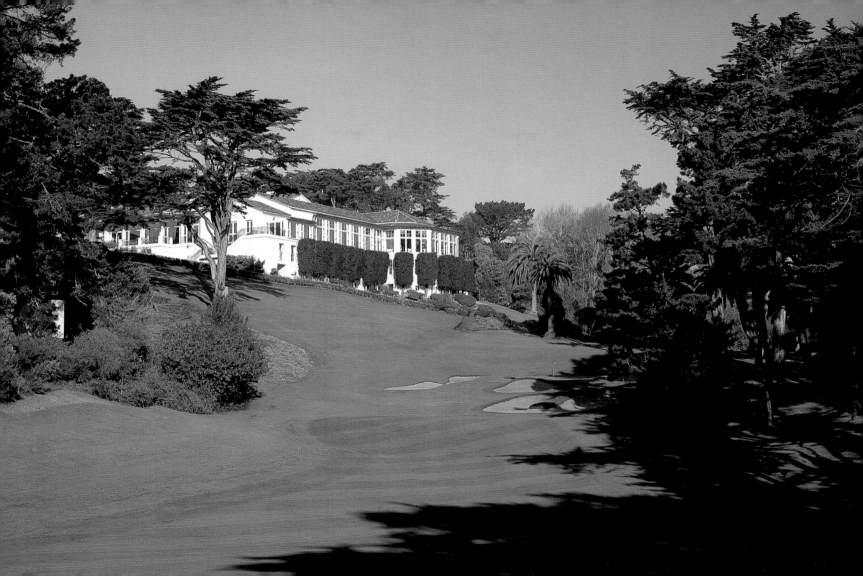

The Course at Wente Vineyards is a public 18 located just east of San Francisco in the Livermore Valley. It is owned by Wente Vineyards, the oldest, family-operated winery in the United States since its founding over 125 years ago. Designed by Greg Norman and opened in 1998, the course is banked below the cliffs of the Cresta Blanca, with 200 feet of elevation change throughout the layout. Norman incorporated the varied and shifting landscape in the course. The fairways weave through woodlands of sycamore, oak, and cottonwood on the first six holes, followed by rolling grasslands on holes 10 through 14, while holes seven through nine and 15 through 18 take a turn through the vineyards. Deer and wild turkeys can be found on the course, while the cattle raised by the Wente family graze on the hillside above. Wente Vinyards is the host course of the Livermore Valley Wine Country Championship, an event on the PGA Nationwide Tour.

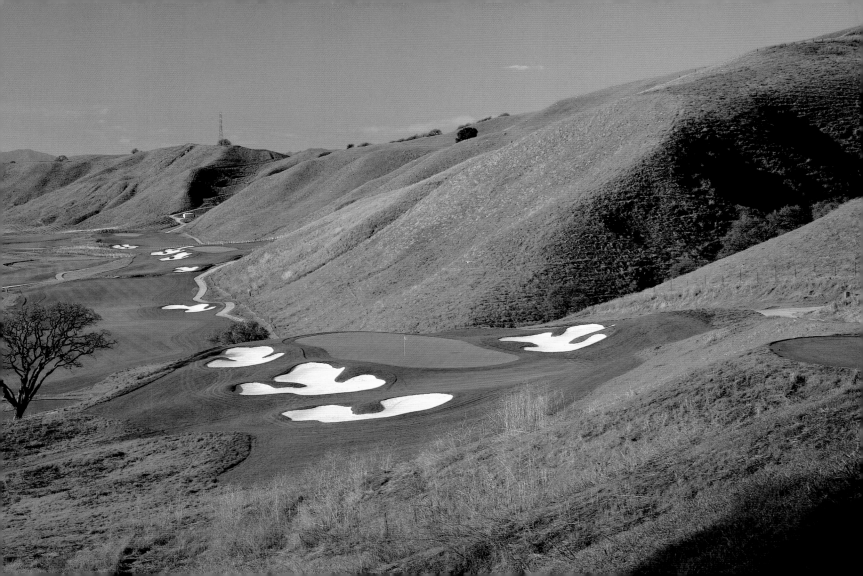

Pasatiempo Golf Club, one of the treasures of American public golf, is a course that is closely linked with golf's glamorous era of the 1920s. Pasatiempo was developed by Marion Hollins, the 1921 U.S. Women's Amateur Champion, first Curtis Cup Captain, and fearless all-around sportswoman, on her estate in the rolling hills and sandy barrancas of Santa Cruz, overlooking Monterey Bay. Hollins had been hired by Samuel F.B. Morse to help develop the Monterey Peninsula and worked closely with Alister MacKenzie on his design for the Cypress Point Golf Club. In turn she hired MacKenzie, who would go on to design Augusta National with Bobby Jones, to create Pasatiempo. The course opened on September 8, 1929, to considerable fanfare, with a match between the team of Hollins and Jones against amateur champion Glenna Collett and British amateur champion Cyril Tolley, before a crowd of over 2,000 spectators. MacKenzie lived in a house to the left of the sixth hole and was particularly fond of the par-four 16th, which climbs uphill and swings to the left, with a three-tiered green guarded by a barranca. Over the years, some of MacKenzie's elaborate bunkering and severe green slopes were altered or disappeared to make course maintenance easier. The club decided to hire Tom Doak to carry out a restoration based on vintage photographs of the course, which was completed in the fall of 2007, returning Pasatiempo, or "the passage of time" in Spanish, back to the time of its birth.

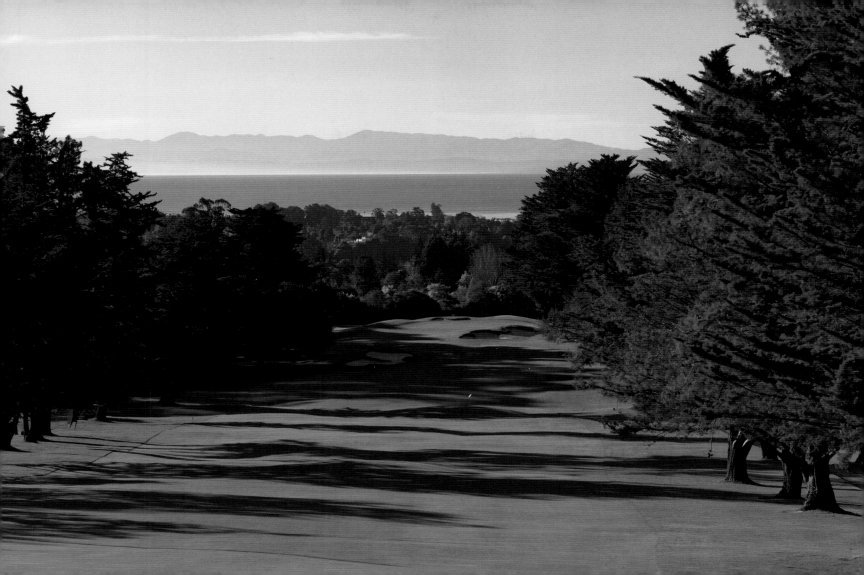

Pebble Beach is to American golf what St. Andrews is to the game in Scotland. This greatest of all American seaside courses leapfrogs across the "Cliffs of Doom" above the cobalt water of the Pacific where the sea lions make their home. Surprisingly, the course was designed in the 1920s by two relative unknowns, California amateur champions Jack Neville and Douglas Grant. They were given the job by Samuel F. B. Morse, the grandnephew and namesake of the inventor of the telegraph, whose inspired vision resulted in the environmentally sensitive and exceptionally attractive development of the Monterey Peninsula. Pebble Beach has hosted four U.S. Opens, including the particularly memorable 2000 event when Tiger Woods destroyed the field, winning by an astounding 15-stroke margin. Pebble annually hosts the PGA Tour's AT&T Pebble Beach National Pro-Am, the event started by Bing Crosby, and is one of the game's great and colorful institutions. The Lodge at Pebble Beach, which overlooks the famous 18th fairway, is one of the world's legendary golf hotels.

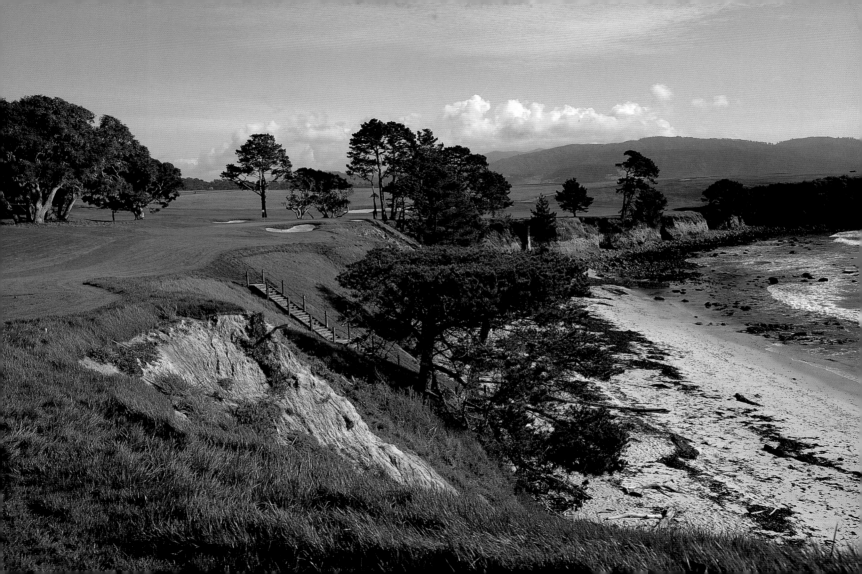

Monterey Peninsula Country Club's Shore Course has its roots in the early years of golf on the peninsula, America's hallowed golfing ground, but it owes its contemporary vitality to the creative imagination of course architect Mike Strantz, who died shortly after completing his inspiring redesign. Monterey Peninsula Country Club originally opened in 1926 with the Dunes Course, developed by Samuel Morse, the impresario of Pebble Beach and Cypress Point. Over 30 years later, Morse agreed to turn the land over to the members for $1, provided that a second course be built, which led to the construction of the Shore Course in 1959, designed by Bob Baldock and Jack Neville, one of the architects of Pebble Beach.

By 2001, the club was looking to redesign and upgrade the Shore Course, which had been built on a low budget. Strantz wowed the committee in charge of the project with his artistic vision, and was given the job in 2002. Although he was already gravely ill with the mouth cancer that would claim his life, Strantz threw his heart and soul into creating 12 new holes and remodeling the other six, completing the work shortly before his death in June 2005. His masterstroke was reversing the course's routing, so that its axis now faces south toward the ocean and neighboring Cypress Point—the course that served as Strantz's design inspiration. As he put it: "I dreamed that the course would appear to dance among the cypress trees on the coastline forever."

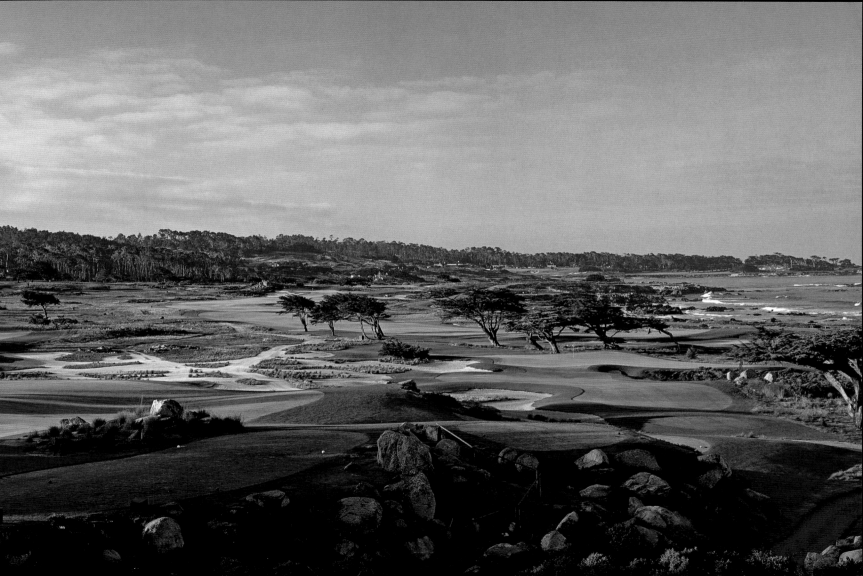

The private Cypress Point Club, on California's Monterey Peninsula, is the ravishingly beautiful creation of Alister MacKenzie, the Scottish-born surgeon turned golf course architect. The 231-yard 16th hole, with its daredevil carry to a promontory of green perched above the frothy cauldron of surf below, is the most famous par-three in the world. The concept for the hole, however, came not from MacKenzie but from Marion Hollins, the outstanding woman golfer who had won the U.S. Amateur in 1921. Hollins, who had been entrusted with developing the Cypress Point property in 1923, was directly responsible for hiring MacKenzie, and the two became close collaborators. The fairways fringed with ice plant gambol above the sea cliffs and through the groves of wind-warped cypress from which the course takes its name. MacKenzie wrote of the unique Monterey cypress: "It has an elbowed gnarled appearance and is twisted into such fantastic shapes as to be almost frightening. It is even beautiful when dead and the elbowed limbs give the impression of huge white gaunt skeletons of giant men. If one first visits Cypress Point in foggy weather, these weird white skeletons looming out of the mist are so terrifying that they are apt to create a depressing effect which is only dispelled when the sun breaks through the mist and brings to view a wonderful variety of color unsurpassed on any golf course."

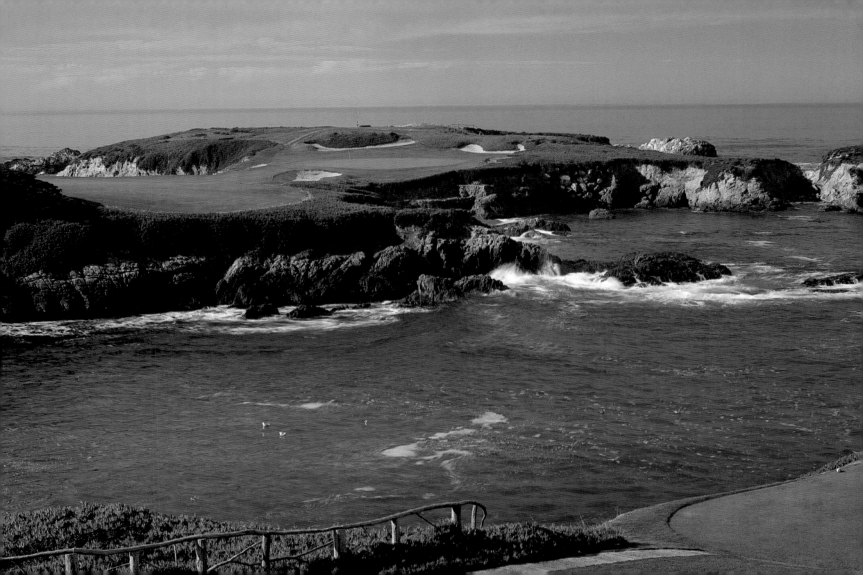

Rancho San Marcos is a daily-fee course situated 12 miles north of Santa Barbara in the lovely bower of the Santa Ynez River Valley, encircled by pleated green mountains. Designed by Robert Trent Jones, Jr., and opened in 1998, the course takes full advantage of its natural assets, starting out over the former cattle ranch and alfalfa farm on the valley floor, then rising to the meadow plateau with its old, black-boughed oaks, and climbing the ridgeline overlooking Cachuma Lake before dropping back down into the meadow. The course is proud of its history, Rancho San Marcos having been established around 1804 as an outpost of the Santa Barbara Mission. It was named for Fray Marcos Amestoy of the mission, whose padres taught the Chumash Indians European methods of agriculture. The land was sold by the Mexican governor in 1846, and by 1868, construction was begun on a stagecoach route from Santa Ynez to Santa Barbara, which became a major link on the inland route from San Francisco to Los Angeles, and operated until 1901. From 1938 until the mid-1990s, the property was run as a cattle ranch and farm. Dwight Murphy, the original owner, was an accomplished breeder of the golden-colored palomino. Remnants of the 19th-century mission adobes and the old stagecoach trail have been preserved on the golf course.

JANUARY 14 | VALLEY CLUB OF MONTECITO—CALIFORNIA, U.S.A.

The Valley Club of Montecito is an old-line, understated club secreted away in the hills outside Santa Barbara under the Santa Ynez mountains. The course was created in 1929 by the demigod of golf course design, Alister MacKenzie, in between his work on Cypress Point and Augusta National. MacKenzie collaborated with Robert Hunter, who supervised the construction. Hunter, who was a leader of the American Socialist movement, became enamored of golf course architecture while playing the great Scottish links courses and authored *The Links*, a seminal book on the subject. The Valley Course is a low-key design by MacKenzie's standards but flows effortlessly, with the middle holes playing through an isolated canyon. The course features MacKenzie's very recognizable fluted bunkering and greens sheltered by old sycamores, oaks, and immense cypress trees with forked trunks. The club hired Tom Doak in the mid-1990s to restore some of the subtle details that had been lost over time, and he exercised admirable restraint during the project. In particular, Jim Urbina of his firm carefully restored the bunker edges and enhanced the chipping areas to offer more strategic options around the greens.

JANUARY 15 | RIVIERA COUNTRY CLUB—CALIFORNIA, U.S.A.

Riviera Country Club in Pacific Palisades is the most famous of the series of Southern California golfing gems designed by George C. Thomas and built by his construction superintendent Billy Bell. The site of the annual Nissan (formerly Los Angeles) Open on the PGA Tour, Riviera became known as Hogan's Alley after he won the 1947 and 1948 L.A. Opens and then also captured the 1948 U.S. Open at Riviera. The location shots for *Follow the Sun*, the 1951 movie about Hogan's life, were also filmed at Riviera. Laid out in the mid-1920s, the essential feature of the course is the barranca, or ravine, which figures on eight of the holes, while the fairways and rough consist of spiky kikuyu grass, which spread after it was introduced to stop erosion within the walls of the barranca. On the sixth hole, there is a small sand trap in the middle of the green. The 18th hole, which threads its way through a valley with the green perched below the Mediterranean palazzo of a clubhouse, is one of the most famous in golf. In 2004, Mike Weir duplicated Hogan's feat by winning his second consecutive Nissan Open at Riviera.

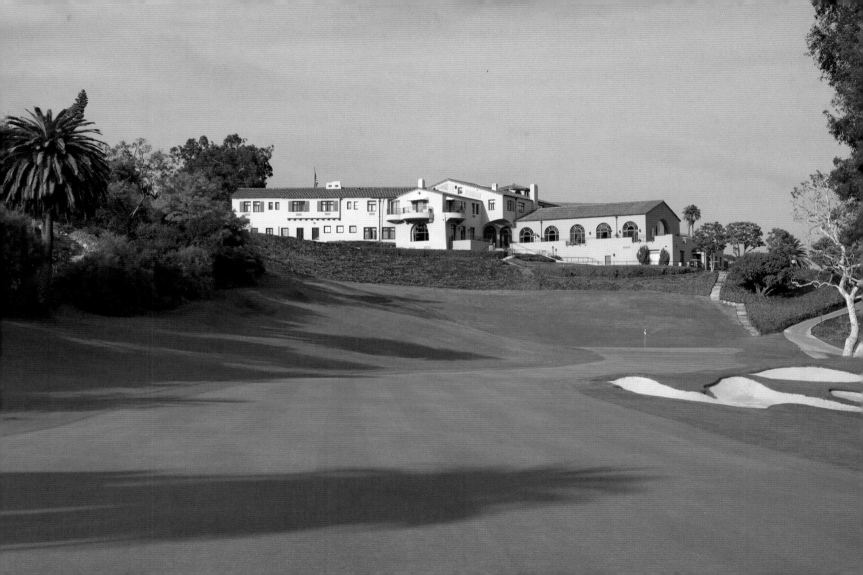

Bali Hai is a course that exudes the exotic glitz of Las Vegas while sticking to a solid, straightforward design. The swank Mandalay Bay Hotel looms over the layout, the only resort course actually located on the Vegas Strip—from the more elevated, southern end of the course, the glamour of the skyline is on full display. Designed by Lee Schmidt and Brian Curley in 2000, Bali Hai takes its name from the Indonesian land of enchantment. This being Las Vegas, the South Pacific theme is puckishly played out, with over 2,500 stands of palm trees imported from around the world, fairways peppered with volcanic black rock, and splayed bunkers of shimmering white sand. Water features were also created, with the 16th hole, named "Pacific Rim," sporting an island green. The attractive Balinese-style clubhouse features a large water tank full of exotic fish in its upscale restaurant.

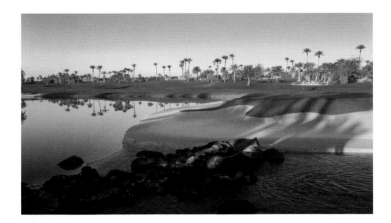

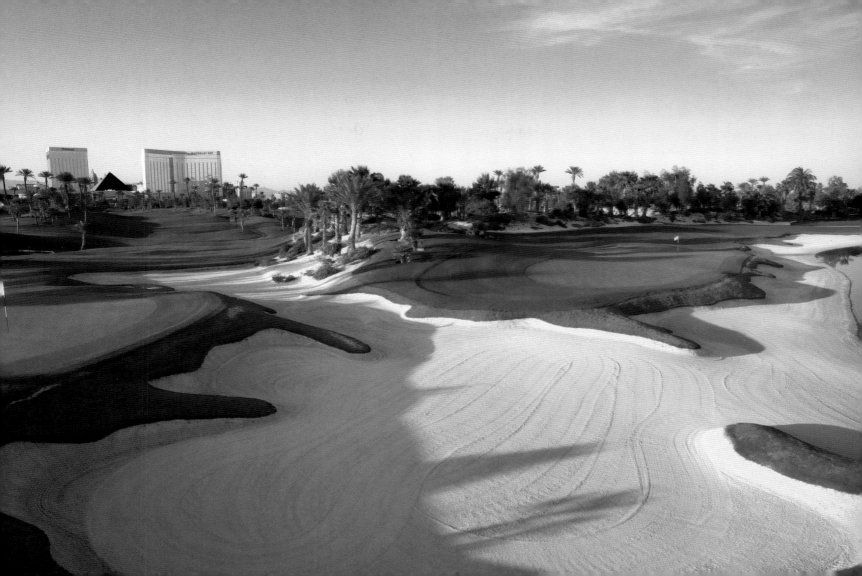

When it comes to golf, Cascata Golf Club is the last word in Las Vegas extravagance. Designed by Rees Jones and built by the MGM Grand, the course is intended as the ultimate golf experience, open by invitation only to the highest of high rollers. In particular, MGM wanted to trump rival Steve Wynn's Shadow Creek course. But when MGM bought Wynn's Mirage Resorts in 2000, it sold Cascata to Park Place Entertainment, whose Las Vegas holdings include Caesar's Palace. Opened in 2001, Cascata is laid out in the desert mountains, with the fairways slippered through the canyons offering generous landing areas. Cascata is Italian for waterfall, and the course takes its name from the 417-foot cataract that cascades down the mountain face and flows through the center of the opulent clubhouse. Jones created waterworks throughout the course by pumping water from nearby Lake Mead into an ancient dry riverbed that ran through the property, while the fairways are rimmed by tens of thousands of individually drip-irrigated date palms and desert plants. The price tag for the course came to a Caesar's ransom of nearly $60 million.

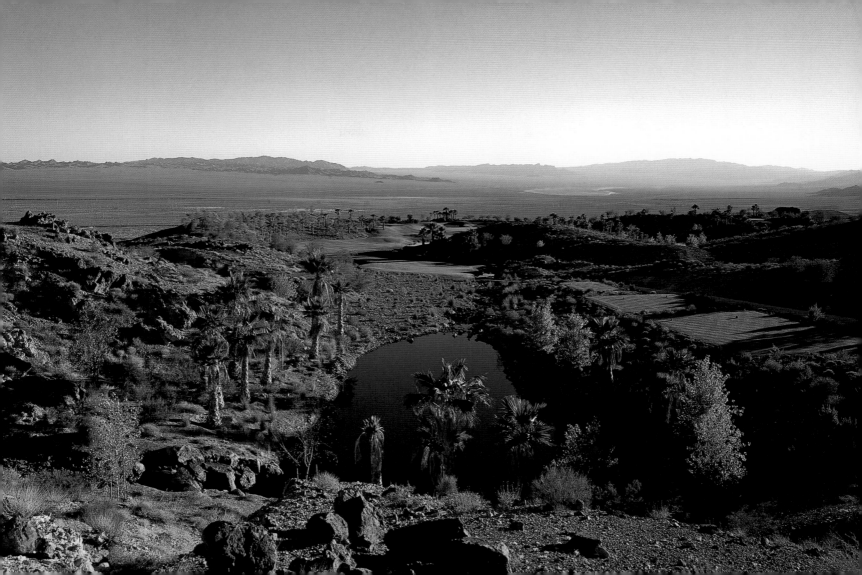

JANUARY 18 | SHADOW CREEK GOLF CLUB—NEVADA, U.S.A.

When it was unveiled in 1989, Shadow Creek expanded the boundaries of golf course architecture and helped to establish Tom Fazio's reputation as the contemporary course architect most accomplished at creating artistically conceived and rendered golf holes. Shadow Creek was initially developed as the private golfing reserve of casino bigwig Steve Wynn, who provided Fazio with a flat-as-a-pancake, 350-acre piece of completely nondescript desert in North Las Vegas as his blank canvas—plus an unlimited budget. Over three million cubic yards of earth were dug from the desert to create a berm that blocks any view of the course from the outside. Within the confines of the site, Fazio proceeded to create an Eden-like wonderland of blue-water lakes, rock-lined streams, and a waterfall flowing behind the par-three 17th green. At Wynn's request, most of the fairways run north or south in order to create perpendicular shadows. The holes are secluded from one another by a forest created by transplanting 21,000 mature trees of over 200 varieties. A menagerie of unusual wildlife was also imported, including Australian wallabies and exotic birds. Wynn sold his hotel empire, including Shadow Creek, to MGM, and so now this seeming mirage of a course in the Nevada desert is open to guests at MGM/Mirage hotels for a hefty green fee that includes a roundtrip limousine ride from the Las Vegas Strip.

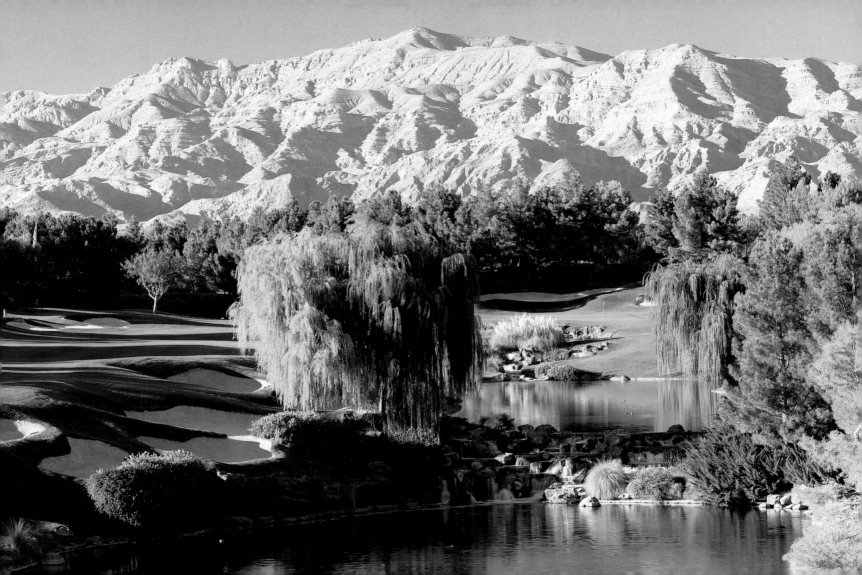

Wolf Creek is a surreal course, located in the gambling and golfing outpost of Mesquite, Nevada, reached by a 90-mile drive due north from Las Vegas through the flat, barren desert. There awaits a Daliesque landscape of fir-green fairways squeezed through the sharded walls of gold and salmon-colored desert canyons as far as the eye can see. Designed by Dennis Rider and opened in 2000, Wolf Creek is a fantasy golf course come to life. There are five holes where the tee is perched more than 100 feet above the fairway, and virtually every hole features exhilarating cliff-diving tee shots. The par-three eighth is emblematic of the Wolf Creek experience, a sky-high tee shot to a green set in a canyon nook and lassoed by the man-made Wolf Creek. Not surprisingly, the course is one of the toughest in the country, even though the fairways are relatively wide. Because of its steep cart path descents and hairpin turns around the canyons, every golfer is required to sign a waiver of liability before being permitted on the course, but for those with no fear of flying, Wolf Creek is a challenge and a joy.

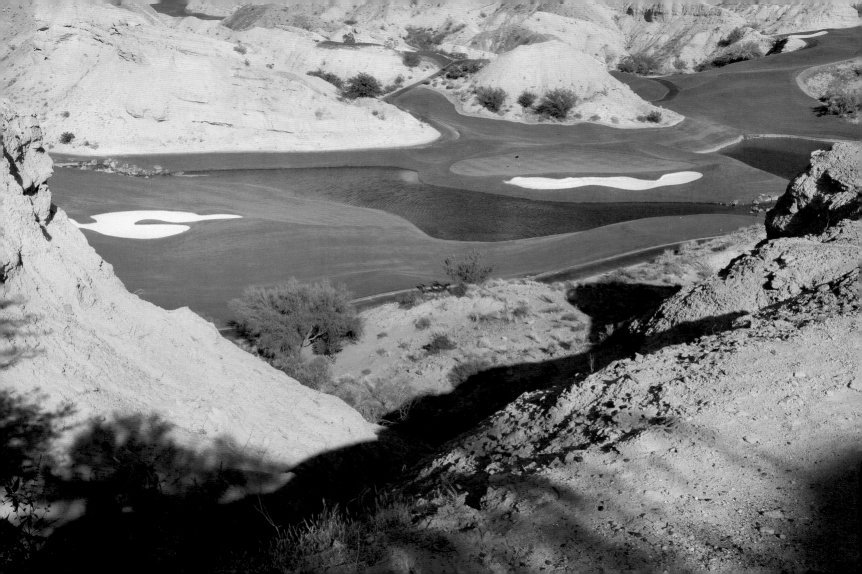

Sand Hollow Resort is a gaudy and gorgeous course of immense sheets of green spread through red rock formations that give way to long plumes of sagebrush in southwestern Utah. The course is located just past St. George in Hurricane, in the heart of Utah's red rock country and near Sand Hollow State Park. The layout was designed by John Fought, a talented architect who starred on the Brigham Young University golf team and won the 1977 U.S. Amateur Championship before playing on the pro tour. Fought made the most of the rubicund site, designing oversized features, including 80 plunging bunkers filled with orange sand, to match the scale of the terrain. The front nine is fairly flat, and allows for the bump and run style of play around the greens found on links courses. The most entrancing views start on the 12th, with the tee at the edge of a ridge with the fairway below. The par-three 15th, nicknamed the Devil's Throat, is Sand Hollow's signature hole, with the green ensnared by tentacles of red rock and a backdrop of the Virgin River.

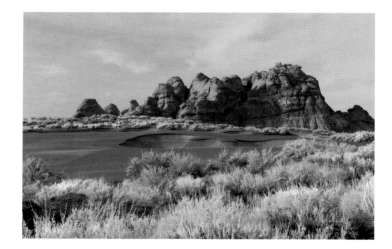

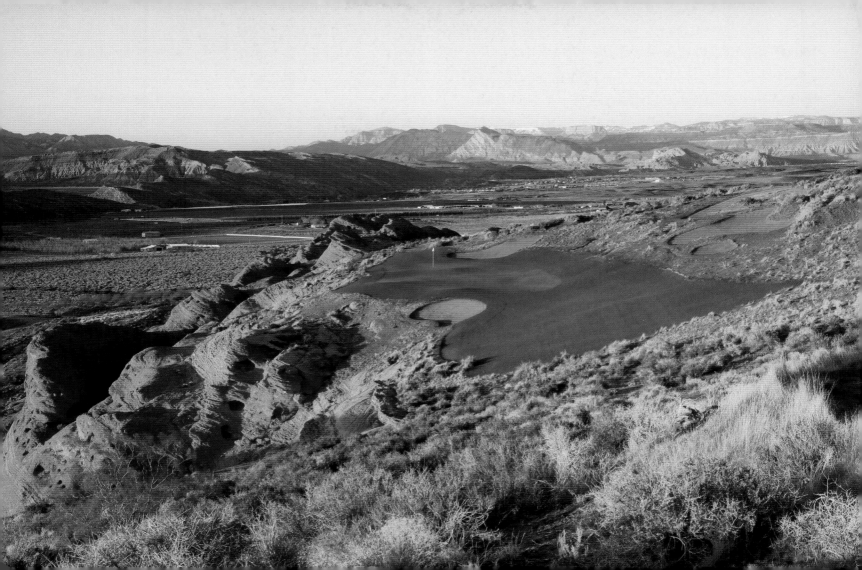

Desert Forest Golf Club is the unsung masterpiece of Robert "Red" Lawrence. Designed in 1962, Desert Forest was the first true desert-style course, the progenitor of all subsequent target-style designs in which there is no buffer between the distant fairway and the vast desert floor with its bristling armamentarium of pipes, spikes, and barrels of cactus—staghorn, agave, prickly pear, yucca, ocotillo, and saguaro. Desert Forest was built as part of the development of the newly founded town of Carefree, north of Scottsdale. Lawrence had moved to Arizona in the 1950s and designed a number of courses in the southwest, earning him the nickname of the Desert Fox. Born in White Plains, New York, in 1893, Lawrence worked early in his career for such legendary figures as Walter Travis in New York and the Philadelphia firm of Toomey & Flynn. Desert Forest also played an important role in the career of Tom Weiskopf, who is an honorary member of the club. Weiskopf first played the course in 1965, when he was 22, and was so captivated by the design and landscape that his round at Desert Forest contributed to his decision eventually to settle in Scottsdale and become involved in designing courses.

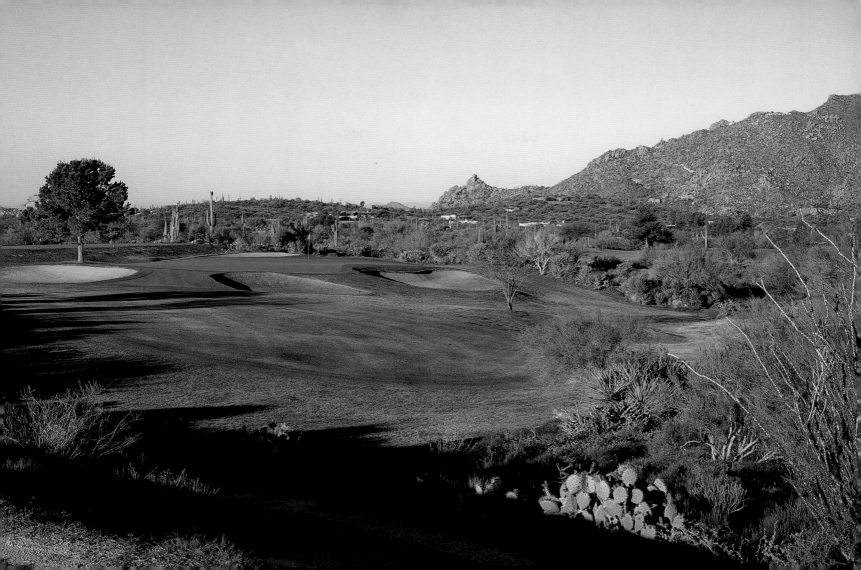

Superstition Mountain is a residential golf community at the base of the Superstition Mountains east of Phoenix, with two Jack Nicklaus–designed courses—the Prospector and Lost Gold—snaking through natural desert washes at an elevation of 2,000 feet. The Prospector Course, designed by Nicklaus and son Gary, is named for Jacob Waltz, the miner who claimed he had discovered gold in the 1880s and hidden his cache in the Superstition Mountains, revealing its location only on his deathbed. According to the legend of the Lost Dutchman's Gold Mine, the "lost gold" is still buried in the mountains, giving rise to the second layout's moniker. Opened in April 1998, the Prospector hosted the LPGA Safeway International tournament from 2004 to 2008. Lost Gold, designed by Nicklaus and son Jackie, is a more links-style course that measures 7,351 yards. Opened in February 1999, the course rambles through the rough-hewn desert terrain explored by the conquistadors in search of the Seven Cities of Cibola. The back nine offers striking views of the Superstition Mountains, particularly from the par-five 14th, which is guarded by a dry wash bed down the right side.

RIGHT: Lost Gold Course

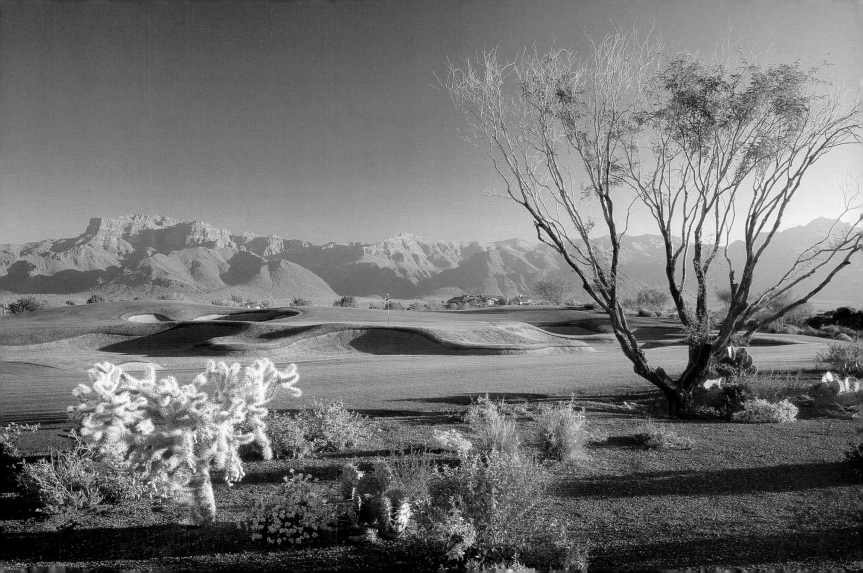

JANUARY 23 | TROON NORTH GOLF CLUB—ARIZONA, U.SA.

Since it opened in 1990, Troon North has personified golf in the high Sonoran desert of Scottsdale and established the model of a high-end, daily fee course that has been emulated around the country. Troon North has two exceptional courses. The Monument Course, designed by Jay Morrish and Tom Weiskopf, opened in 1990. Weiskopf returned five years later to design the Pinnacle Course. Both courses feature all the trappings of desert golf, with ravines, piles of juggling boulders, and centurions of cactus guarding the fairways. The Monument Course is named for the hunky boulder in the middle of the fairway on the par-five third. The Pinnacle Course takes its name from the pyramidal peak that stands behind the 407-yard par-four tenth. Weiskopf, who has become a highly respected solo designer since his first foray into the field at the Monument Course, returned in 2006 to reconfigure and renovate the two courses. Weiskopf blended holes from the two layouts to eliminate distances between the holes and improve the routing, so that Troon North is now better than ever.

RIGHT: Monument Course

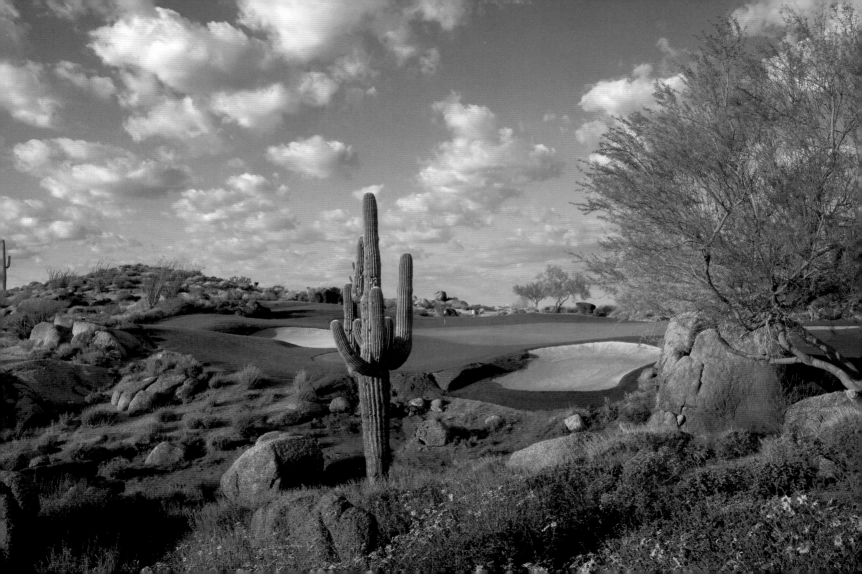

Seven Canyons Golf Club is a course that revels in the famous red rocks of Sedona, Arizona, its fairways cocooned by the surrounding 100,000 acres of the Coconino National Forest. The course, designed by Arizona-based Tom Weiskopf, opened in 2005. The emphasis at Seven Canyons is on precise shot-making over length, with the course measuring 6,746 yards and playing to a par of 70. At 4,500 feet above sea level, the layout features tight landing areas, small greens, and natural water hazards, with the fairways cloistered by the red rocks beneath the ruddy escarpments of the Mogollon Rim. Seven Canyons is a private golf and residential club.

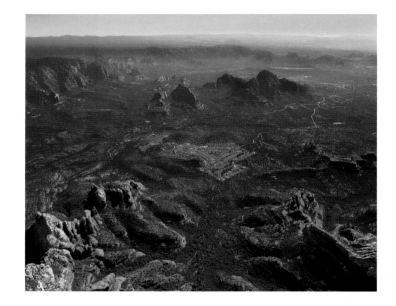

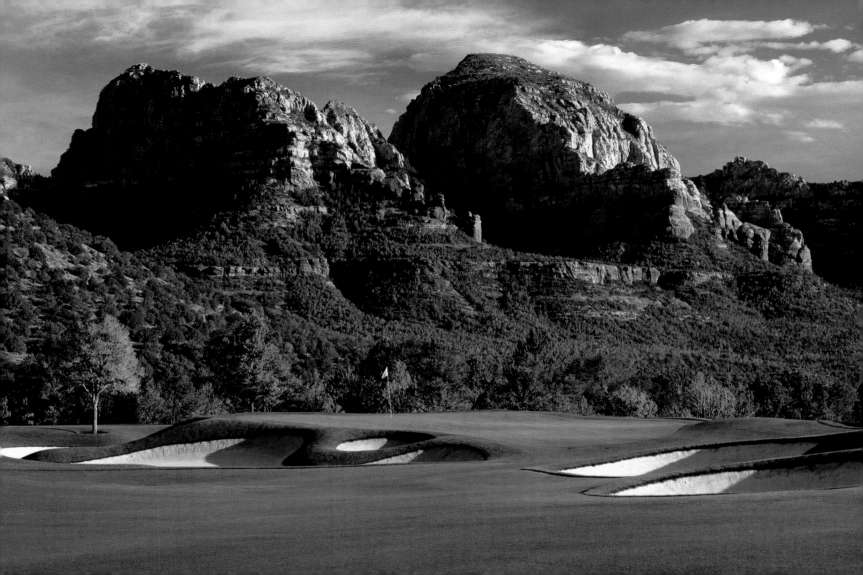

JANUARY 25 | WHISPER ROCK GOLF CLUB—ARIZONA, U.S.A.

Whisper Rock in Scottsdale, Arizona, has created considerable buzz in the golf world, as much for its reputation as a place where PGA Tour pros come to hang out and enjoy the convivial atmosphere, good fellowship, and milkshakes, as for its two distinctive desert layouts. The Lower Course was the first course designed by Phil Mickelson, working with architect Gary Stephenson. It opened on March 1, 2001. The Upper Course, designed by Tom Fazio, opened in January 2005. The Mickelson course is the tighter of the two, with long carries over desert washes and monumental boulders. Whisper Rock was created by Gregg Tryhus, the Scottsdale real estate developer who founded Grayhawk, with its Raptor and Talon courses, a few miles to the south. Whisper Rock's membership reads like a Who's Who of the PGA Tour, including U.S. Open winner Geoff Ogilvy, Paul Casey, Aaron Baddeley, Tim Herron, Billy Mayfair, Mickelson and his longtime caddie, Jim "Bones" McKay, as well as TV commentator and chief raconteur Gary McCord, who serves as the club's unofficial goodwill ambassador. The club championship is virtually a mini PGA Tour event, whose winners include Mayfair, Chez Reavie, Tom Dempsey, and former Whisper Rock caddie turned Tour winner Kevin Streelman.

RIGHT: The Lower Course

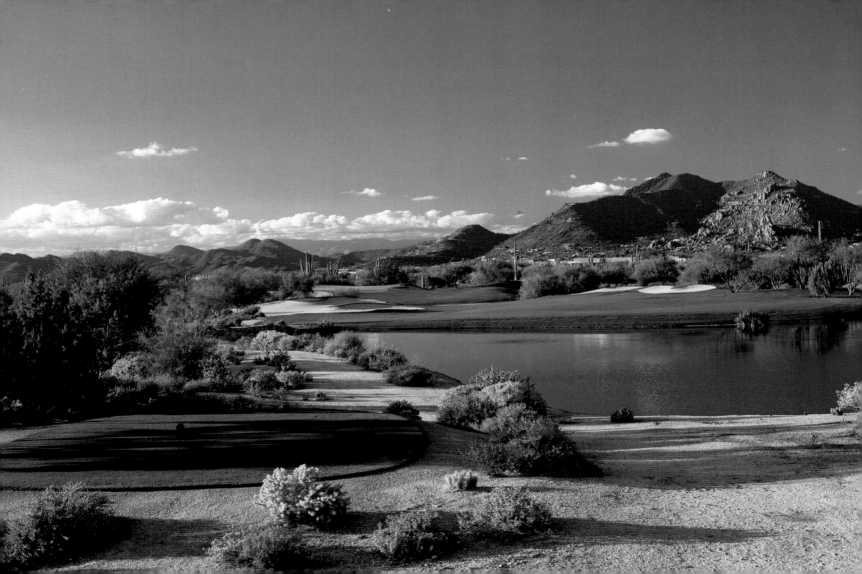

Ojai Country Club is the old-line course at southern California's storied Ojai Valley Inn and Spa. The resort is located in the valley that the Chumash Indians called Ojai, or Valley of the Moon, which runs east to west some 15 miles inland from Santa Barbara and is bounded by the Topatopa Mountains. The country club was developed in 1923 by Edward Drummond Libbey, owner of the Libbey Glass Company in Ohio, who hired southern California architect Wallace Neff to design the clubhouse in the Spanish colonial revival style and George Thomas to create the course through the old oaks. The guest rooms were then added from 1925 to 1930. Libbey, who had fallen in love with the beauty of the valley, with its Pink Moment sunsets off the mountain bluffs, was the driving force behind the development of the town of Ojai after 1917, including its colonial revival arcade and bell tower modeled after the campanile in Havana. The golf course, which has been frequented by Hollywood celebrities over the years—from Bing Crosby and Bob Hope to Kevin Costner and Will Smith—is one of the classic southern California designs of Thomas and his construction supervisor Billy Bell. Over the years, some of the original Thomas design features were lost, but in 1999 the course was restored, including two of the lost original Thomas holes. The inn underwent extensive renovations in 2004.

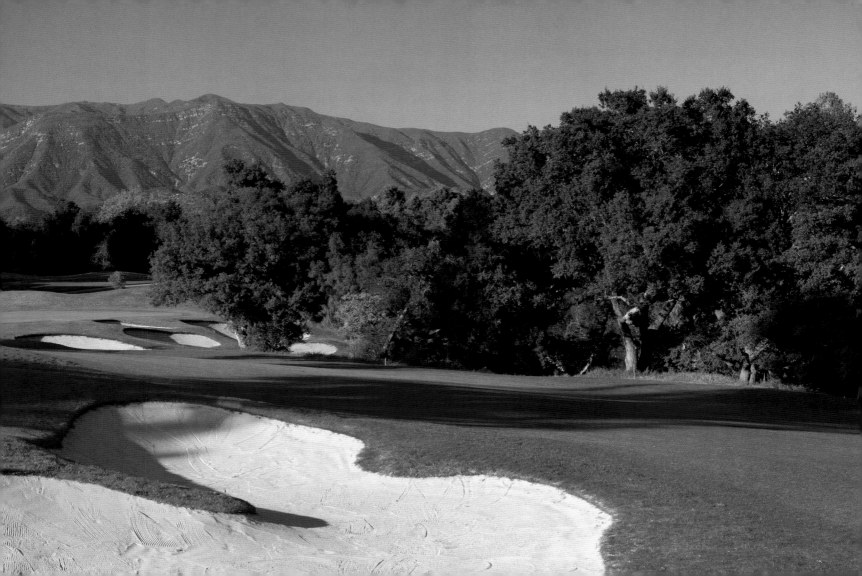

Lost Canyons Golf Club started out as a 36-hole public access layout located in the Simi Valley, just minutes north of Los Angeles. Both courses, the Sky and the Shadow, were designed by the inimitable Pete Dye in 2001, with Fred Couples serving as a consultant. The bold and beautiful Sky Course follows the ridge lines of the tricorned canyons, with panoramic views of the surrounding Santa Susana Mountains and oversized greens and bunkers to match the scale of the terrain. The treeless, brown-baked canyons are familiar as the backdrop for the TV show *MASH*, with White Face Mountain in the distance. The Sky Course will continue as a private golf course while the Shadow Course, which winds through the old oaks on the rolling canyon floor, will be lost to housing.

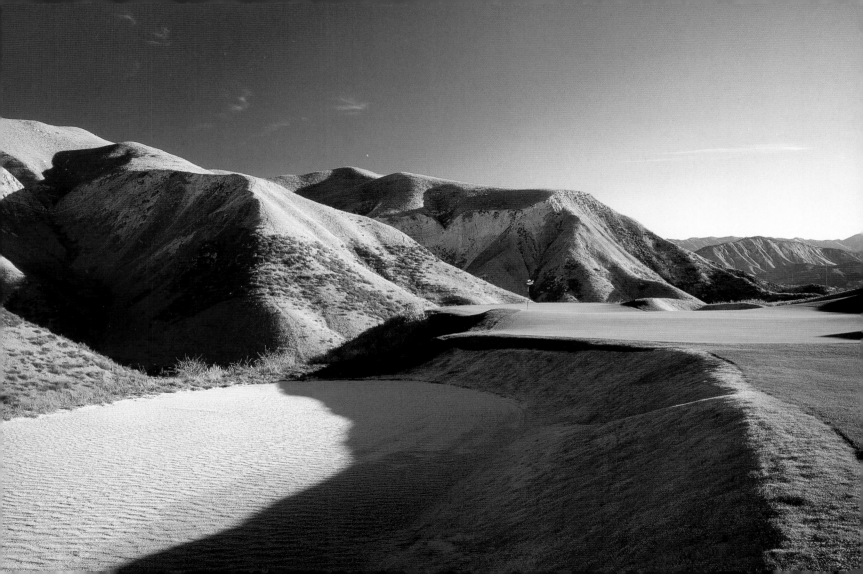

JANUARY 28 | THE RESORT AT PELICAN HILL—CALIFORNIA, U.S.A.

The Resort at Pelican Hill, located in Newport Beach overlooking the southern California coastline, has two courses designed by Tom Fazio. Both the Ocean North and Ocean South courses reconnoiter through the cliffs, arroyos, and coastal scrub, with the fairways positioned to enhance views of the Pacific from almost every hole. Santa Catalina Island, 22 miles offshore, is visible on a clear day. Covering nearly 400 acres, Fazio originally designed the courses in the early 1990s, and then returned in 2005 to renovate both, including upgrading the turf, introducing tall fescue and rye rough, and adopting lower-growing coastal plants to open up the ocean vistas. The revamped courses reopened in 2007 and the resort, with its Palladian inspired design, opened in November 2008. The terraced bungalows and villas overlook the South Course and there is a circular Coliseum Pool, whose diameter of 136 feet makes it the largest circular pool in the world. The North Course runs along the plateaus above the barrancas, while the South Course is silhouetted with gardens of coastal sagebrush and eucalyptus.

RIGHT: North Course

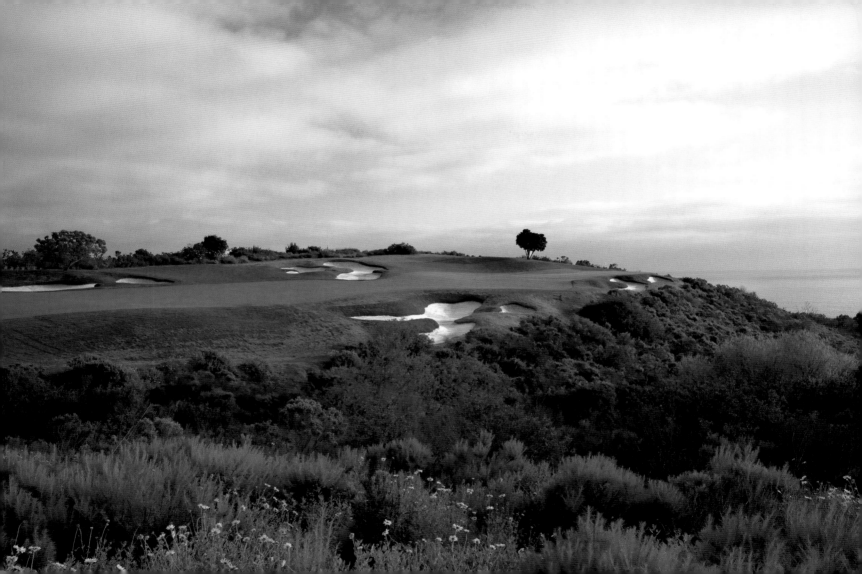

Trump National Golf Club, which occupies a regal setting on the Palos Verdes peninsula 30 minutes south of downtown Los Angeles, is a golf course that has enjoyed two lives. It began life as Ocean Trails Golf Club, with an audacious Pete Dye design along the coastal bluffs. Groundbreaking commenced in January 1998, and the course was one month away from opening when, on June 2, 1999, a landslide destroyed the 18th hole. A year later, Ocean Trails opened as a 15-hole course and shortly thereafter work began on restoring the 18th hole, with a massive underground retaining wall installed to prevent further landslides. Donald Trump then entered the scene, purchasing Ocean Trails in November 2002 and embarked on an extensive renovation program that included enormous, marble-white bunkers, large lakes, and waterfalls along the scalloped fairways that overlook the ocean from every hole. The overall price tag for the finished course reputedly came to over $250 million, making Trump National the world's most expensive course to build. The course also includes public access trails that lead to the ocean bluffs and coastal habitat corridor.

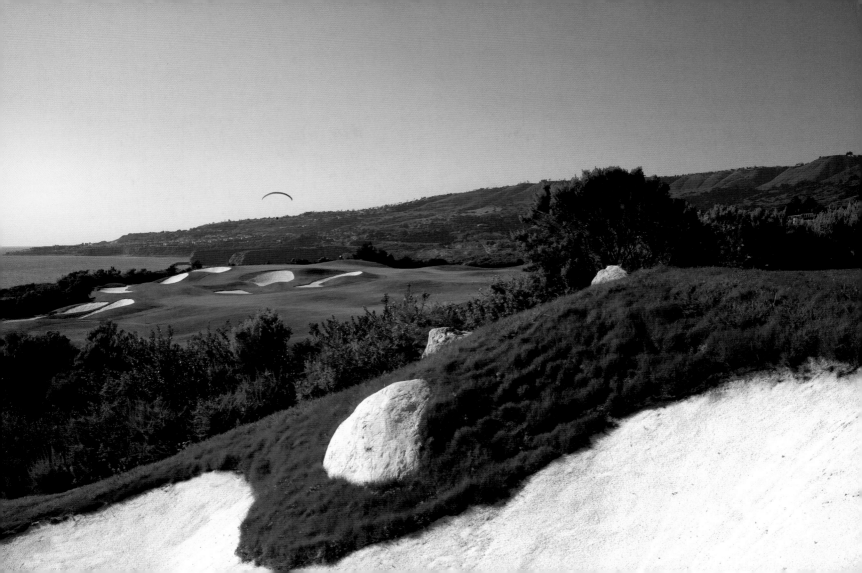

JANUARY 30 | STONE EAGLE GOLF CLUB—CALIFORNIA, U.S.A.

Stone Eagle, a course of lofty views, lies in a broad bowl above the Coachella Valley in Southern California's Palm Desert, surrounded by the Santa Rosa and San Jacinto Mountains. Opened in the fall of 2005, the private course covers 210 acres, with the remainder of the 640-acre site left as a preserve, creating a secluded golfing experience unmarred by housing. Stone Eagle was a departure for its designer, Tom Doak, who had not previously worked in the desert, having made his reputation designing untamed links courses from Ballyneal in Colorado to Oregon's Pacific Dunes to Cape Kidnappers in New Zealand. The steep terrain, swinging 300 feet between the highest and lowest points, required grading the holes over the ridgelines, with Doak creating wide grassed corridors and leaving rocky outcroppings around tees and greens. The immense, craggy bunkers were used to create transition areas to the desert, with care taken to align the trees and greens to the views of the crumpled mountains. Stone Eagle also offers some special touches, such as the Den at Ten, a fish taco stand at the 10th hole, and a par-three 19th hole. The club's goodwill ambassador is Al Geiberger, "Mr. 59."

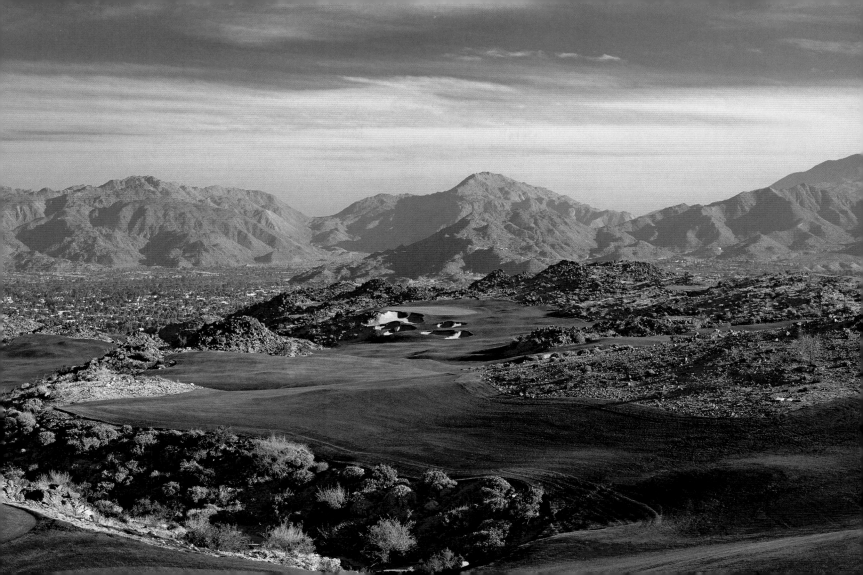

Barona Creek Golf Club is located next to the Barona Valley Ranch Resort & Casino, which is owned and operated by the Barona Band of Mission Indians in the foothills outside San Diego. Designed by Todd Eckenrode when he was with Gary Roger Baird Design, the course has been stretched to 7,448 yards, with more than 100 bunkers and a series of lakes and ponds connected to naturally fed streams. The course is also sprinkled with 170 resplendent oak trees transplanted from other areas of the Barona Indian Reservation, which was established in 1932 with the acquisition of Barona Ranch. The Barona tribe has been in the forefront of water conservation and environmental initiatives in golf course maintenance, including turf reduction, limiting overseeding to tees and greens, and use of a state of the art water reclamation facility that captures and re-uses water runoff from the resort and course. One of the top-ranked courses in California since it opened in 2001, Barona Creek hosted the 2007 Nationwide Tour Championship, which will return there in 2010.

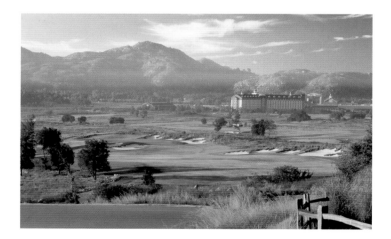

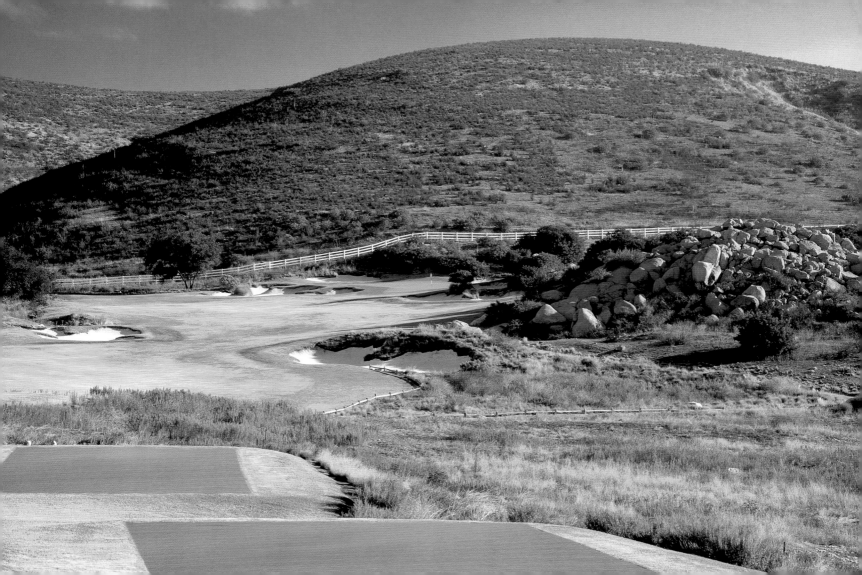

Cabo del Sol's Ocean Course may well be the best course ever designed by Jack Nicklaus, and the setting in Mexico's Baja Desert, overlooking the splendor of the Pacific, is certainly one of the most bedazzling. Not long ago, the tip of the Baja Peninsula was an area visited only by serious fishermen in search of trophy marlin and billfish. Nowadays, Los Cabos, or the Capes, the 20-mile stretch between the sleepy 17th-century mission village of San José del Cabo and the rowdy late-night bars of Cabo San Lucas, has become Mexico's top golf destination, with superb courses blossoming in the desert. Opened in 1994, Cabo del Sol is a memorable excursion through the profusion of the desert—organ-pipe and paddle cacti, palo verde, ironwood, wild plum, and fig trees—punctuated by peppermint fairways that spill onto the rocky coast surrounded by the searingly blue sea. The par-five 15th fans out to the Pacific and the lighthouse on *cabeza ballena*, or whale's head, overlooking the waters where the right and gray whales spend the winter after their long migration from Alaska. Nicklaus has called the 16th through 18th three of the best ocean finishing holes in the world, with the par-three 17th playing over the sandy scimitar of beach to a raised green barricaded by the pink and gray sea rocks.

FEBRUARY 2 | DIAMANTE CABO SAN LUCAS—MEXICO

Golf flourishes at Los Cabos, with its entrancing contrasts of verdant green fairways ringed by a desert forest of elephant trees with their papery bark, ironwood trees, agave, and cactus overlooking the Prussian blue waters of the Pacific. A decade ago there was only a quartet of courses, but new layouts are springing up, including a sprawling 1,500-acre golf community being developed at Diamante Cabo, just north of Cabo San Lucas. The Dunes Course designed by PGA Tour star Davis Love III, a committed course architect, opened in 2009. It is an oceanside links across from the massive rock archway of Los Arcos that dips into the sea. On the drawing boards is a second, Oasis Course to be designed by Phil Mickelson, whose debut design, Whisper Rock in Scottsdale, Arizona, has received high marks.

BELOW: Los Arcos at Cabo San Lucas

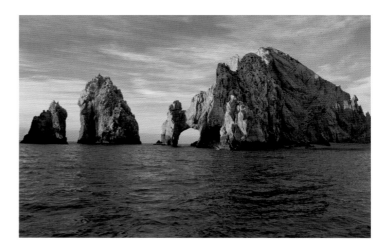

Jack Nicklaus has been the godfather of golf in Los Cabos, beginning with his course in 1993 for the elegant One & Only Palmilla Resort, which dates back to the 1950s, when Cabo was a hideaway for the Hollywood elite. The original Arroyo and Mountain Nines, with their desert cutaways, have been enhanced with an Ocean Nine that sports two holes along the sea. In 1994, Nicklaus completed his gorgeous and unsurpassed Ocean Course at Cabo del Sol, subsequently joined by Tom Weiskopf's Desert Course. Nicklaus's next Cabo effort, Club Campestre San José Golf, opened in 2007, anchoring a residential development in the foothills above San José del Cabo. Puerto Los Cabos Golf Club, his most recent encounter with the Baja desert, features an 18-hole course consisting of the Marina back nine designed by Nicklaus and the Mission front nine designed by Greg Norman. Each designer will eventually have a complete 18-hole design to his credit. Puerto Los Cabos is situated on 2,000 acres east of San José del Cabo. From the high point of the tee of the par-three sixth hole, the golfer stands like stout Cortés, whose expedition arrived here in 1532, surveying the ten miles of Pacific coastline running out to Land's End.

BELOW: The Westin Resort & Spa Los Cabos

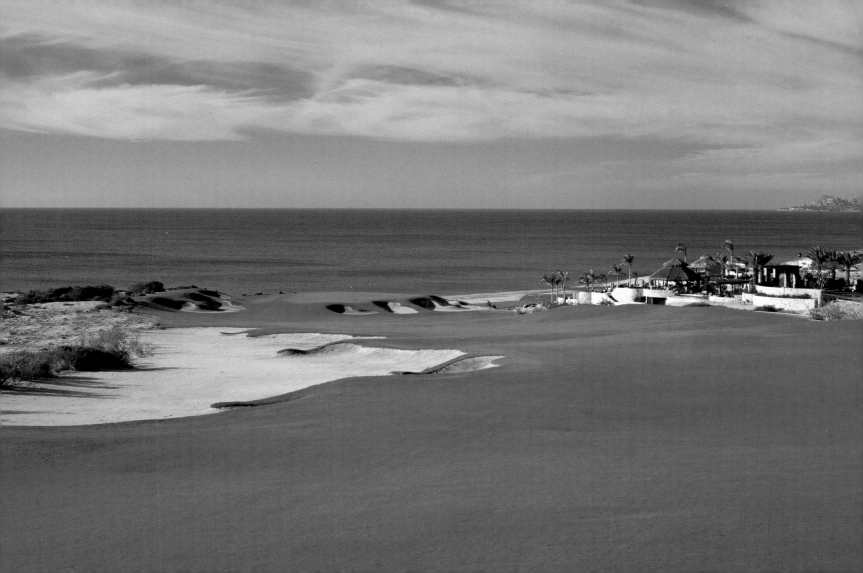

Querencia was the first private course and residential community in the golfing galaxy of Los Cabos, with its chichi hotels along the 20-mile corridor between San José del Cabo and Cabo San Lucas. Querencia represents a rare foray outside the United States by its famed designer, Tom Fazio. Opened in 2000, the course is cambered on the stony cactus- and mesquite-covered hills between Palmilla and the surfing hot spot of Playa Costa Azul two miles south of San José del Cabo. The sculpted fairways of bull's-eye Bermuda grass are cut generously, serving up sweeping views over the Pacific from the shifting elevations. Querencia is also planning a second course, to be designed by Gil Hanse, whose lay-of-the-land approach contrasts with Fazio's more crafted contouring. Fazio's work will also be on display at the Chileno Bay Club, a 1,300-acre development nearer to Cabo San Lucas.

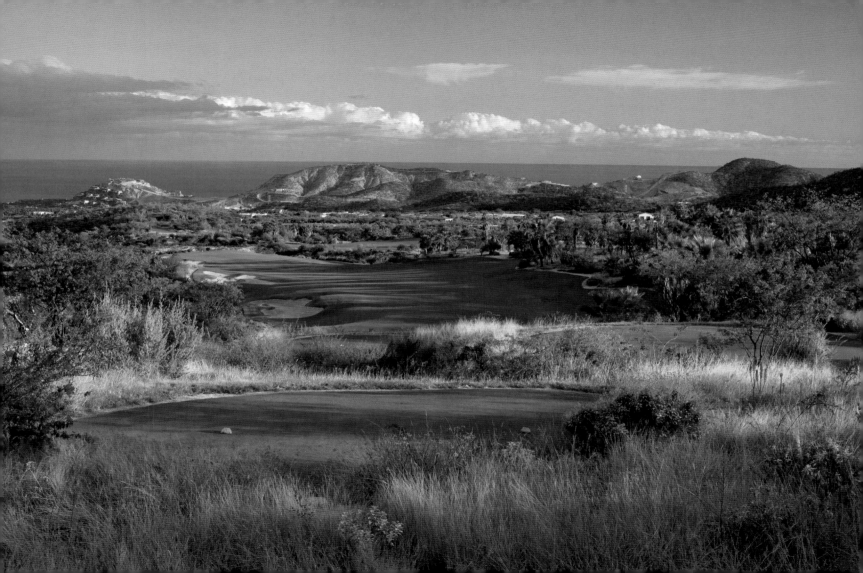

The Four Seasons Resort Punta Mita is a shining example of Jack Nicklaus's flair for designing Edenic courses in tropical settings. The resort is spread out over nearly 1,500 acres on a peninsula between the Pacific and the Sierra Madre foothills some 45 minutes north of Puerto Vallarta. The course is routed around a narrow point, with five holes flirting with the Pacific, and three more wrapping around Banderas Bay. Some 1,800 palm trees frame the fairways, with waste bunkers of soft white sand. The showstopper at Punta Mita, or Tip of the Arrow, is an optional 194-yard par-three hole, No. 3B, that plays across the ocean to a featherbed of green on a small rocky island. Golfers are ferried to the island by an amphibious golf cart.

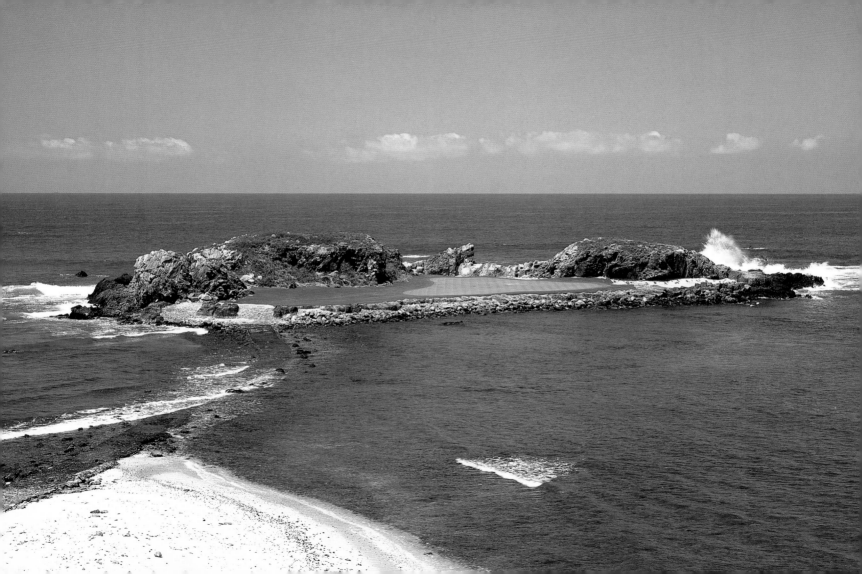

FEBRUARY 6 | EL CAMALEÓN GOLF COURSE AT THE FAIRMONT MAYAKOBA RESORT—MEXICO

The El Camaleón Golf Course or "The Chameleon" is located 45 minutes south of Cancún on the Riviera Maya. The course takes its name from its ever-changing landscape. The plush green paspalum fairways are pocked with *cenotes*, or subterranean sinkholes, beginning with one in the center of the first fairway. Designed by Greg Norman, the routing incorporates holes hewn from dense mangrove swamps and jungle, interspersed with open seaside holes ringed by sand—including the par-three 15th, which plays out to the Caribbean. The most distinctive feature of all is the series of limestone-lined canals that lace through the layout, with the first tee reached by boat from the resort's bungalows. In 2006, El Camaleón became the annual host course for the PGA Tour's Mayakoba Golf Classic, the first official Tour event ever held outside the United States or Canada. The appealing clubhouse is a triangular modern design with a three-tiered copper roof.

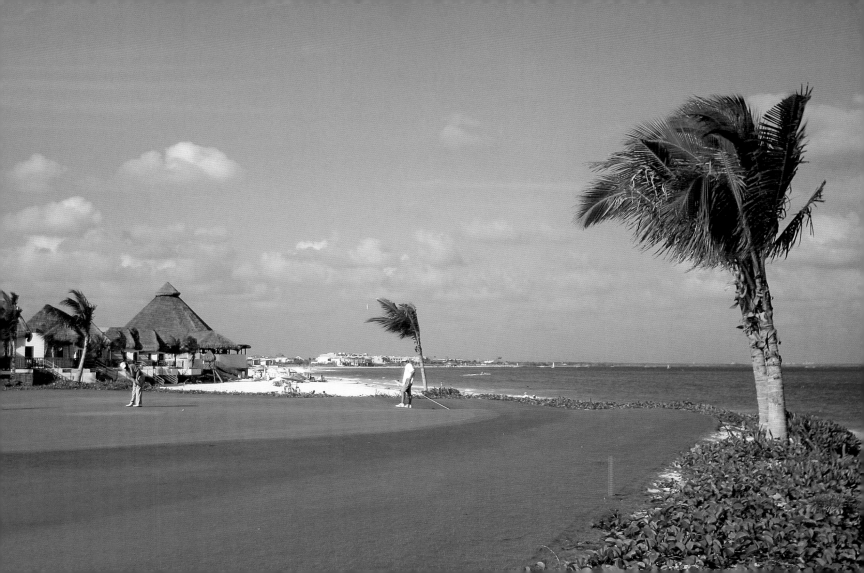

Fuego Maya, the Spanish for Mayan Fire, is the golf course at La Reunión Resort in Antigua Guatemala, crowned by the four majestic volcanoes of Guatemala's central highlands—Agua, Fuego, Acatenago, and Pacaya. The course is 11 miles from Antigua Guatemala, the city founded by the Spanish conquistadors in 1543. It served as capital of the Spanish colony for over 200 years, until a series of earthquakes in 1773 leveled much of the town. With its ruined 16th-century churches and well-preserved Spanish-influenced Baroque architecture, Antigua was designated a UNESCO World Heritage Site in 1979. The architects of the golf course are the venerable Pete Dye and his eldest son, Perry, who created a 7,300-yard, par 72 layout that spills across the slopes of the Volcán de Fuego (Volcano of Fire) at an elevation of nearly 4,000 feet on what was once a coffee plantation. At 12,346 feet high, Fuego is an active volcano, constantly puffing out smoke but without any major eruptions. Because of cool evenings owing to the altitude, the Dyes were able to seed the fairways and greens in this setting of tropical foliage with bentgrass and to grow bluegrass rough, strains familiar to golfers in the northeast United States. In typical Dye fashion, there is a humdinger of a finish, with a par-five that measures almost 700 yards, a par-three with a waterfall to the right, and a downhill 18th. The first golf resort in Guatemala, La Reunión offers 26 casitas built to echo the style of colonial Antigua.

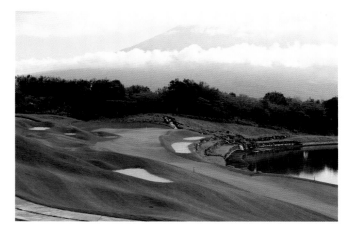

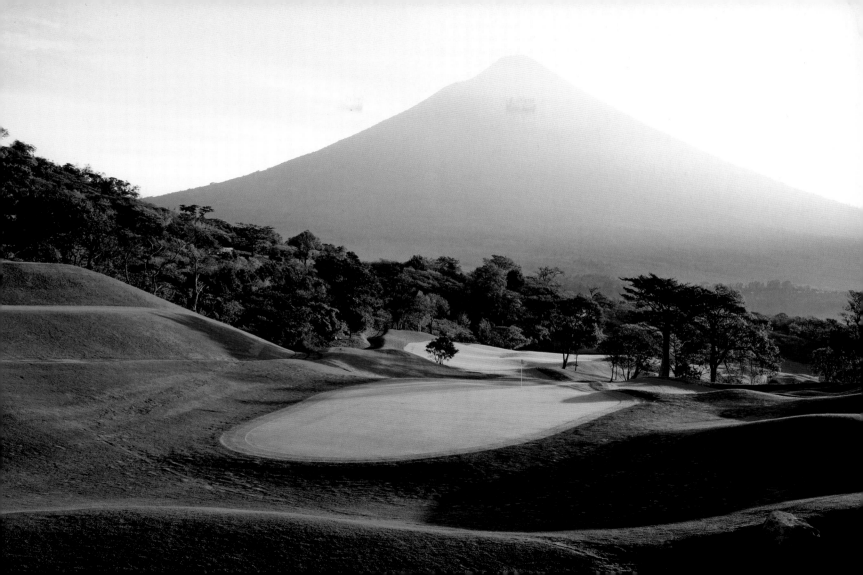

FEBRUARY 8 | FOUR SEASONS GOLF CLUB COSTA RICA AT PENINSULA PAPAGAYO—COSTA RICA

The Four Seasons Golf Club Costa Rica at Peninsula Papagayo is located in the northwest province of Guanacaste, on the 2,300-acre spear-shaped peninsula that barbs the blue waters of the Golfo de Papagayo. Designed by Arnold Palmer, great care was taken to preserve as much as possible the habitat of the surrounding rain forest, whose tree dwellers include howler and squirrel monkeys. From sharply shifting elevation changes, 15 of the 18 holes have views of the Pacific and of the miles of white, coral, gray, and black sand beaches that trace the coastline. The Four Seasons Resort, opened in 2004, was designed by Costa Rican architect Ronald Zürcher.

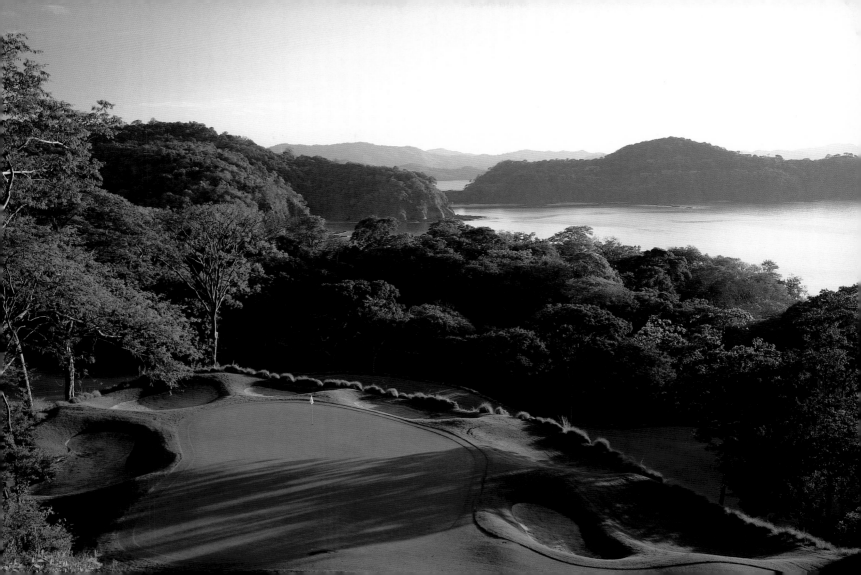

FEBRUARY 9 | THE JOCKEY CLUB (RED COURSE)—ARGENTINA

The Jockey Club, with its Tudor clubhouse fit for a king, is located on Avenida Márquez in San Isidro, a suburb on the north side of Buenos Aires. One of the most famous and stylish of South American clubs, the Jockey Club has two 18-hole courses, the championship Red Course and the Blue Course, both designed by the illustrious Dr. Alister MacKenzie. The site of the courses, adjoining the club's racetrack and polo fields near the River Plate, is flat. MacKenzie therefore had to create features and give the courses definition, which he accomplished by constructing pushed-up greens, mounds, and clever use of bunkering. The courses opened in 1935, one year after MacKenzie's death. The Red Course hosted the World Cup in 1962, when the American team of Arnold Palmer and Sam Snead won, and in 1970, when the Aussie duo of Bruce Devlin and David Graham were victorious.

BELOW: The clubhouse

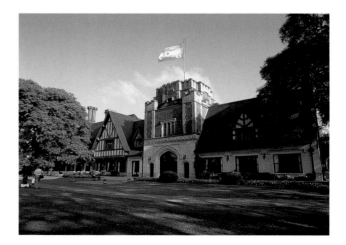

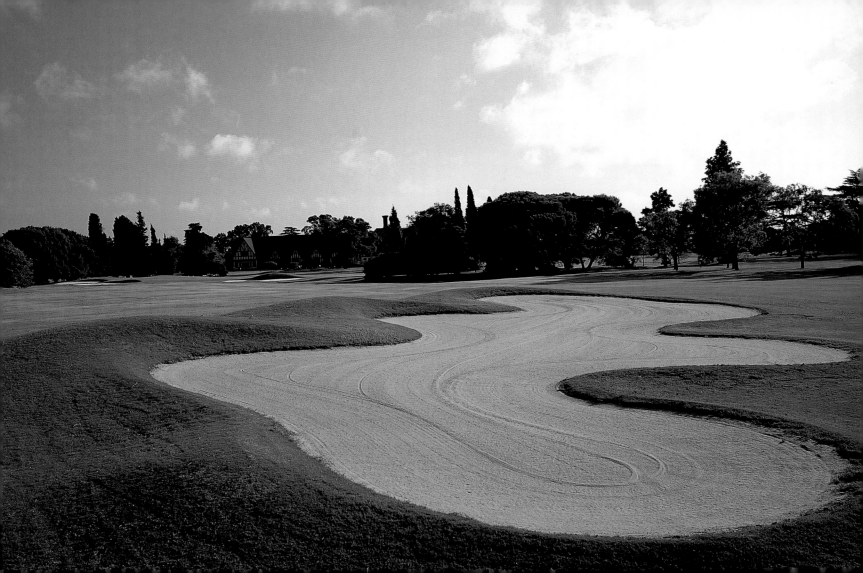

Llao Llao Resort & Hotel is set in the Andean grandeur of Argentina's Nahuel Huapi National Park in Patagonia. Located 22 miles from the town of Bariloche and 17 miles from the main ski center of Cerro Catedral, the hotel sits on the hill between Lakes Nahuel Huapi and Moreno, with the snowcapped Andes as a backdrop and the golf course spread out below. The hotel, opened in 1940, is the work of the well-known Argentine architect, painter, and sculptor Alejandro Bustillo. Designed in the style of a Canadian mountain lodge, it features cypress logs, Norman red roof tiles, and a stone base. The golf course was situated and designed by Alberto Solar Dorrego. The course loops around the shores of ice-blue Lake Nahuel Huapi, with specimen trees of cypress, coigue, and arrayan. Above the course loom Mounts López and Capilla and the towering Tronador.

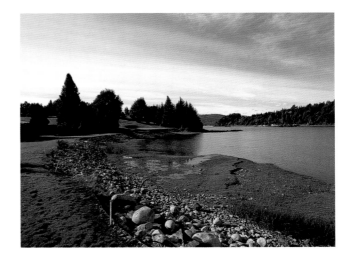

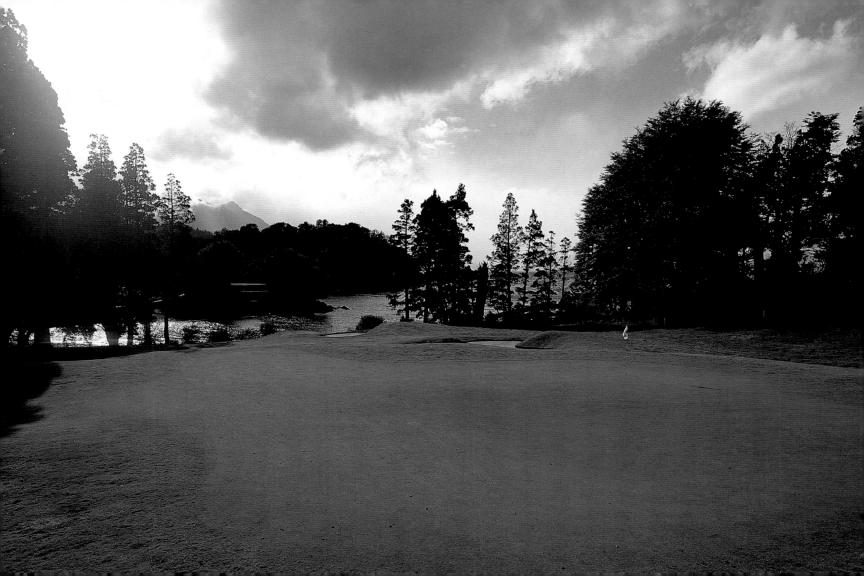

FEBRUARY 11 | ARELAUQUEN GOLF AND COUNTRY CLUB—ARGENTINA

Arelauquen Golf and Country Club is set in the mountain splendor of Patagonia, eight miles from Bariloche, surrounded by the Andes. The resort covers 1,400 acres, of which 1,000 are maintained as wilderness. The course, for which Argentine pro and Champions Tour player Vicente "Chino" Fernandez served as the design consultant, borders Gutiérrez Lake and is crossed by Longochinoco Stream. There are views throughout the course of the peaks of Cerro Otto and Cerro Catédral, the home of the area's main ski resort. There is also a five-star, 23-room mountain lodge at the course, built of native stone and timber.

BELOW: The clubhouse

Gávea Golf and Country Club lies on the coast south of Rio de Janeiro, beyond Copacabana and Ipanema beaches. As Sir Peter Allen put it: "The location of Gávea—which Herbert Warren Wind tells us means Crow's Nest—is spectacular in the extreme as it is dominated by the huge monolithic Rock of Gávea which hangs 2,000 feet over the course like a great monster." The first nine holes and the final four are laid out through the hills, while the remaining five run through the palms and the flat sandy stretch near the shore. The second-oldest golf club in Brazil, Gávea was founded in 1923 by a group of Scots and Englishmen, with the course laid out by Arthur Morgan Davidson, a young assistant professional from Peterhead in Scotland, who continued as the pro for another 20 years.

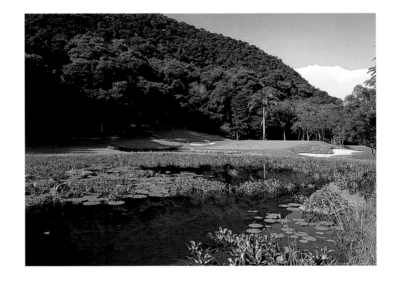

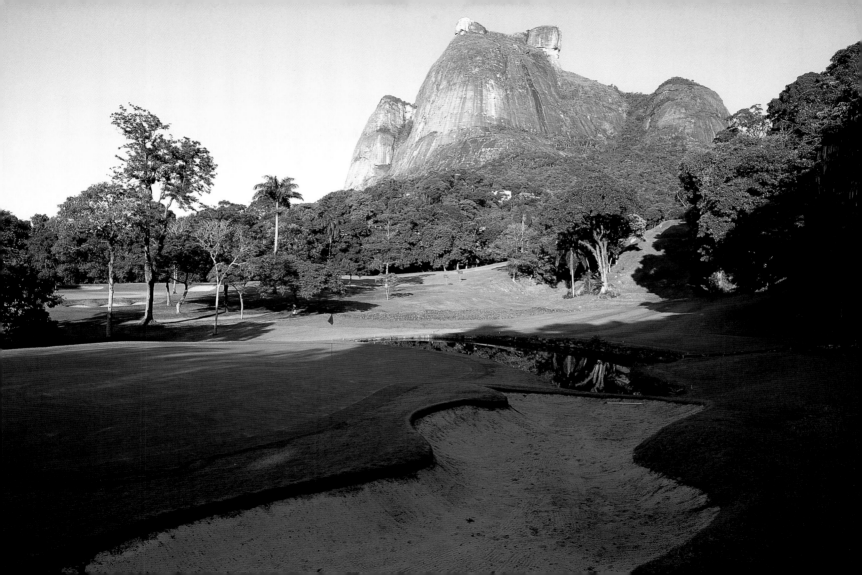

Terravista Golf Course is part of a new resort located in the Brazilian state of Bahia, a 90-minute flight north from São Paulo to Porto Seguro and then a 50-minute drive or, if you prefer, a ferry ride across the bay to Arraial D'Ajuda and a short drive to Trancoso. Terravista may not be easy to get to, but it is worth the journey, with spectacular holes spread out across the tabletop of the wrinkled sandstone cliffs that soar above the white sand beaches of the Atlantic. The 12th through 15th holes all run along the 120-foot high cliffs. This highwire act of a golf course, completed in 2004, was designed by Dan Blankenship, an American who worked with Pete and Perry Dye on the course at the Rio beach resort of Buzios, and decided to settle in Brazil. Trancoso is a tranquil fishing village and one of the earliest Portuguese settlements in Brazil, dating from 1586.

FEBRUARY 14 | GREEN MONKEY GOLF COURSE AT THE SANDY LANE HOTEL—BARBADOS

The Green Monkey Golf Course is a spectacular course overlooking the Caribbean at the ultra-luxurious Sandy Lane Hotel in Barbados, where Tiger Woods tied the knot with his Swedish valentine, Elin Nordegren, in the fall of 2004. Unofficially opened in 2003, the course took years to build, with the fairways blasted and chiseled in terraces through a coral stone quarry, its bare, 100-foot high walls striated with pinks and grays. The massive undertaking, including the creation of artificial lakes through the landscape of coral boulders, was orchestrated by Tom Fazio, who also completely reworked and expanded Sandy Lane's existing resort course. The Green Monkey owes its creation to Dermot Desmond and J. P. McManus, two Irish entrepreneurs and passionate golfers who purchased the Sandy Lane Hotel and rebuilt it from scratch. The course takes its name from the small green monkeys that came to Barbados as stowaways on slave ships 350 years ago. One of the bunkers is emblazoned with a grass island in the shape of a monkey.

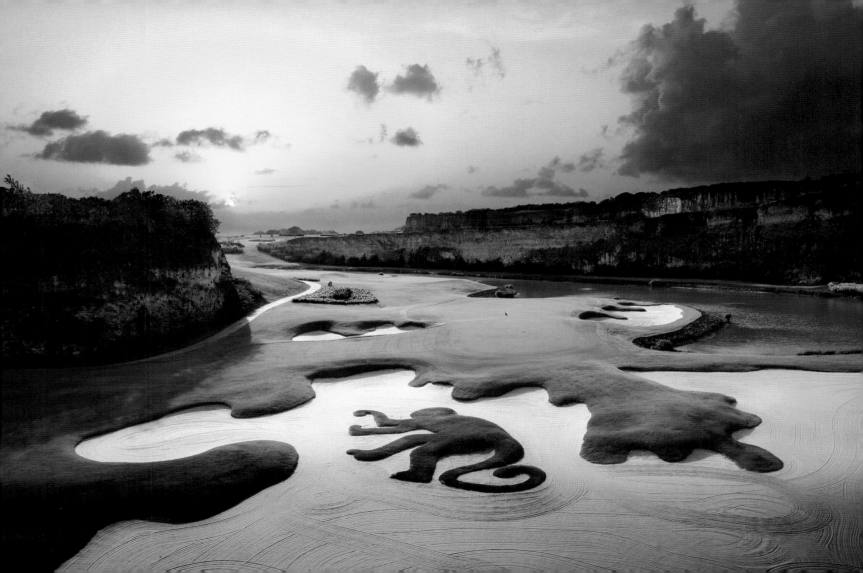

Royal Westmoreland in Saint James Parish, on the west coast of Barbados, is a broad, tumbling course situated high above the Caribbean and fanned by the trade winds. Designed by Robert Trent Jones, Jr., the course has some of the most dramatic and challenging par threes in golf, with carries over coral rock, equatorial gorges, and water-filled quarries. While there is room off the tee, stray shots are likely to end up in one of the sugary bunkers or borders of purple feather grass and pandana, the spiky green and yellow cane lilies used to weave native baskets. Royal Westmoreland finishes with a flourish—a par five that requires a drive over a ravine brimming with mahogany, river tamarind, and dwarf bamboo. The course is surrounded by villas overflowing with bougainvillea and hibiscus, including Lazy Days, the home of Masters champion Ian Woosnam that is just below the 18th tee.

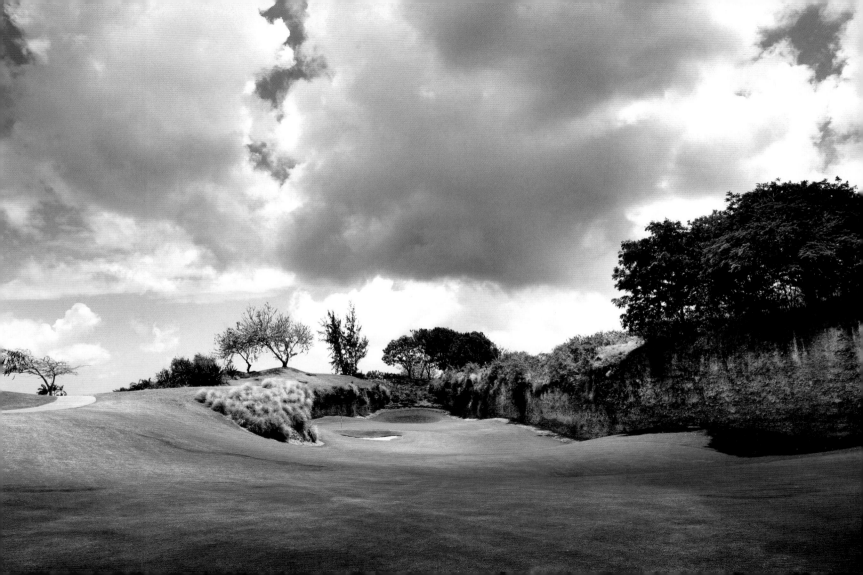

The Commandatuba Ocean Course is a tropical idyll located on Ilha de Commandatuba off the coast of Brazil's Bahia province. Part of the Transamerica Ilha de Commandatuba Resort, the course, which opened in 2000, was designed by American Dan Blankenship, who is based in Brazil. The course is laid out on a flat spit of sand between the Atlantic beach and a mangrove swamp. The fairways run through scattered stands of centennial coconut trees, jupatis, and a patchwork of small lakes. The five finishing holes all skirt the beach, with fairways and greens blocked out on the surrounding sandy waste areas. The course is inhabited by capuchin monkeys, exotic birds, foxes, and anteaters.

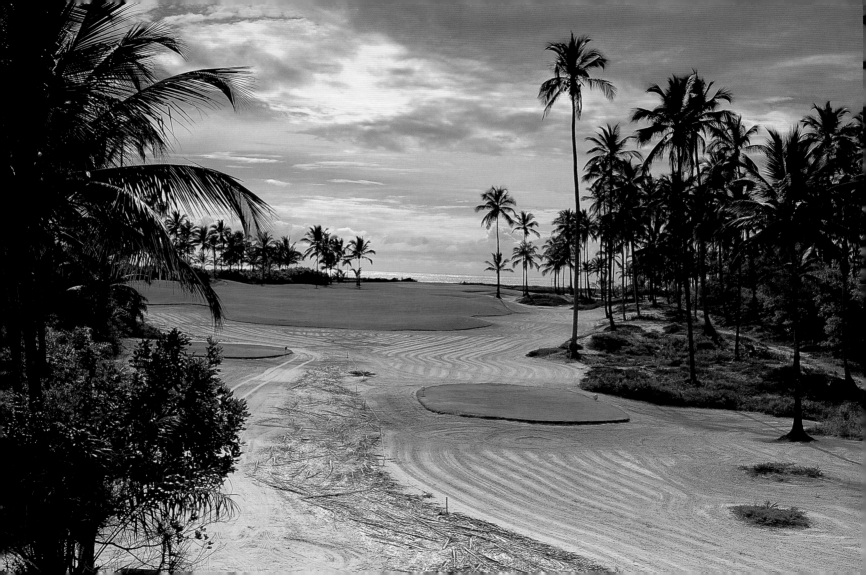

There are several fine courses in Colombia, but the most famous is El Rincón, located on the eastern outskirts of Bogotá. The course was designed by Robert Trent Jones in 1953, when he was gaining international prominence, on an open plain spotted with eucalyptus and pines near the Bogotá River. Jones planted numerous trees, seeded the fairways with kikuyu grass, and used the natural depressions to create lakes, so that water comes into play on 11 of the 18 holes. Jones also took into account the effect of the altitude in increasing the flight of the ball, since Bogotá is situated in the eastern range of the Andes, stretching the course to over 7,500 yards. The course has changed little over the years, except that the order of the two nines has been reversed, and Jones revised the par-three seventh to make it more closely resemble his famous par-three fourth over the water at Baltusrol. In 1980, El Rincón hosted the World Cup won by the Canadian pairing of Dan Halldorson and Jim Nelford.

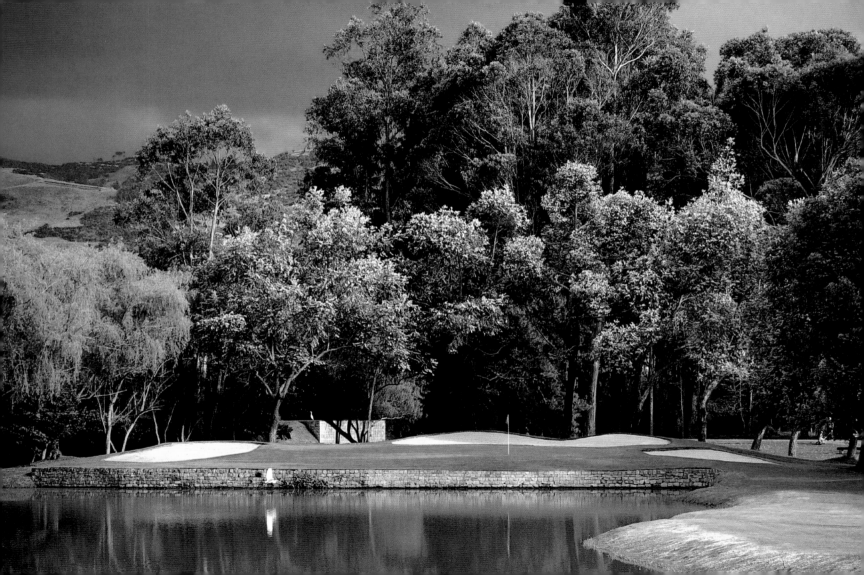

Canouan is one of the out-of-the-way islands forming the Caribbean nation of St. Vincent and the Grenadines, a mile-wide cluster of lush green hills trailed by a long skein of white sand beaches wrapped around the blue bays of Glossy and Friendship. The Trump International Golf Club is part of the Raffles Canouan Resort, the sybaritic site of the 2009 *Sports Illustrated* swimsuit issue photo shoot. The 6,900-yard course gradually ascends through forested hills, including Mount Royal—an extinct volcano that rises 787 feet, offering breathtaking views over the aquamarine waters. From the signature 13th hole, the entire formation of the Grenadines is on display, with a bird's-eye view of Grenada to the south and St. Kitt's in the distance to the north. The original course at Canouan, known at Carenage Bay, was an innovative creation by architect Roy Case, consisting of 13 greens with 16 tee boxes, that was wedged into a tight site of only 60 acres. Donald Trump brought in Jim Fazio to revise and expand the original layout on a larger site, and in 2004 the Trump International Golf Club was born, putting tiny Canouan on the Caribbean's map of golfing treasures.

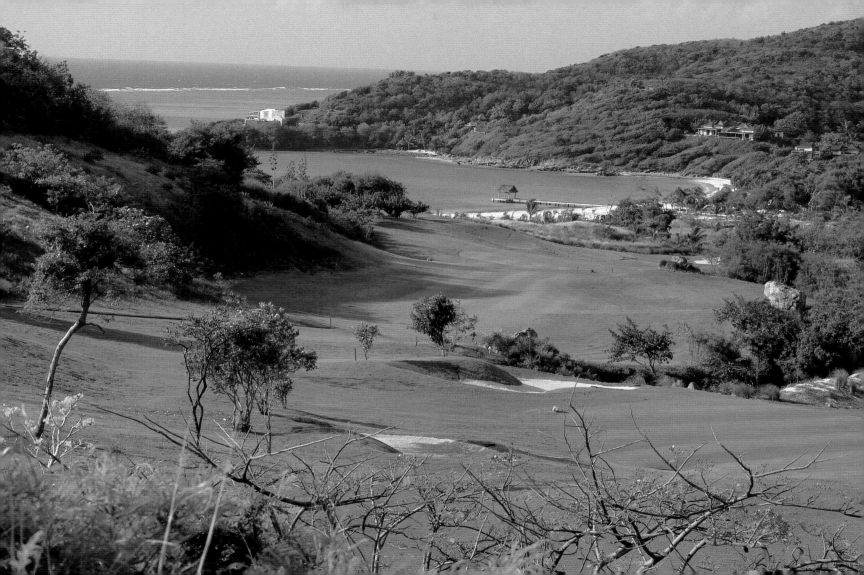

Royal St. Kitts Golf Club, located on the larger of the twin-island nation of St. Kitts and Nevis in the West Indies, is a capacious course of broad fairways, cavernous bunkers, and scattered coconut palms. It has the distinction of offering two holes that run along the Caribbean while another three trail along the Atlantic coast. Though the course dates from 1976, it was entirely remodeled and several new holes were added by leading Canadian architect Thomas McBroom, opening for play in November 2004. The course is part of the Marriott Resort and Royal Beach Casino located at Frigate Bay, south of the capital of Basseterre. St. Kitts is an island of tropical beauty, with graceful green hills rising in the central highlands that can best be viewed from the Four Seasons Resort Course on neighboring Nevis as it scales volcanic, cloud-capped Mount Nevis. The inland holes feature a series of interconnected lakes, while the finishing holes, including the downhill par-three 15th, traverse the ocean coast. St. Kitts was the center of the British sugar trade going back to the 1640s, and, as on Nevis, several of the elegant plantation houses on the north end of the island have been restored as small hotels.

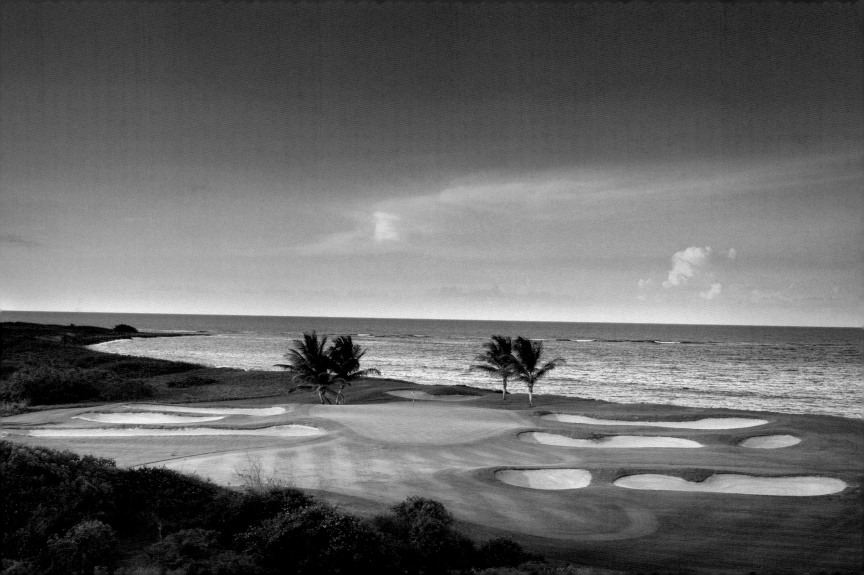

Bahía is the most recent beachcomber of a links laid out along Puerto Rico's golfing shores. Located 25 minutes from San Juan at Rio Grande on the north coast, it sambas out along two miles of beach, bounded by the Espíritu and Herrera Rivers that flow from the El Yunque National Rainforest. The fairways are cut through 100-foot high coconut palms, almond and flamboyan trees, and the sea grapes that form a natural maritime forest. Opened in 2008, Bahía is the first design in Puerto Rico by Robert Trent Jones, Jr., whose father created the enduring classics of Caribbean golf at Dorado Beach for Laurance Rockefeller. The course is home to frigate birds, pelicans, West Indian whistling ducks, and many songbirds. Bahía will anchor a new St. Regis Resort that is part of a planned residential community.

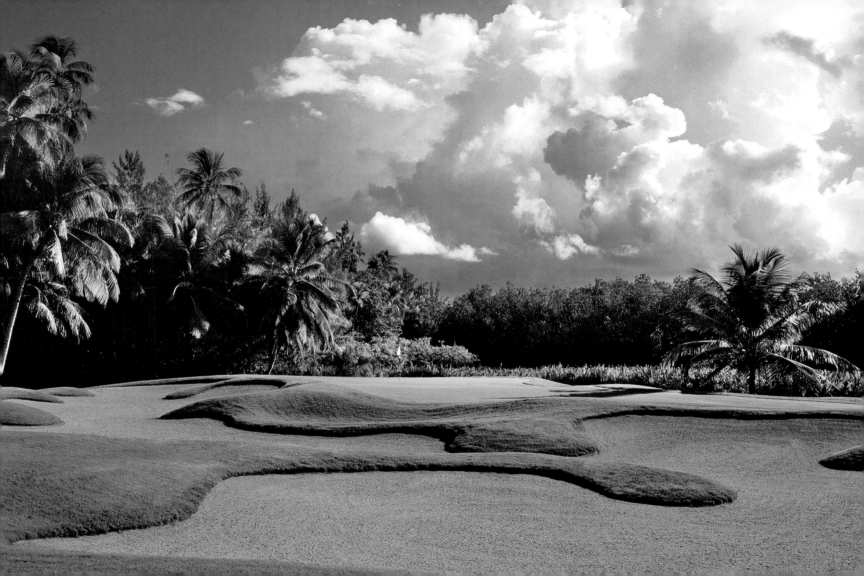

Casa de Campo's Teeth of the Dog is Pete Dye's Dominican masterpiece, one of the world's truly great seaside courses and perennially ranked as the top course in the Caribbean. Located on the southeast coast outside La Romana, Dye first surveyed the site in 1969, when it was part of the vast holdings of Gulf & Western Corporation, whose CEO Charles Bluhdorn launched the Casa de Campo resort. The course was painstakingly constructed by hand, with 300 local laborers chiseling the fairways from the sharp coral known as *dientes del perro* that gives the course its canine moniker. Topsoil was brought from the mountains by ox-drawn carts and the grass was all planted by hand. The entire course bears Dye's unmistakable stamp, from the cinnamon-colored waste bunkers to the coral tee boxes, to the small, contoured greens. Dye created a variety of inland holes but showed his true brilliance in letting Mother Nature take care of the seven holes that straddle and somersault across the azure waters of the Caribbean. Combined with the lavish tropical beauty of the setting, it is not hard to understand why Dye admits that Teeth of the Dog is the favorite of all his courses, and where he built a thatched-roof home alongside the fifth hole. In April 2003, Casa de Campo unveiled Dye's latest creation, dubbed Dye Fore, a course that spans cliffs and chasms above the ominous, 300-foot deep gorge of the Chavon River, its banks lined with endless rows of palm trees. The course also overlooks Altos de Chavon, a cobble-stoned replica of a 16th-century Spanish village built by Bluhdorn that houses restaurants, galleries, and artists' studios, as well as a stone amphitheater. The course follows the Chavon River out to the delta where it empties into the sea.

RIGHT: Teeth of the Dog

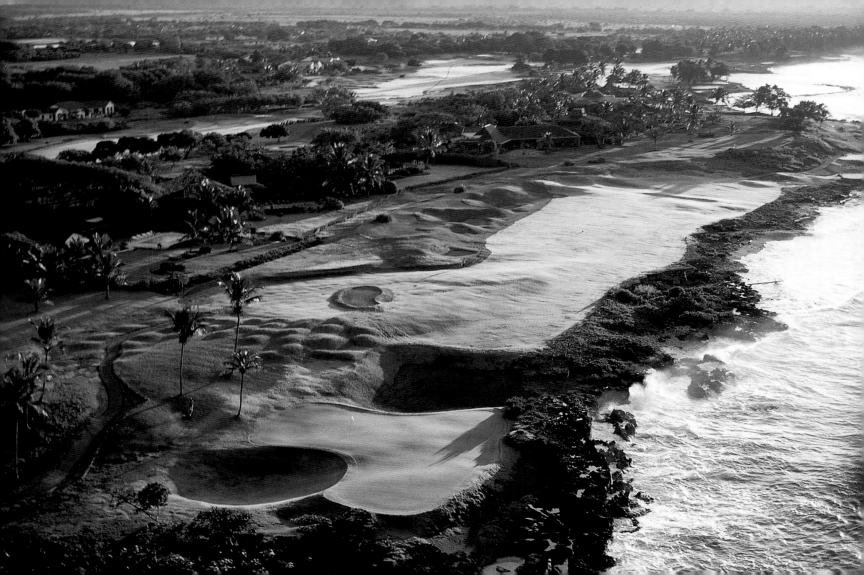

Punta Espada is the ravishing layout at the Cap Cana Resort opened by its designer Jack Nicklaus in November 2006. Cap Cana, on the southeastern coast of the Dominican Republic, is 10 minutes south of the Punta Cana airport, while the Roco Ki Resort is 10 minutes to the north; in between is the Puntacana Resort, the first luxury golf resort along the Punta Cana coastline. It was developed by Frank Ranieri and Theodore Kheel, working together with Julio Inglesias and Oscar de la Renta. Eight of the holes at Punta Espada play along the sea, with the verdant green fairways of seashore paspalum stenciled from the surrounding sand and framed by the waters of the Caribbean. The eighth is a short par-four with an infinity bunker of white sand running out to the shoreline, while the 250-yard par-three 13th plays across an ocean inlet with a bailout area to the right. Since 2008, Punta Espada has been the site of a popular event on the PGA Champions Tour. Punta Espada is the first of three planned Nicklaus-designed courses at Cap Cana, with the second, named Las Iguanas, in the construction phase.

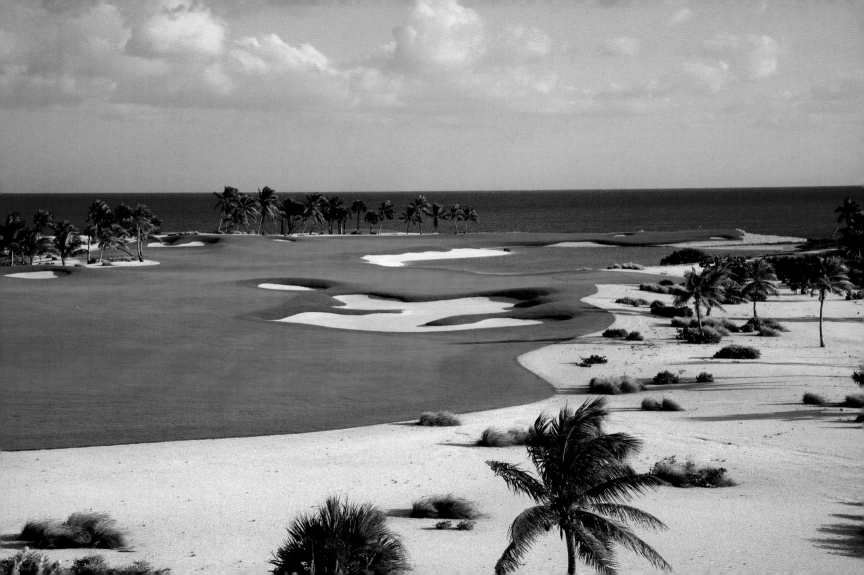

Roco Ki is a new and immense resort playground in the Punta Cana area of the Dominican Republic, joining the Puntacana Resort and Cap Cana. The Legacy Course, the first course designed by Nick Faldo in the Caribbean, is a seaside spellbinder and another one of the trophy courses that make the DR the Caribbean's leading golf destination. The course kicks off on the coral ledges above the sea before dipping into an old mangrove forest and crossing meadows of sawgrass that run across the fairways. The 15th fairway, which is webbed with exposed mangrove roots, returns to the sea. The 17th, which tips its cap to the seventh hole at Pebble Beach, is a short downhiller to a green ringed by coruscated rock formations and the dark blue sea. The 18th, named Los Dos Rezos, or The Two Prayers, is a worthy finisher that plays over two ocean inlets. The 2,500-acre resort is anchored by the Westin Roco Ki, with additional courses on the drawing board.

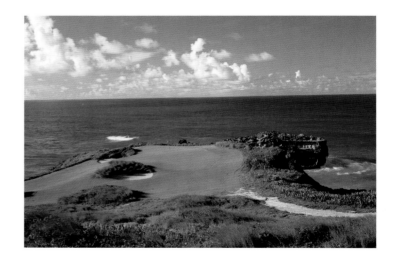

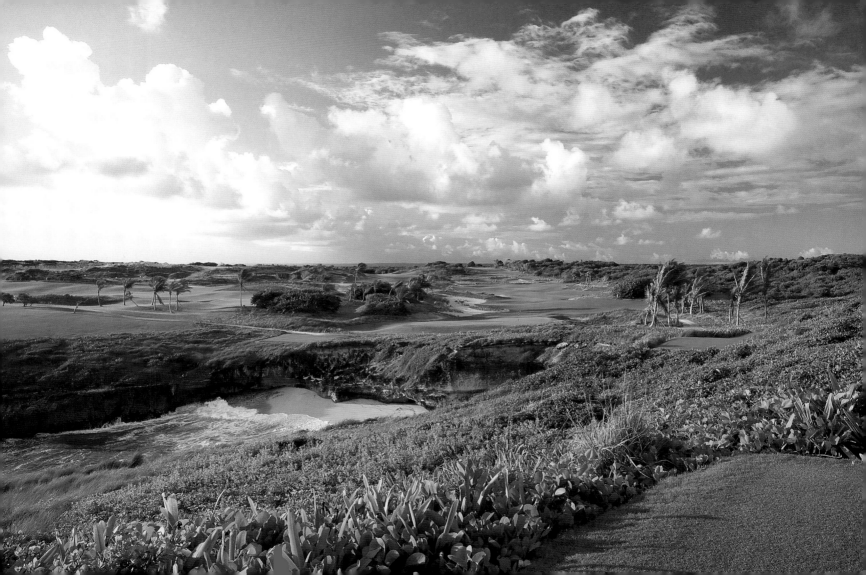

The Dominican Republic has earned a well-deserved reputation as the Caribbean's leading golf destination. The courses that have received all the attention are in the southeast, with four Pete Dye-designed courses at Casa de Campo and courses popping up left and right at Punta Cana, with several more on the drawing board. Playa Grande Golf Course is a spectacular but unheralded layout east of Puerta Plata in a remote area of the Dominican Republic's north coast. The last course worked on by legendary architect Robert Trent Jones, it was completed after many years in 1997. The course runs across tabletop cliffs 100 feet above the royal blue waters. With 11 holes circumnavigating the seaside cliffs, Playa Grande is truly the Pebble Beach of the Caribbean.

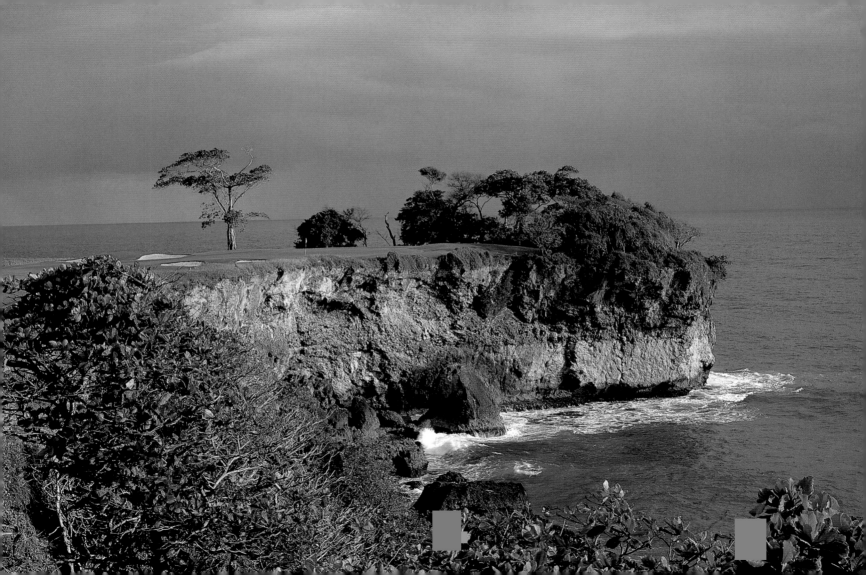

Cinnamon Hill, the course at Jamaica's Wyndham Rose Hall Resort, romps over a 400-acre former sugar plantation with rousing views of the Blue Mountains, tropical ravines, and the Caribbean coastline. Originally designed in 1969, the course was redesigned and renovated by Robert von Hagge and Rick Baril in 2001, vaulting it into the top ranks of Caribbean courses. The Cinnamon Hill Great House was completed in the mid-18th century by Edward Barrett, a relative of poet Elizabeth Barrett Browning, whose family lived off the plantation's revenues at their home on Wimpole Steet in London. In more recent times, the house was the second home of Johnny Cash and his wife, June Carter Cash. The course features a stone aqueduct, built in 1761, used in grinding sugar cane, and remnants of the old millworks rim the course, with the 17th hole called The Ruins. The front nine plays along the sea, with the Barrett family burial plot located near the fourth tee. The back nine climbs into the mountains, the fairways fringed with hibiscus, wild orchids, and flame-of-the-forest trees. The par-three 15th plays downhill across a jungle ravine to a green with a waterfall as backdrop. This hole is a favorite spot for Jamaican weddings and was the site of a scene in the James Bond movie *Live and Let Die*.

BELOW: The Rose Hall Aqueduct

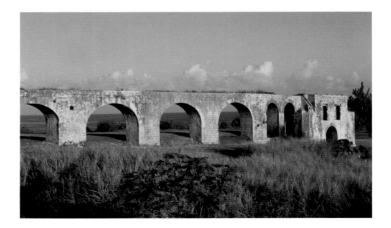

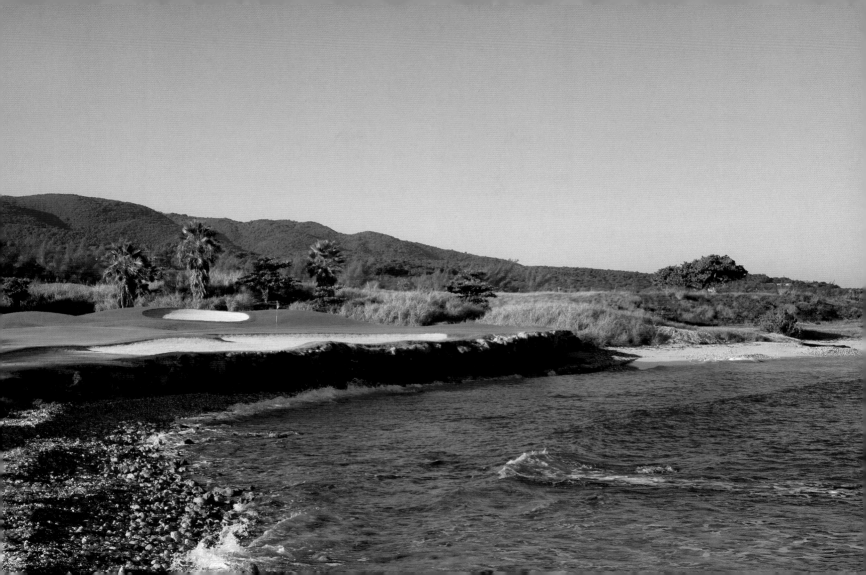

Miami's Biltmore Hotel, built in a Mediterranean revival style, is a triumphant Jazz Age architectural statement of the arrival of southern Florida as a tourist destination. The hotel, with its 93-foot copper-clad tower modeled after the Giralda Tower in Seville, hand-painted frescoes, travertine floors, and what remains the largest hotel pool in the continental United States, was developed by George Merrick and Biltmore hotels magnate John McEntee Bowman as the centerpiece of Coral Gables. The great Donald Ross designed the course, which opened in January 1925, a year before the hotel. The rich and famous came to play golf at the Biltmore, which in the 1930s hosted the $10,000 Miami Biltmore–Coral Gables Open, professional golf's richest tournament. After World War II, the Biltmore became a Veterans Administration Hospital and the golf course became a municipal track, retaining its original skeleton but losing much of its distinctive detail. The City of Coral Gables acquired the hotel and renovated it in the 1980s, selling it to a consortium in 1992. The new owners embarked on a 10-year renovation that included the restoration of the classic Ross design by Brian Silva. Silva revived Ross's strikingly deep, high-bermed bunkers and gargantuan putting surfaces, including the 50-yard green on the par-four 17th that plays along the Coral Gables Waterway, a canal built in the 1920s to provide hotel guests with access to Biscayne Bay in Venetian gondolas.

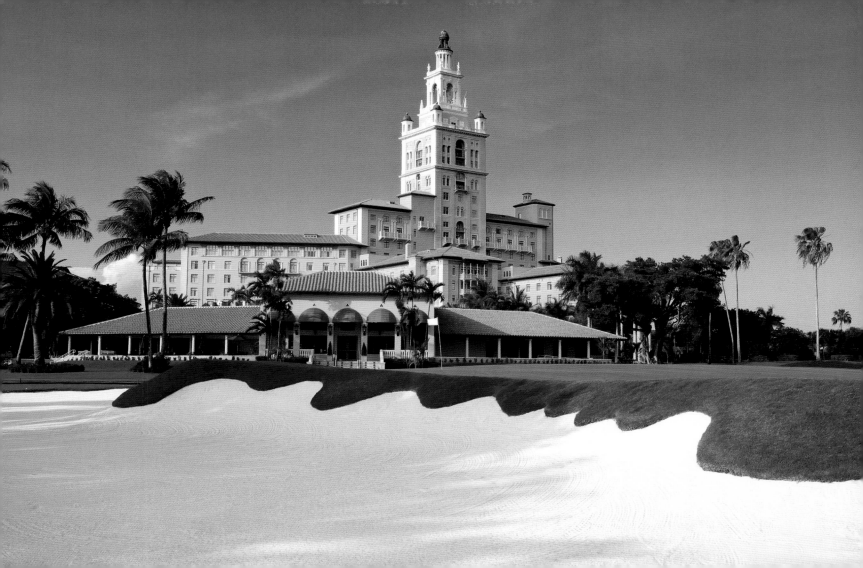

Doral's Blue Monster has had a long and storied history with the PGA Tour since the first Doral Open was held in 1962, the same year the resort opened. The Doral Hotel and Country Club was developed by Alfred Kaskel and his wife Doris, who found 2,400 acres of swampland in West Miami in 1959. The Kaskels, who combined their first names to give the resort its name, hired leading course architect Dick Wilson to design the Blue Course. The Doral Open Invitational became Florida's first PGA Tour event, with the famous, risk-reward 18th hole circling around the lake deciding many a championship. In 1993, the resort was sold, resulting in a redesign of the Blue Monster by Raymond Floyd. Doral now has five courses, as well as a golf academy headed by famed instructor Jim McLean. The Great White Course, designed by Greg Norman, opened in 2000, using coquina or crushed seashells as a design element on every hole of the palm-lined course. The Great White underwent a major upgrade in 2005, which included the planting of thousands of native grasses. While the tournament has been known as the WGC-CA Championship since 2007, Doral is continuing to make golf history every year.

BELOW: The Blue Monster
RIGHT: The Great White Course

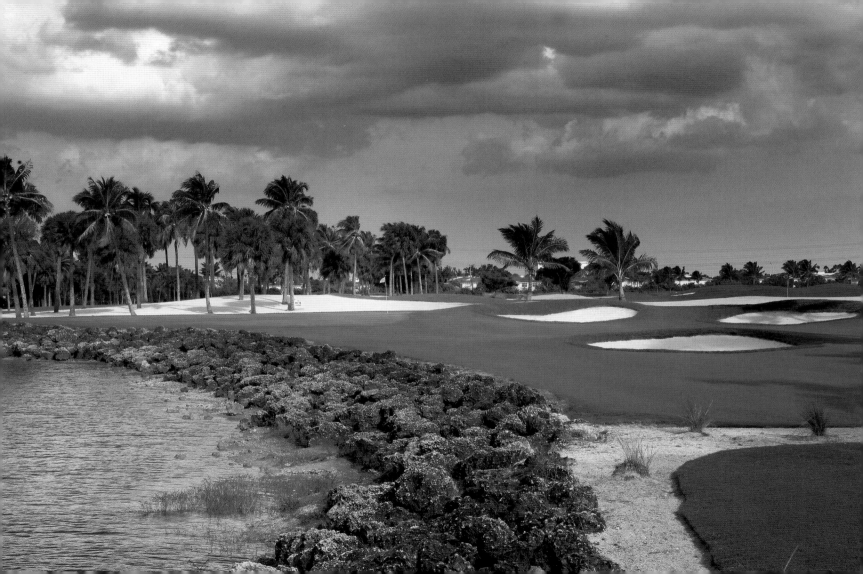

The Abacos, a 120-mile long tiara of islands within the Bahamas, is now a golfing port of call as well as a world-class destination for sailing and bone fishing. With its network of offshore cays and reefs, Great Abaco Island served as a safe harbor for British loyalists during the American Revolution. The first settlement on the island was established in 1783 by 600 loyalist refugees from New York at Carlton Point, on the northern end of the island near the site of Treasure Cay Golf Club, the last course designed by the famed Dick Wilson before his death in 1968. Given its loyalist origins, it is fitting that Great Abaco now boasts a stunning, members-only club developed by London-based Peter de Savary and designed by English architect Donald Steel. De Savary and Steel, a former English amateur champion and connoisseur of links golf, also teamed up to create the Carnegie Club in Scotland, Carnegie Abbey in Rhode Island, and Cherokee Plantation in South Carolina. Steel and design partner Tom McKenzie describe the Abaco Club, located at Marsh Harbour on Winding Bay, as the first Scottish links-style course in a tropical setting. The inland holes are cut from the dense vegetation, while the finishing holes unfurl over the rocky bluff 60 feet above the surf below. Members and homeowners at the Abaco Club, which is the site of a Ritz-Carlton resort, include Ryder Cup stars Darren Clarke and Lee Westwood.

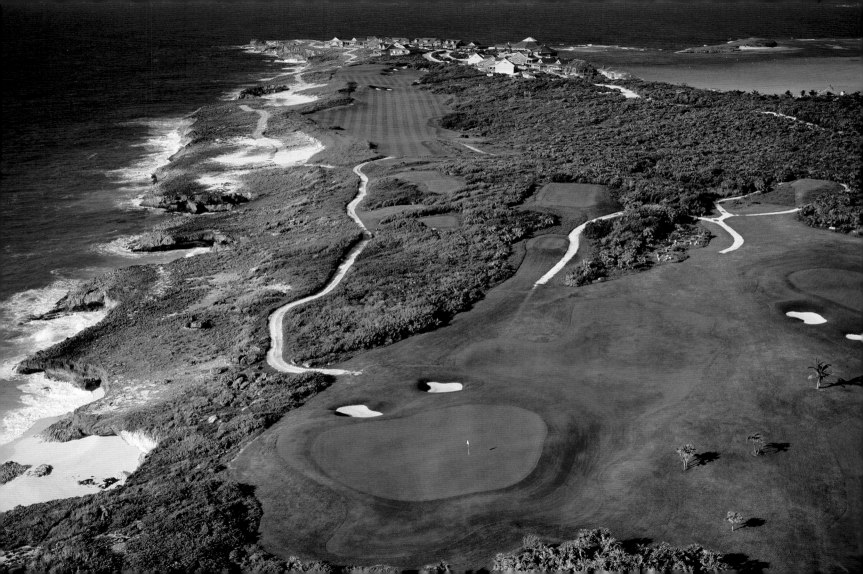

Golf has been booming in the Bahamas, with new luxury resorts like the One & Only Ocean Club Golf Course on Paradise Island, designed by Tom Weiskopf, Four Seasons Great Exuma at Emerald Bay, with its exhilarating Greg Norman-designed course that debuted in 2003, and Our Lucaya Resort on Grand Bahama Island, with its Reef Course designed by Robert Trent Jones, Jr., joining the original Lucayan Golf Course. The granddaddy of golf in the Bahamas, Cable Beach Golf Club on Nassau, which dates from the 1920s, was completely remodeled in 2002. Blue Shark Golf Club on Nassau is another older course, originally designed by Joe Lee, that has been given a brand new look and added length by Greg Norman, golf's Great White Shark. Blue Shark, at the center of a planned luxury development and casino, is laid out on a 160-acre former plantation on Nassau's south coast, which was granted to British loyalist Peter Edwards in the 1780s. The stone remnants of the great house and slave quarters run across the hill below the 11th and 12th tees. There are also two blue holes, subterranean sinkholes filled with water, that come into play on Nos. 15 and 17. The broad fairways are framed by Bahamian broadleaf coppice, which Columbus described as "marvelous groves" of trees.

Seminole Golf Club, ten miles north of Palm Beach, may have the most mystique of any club in the United States, in part because it was a favorite haunt of Ben Hogan, who was a member. Each year late in his career Hogan would play the course for 30 days straight to prepare himself for the Masters. Opened in 1929, Seminole was designed by Donald Ross, who made the most of the 40-foot high dune ridge running through the site. Seminole features the sloping, crowned greens for which Ross became famous at Pinehurst, but Seminole runs directly along the Atlantic, its fairways dotted with palms, and the wind is a constant factor. The nearly 200 swagged and sculpted bunkers encircling the greens and rippling across the fairways also weigh heavily on the player's mind. Ross was a modest man, but he was clearly pleased with his work at Seminole, declaring: "I don't say it is the best I have ever designed. Nevertheless, I like it very much." Claude Harmon, who was the professional at Seminole during the winter months and Winged Foot in the summer, shot the course record of 60 in 1947.

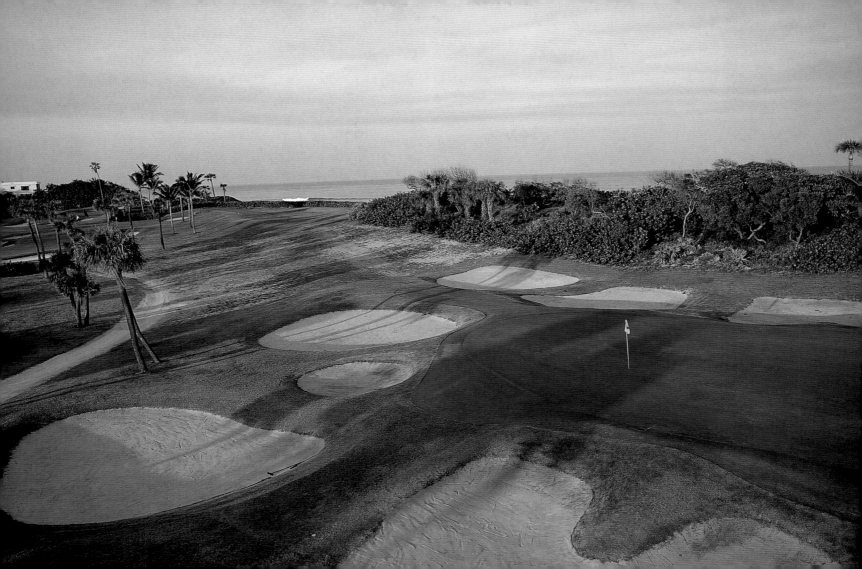

MARCH 3 | McARTHUR GOLF CLUB—FLORIDA, U.S.A.

McArthur Golf Club was conceived as a very private and understated golf club in a pristine setting of sand pines and palmettos in Hobe Sound, Florida. The property's owner, Nancy McArthur Davis of the McArthur Dairy family, decided to establish a golf club in 2000. She hired Tom Fazio, who consulted with Nick Price, to design a walkable layout on the 480-acre site, which encompasses 120 acres of wetlands and 180 acres of uplands. The course, which plays 7,251 yards from the back tees, is routed through four of Florida's distinctive ecosystems comprising flat-bottomed wetlands, sand pine scrub, barrier dunes, and hardwood hammock. Fazio moved a million cubic yards of the sugary sand base to shape the fairways and create lakes, including the lake that dominates the 15th hole. Opened in October 2002, McArthur was ranked as one of America's Top 100 Modern Courses by *Golfweek* in 2009.

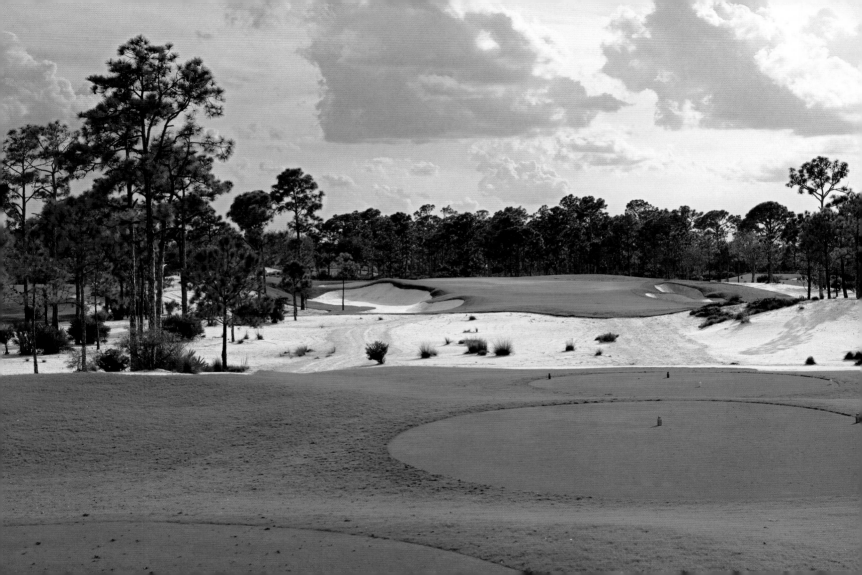

Black Diamond Ranch's Quarry Course is one of the most dazzling designs in the impressive portfolio of architect Tom Fazio, whose skill in enhancing the aesthetic appeal of any landscape is unsurpassed. Located in Lecanto, in Florida's Citrus County just 15 minutes from the Gulf of Mexico, Black Diamond Ranch is a 1,320-acre private golf club community. The Quarry Course, which opened in 1987, plays through a limestone quarry with fairways bracketed by live oaks, dogwoods, myrtles, and magnolias. The quarry holes begin with the 13th, a par-three that plays 180 yards over the smaller of the two quarries, with the back tee perched over 80 feet above the quarry floor. The next four holes bob and weave through the limestone escarpments, with the green of the 218-yard par-three 17th guarded by 30-foot cliffs. Dan Jenkins called this stretch of holes "the best five consecutive holes of golf anywhere in the world."

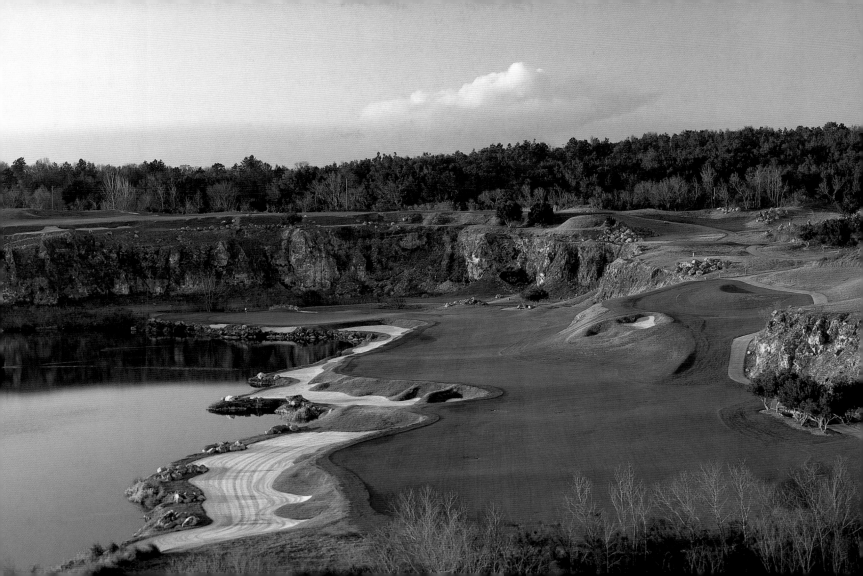

Isleworth, located southwest of Orlando, is an exclusive gated country club community of Mediterranean villas that is best known as the home of Tiger Woods, his friend and mentor Mark O'Meara, and a host of other PGA Tour stars as well. The 600-acre community is set in the Butler chain of lakes, with over seven miles of shoreline. The golf course has an interesting provenance in an area that was long prized for its orange groves. The property was originally owned by leading citrus growers, Sydney and Joshua Chase. Searching for an additional source of fruit after a freeze in 1886, they discovered an island of orange and lemon trees that they named Isle of Worth. Almost a century later, in 1981, Arnold Palmer flew over the groves and recognized the area's potential for a golf course and resort community. He purchased the land in 1984, designed the course, and developed the property with a corporate partner. It was sold in 1993 and the course was subsequently revised by Steve Smyers. Isleworth and the nearby golf community of Lake Nona, which is also home to many international golf stars, alternate hosting the Tavistock Cup, a friendly annual competition between the PGA Tour members of the two clubs, which is televised on the Golf Channel.

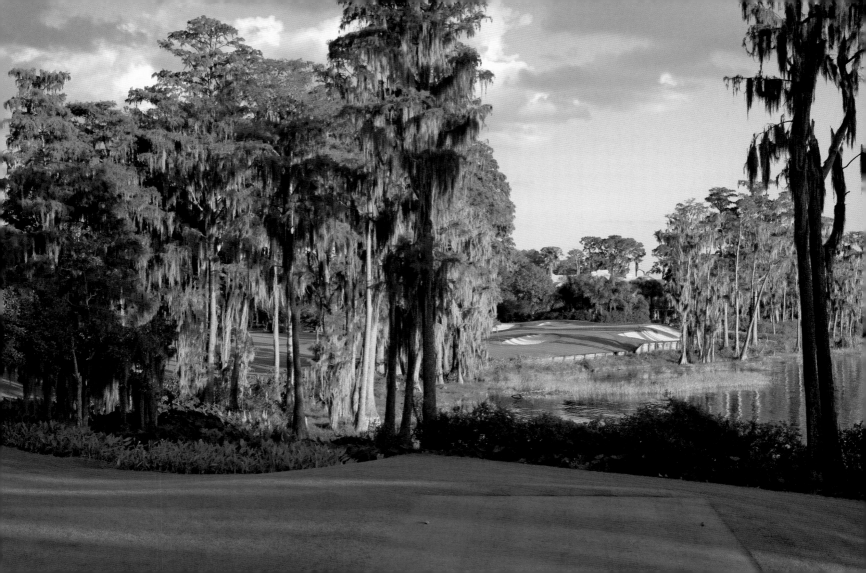

Calusa Pines Golf Club is an exclusive private club in Naples, Florida, where 550 acres of flat land was transformed into a sweeping ridge that holds seven holes in a layout traversing palmetto prairie, cypress hammock, and pine-palmetto forest. Architects Michael Hurzdan and Dana Fry achieved the 58-foot elevation change by blasting through tons of coral rock to excavate 72 acres of blue water ponds at a depth of 25 feet. The two million cubic yards of fill from the pond excavation were then used to create the ridge, which stretches for a couple of thousand yards. The bill for the dynamite used in the course construction alone came to a million dollars. Hurzdan and Fry worked with their course shapers to create flowing contours and wove the enormous earth mass to the rest of the course by carving waste bunkers and planting 145 large oaks, 1,200 pines, and 900 sable pines. The finished product was already a remarkably natural and mature-looking layout when Calusa Pines was unwrapped for play in November 2001.

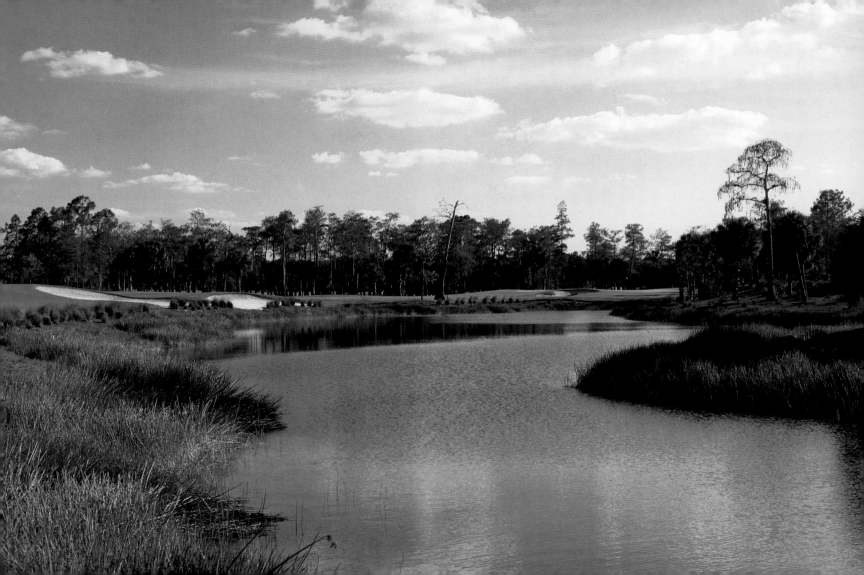

Located at Ponte Vedra Beach near Jacksonville, the Stadium Course at the Tournament Players Club at Sawgrass is a landmark course in the annals of golf course architecture. Designed by Pete Dye as the first TPC course and opened in 1981, Sawgrass came to define a new style of target golf, in which the player had to find the salvation of fairway amidst a diabolical array of waste bunkers and lagoons. The course was conceived by Deane Beman, the then-commissioner of the PGA Tour, specifically to hold the Players Championship, with spectator mounds used to create the concept of stadium golf. While the pros found the course hellish and complained long and loud (leading to the course being revised two years after it opened), the golfing public relished the dramatic spectacle that builds to a crescendo on the three finishing holes. Dye became a household name among golfers and the term signature hole entered the golf lexicon with the famous par-three, 17th island hole. While there had been earlier island greens, none matched the stark severity of Dye's creation—a green omphalos surrounded by a sea of blue.

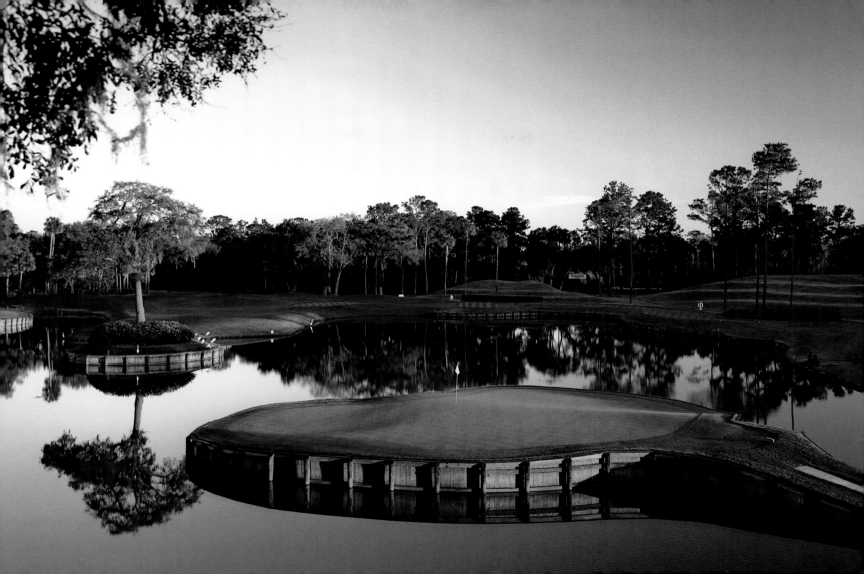

The Fancourt Resort and Hotel near George, South Africa, is in the heart of the Garden Route, the strip of coastline east of Cape Town that stretches from Heidelberg in the west to the Tsitsikamma Forest and the Storms River in the east. All three of Fancourt's courses, the Montagu, the Outeniqua, and the Links, were designed by Gary Player, South Africa's paragon of golf. Framed by the Outeniqua Mountains, the Montagu Course offers lush green fairways, sapphire lagoons, and bands of the brilliant heathland vegetation that exemplifies the landscape for which the Garden Route is famed. The Links Course played host to the 2003 Presidents Cup. The potboiler of a match ended in a controversial tie agreed to by team captains Jack Nicklaus and Player with darkness approaching, after Tiger Woods and Ernie Els had played three holes of a pressure-packed sudden death playoff. The Links Course is an exposed, rumpled layout with authentic links features, spread out against the unkempt savannah grasses with the mountains hovering above.

RIGHT: The Links Course

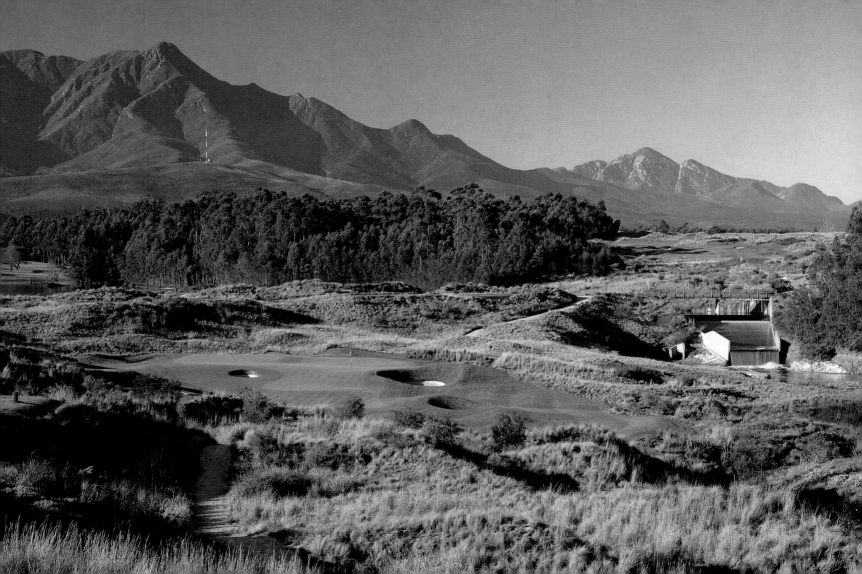

Erinvale Golf Club, in Somerset West, hosted the 1996 World Cup, in which the hometown team of Ernie Els and Wayne Westner triumphed. The course is nestled in the winelands regions of the Cape area, enveloped by the Helderberg and Hottentots Holland mountains. Designed by Gary Player, the course kicks off with a dogleg over a dam bedecked with fynbos (fine bush in Afrikaans), South Africa's unique heathland flora. The two nines are a study in contrasts, with the front nine laid out over the low ground, featuring water hazards and sod-faced bunkers. The back nine plays through the rumpled foothills of the Helderberg Mountains, surrounded by pinot noir vineyards, with the par-five 13th overlooking False Bay. The 17th swoops downhill, with tall pines guarding the left side of the narrow fairway and out of bounds on the right.

BELOW: The clubhouse

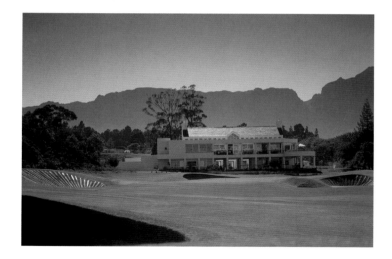

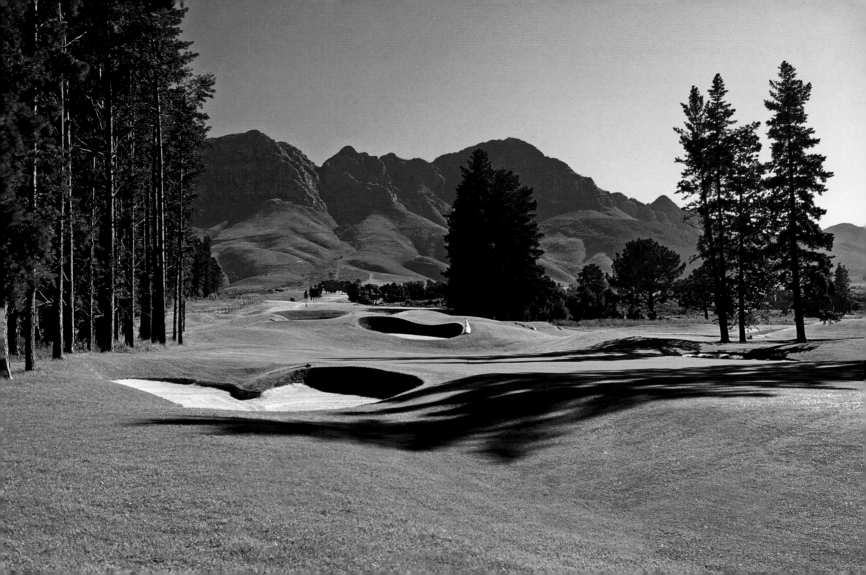

MARCH 10 | PINNACLE POINT GOLF COURSE—SOUTH AFRICA

Pinnacle Point Golf Course provides an exacting excursion along the rugged cliffs near Mossel Bay on South Africa's southern coast. The course, which opened in November 2006, was designed by South African Peter Matkovich in collaboration with Northern Ireland's Ryder Cup standout Darren Clarke. The fairways and foamy white bunkers hover over nearly three miles of untrammeled coastline. About a quarter of the resort's property has been given over to a nature reserve, replete with 264 varieties of fynbos—flowering bushes that are the defining feature of South Africa's Garden Route. Pinnacle Point is at the center of the Garden Route, whose golfing bouquet includes the Fancourt Links Course, Pezula (formerly known as Sparrebosch), Oubaai, and Goose Valley.

Durban Country Club, just two miles from the downtown Durban skyline, is South Africa's premier course and one of the best in the world on any score. The course runs parallel to the Indian Ocean with its wide sandy beach, separated only by the coastal highway. The heaving fairways, built over the coastal sand hills, crest and dip through indigenous trees and thick bush. The most famous hole is the par-five third, with the tee atop a dune and the drive down to the chute of rolling fairway below. The short par-three 12th is named for the Prince of Wales, who took 17 shots when he played here in 1924. Durban was designed in 1922 by the South African professional Laurie Waters working with George Waterman. Waters had been an assistant to Old Tom Morris at St. Andrews before emigrating to South Africa in 1901 for his health.

The tropical island of Mauritius, with its 205 miles of coastline, lies in the Indian Ocean 1,250 miles off the southeastern coast of Africa and 550 miles due east of Madagascar. Le Touessrok Golf Course is not actually on the mainland of Mauritius, but occupies its own island off the east coast, the Ile aux Cerfs or Island of Deer. A golfing special water taxi transports players on the 10-minute hop from the fabulously chic One & Only Le Touessrok Resort across the robin's egg blue waters of the coral lagoon to the course. Designed by Bernhard Langer in 2003, the course itself is a little bit of golfing paradise, with the fairways filling the curvaceous outline of the volcanic rock island, hemmed with white sand beaches and surrounded by the aquamarine gradations of the Trou d'Eau Douce Bay. There are nine lakes on the course and a number of holes require forced carries across the sea inlets and the mangrove forest shrouding the fairways, while the green on the fifth is guarded by a tidal pool. The sea is visible from every hole and the 12th, which doglegs down to the beach, faces Cat and Mouse Mountain. Near Le Touessrok is the Four Seasons Golf Club Mauritius at Anahita, designed by Ernie Els and opened in 2008, with the course sandwiched between the Indian Ocean and the Bambou Mountains. Farther up the coast, the Belle Mare Plage Resort is home to the Legend Course, designed by Hugh Baiocchi and site of the Mauritius Open, and the more benign Links Course crafted by Peter Alliss and Rodney Wright.

Mauritius was first discovered by Arab sailors in 975 and was then rediscovered by the Portuguese in the 16th century. In the past few years, the exotic island has been discovered anew by adventurous golfers. The Dutch established the first permanent settlement in 1638, naming the island after Prince Mauritius van Nassau. The French took control in 1715, but the British captured Mauritius during the Napoleonic Wars and held the island until it became independent in 1968. The first golf club was introduced at Vacoas back in 1902. The Tamarina Golf, Spa and Beach Club, located on the southwest coast overlooking Tamarin Bay, is the first residential golf estate on Mauritius. Designed by Rodney Wright over what was once a deer hunting chassé, the focal point of the course is saw-toothed Rempart Mountain and the surrounding peaks. The fairways are shorn from the coastline savannah and crossed by Black River gorges and the Rempart River. Another 20 minutes down the west coast is Le Paradis Golf Club, beneath Le Morne Mountain. Continuing to the south, there is Golf du Chateau at Le Telfair Golf & Spa Resort, laid out over a former sugar plantation overlooked by the chateau where the 19th-century botanist Charles Telfair once lived. Designed by South African Peter Matkovitch on the Plaine Champagne hills, the course is crossed by the Citronniers and St. Martin rivers.

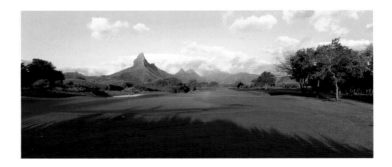

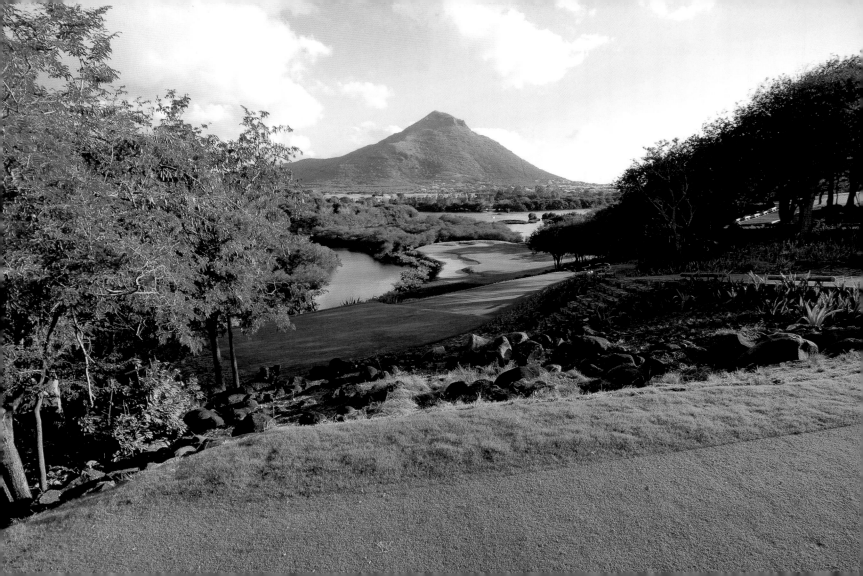

The Sun City Resort, the lavish playground and casino built by Sol Kerzner in South Africa's Northwest Province, is the home of the Lost City Golf Course and the Gary Player Golf Course, both designed by Gary Player. The desert-style, boulder-strewn Lost City Course lies beneath the hills of the Pilanesberg bushveld, with the backdrop of the domed towers of the Palace of the Lost City, a fantasy of African fable turned into stunning reality. The ninth and 18th holes both circle the central lake, and several holes on the back nine adjoin the Pilanesberg Game Reserve. The green of the par-three 13th is in the shape of the African continent, with each of the three bunkers filled with a different color sand to symbolize the country's racial diversity. The hazard just left of the green is home to some 40 Nile crocodiles.

BELOW: A baboon strolls past Miki Saiki during the 2008 Women's World Cup held at Sun City

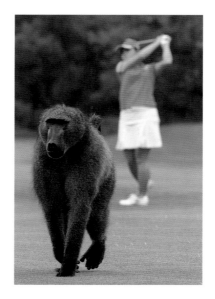

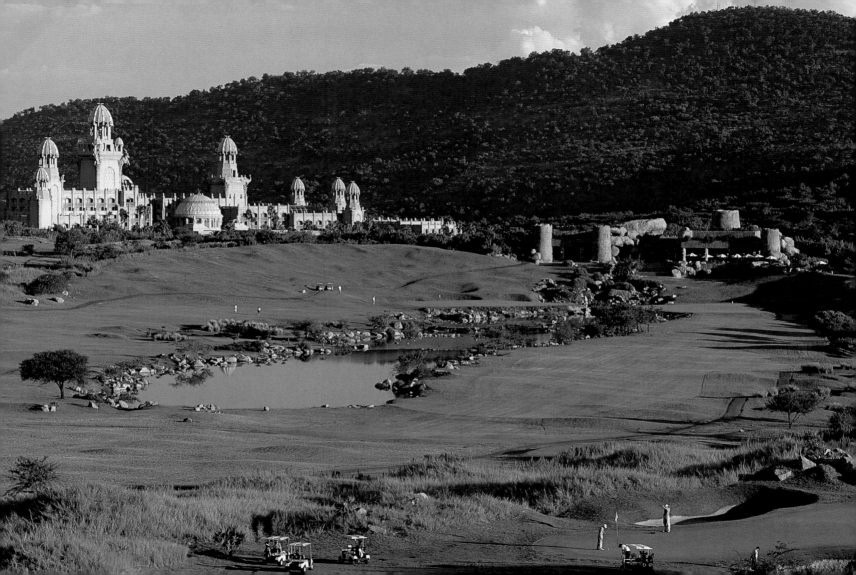

Leopard Creek, bounded by world-renowned Kruger National Park to the north and east, was founded by reclusive South African billionaire Johann Rupert, who in 1995 enlisted Gary Player to create an African version of Augusta National—with no expense spared. The broad, rippling fairways of kikuyu grass, framed by the bushveld hillocks, are patterned with large lakes and dammed rivers that are home to families of hippos. Several of the holes overlook the Crocodile River, including the signature par-five fourth and the 16th, which offer sightings not only of crocodiles but also antelope, buffalo, wild boar, and elephants strolling along the river's edge. The course finishes with a par-five played to an island green beneath the thatch-roofed clubhouse. Leopard Creek is the site each December of the Alfred Dunhill Championship, an event sanctioned by the PGA European Tour. Members in the exclusive club includes Ernie Els and Jack Nicklaus; the course has also been open to guests at the Malalene Sun Intercontinental Resort.

BELOW: The clubhouse

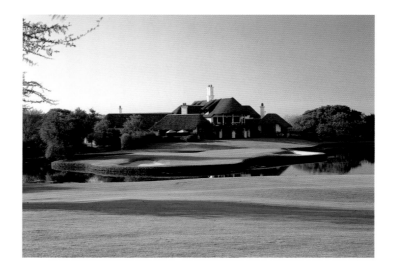

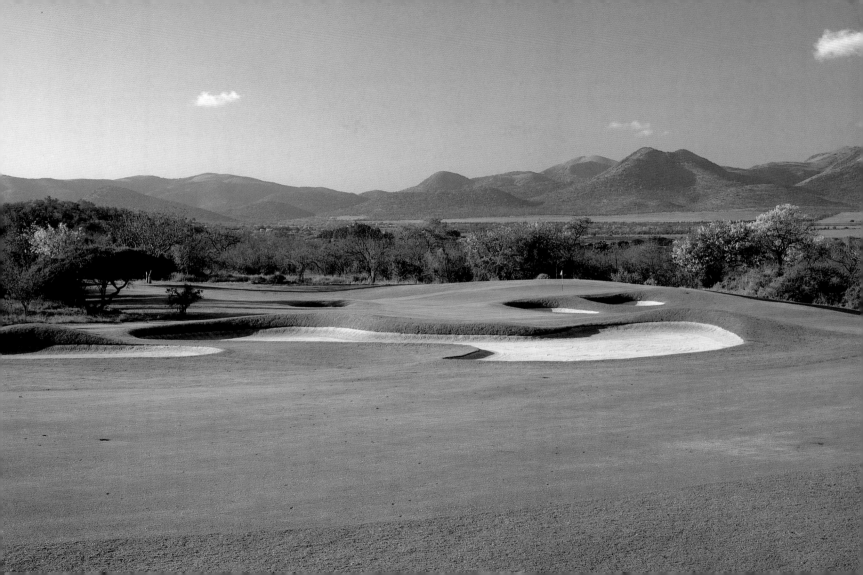

It should come as no surprise that there are several fine courses in Kenya, which was colonized by the English as British East Africa, with golf in Nairobi dating back to 1906. Karen Golf Club is located in the genteel Nairobi suburb of Karen, named for Baroness Karen von Blixen, the Danish author who wrote *Out of Africa* under the pen name Isak Dinesen. In her book, which was made into an Oscar-winning movie, she describes her love affair with Denys Finch-Hatton and how she came to leave the coffee plantation where she had lived for nearly 20 years in 1931. The golf course was established in 1938, and was one of the first courses in Kenya to have grass greens, rather than using sand to create "browns." The course is adorned with a profusion of flowering native trees and shrubs framed by the Ngong Hills. Von Blixen allowed the club to use the center portion of her coat of arms in the design of its flag and her stone farmhouse now houses the Karen Blixen Museum near the course.

Taba Heights is a golfing oasis located on the east coast of Egypt's Sinai Peninsula, at the northern tip of the Red Sea Riviera. With the cream and cinnamon–colored Sinai Mountains as a backdrop, the course offers sweeping views across the translucent waters of the Gulf of Aqaba out to the Israeli, Jordanian, and Arabian coastlines. Designed by John Sanford, three of its holes hug the shore of the Red Sea, with the course laid out between the central resort with its five hotels and the beachfront. Three man-made lakes serve as a reservoir; the irrigation piping under the fairways was produced by the resort's own recycling plant and was made from discarded plastic. The resort takes its name from the nearby Bedouin village of Taba, just across the Israeli border from the seaside resort of Eilat. Taba Heights is also a center for water sports, with a marina and Waterworld dive center, and offers Red Sea cruises as well.

MARCH 18 | TABARKA GOLF CLUB—TUNISIA

For many years the Carthage Golf Club in La Soukra, six miles from Tunis, was the only course in Tunisia, laid out near the Punic and Roman ruins of ancient Carthage. In recent years, however, Tunisia has become a major vacation destination for golfers from Northern Europe. Tabarka, like several other courses in Tunisia, was designed by American golf course architect Ronald Fream. The course is located two hours northwest of Tunis, near the Algerian border. Opened in 1992, it takes its name from the nearby fishing and coral harvesting village of Tabarka that traces its history to Carthaginian times. The course is laid out through the cork oaks and dunes running along the seaside cliffs, making this the Cypress Point of Tunisia. From the 14th hole there is a good view of the 16th-century Genoese fort that sits on the crest of a small island off of Tabarka's harbor, and inland are the mountains covered with oak forest.

The Fajara Club is an 18-hole, par 69 course located in Gambia, the small western African nation that runs along the Atlantic coast below Senegal. Instead of grass greens, Fajara has "browns"—greens made of oily sand, which were common on courses in Africa and the Mideast before the development of drought- and saltwater-resistant strains of grass. Golfers at Fajara are typically accompanied by a caddie and a brown-sweeper, who smoothes the putting surfaces. The signature hole is the island brown 13th, known as Devil's Island. Gambia is home to over 540 exotic and radiantly colorful bird species in a variety of ecosystems, making it a leading destination for bird-watchers. Many species can be seen on the course, which is near the Gambian coast. In the best time-honored tradition, the fairways are kept neatly trimmed by the local herdsmen's grazing flocks.

BELOW: Sweeping one of the "browns" at the Fajara Club

Golf in Morocco dates to Royal Tangier, opened in 1917, but flourished in the last few decades under the royal patronage of the late King Hassan II, an avid golfer who commissioned many courses. In 1971, Robert Trent Jones was hired to design the Red Course at Royal Dar Es Salam near Rabat, which remains Morocco's top course. The course is carved through a forest of thousands of cork oaks and flowering trees and shrubs, including mimosa, bougainvillea, and orange trees, in the 1,000-acre forest of Zaers, near the royal hunting ground. Jones created the lakes that form the water hazards, and which are now home to colonies of flamingos and waterfowl. The course was the site of the annual Hassan II Trophy tournament, an invitation-only pro-am that attracted top pros from around the world.

Valderrama is the crown jewel of golf in Spain and the top-ranked course in continental Europe. It is tucked away in a quieter corner of the Andalusian coast—to the west of the Costa del Sol and close to the Rock of Gibraltar—in the hills above Sotogrande with its swank marina. The patriarch and guiding force of Valderrama is Jaime Ortiz-Patiño, heir to the Bolivian tin fortune, who has worked relentlessly to bring the course into the forefront of world golf. While Valderrama's manicured fairways and pampered greens earn it comparisons to Augusta National, the abundant ancient cork oaks and flowering mimosa give it a distinctively Andalusian character. Two of the most memorable holes are the par-five fourth, with the green guarded by a waterfall, and the par-five 17th, where the sloped green fronted by the pond creates havoc for the pros. There is a good mix of short, tight par-fours and longer holes, and each of the four par-threes is memorable. Valderrama was designed by Robert Trent Jones and originally known as Los Aves, before Patiño and a few friends acquired the course in 1985, and brought Jones back for further refinements. In 1997, Valderrama elevated Spanish golf to new heights when it became the first course in continental Europe to host the Ryder Cup, with the European team captained by Seve Ballesteros holding off the favored Americans to claim a one-point victory.

La Cala Resort, on Spain's Costa del Sol, offers a trifecta of distinctive 18-hole courses terraced through the steep terrain between the Serra de Mijas National Park and the Mediterranean. The courses—La Cala America, La Cala Asia, and La Cala Europa—were all designed by Spanish-based American architect Cabell Robinson, who managed to create comfortable landing areas despite the hilly terrain. The America Course, longest of the three, hosted the Ladies European Tour Q-School in 2005 and 2006. The Asia Course, which is tighter, with water figuring on the fifth and 12th holes, hosted the 18th PGA Spanish Pairs Championship, won by Miguel Angel and Andrés Jimenéz, in 2007. Campo Europa, the newest layout, opened in 2005. The Ojen River, which cuts across the fairways, comes into play on eight of its holes.

RIGHT: La Cala Europa

Spain's Canary Islands, perched in the Atlantic some 100 miles west of the Moroccan coast, are a golfing sanctuary with over a dozen courses located on the seven main islands, particularly Tenerife and Gran Canaria. The Abama Golf & Spa Resort is situated on the cliffs above the Atlantic at Guia de Isora, on the southwestern shore of Tenerife. The course, designed by Dave Thomas, rambles among 22 lakes, streams, and waterfalls, rising to 900 feet above the sea, with views of the neighboring island of La Gomera. The course is an alluring arboretum that showcases the floral diversity of the Canaries, with both tropical Saharan and temperate Mediterranean species. The fairways are lined with thousands of towering palms and more than 300 subtropical varieties of trees, cacti, and flowering plants.

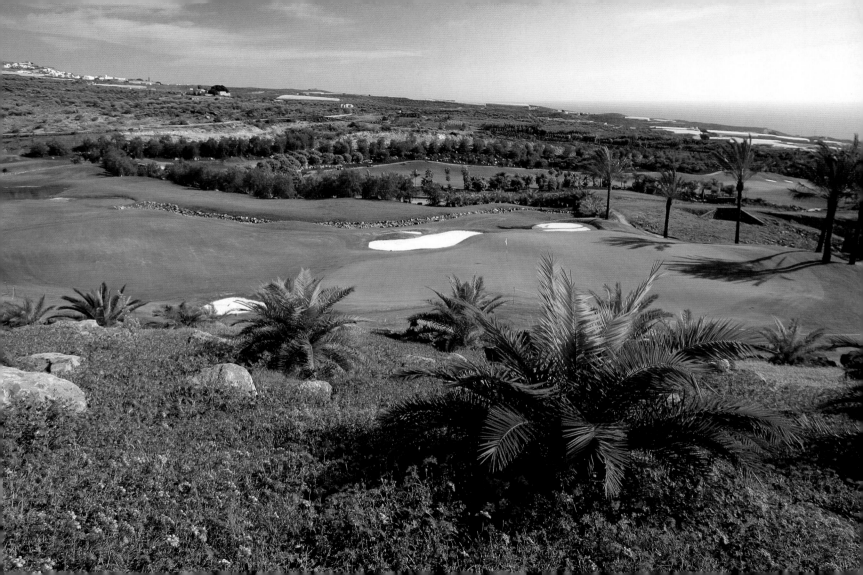

Lanzarote is the easternmost of the Canary Islands and one of the most geologically interesting and ecologically diverse. The Costa Teguise Golf Course is situated near La Villa de Teguise, the island's ancient capital (officially demarcated in 1418), whose historic palace and homes have been well preserved. Laid out at the foot of a dormant volcano by British course architect John Harris in 1978, it is one of the older courses in the Canaries. Its fairways are framed by 3,000 Canary Island date palms and by brown lava flows; at every turn there are lovely views of the ocean, the modern capital of Arrecife, and the coastline. Costa Teguise has recently been joined by a new course, Lanzarote Golf Resort, designed by American architect Ron Kirby in the hills overlooking Puerto del Carmen. The island's arid landscape is dominated by the volcanic mountain ranges of Famara in the north and Ajaches to the south, and the entire island was designated a UNESCO Biosphere Reserve in 1993.

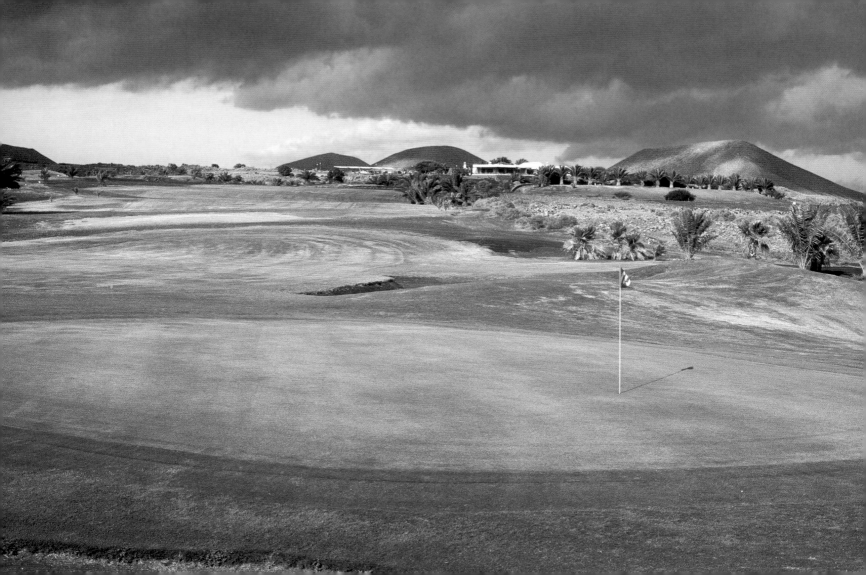

During the past 30 years, Portugal's southernmost province, the Algarve, has become a showcase of golf, with splendid courses spread among modern hotels and whitewashed villas along the Atlantic. Of all the Algarve's courses, the most stunning is San Lorenzo, or São Lourenço, one of four courses that make Quinto do Lago the Algarve's leading resort. Designed by the late Joe Lee and opened in 1988, the course straddles the western edge of the Ria Formosa Nature Reserve, a wetlands sanctuary for aquatic birds migrating from the Arctic to Africa. The elevated tee of the sixth hole offers a view of the fairway curving along the Ria's expansive salt marsh with a rickety wooden bridge leading out to the coastal dunes beyond. The seventh continues along the marsh, while the eighth and ninth skirt a large lagoon echoing with the cries of egrets, cranes, and purple gallinules, where once there had been a tomato field. The course returns to the lagoon on the 17th and 18th, with the final hole requiring a heroic shot across the lagoon to a beachhead of green. The course is named for the Church of São Lourenço, one of the most beautiful of the blue-and-white-tiled churches in the Algarve, located just outside the nearby town of Almancil.

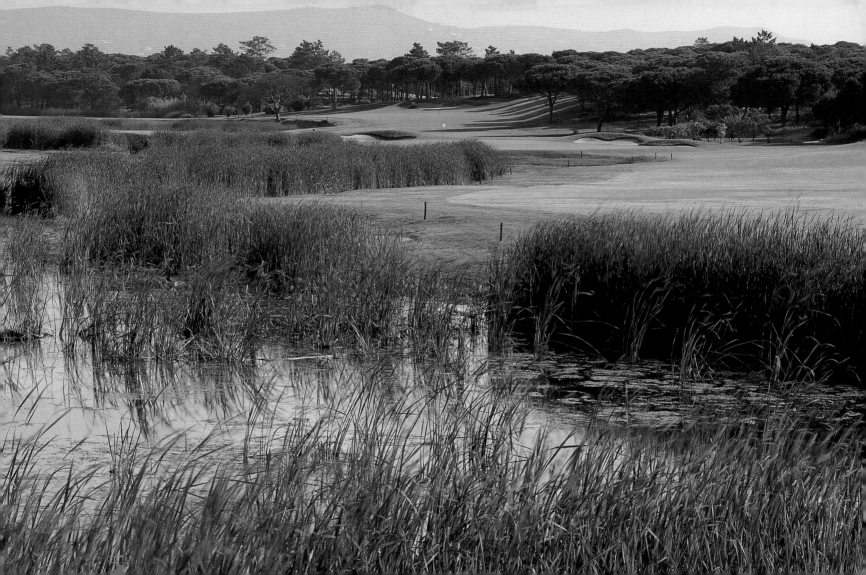

MARCH 26 | AMENDOEIRA GOLF RESORT (FALDO COURSE)—PORTUGAL

The Amendoeira Golf Resort is located in Portugal's Algarve, near the old walled town of Silves, which dates back to Roman times. Amendoeira's flagship course, designed by Nick Faldo, opened on September 1, 2008, with a second course designed by Christy O'Connor, Jr. The Faldo Course spreads out over a terra-cotta landscape dotted with almond, olive, and carob trees, with the largest lake coming into play on the fifth hole. The back nine climbs into the hills above the plain below, reaching its apex on the 13th hole, which offers commanding views of the Monchique Mountains.

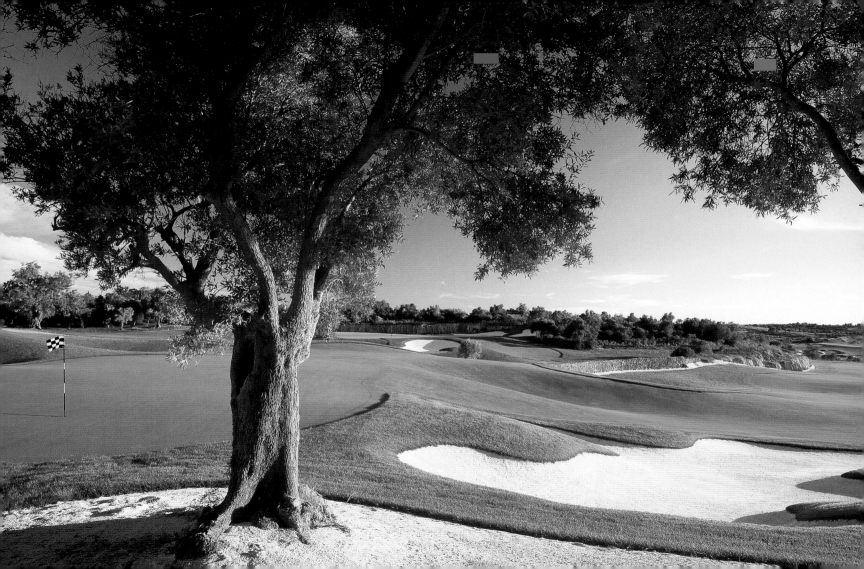

The Algarve has been the locus of Portuguese golf for many years, but until very recently all of the courses were strung along the dramatic coastline of striated sandstone cliffs of the western portion, between the provincial capital of Faro out to Sagres, which was once the bastion of Henry the Navigator. Monte Rei is a new luxury golfing community located in the less-developed eastern Algarve, with its sandy beaches, tidal marshes, and salt pans. It will revolve around two Jack Nicklaus–designed courses, the first of which, the Northern Course, opened to great acclaim in 2007. The course pinwheels around five lakes, with water figuring on 11 of the 18 holes. The hilly fairways are defined by bunkers shaped like puzzle pieces and by the ubiquitous cork oaks, with long vistas over the Atlantic and inland to the foothills of the Serra do Caldeirão. Monte Rei is located between the 18th-century village of Vila Real de Santo António to the east, near the Spanish border, and the ancient town of Tavira to the west, its two parts linked across the River Gilão by a seven-arch Roman bridge.

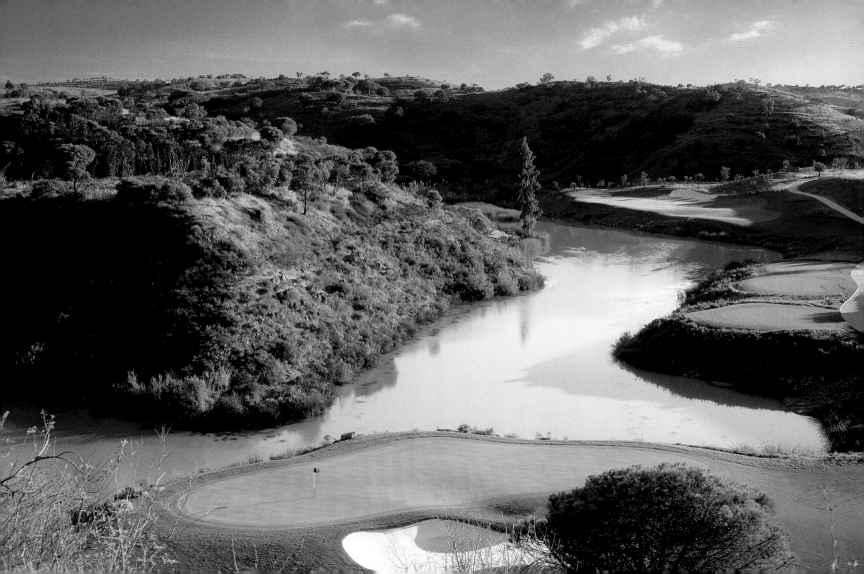

Oitavos Dunes enjoys a sublime setting at the Quinta da Marinha Resort within Portugal's Sintra and Cascais National Park on the Atlantic coast west of Lisbon. The first course designed outside the United States by architect Arthur Hills, Oitavos is a true seaside links, funneling through wind-wracked umbrella pines before opening out to the sea. The craggy Sintra Mountains, which Byron referred to as "that glorious Eden," dominate the landscape. From the 9th, 10th, 11th, and 14th holes there are views out to Cabo de Roca, Europe's most western point, and of the old lighthouse that signals ships arriving across the Atlantic. The 14th is a par-three that plays across a ravine running down the right side, while the 18th is a demanding 440-yard dogleg to a green guarded by a dune. Opened in 2001, Oitavos hosted the 2005 Portuguese Open.

RIGHT: José Rivero watches his shot during the 2006 Estoril Seniors Open played at Oitavos Dunes

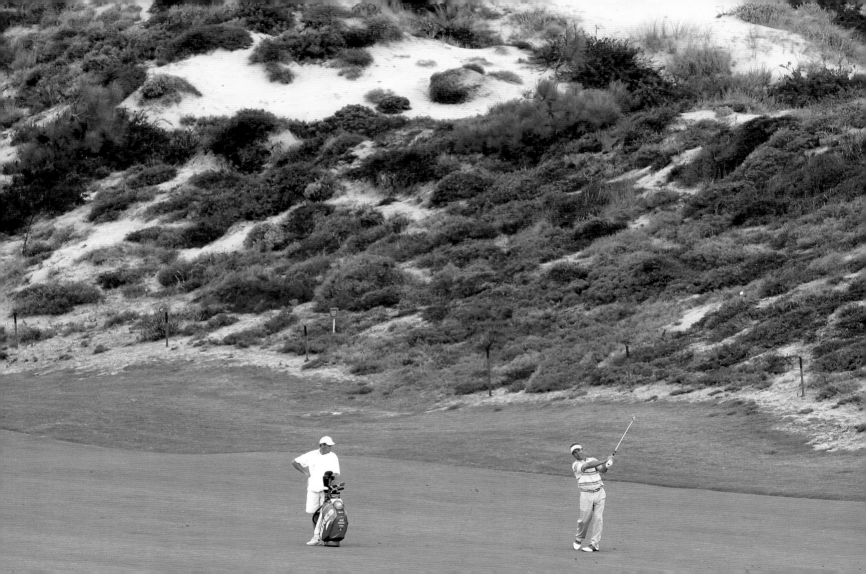

Portugal's island archipelago of the Azores, in the North Atlantic 950 miles west of Lisbon, is a land of volcanic craters and thermal grottos cradled by the Gulf Stream. The Azores are also a hotbed of golf, with two courses, Batalha and Furnas, located on São Miguel, the largest of the islands, and a third course on Terceira. Batalha Golf Club, which sports 27 holes and dates from 1996, sits perched above the Atlantic eight miles north of the capital of Ponta Delgado and near the seaside town of Fenais da Luz. The course marches through pine forests and volcanic rock outcroppings, with views across the northern coastline and of whitewashed villages and green hilltops. Achada das Furnas, 130 miles to the South, is a secluded course on the high ground near the volcanic Lake Furnas, its fairways sprayed with hydrangeas and pampas grass and ringed by giant Japanese cryptomeria, cypress, and pines. The original nine was laid out by Philip MacKenzie Ross, the architect of Turnberry, in the 1930s, and expanded to 18 in the 1990s by the firm of Cameron & Powell, which also designed Batalha. The third course, Golf da Ilha Terceira, was built in 1954 by American servicemen stationed at Lajes Airforce Base.

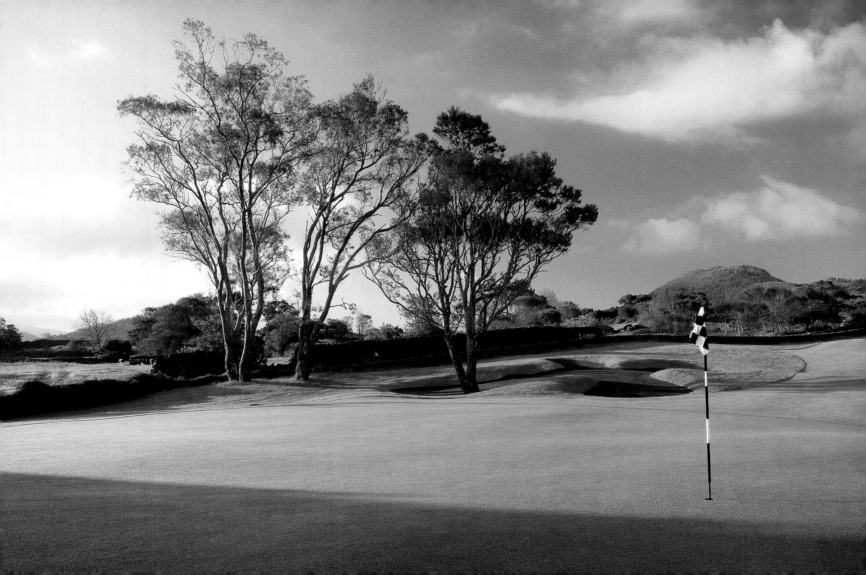

MARCH 30 | PRAIA D'EL REY GOLF & BEACH RESORT—PORTUGAL

Praia d'El Rey is located on Portugal's Silver Coast, 45 minutes north of Lisbon on a headland that juts into the Atlantic at Cabo Carvoeiro. The course, designed by Cabell Robinson in 1997, sweeps in a clockwise loop across wide blankets of duneland and pine forest above the ocean, giving the layout a distinctively links quality. The back nine offers stirring views over the coastline, particularly on the 12th and 14th holes, taking in the beaches around the small island village of Baleal and out to Berlengas Island, seven miles away in the Atlantic. Fifteen minutes inland from the resort is the town of Óbidos, with its whitewashed and ocher medieval town center highlighted by Óbidos Castle.

MARCH 31 | SANTO DA SERRA GOLF CLUB—MADEIRA, PORTUGAL

Madeira, the garden island in the mid-Atlantic, was first settled by the Portuguese in the 15th century. Renowned for its Madeira wine, it is also an intoxicating setting for golf. Santo da Serra Golf Club sits high above the coastline in the steeply pitched interior, overlooking the islands of Desertas and Porto Santo, home of the Porto Santo Golf Course designed by Severiano Ballesteros. The current course is the handiwork of Robert Trent Jones in 1991, but a nine-hole course was originally established back in 1937, with the Pousada da Serra Hotel serving as clubhouse. The course comprises three nines, known as Machico, Desertas, and Campo Serras. Since 1993, the course has regularly hosted the Madeira Island Classic, an event on the European PGA Tour. Palheiro Golf, designed by Cabell Robinson, who headed Jones's European operations, is another fine, hilly layout on Madeira. Set on the 200-year old country estate of Quinta do Palheiro, the course overlooks the colonial-era capital of Funchal, with its famed harbor that is a favorite port of call for cruise ships.

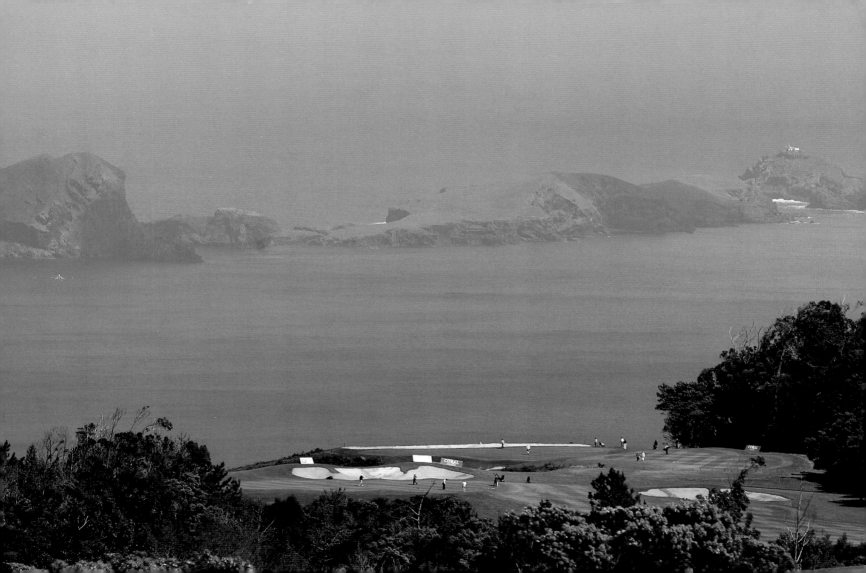

Located outside Valencia with its orange groves and rice fields, El Saler is recognized as the masterpiece of the Spanish architect Javier Arana, who was responsible for designing the classical courses that continue to set the standard in Spain. More than half the holes run through a pine forest, beginning with the first four, but El Saler is best known for its links-style holes bordering the Gulf of Valencia. The waste areas of powdery sand are drifted with myrtle and mimosa bushes and succulents known as "cat claws." The Parador de El Saler, one of Spain's state-owned hotels, adjoins the 18th green. El Saler hosted the Spanish Open in 1984, 1989, and 2001, and also was the site of the 2003 Seve Trophy Competition, pitting the top pros from Great Britain and Ireland against the Continental European team captained by Seve Ballesteros himself.

Platja de Pals is an elegant club with fairways promenading through colonnades of umbrella pines on the Costa Brava, near Pals beach. Pals, which is 20 miles east of the medieval walled city of Girona, is a restored medieval village whose narrow streets spiral up to a hilltop crowned by a Romanesque bell tower overlooking the green fields of the Empordà plain below. Founded in 1966, the course was designed by British architect F.W. Hawtree on what had originally been Arenales de Mar, a farm spread over dunes covered by pine forest planted 70 years ago. The ninth and 11th holes are both attractive par-threes, the former playing uphill to a gumdrop of a green over a duck pond, the latter a downhill shot over the pines to a green fronted by three eyelid-shaped bunkers. Pals is not a long course, and there is virtually no rough to speak of, but its sandy, pine-clad dunes and traditional British layout capture the essence of golfing on the Costa Brava.

APRIL 3 | CLUB DE GOLF D'ARO (MAS NOU)—SPAIN

Club Golf D'Aro, known as Mas Nou (New Farm in Catalan), is an exhilarating course located in the Les Gavarres Mountains between the coastal towns of Patja d'Aro and Santa Cristina d'Aro on Spain's Costa Brava. Designed by architect Ramón Espinosa in 1992, it offers captivating views over the coastline to the sea and of Les Gavarres, the Montseny mountain range, and the surrounding valley of the Valle de Selva. The course twists up and down through pines, cork, and olive trees and around two large man-made lakes. The 13th hole climbs to the brim of the course, with the 15th plunging back downhill to a green guarded on the left by one of the ponds and a triangular formation of sandstone spears jutting from the bunker. Mas Nou hosted the Catalonian Ladies Masters in July 2006.

APRIL 4 | LE PRINCE DE PROVENCE—FRANCE

Le Prince de Provence, something of a well-kept secret, is located near Vidauban, a town that lies above the Argens River. The property was purchased in the 1970s by legendary golf course architect Robert Trent Jones, who was struck by the potential for creating a superb course in the Var countryside with its picturesque landscape of forests harboring the world's finest truffles, vineyards, fruit orchards, and fields of lavender.

The property remained undeveloped for many years until Jones *père* brought in his son Bobby to collaborate on the design of the course, which was completed in 1999. Prince de Provence, threading its way through parasol pines and vineyards, is a private and exclusive enclave, with a few homes and its own small village. The membership is reputed to include Bill Gates and Formula One racing champion Alain Prost.

APRIL 5 | GOLF DE SPERONE—CORSICA, FRANCE

Golf de Sperone stretches across the southern tip of the French island of Corsica, not far from Bonifacio with its medieval Genoese ramparts overlooking the Mediterranean. It is one of the monumental designs of Robert Trent Jones, with 12 inland holes cleared of scrub and heather and another six clambering across the rocky headland, earning Sperone the sobriquet of the "European Pebble Beach." The journey along the sea begins with a blind drive on No. 11 and continues until the 16th marks the southernmost point in Corsica, with languorous views across the sweep of Piantarella Bay out to the Lavezzi archipelago and the tiny island of Cavallo, dubbed "Billionaire's Island." On a clear day one can see the peaks of Sardinia, the home of Pevero on the Costa Smeralda, another Jones stunner. The par-five 18th climbs back to the clubhouse, where a cold Pietra, the Corsican beer brewed from chestnut flour, awaits at the 19th hole.

Pevero Golf Club is on the Costa Smeralda, the northeast coast of Sardinia developed by the Aga Khan as the playground for the international jet set. Designed by Robert Trent Jones in 1971, Pevero is one of his grandest and most scenic creations. The course is laid out in two loops, rising and tumbling through a valley with the front nine curving around Pevero Bay and the back nine overlooking the beach of Cala di Volpe (Bay of Foxes). The fairways are hewn from the coastal rock and run through dwarf pine, broom, and gorse, with the ponds created by Trent Jones coming into play on the sixth and seventh and the 16th and 17th holes. From the fourth tee, with the green far below, the snow-capped mountains of Corsica can be seen across Pevero Bay.

Circolo Golf Bogogno, which was completed in 1997, was crafted out of the Lombardy countryside outside Milan, near Lake Maggiore and the Ticino Nature Reserve. Both courses, the Bonora and the Del Conte, were developed by Renato Veronezi and designed by American architect Robert von Hagge. They were created as part of a residential golf development, a novel concept in Italy. The Del Conte is a flatter, links-style course that sweeps around lakes framed by the Monte Rosa Mountains. The Bonora, with water lurking on 13 of the 18 holes, has wider fairways and offers a pastoral sojourn through the surrounding woodlands, vineyards, and farmland.

RIGHT: The Bonora Course

Castelconturbia Golf Club is a 27-hole course set in the secluded woodland of Italy's Agrate Conturbia region near Milan. Golf at Castelconturbia dates back to 1898, when Count Gaspar Voli, who developed a passion for the game on his travels to Scotland, built a nine-hole course on his estate. This course was popular with the Savoy royal family but was eventually abandoned around 1963. The contemporary, championship layout, designed by Robert Trent Jones, made its debut in 1984, taking its name from the nearby 17th-century castle. The three nines, known as the Blue, Yellow, and Red, roll through mature oaks and chestnuts beneath the backdrop of Monte Rosa, with small lakes and streams coming into play. The championship course is composed of the Blue and Yellow nines, with the island green seventh hole on the Yellow course being a particular standout. Castelconturbia hosted the Italian Open in 1991 and 1998, with José Maria Olazábal and Costantino Rocca sharing the course record of 66.

Since its founding over a century ago, the Evian Masters Golf Club, part of the Royal Parc Evian Resort in Evian-les-Bains, has dazzled golfers with its luminous views over the southern shore of Lake Geneva and of the Mémises and Dent d'Oche Mountains that form part of the French Alps. In 1904, the Société des Eaux Minerales d'Evian (the Evian Mineral Water Company) bought the farmland to create a nine-hole course in conjunction with the opening of the Hotel Royal, which was expanded to 18 holes in 1922. The course was revised in 1988 by Cabell Robinson, Robert Trent Jones's right-hand man in Europe at the time, and then extended in 2002. It remains an attractive medley of stately spruce, bright flower beds, and low stone walls set above the waters of the lake. Since 1994, the club has been in the international spotlight as the host course of the Evian Masters, a major event on the Ladies' European Tour as well as a popular event on the LPGA Tour since 2000. The inaugural event was won by Sweden's Helen Alfredsson, who repeated in 1998 and 2008. Other past winners have included Annika Sorenstam, Paula Creamer, and Natalie Gulbis.

Peachtree is the blueblood of courses in Atlanta and owes it creation to both of golf's illustrious Joneses. The club was founded in 1948 by Atlanta's favorite golfing son, Bobby Jones, after his playing days were over, and was designed by Robert Trent Jones, helping to establish him as America's preeminent course architect. Together, they selected a 240-acre site in north Atlanta that had been the home of the Ashford Park Nurseries, with the namesake trees sprinkled around the property, as well as plentiful magnolias, dogwoods, pines, and oaks. Jones created the molded greenside bunkers and distinct quadrants on the putting surfaces that became his trademark, but used nary a fairway bunker. Some of the more notable holes are the fourth, a par-three over water to a shallow green, and the long par-four 12th, with a landing area protected by a creek and statuesque weeping willow. The clubhouse is an antebellum mansion that survived Sherman's March. Peachtree was Trent Jones's first major American project, during which he adopted the name Trent, after the river in England near where he was born, to avoid being confused with Bobby Jones.

BELOW: The clubhouse

Reynolds Plantation is a resort and residential community set around Lake Oconee in central Georgia, 75 miles east of Atlanta. The resort developed by Mercer Reynolds boasts four top-drawer courses—the Great Waters Course designed by Jack Nicklaus, the National Course designed by Tom Fazio, the Plantation Course created by Bob Cupp, and the Rees Jones-designed Oconee Course—as well as the private Creek Club. The resort is also the home of a Ritz-Carlton hotel. The Great Waters Course that opened in 1992 is carved from the Georgia pines around the nooks and crannies of the lakeshore. Nine holes play along or across Oconee, including the par-five 18th with water down the entire left side of the fairway and sickled green. Lake Oconee is Georgia's second-largest lake with 374 miles of shoreline and it makes a literary appearance in the opening paragraph of James Joyce's *Finnegan's Wake.*

RIGHT: Great Waters Course

Reynolds Plantation is one of America's most bountiful golf resorts and lake communities, with more than 80 miles of shoreline on Georgia's Lake Oconee. The Creek Club is the fifth and most recent course at the resort and the only one that is private, opening for play on June 1, 2007. With four top courses designed by Jack Nicklaus, Tom Fazio, Rees Jones, and Bob Cupp, Reynolds decided to shake things up and commissioned Jim Engh to design the Creek Club. Engh had earned a reputation for building big-boned courses on sites straight out of a John Ford Western, layouts like Fossil Trace in Colorado, Hawktree in North Dakota, and Blackstone Country Club in Arizona, but had done virtually no work east of the Mississippi. He got a chance to show his stuff at the Creek Club, creating distinctive "muscle" bunkers with rolling sidewalls and sculpting cross hazards through the Georgia pines. The Creek Club also lives up to its name, with the tributaries of Richland Creek coming into play on fourteen of its holes.

Augusta National Golf Club, the home of the Masters Tournament that signals the coming of spring every April, was founded by Bobby Jones as his dream course. Jones started with the ideal property, a former nursery named Fruitlands founded by the Belgian horticulturalist Baron Prosper Berckmans. The old manor house is now one of the world's most famous clubhouses and the pitching fairways and greased lightning-fast greens are surrounded by floral fireworks in the form of azaleas, rhododendrons, camellias, and redbud. Jones engaged Dr. Alister MacKenzie as the architect, and together they created a course that brilliantly reflected their shared belief in strategic design based on the model of the Old Course at St. Andrews. The 11th through 13th holes, which play around Rae's Creek, embody the risk-reward strategy of Jones and MacKenzie. This stretch of holes is known as Amen Corner, a name that the *New Yorker* golf writer Herbert Warren Wind came up with based on the jazz song "Shouting in that Amen Corner." The Masters began in 1934 as the Augusta National Invitational and quickly blossomed into one of golf's four major championships. Through the Masters, Augusta National has come to symbolize the perfectly maintained and abiding beauty of the American parkland course.

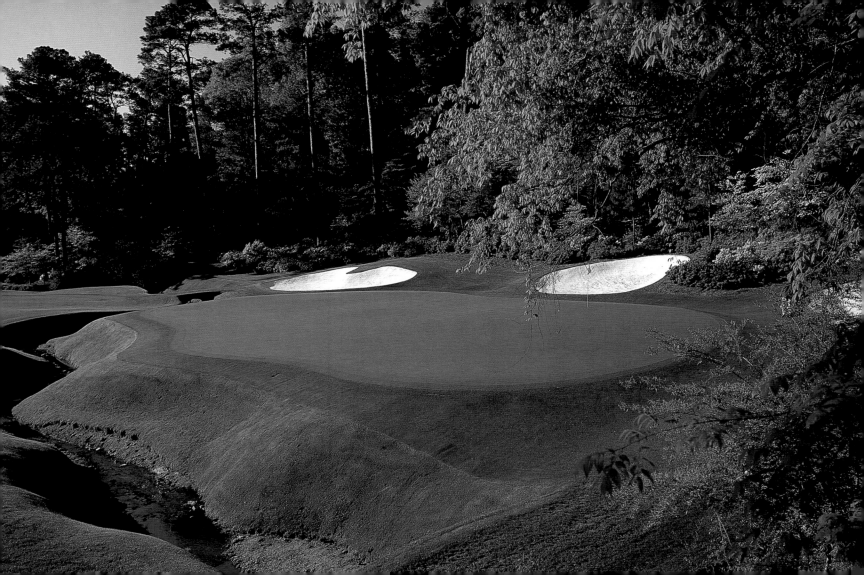

The Sea Island Resort was started by Howard Coffin, an automotive engineering whiz who founded the Hudson Motor Company. While visiting the Savannah racetrack in 1910, Coffin and his wife made a trip to Sapelo, a small island south of Savannah, and became enchanted with the beauty of the Georgia coast. Coffin purchased the 20,000-acre island in 1911 and continued to acquire additional land over the next decade, including the small island that was to become known as Sea Island. Coffin enlisted his cousin Alfred W. "Bill" Jones as his business partner, originally envisioning construction of a grandiose hotel on the scale of the Waldorf Astoria. Jones came up with a more realistic plan for an overnight inn and in 1928 the Cloister was born. The hotel has endured and flourished as a landmark of American golf and a popular honeymoon destination for newlyweds, including George and Barbara Bush, who spent their honeymoon there in 1945 and returned for their 50th wedding anniversary. The original course consisted of the Plantation Nine designed by Walter Travis and the Seaside Nine designed by the famed team of Harry Colt and Charles Alison; later, the Retreat Nine designed by Dick Wilson was added. In 1998, Rees Jones modified and seamlessly combined the Plantation and Retreat nines, creating the Plantation Course. At the same time, Tom Fazio created a completely redesigned and stunning 18-hole Seaside Course that unfolds through the lowland scenery of marsh and moss-draped live oaks with powder-puff bunkers of talcum white sand.

RIGHT: Seaside Course

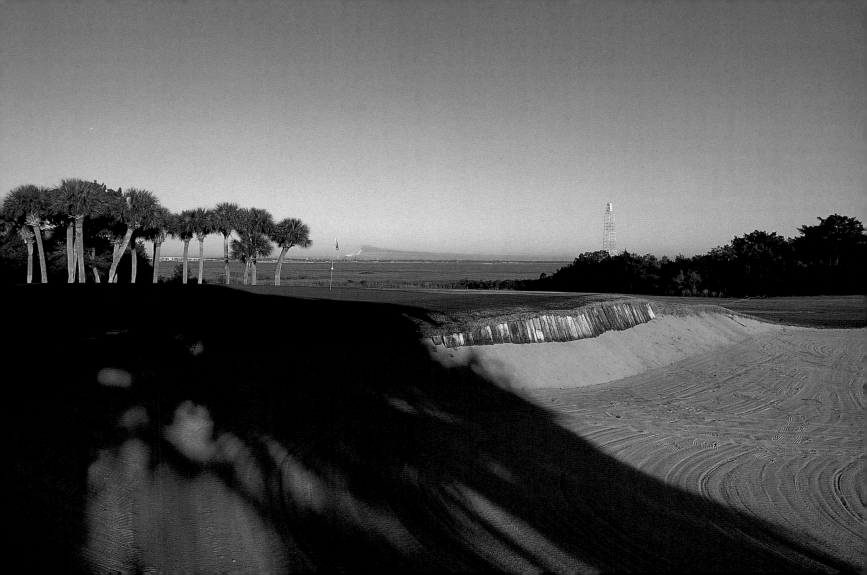

Harbour Town Golf Links on Hilton Head Island is the inspired design of Pete Dye that in many ways came to define the modern school of golf course architecture. When Dye designed the course in 1967, he was largely unknown outside his native Midwest, and his player consultant, Jack Nicklaus, was just getting started in the design business. Dye created small greens, Scottish-style pot bunkers, waste areas, and used railroad ties and telegraph poles as bulkheads for the hazards, all of which was very avant garde at the time and represented a reaction to the designs of Robert Trent Jones, the leading American golf course architect. Harbour Town was a phenomenal success and became the centerpiece of the Sea Pines Resort developed by Charles Fraser. In 1969, the PGA Tour started playing the Heritage Classic at Harbour Town, with the inaugural tournament won by Arnold Palmer. With the marsh and Calibogue Sound fronting the tee and running along the entire left side of the fairway, and the famous red and white candy-striped lighthouse of the Hilton Head marina behind the green, the 18th at Harbour Town is one of the great finishing holes in golf.

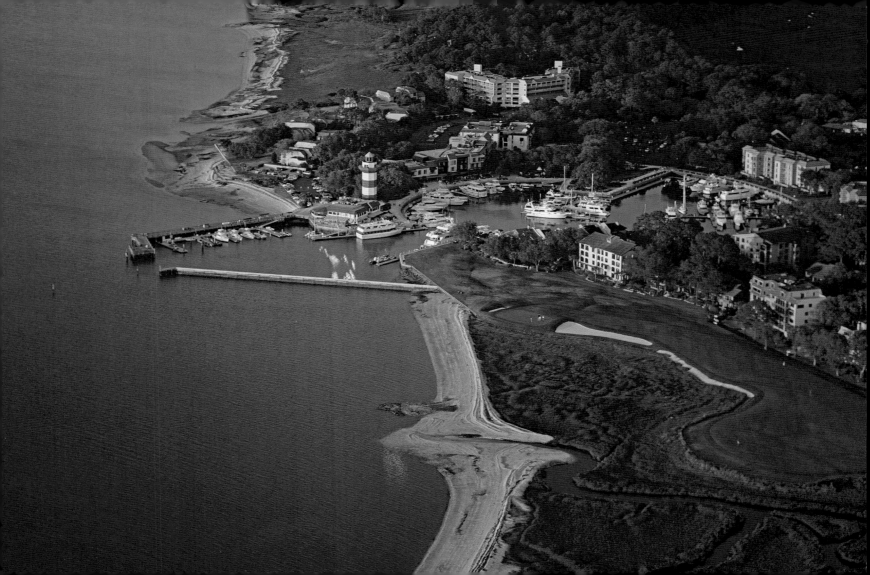

Haig Point Golf Club is a private course designed by Rees Jones on Daufuskie Island, which can only be reached by ferry across Calibogue Sound from Hilton Head. The demanding layout has a routing that alternates with rhythmic cadences between open holes that wend through immense live oaks festooned with Spanish moss, holes bounded by forests and ponds, and forced carries across the tidal marsh along the sound, which comes into play on the par-three eighth and 17th holes. The clubhouse is the former Strachan mansion, which was built in 1910 on St. Simons Island, Georgia. The mansion was saved from destruction by the International Paper Company, the developer of Haig Point, and moved by barge 100 miles up the Intracoastal Waterway to Daufuskie.

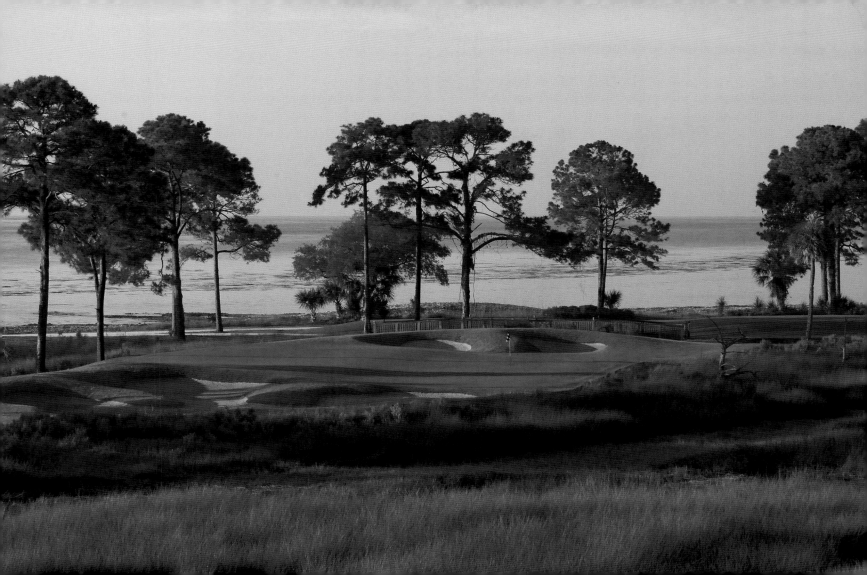

The May River Golf Club at the Inn at Palmetto Bluff captures the fragile beauty and solitude of South Carolina's Low Country tidal marshes. The course is located in Bluffton, a small village roughly halfway between Savannah and Hilton Head Island that was once devoted to rice and turpentine plantations. The course is a veritable nature excursion, where walking is encouraged, carefully routed by Jack Nicklaus and his team through the May River maritime forest of longleaf pines and live oaks, some of which are 300 years old. Several of the fairways, seeded with heat- and salt-resistant paspalum, laze along the banks of the river with its herons, snowy egrets, cormorants, and, of course, alligators. The waste bunkers are fringed with native sweet grasses. Nicklaus even had a special type of angular sand that is more adhesive during coastal storms shipped from Ohio for the bunkers. The May River Golf Club opened in late 2004 as the golf course of the Inn at Palmetto Bluff, which offers 50 residential cottages along the river and its feeder streams.

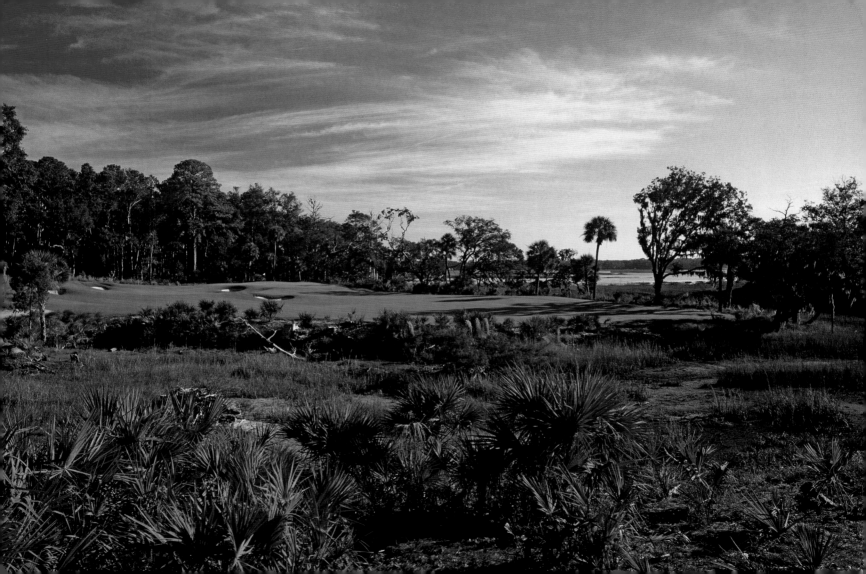

The Ocean Course at the Kiawah Island Resort near Charleston, is one of the few truly great links or duneland courses in the United States and one of the few great links courses to be constructed, rather than routed through the natural hollows and bowls. The Ocean Course also has the distinction of having been awarded the 1991 Ryder Cup before it was even built. Pete and Alice Dye began work on the course in 1989, and despite the publicity and pressure that went with it, they produced a bold and dramatic layout that remains true to the Scottish linksland ideal. The course is laid out in a figure eight, with the front nine looping clockwise and the back nine running counterclockwise as it hugs the shoreline. The first few holes are both excruciatingly difficult and exciting, followed by a series of holes that saunter along the salt marsh. The back nine is uninhibited seaside golf, with a string of fairways that rumble along the ocean before arriving at the famous par-three 17th, with its petrifying carry over the eight-acre lake that was created at the suggestion of Alice Dye. The Ocean Course produced one of the most epic encounters in the history of the Ryder Cup, with the U.S. winning the War by the Shore when Bernhard Langer missed an agonizing six-foot putt on the 18th hole of the final match that would have given him a win over Hale Irwin and the point the Europeans needed to keep possession of the Cup. The Ocean Course has been selected as the site of the 2012 PGA Championship.

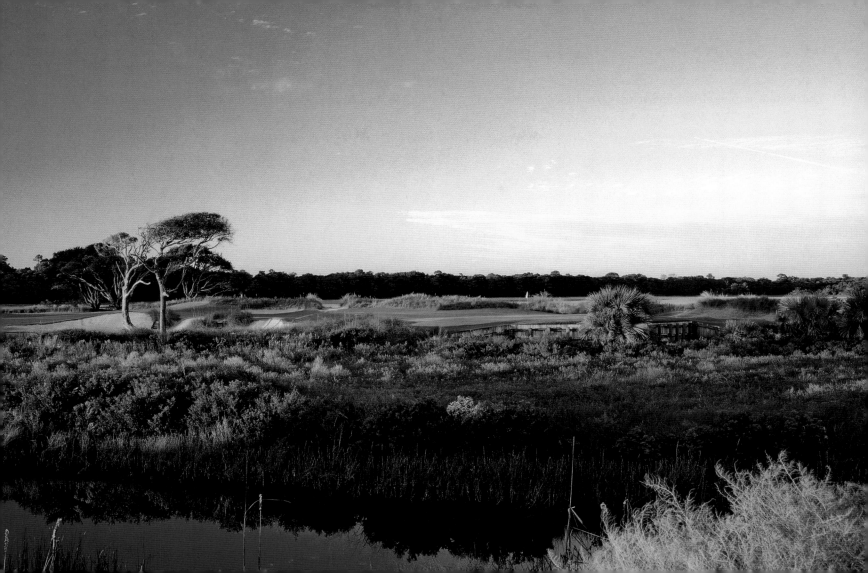

The Cliffs at Keowee Falls is part of a collection of three residential golf communities, each with a separate golf course, located on the shores of South Carolina's 18,500-acre Lake Keowee, which is fed by hundreds of Appalachian mountain streams. The Cliffs at Keowee Falls, designed by Jack Nicklaus, opened in May 2007; Tom Fazio created the layouts at Keowee Springs and Keowee Vineyards. The complex is located at the edge of the Blue Ridge Mountains, surrounded by Jocasee Gorges State Park and the Pisgah National Forest. The course takes its name from the Falls Creek waterfall, which empties into the lake. Nicklaus used the creek that runs through the valley as a design element on the first, ninth, tenth, 15th, 16th, 17th, and 18th holes. Ponds were also added on holes eight and 17, while the 15th was designed around the largest known fruit-bearing North American pear tree. During construction of the course, Falls Creek was completely restored, a project carried out over 5,300 feet of creek bed. The work included bringing in 4,900 boulders, each weighing over a ton, to anchor and beautify the creek.

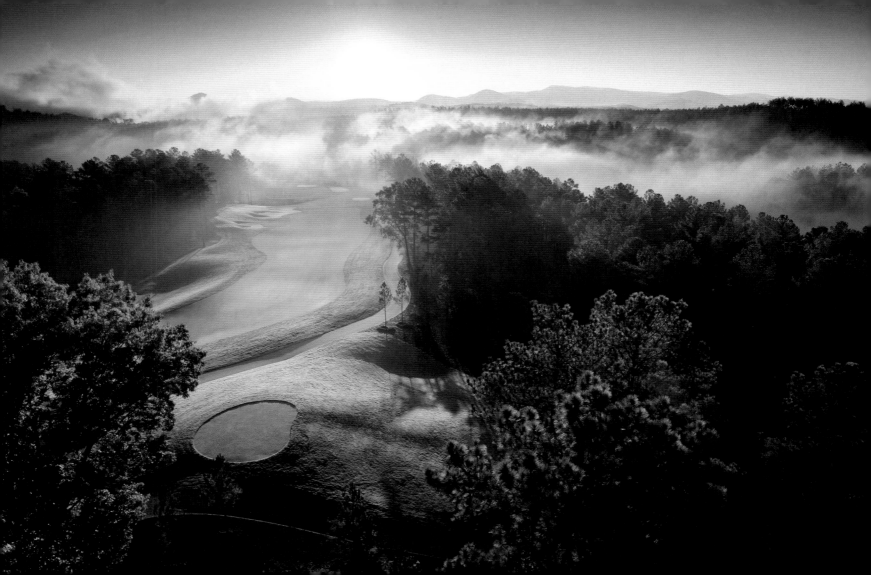

The Club at Irish Creek is home to a new course by Davis Love III on the site of what had been the Kannapolis Country Club in Kannapolis, North Carolina, outside Charlotte. The design is yoked to the 400-acre lake at the center of the property, which is visible from 16 of the 18 holes, with fairways separated by the dense, full-bodied forest of hardwoods and pines. Love, who successfully combines playing the PGA Tour with serious golf course design, constructed four new holes and extensively reworked 14 others within the corridors of the existing course to create the new design. Love's layout, which includes the same kind of subair ventilation system and white Spruce Pine sand used at Augusta National, is a traditional, walkable course. It opened in 2007. The original club had been purchased in 1982 by David H. Murdock, the chairman of Castle & Cooke, the company that developed its Hawaiian pineapple plantations into the Dole Food Company. Castle & Cooke undertook both the creation of the Irish Creek course and its development as a luxury home community. It also established the North Carolina Research Center in Kannapolis, one of the world's most advanced centers for biotechnology research.

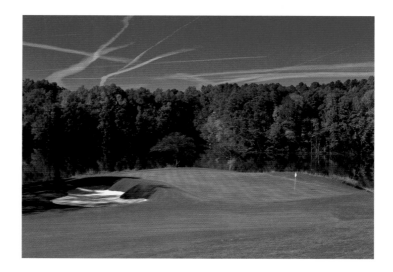

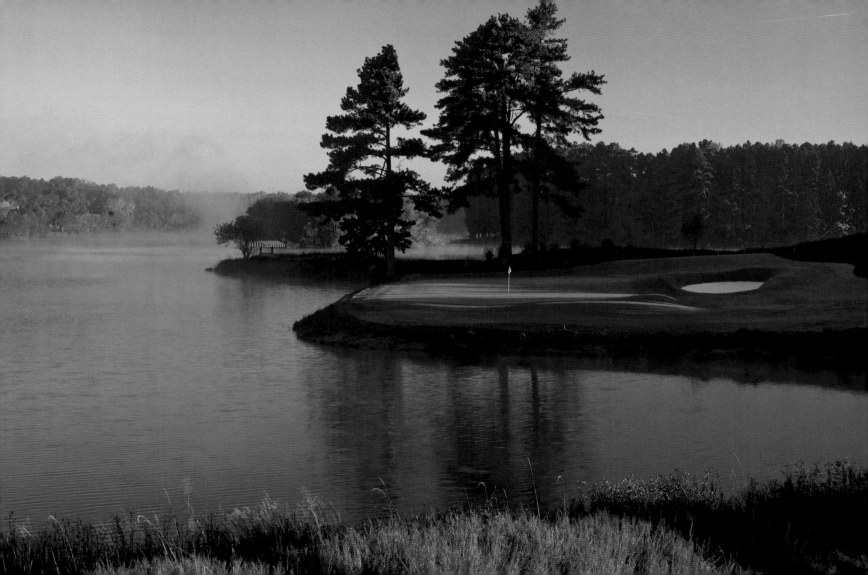

Wade Hampton Golf Club is set in the heart of the Blue Ridge Mountains of western North Carolina near the village of Cashiers. The course is named after the famous Confederate general who also served as governor of South Carolina and as U.S. Senator. The property was the summer retreat of the Hampton family for more than 150 years. In 1922, the Hampton estate was purchased by E. Lyndon McKee, who converted it into the High Hampton Inn, which has remained a popular rustic mountain getaway for generations of Southerners seeking to escape the heat of summer. McKee's grandchildren, A. William McKee and Ann McKee Austin, developed Wade Hampton as a private and refined golf club that opened in 1987. The course is one of designer Tom Fazio's loveliest and most natural creations, lying directly below the imposing stack of Chimney Top Mountain. The course flows effortlessly through tall pines and rushing mountain streams with rocky beds banked with rhododendron that guard the greens of the par-threes.

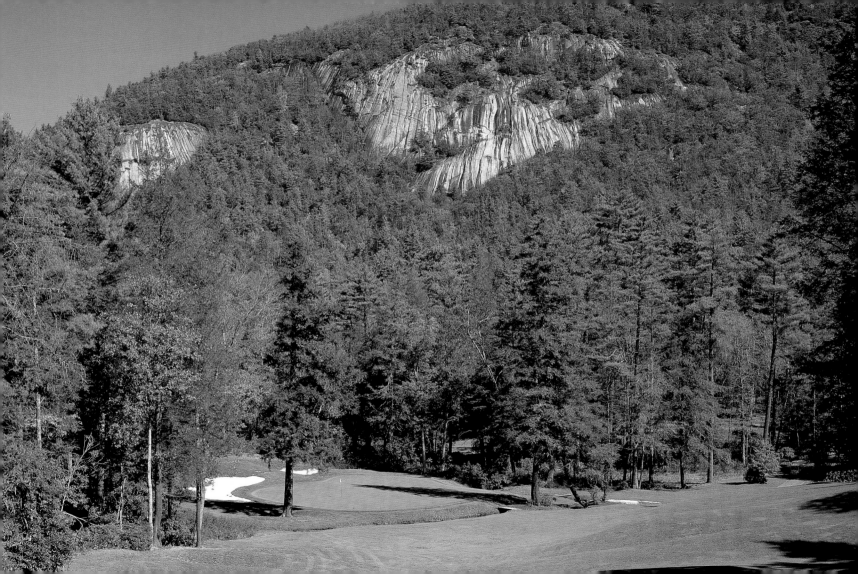

The Pinehurst Resort is the most famous American golf resort and the one that most often draws comparisons with St. Andrews, for although it is far from the sea in the sandy wastes of central North Carolina, it is a planned village that has become dedicated to golf. The irony is that when Pinehurst was founded in 1895 by James Tufts, the wealthy Bostonian manufacturer of soda fountains, there was no golf there at all. In its first few years, Pinehurst was a retreat for New Englanders of modest means who were convalescing from respiratory illnesses, where the favorite pastime was roque, a form of croquet. The recreational picture began to change in 1899 when a nine-hole course was built. In 1900, Tufts hired Donald Ross, the transplanted Scottish professional, to come to Pinehurst to embark on designing what was to become a series of courses. Ross's Pinehurst No. 2 is an endless source of inspiration and fascination—a course that appears relatively benign but whose challenging angles of play and crowned greens with fall-away slopes make it inordinately difficult. The 310-room hotel is a national landmark, and the resort also owns the Holly Inn. In 1999, Pinehurst hosted its first U.S. Open, which proved to be a worthy and exacting test for the pros, with the late Payne Stewart winning the championship. The Open returned to Pinehurst in 2005, with New Zealand's Michael Campbell outlasting Tiger Woods to claim victory.

BELOW: Statue of Donald Ross

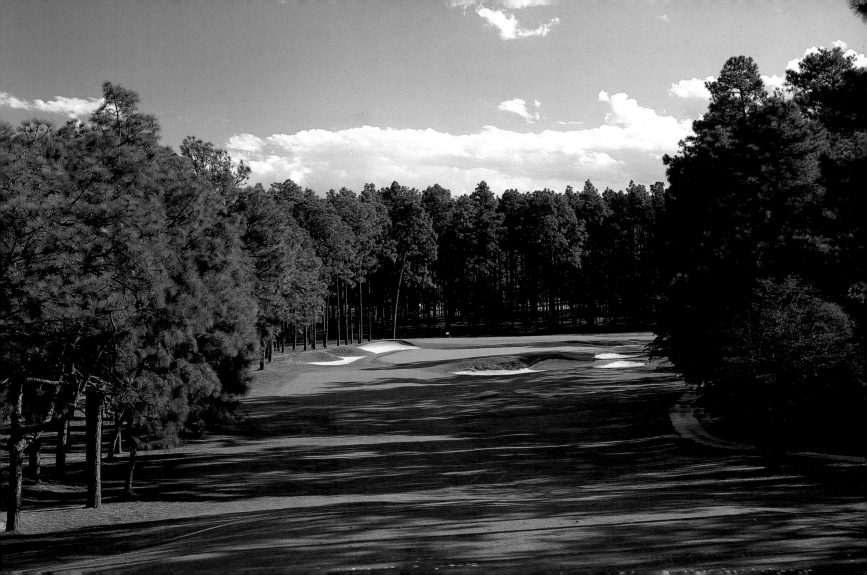

The Cardinal Golf Club is located in Greensboro, in North Carolina's Piedmont Triad. The course was originally developed by the Cardinal Corporation and designed by Pete Dye in 1972, when he was just entering his high style. The members purchased the club in 1985, and over the years it ran into financial difficulties and conditions deteriorated. In June 2006, Raleigh-based healthcare entrepreneur John McConnell and his McConnell Golf Properties came to the rescue and acquired the course. McConnell brought Dye back to perform a thoroughgoing renovation and restoration of his original par-70 design, which reopened on July 25, 2007. The rolling, wooded site, cleaved by lakes and Brushy Creek, has water coming into play on virtually every hole. Dye added and repositioned bunkers to account for modern technology, refashioned the greens, and greatly improved the conditioning with a state of the art irrigation system. Dye extended the original 160-yard par-three 12th, which now plays a truly diabolical 220 yards over the lake.

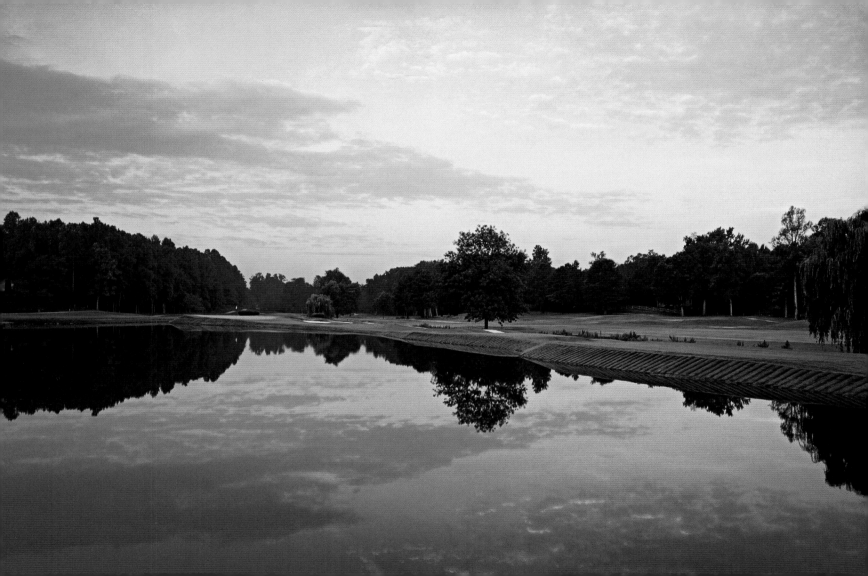

The Cascades Course at The Homestead Resort in Hot Springs, Virginia is the Allegheny Mountain masterpiece of William Flynn, the great Philadelphia golf course architect of the golden era of design. Opened in 1923, the course's strength is how seamlessly the narrow, sloping fairways are contoured through the valley floor, surrounded by the dense overgrowth of white and red oaks, red, sugar, and silver maples, white pines, and Norway spruce. A mountain stream comes into play on many of the holes, particularly the final three. The course finishes with a 192-yard par-three over the stream, with the green overlooking the clubhouse that was once the summer home of New York Stock Exchange trader Jakey Rubino. In 1967, Catherine LaCoste, the daughter of French tennis star René "the Crocodile" LaCoste, won the U.S. Women's Open at the Cascades as a 20-year-old amateur, the only amateur ever to win the championship. The resort has two other courses: The Old Course is a 1913 Donald Ross design and the Lower Cascades Course is a Robert Trent Jones design from 1963.

BELOW: Lower Cascades Course

RIGHT: The Cascades Course

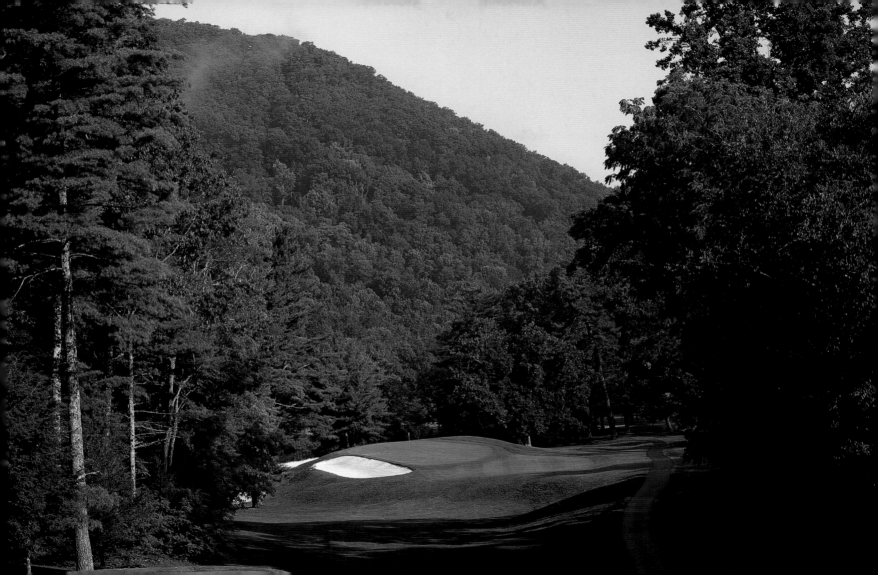

Kinloch Golf Club, or By the Lake, is a private club that opened in April 2001 twelve miles northwest of Richmond. The centerpiece of the course is the 70-acre lake, which is also home to a fishing club. The lake was built by Richmond real estate developer C.B. Robertson, who showed the property to Marvin "Vinny" Giles, the 1972 U.S. Amateur Champion who is now an agent representing a number of Tour players. Giles persuaded Robertson that they should create an exceptional course, and they proceeded to work with Richmond-based course architect Lester George. Kinloch is routed through forests of pines, fruit trees, and dogwoods, and the construction crew was given leaf packages to enable them to identify and preserve specimen flowering trees during clearing. Most of the holes on the back nine skirt the lake, which is overlooked by the Tudor-style clubhouse with its steeply pitched, oversized roof.

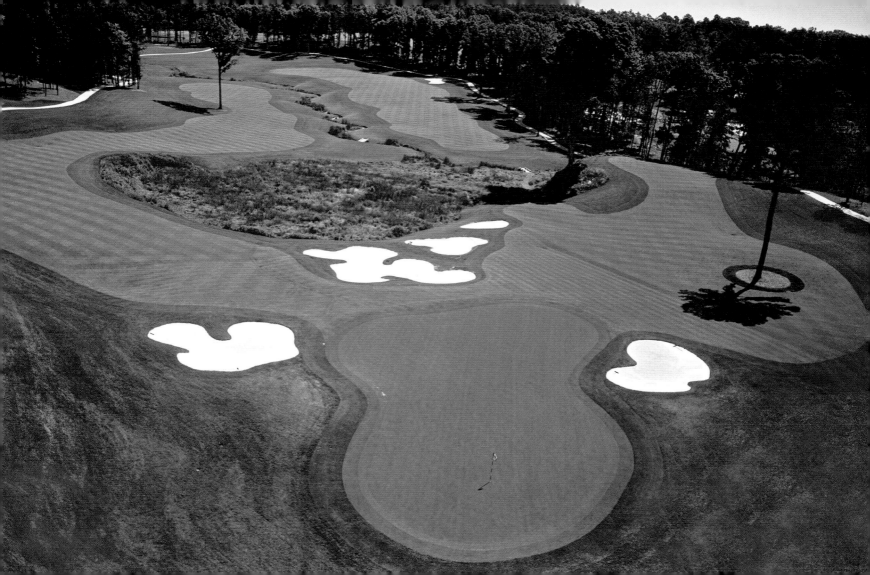

Royal New Kent, located in New Kent County, is an interesting fusion of links golf with the modern sculpted style of the late Mike Strantz, who headed several projects for Tom Fazio before embarking on a solo design career. The course is in the town of Providence Forge, named for a forge that was destroyed in the Revolutionary War and one of the earliest settlements in New Kent County. The layout takes its inspiration from Royal County Down and Ballybunion in Ireland, with Strantz creating the stone walls that run through the course. While it bears only a distant resemblance to its Irish cousins, Royal New Kent is an altogether striking design in its own right, with the fairways flowing in big, sinewy coils and humps of land. Strantz used shaggy red and brown fescue grasses to demarcate the roiling mounds and added 134 plunging bunkers, many with fringed edges that recall the "eyebrow" bunkers of Royal County Down. The back tees at 7,291 yards are named Invicta, the Latin word for "unconquerable."

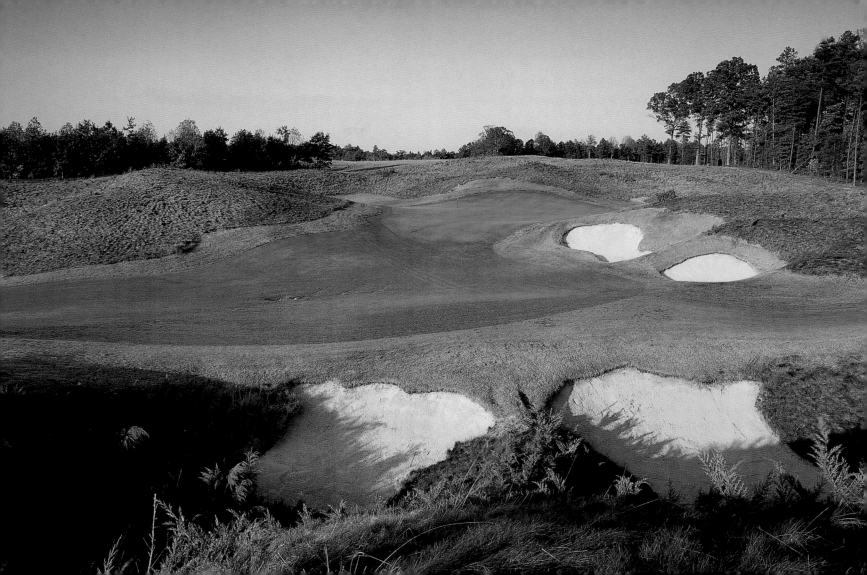

The Robert Trent Jones Golf Club is a tribute to its designer, who dominated golf course architecture both in the United States and internationally, leaving his indelible mark on some 450 courses in 45 states and 29 countries. RTJ, which coils around Lake Manassass, the 850-acre reservoir in northern Virginia's Prince William County, is a gathering place for movers and shakers from inside the Beltway. Jones first discovered the sylvan property in the late 1970s, but it was not until his Ft. Lauderdale neighbor, Wendy's founder Dave Thomas, put him in touch with developer Clay Hamner in the mid-80s that the project became a reality. Completed in 1990, when Jones was at the end of his career, half of the holes cavort along the banks of the lake, including six on the back nine, and there are two inland ponds to boot. All of this has made for high drama at the Presidents Cup, which the club has hosted four times beginning with the inaugural match in 1994, with the U.S. team victorious each time. In 2005, the contest came down to the final hole, with Chris DiMarco birdieing the 18th hole to defeat Stuart Appleby. The clubhouse is presidential in stature, a redbrick Georgian mansion with a colonnaded rotunda.

BELOW: The clubhouse

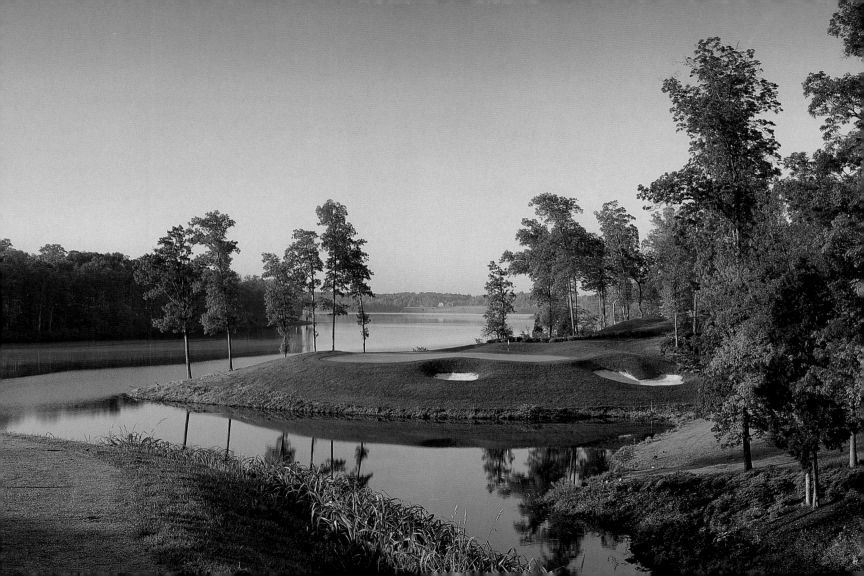

The Pete Dye Golf Club in the town of Bridgeport, near Clarksburg, is one of the most unusual and creative courses in the United States. The course is a testament to the perseverance of Dye, the most inventive golf course architect of the modern era, and to the dream of the club's founder, James LaRosa, of building a golf course over land that had been used for coal mining that would commemorate the tradition of the region. LaRosa, who became interested in golf through his son, invited Dye to West Virginia in 1979, and 16 years later the project was finally completed. The final product is a tour de force, with carries over creased, stream-laced countryside and along the plateaus created by strip mining of the wooded hillsides. There is a 40-yard walk or cart ride through a replica mineshaft between the sixth and seventh holes and the par-five eighth incorporates a 120-foot high wall exposing the Pittsburgh seam of coal and a ventilation entry. Pete Dye Golf Club is a private national golf club, with members from 27 states and five countries.

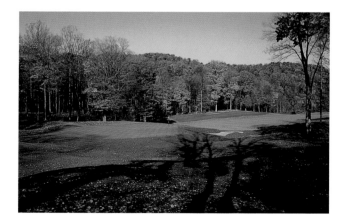

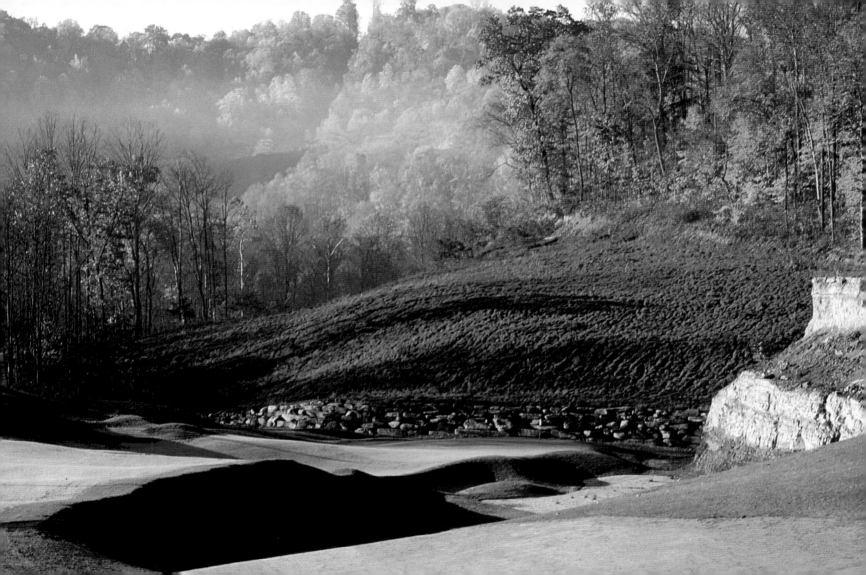

The Greenbrier is one of America's grandest and oldest golf resorts, set on 6,500 acres in the Allegheny Mountains in White Sulphur Springs, West Virginia. Over the years the resort has been a favorite golfing haven for presidents and high-powered Washington politicians. Twenty-two presidents have slept in the white Georgian hotel with its towering portico. There are three courses at the Greenbrier. The Old White Course, named for the original hotel that stood from 1858 to 1922, was designed by Charles Blair Macdonald in 1913, and remains one of America's finest mountain courses. Robert Trent Jones chose the first hole of the Old White for the dream 18-hole course he put together for an article that appeared in *Town & Country* in 1938. The Greenbrier Course, designed by Seth Raynor in 1924, was revised by Jack Nicklaus when the course was selected as the site for the 1979 Ryder Cup Match. From the ninth tee, there is a view of the Midland Gap in the Allegeheny Mountains, where the early settlers passed through on their way to the West. In 1999, the Lakeside Course, designed by Dick Wilson in the 1960s, was completely revamped by Bob Cupp. The Course was renamed the Meadows, harkening back to the original nine-hole course built in the stream valley known as the meadows.

RIGHT: The Meadows Course

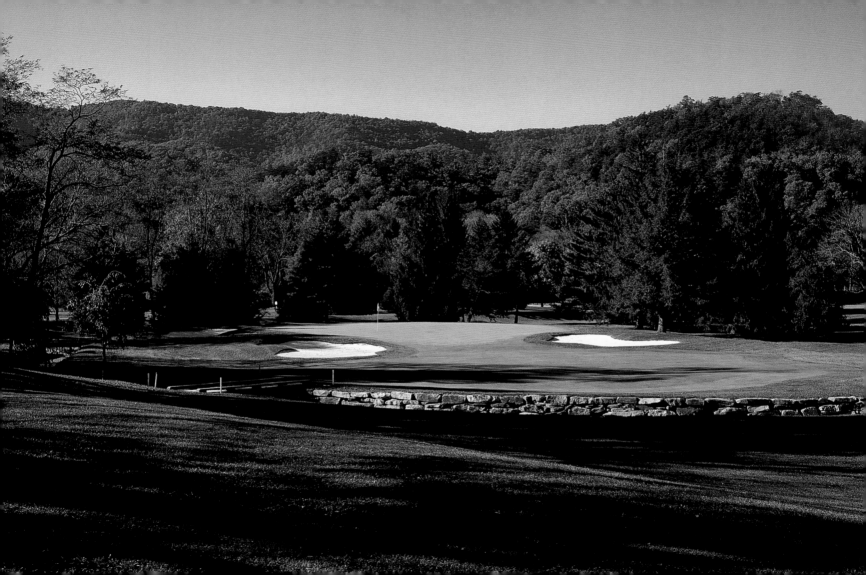

Valhalla Golf Club, named for the resting place for warriors in Norse mythology, is a course of lusty proportions that has put Louisville on the world golf map. Designed by Jack Nicklaus and opened in 1986, the course was developed by leading Louisville businessman Dwight Gahm and his three sons. Nicklaus was given a ruggedly rustic 263-acre site as his canvas, consisting of two farms and an old Boy Scout camp crossed by a stream called Floyd's Fork. The first nine is laid out through relatively open land, while the back nine is hewn from more rolling terrain covered with sycamore, oak, locust, and walnut trees. The PGA of America was so smitten with the design that it purchased a stake in the course and selected it to host the 1996 PGA Championship won by Mark Brooks. In 2000, Valhalla was again the site of the PGA, with Tiger Woods clawing his way to a spine-tingling victory over Bob May in sudden death. In 2008, Valhalla hosted the Ryder Cup Match, in which the U.S. team returned to form and convincingly vanquished the European side.

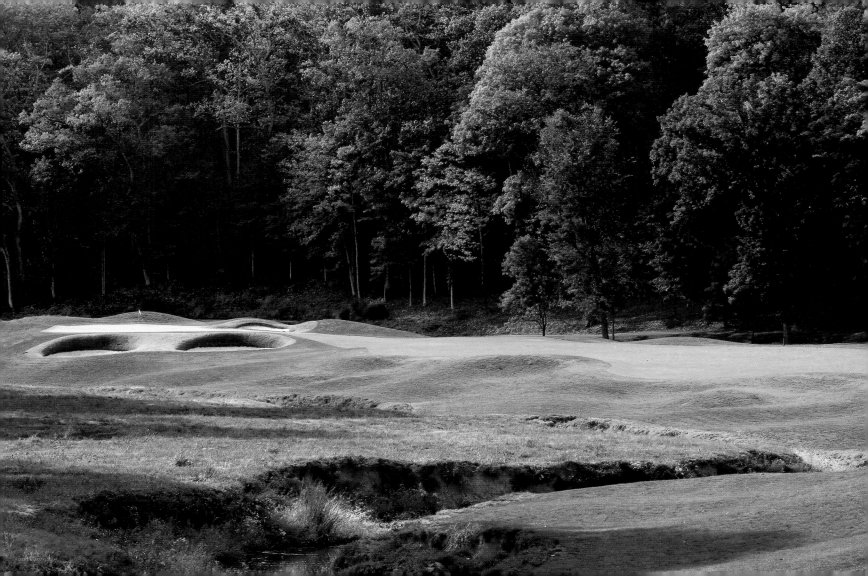

Victoria National Golf Club is routed through a former strip-mining site near Evansville in southern Indiana. Terry Friedman, the developer of the course, wanted to create a private club with a demanding course of the highest caliber. He looked long and hard to find an unusual and dramatic site that would serve as the tableau for one of Tom Fazio's more distinctive creations. Fazio made the most of the jagged contours on the 400-acre site, creating deep, sinuous lakes in the pits left by the strip mines by reaching underwater springs during the construction process. The spoil heaps left over from the mining process resemble shaggy dunes, and Fazio poured the fairways through and, in some instances, across them. With only 27 acres of fairway, and trouble all around, Victoria National is both visually enthralling and constantly challenging.

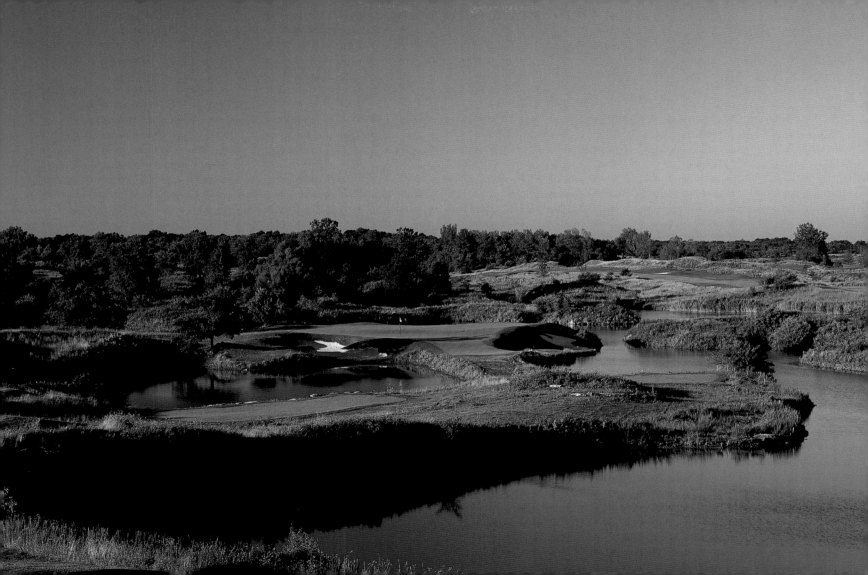

MAY 2 | THE CLUB AT OLDE STONE—KENTUCKY, U.S.A.

Old Stone is located in Alvaton, near Bowling Green, in south central Kentucky, giving the state a one-two golf punch with Valhalla, the site of the 2008 Ryder Cup Match. Opened in 2005, the course has plenty of elbow room, with holes two through seven laid out on the broad flood plain of Drake's Creek. The rest of the course occupies higher, hillier ground, with a total elevation change of 160 feet. The fairways were capped with a layer of sand, allowing for the wicking away of moisture and the planting of bentgrass, which normally only thrives farther north. The result is a firm and fast course with an emphasis on the ground game that fits in with the grassland terrain. Designed by Arthur Hills and partner Drew Rogers, there are water hazards in play on five holes, including the drivable par-four 14th, with a steeply downhill fairway to a green guarded by a pond. The development at Olde Stone follows a New Urbanist approach, with the creation of a village center that leaves the course free of intruding homesites.

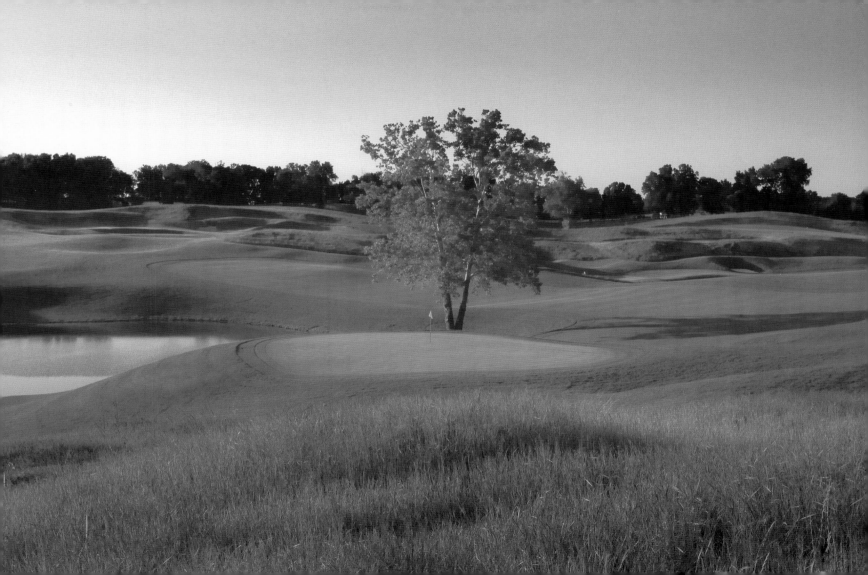

The Honors Course in the town of Ooltewah, just north of Chattanooga, was developed by Jack Lupton to honor the spirit of amateur golf. Lupton selected as his designers Pete and Alice Dye, who were themselves top-notch amateur golfers, Pete having won the 1958 Indiana State Amateur, while Alice won the Indiana Women's Amateur seven times. Opened in 1983, the course is exceptionally tranquil, with softly sculpted, natural fairways winding around two lakes and through groves of southern red oak, shagbark hickory, pines, and dogwoods in an isolated valley beneath the ridge of White Oak Mountain. A distinguishing feature of the Honors Course is the striking array of specimen grasses planted by David Stone, the greenkeeper at the course since its inception. When Stone first accepted the position, he undertook a comprehensive study of the native grasses in the Chattanooga Valley and began introducing them around the fairways and bunkers. The result is a rich fugue of purple, brown, beige, and tan fescues and sedges.

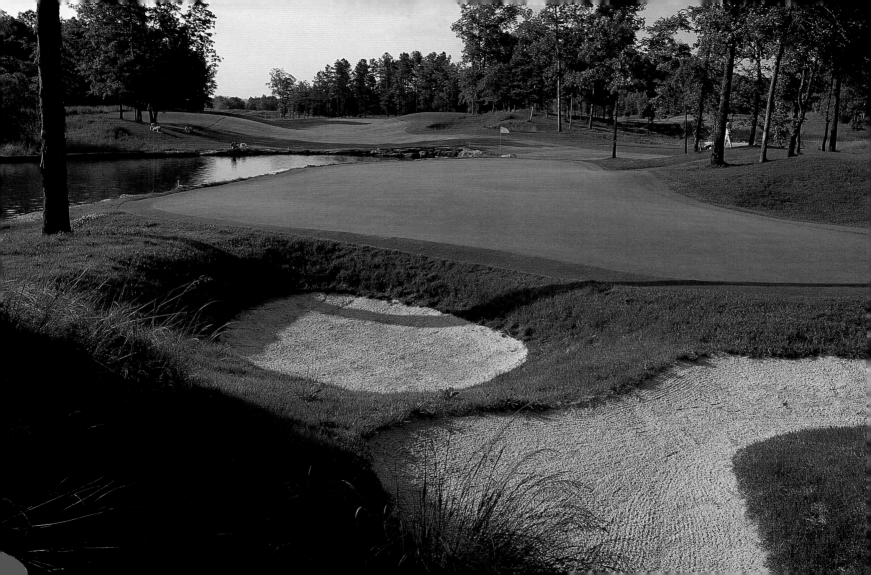

Shoal Creek is carved through the dense woodlands outside Birmingham, Alabama, under the shadow of Double Oak Mountain. The course opened on November 1, 1977, with a ceremonial round played by designer Jack Nicklaus and former U.S. Open champions and native Alabamans Jerry Pate and Hubert Green. Shoal Creek was very much in the public eye when it hosted the 1984 PGA Championship won by Lee Trevino; the 1986 U.S. Amateur won by Buddy Alexander; and the 1990 PGA that went to Wayne Grady. A comment made prior to the 1990 PGA Championship by Hall Thompson, Shoal Creek's founder, about the club's unwillingness at the time to accept African American members, led the PGA and the USGA to institute a rule requiring host clubs to meet inclusive membership requirements. While Shoal Creek has remained out of the spotlight since then, in 2008 the club hosted the U.S. Junior Amateur Championship. Shoal Creek's clubhouse is designed in the style of Colonial Williamsburg, down to the authentic Flemish Bond brickwork and replica of the crest of the Governor's Palace.

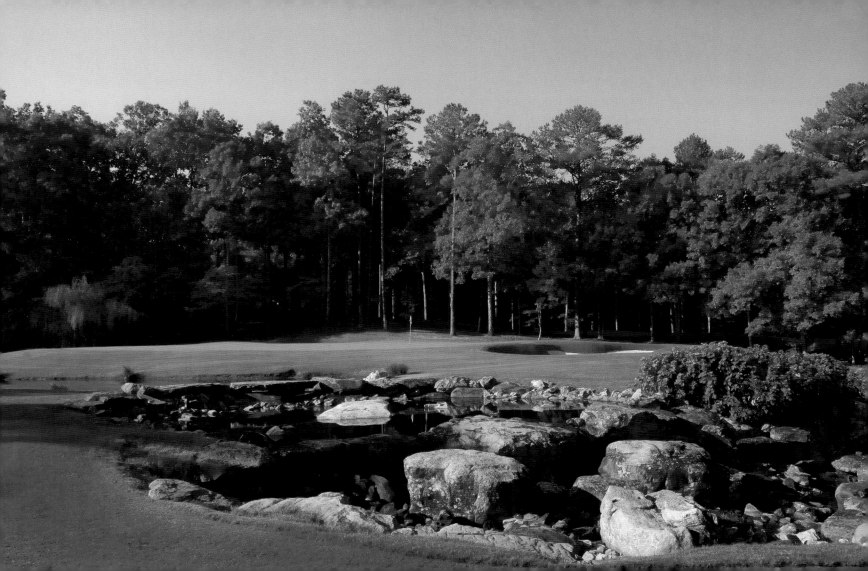

Dancing Rabbit Golf Club is built on the ancestral lands of the Mississippi Band of the Choctaw Indians, most of whom were forcibly relocated to Indian Territory in Oklahoma in the 1830s. This resort in central Mississippi, near Tupelo, consists of two courses, The Azaleas and The Oaks, both designed by Tom Fazio and Jerry Pate, the 1976 U.S. Open champion. The courses are carved through gently rolling forests of high-canopied pines and hardwoods, with more than two miles of spring-fed creeks and streams weaving across the fairways. The clubhouse is located at the head-waters of Wolf Creek. Dancing Rabbit is named for the traditional Choctaw assembly grounds along the banks of the Big and Little Dancing Rabbit Creeks a few miles from the clubhouse.

RIGHT: The Azaleas Course

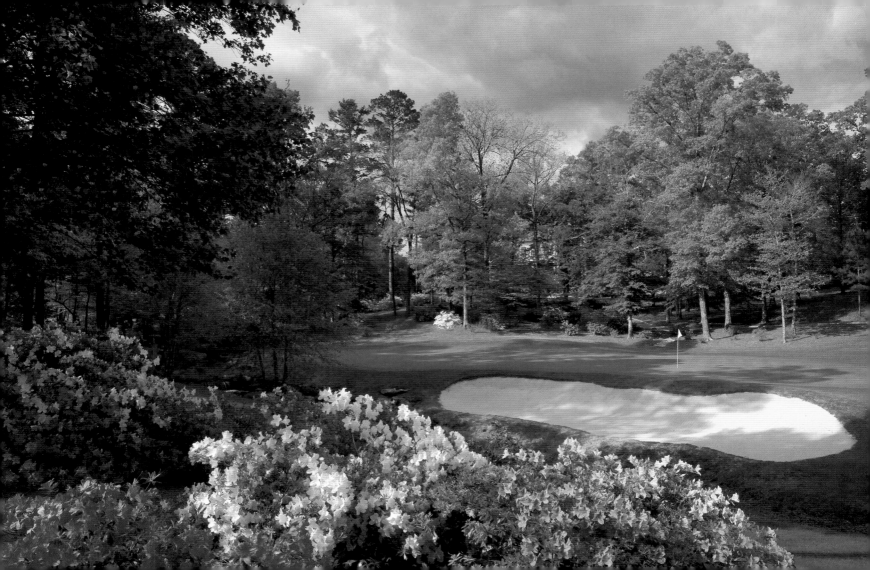

MAY 6 | THE PRESERVE GOLF CLUB—MISSISSIPPI, U.S.A.

The Preserve Golf Club, located at Vancleave near Biloxi, is an ecotour through the flora and fauna of Mississippi's Gulf Coast. Designed by Jerry Pate, the public access course is surrounded by 1,800 acres of dedicated nature preserve. It wraps around pitcher plant bogs and cypress swamps, with fairways peeled away from long leaf pine savannah and groves of live oaks, and Old Fort Bayou bordering the course's eastern edge.

The course is also the home of cranes from the surrounding Sandhill Crane Refuge. The Preserve opened in July 2006, its debut delayed by Hurricane Katrina in August 2005, which flooded the course and downed thousands of trees. Many of the pines were replaced with trees transplanted from Florida. Pate emphasized strategy over distance at the Preserve, with numerous carries over marshes and lakes.

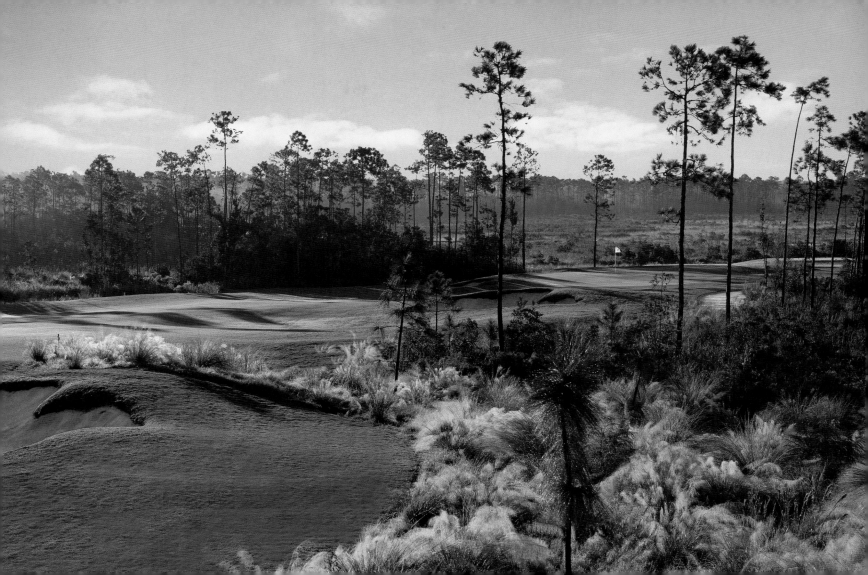

MAY 7 | GRAY PLANTATION GOLF COURSE—LOUISIANA, U.S.A.

Gray Plantation Golf Course is located in the heart of Louisiana's Bayou Country in Lake Charles, at the western end of the Creole Nature Trail, a scenic national byway that starts out 186 miles to the east in Sulphur. The Gray, designed by William "Rocky" Rocquemore, laps the Calcasieu Waterway. Its wetlands and 60 acres of man-made lakes are home to wood ducks, egrets, and alligators. There are two island-green par-threes, the signature sixth playing over the Waterway and the 17th, while the irrigation lake splits the fairway on the drivable par-four 11th. Built in 1999, the course was badly damaged by Hurricane Rita in 2005, which destroyed 75 percent of the tall, frilly pines, but has gradually been restored. Gray Plantation is a charter member of the Audubon Golf Trail established by Louisiana's Department of Tourism, which also includes the TPC of Louisiana outside New Orleans, home of the state's only PGA Tour event.

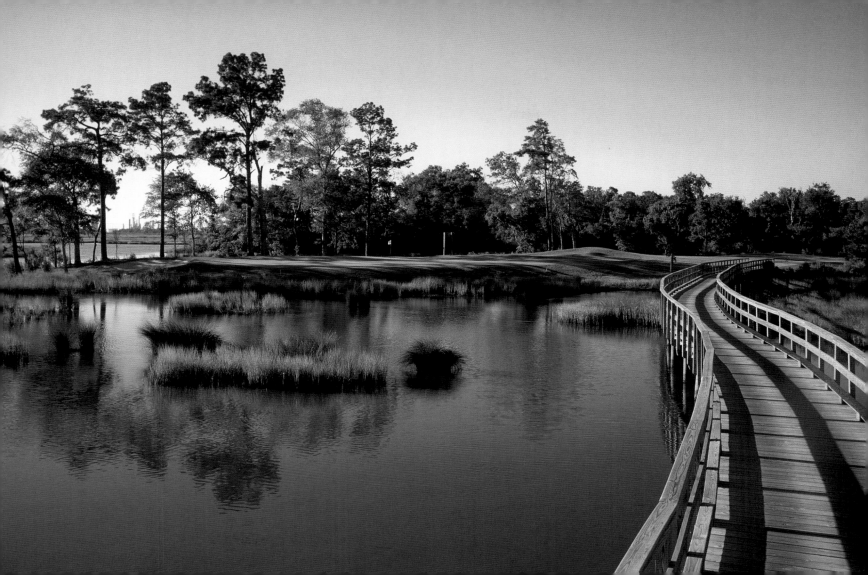

Blessings Golf Club, a private course in the town of Johnson, just outside Fayetteville in the northwest corner of Arkansas, made its debut in June 2004. Designed by Robert Trent Jones, Jr., the course was developed by Jim Tyson of Arkansas-based Tyson Foods. The dominant design feature is Clear Creek, with holes rimmed by wild grasses swooping over the steep elevation changes along and across the creek. Indeed, the course was going to be called the Course at Clear Creek right up until opening day, when Tyson decided to count his blessings. Blessings is the home of the University of Arkansas golf team, whose most famous product is John Daly. The Fred and Mary Smith Razorback Golf Center has six indoor/outdoor practice bays, an indoor video swing analysis station, and locker facilities for the men's and women's teams, while the state-of-the-art practice range was created by leading golf teacher and CBS commentator Peter Kostis. The Golf Center and clubhouse were designed by University of Arkansas architecture professor and emerging international architect Marlon Blackwell.

The Club at Porto Cima on the Lake of the Ozarks was developed by the Four Seasons as the centerpiece of a private golf community. While the site on the Shawnee Bend peninsula of the Lake of the Ozarks is just across the water from The Lodge of the Four Seasons, the property was inaccessible and could not be developed until the Lake of the Ozarks Community Bridge was completed on May 1, 1998. Designed by Jack Nicklaus as a signature course and opened in 2000, Porto Cima loops around the lake and through a forest of native oak trees, with seven holes straddling the water. The inspiration for the Mediterranean motifs of the Porta Cima development, which includes a yacht club, comes from the resort village of Portofino on the Italian Riviera.

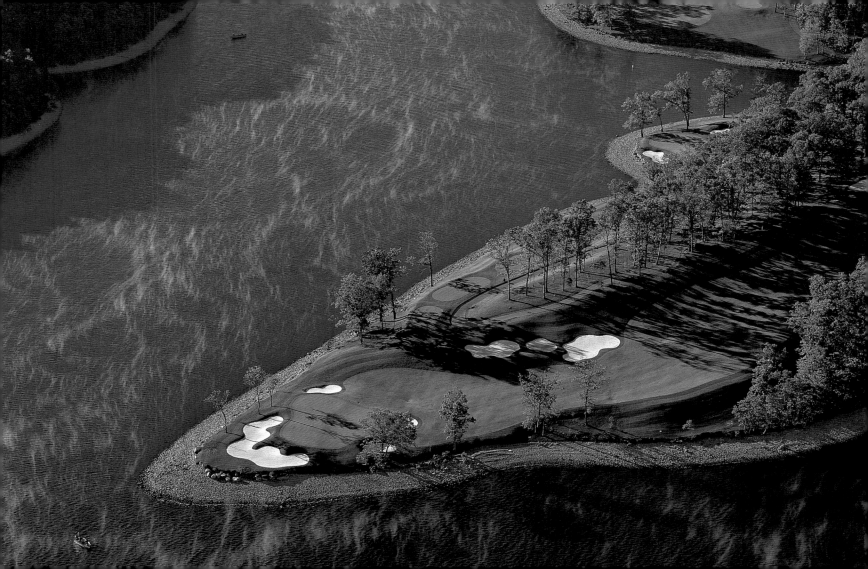

Karsten Creek Golf Club in Stillwater is the home course of the Oklahoma State Cowboys and one of the best public courses in the United States. When Mike Holder became coach of the Oklahoma State golf team in 1974, he dreamed of building a championship course for his squad. He located an ideal site and contacted renowned architect Tom Fazio in 1983 about designing the course. Fazio drew up a plan for the course but the project remained on the drawing board for another eight years, until the late Karsten Solheim, founder of equipment-maker Karsten Manufacturing, agreed to provide the funding. In 1994, Holder's 20-year quest was realized, and Karsten Creek opened. Karsten Creek is a luscious, rolling course of secluded holes through blackjack oaks and hickory trees, with long meadow grasses lapping the fairways and a creek ambling around the 11th hole. The final three holes open up to the 110-acre Lake Louise created by Fazio and named for Solheim's wife. The lake runs all along the left side of the long, par-four 17th, while the 18th curves around the opposite shore back to the clubhouse.

Dallas National, a private course that opened in 2002, is built on 388 acres of rolling land crowned by woods of cedar, elm, and oak, and fields of wildflowers, defying all preconceptions of the topography of North Texas. Founder John MacDonald brought in designer Tom Fazio to build a demanding course that plays a whopping 7,326 yards from the Texas tees. The layout traverses creeks, canyons, and two plateaus on the Dallas-Duncanville-Grand Prairie borders, only six miles from downtown Dallas, with elevation changes of more than 170 feet. There are eight wood-trellised bridges to link the holes across the dramatic terrain. The members of Dallas National include Texas Ranger turned Yankee slugger Alex Rodriguez, baseball's wealthiest player and a dedicated golfer, hockey's Brett Hull, and golf legend and Dallas native Lee Trevino.

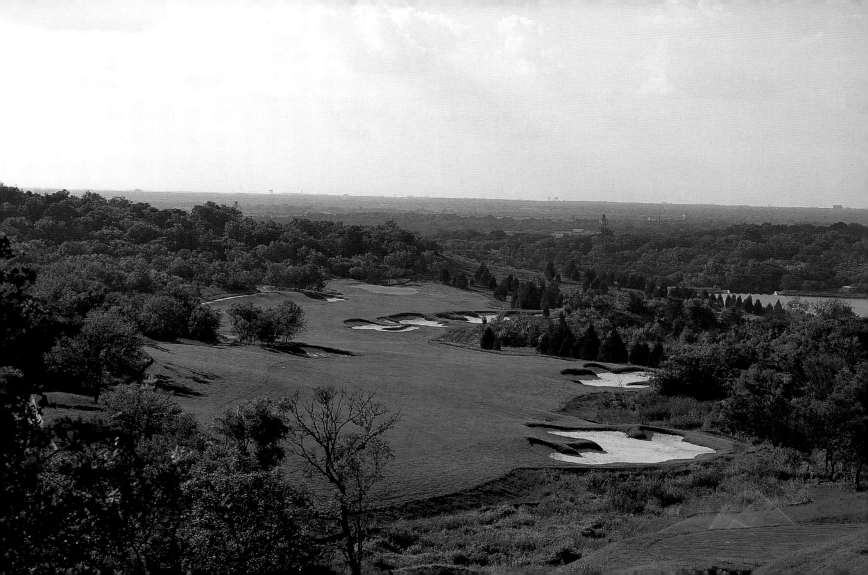

Whispering Pines is located in Trinity, Texas, 88 miles north of Houston, laid out on a 400-acre site whose natural riches include the tall, straight-stemmed, and elaborately layered pines, as well as creeks, lakes, and sandy waste areas. The property is owned by Texas entrepreneur Corby Robertson, whose mission was to create a longhorn equivalent of Augusta National, including lightning-fast greens and flawless conditioning.

The course, designed by Chet Williams of Nicklaus Design, was unveiled in March 2000 and is only open for play by the members for 15 weeks in each of the fall and spring seasons. The final six holes are particularly scenic, running along Caney Creek with shoreline views of Lake Livingston. Members can stay at one of the Club's four cottages, named St. Andrews, Augusta National, Pine Valley, and Ballybunion.

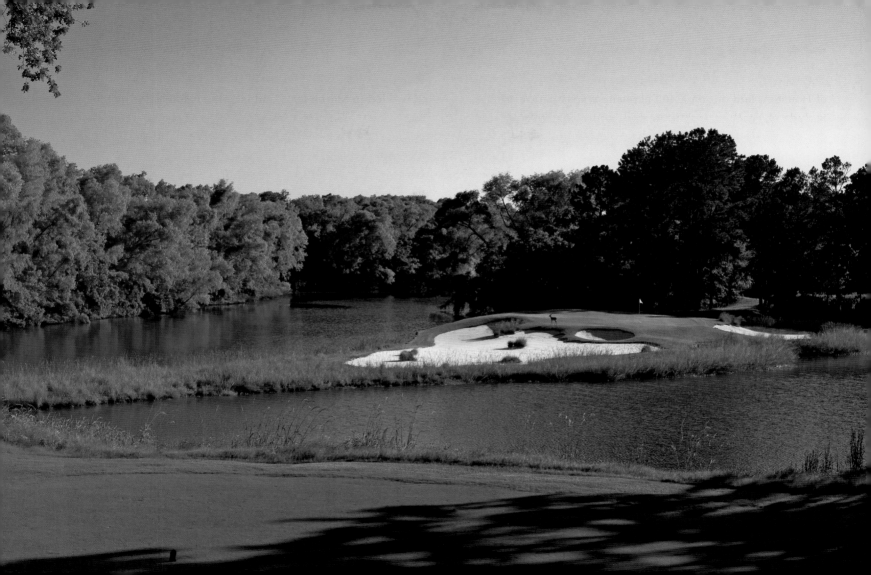

Butterfield Trail Golf Club, which opened in June 2007, is a public course adjacent to the El Paso Airport and owned by the city of El Paso Department of Aviation. Designed by Tom Fazio, the course is laid out over natural dunes, with 55 feet of elevation change, and is raked by the West Texas winds. The course takes its name from John Butterfield, president of the Butterfield Overland Mail Company, which operated the stagecoach trail carrying mail and passengers over the 2,800 mile route from Tipton, Missouri, to San Francisco. The route operated from 1858 to 1861, covering 700 miles through Texas. There are remnants of the stagecoach trail along the eighth hole of the course. The tee of the par-three 17th is the highest point on the layout, serving up views of downtown El Paso and Mexico. The 18th is a par-five that loops to the right around a lake, one of the two water hazards on the course.

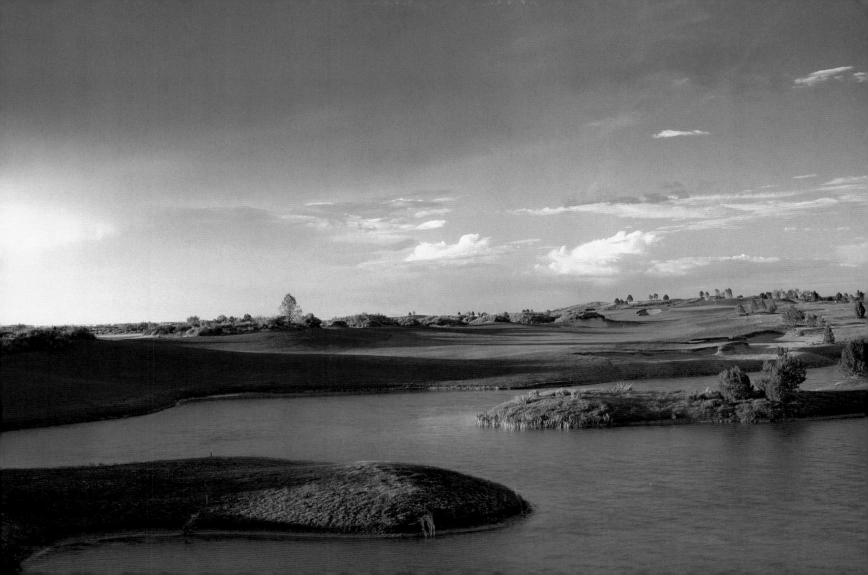

Rainmakers is a golf community just north of Ruidoso in the Rocky Mountains of southern New Mexico. Opened in 2008, the course lies at 7,000 feet, with pitching fairways on the rugged route around canyons and rock outcroppings and a gaping arroyo between the sixth and 10th fairways. The holes are framed by piñon, juniper, and ponderosa pine, with native grasses bordering the fairways under the domes of the Sierra Blanca and Capitan Mountains. The course name is a tribute to the 12th-century shaman or rainmaker of the Jornada Mogollon native people who lived in southern New Mexico between A.D. 900 and 1400; archaeological artifacts found on site are displayed in the clubhouse. Architect Robert Trent Jones, Jr. worked closely with the developers to craft a course that conserves water and protects the environment, including the use of low-distribution sprinkler heads and polymers that absorb water and then release it directly to the root zone. The design also set aside 135 acres as a preserve for wildlife, including migratory waterfowl.

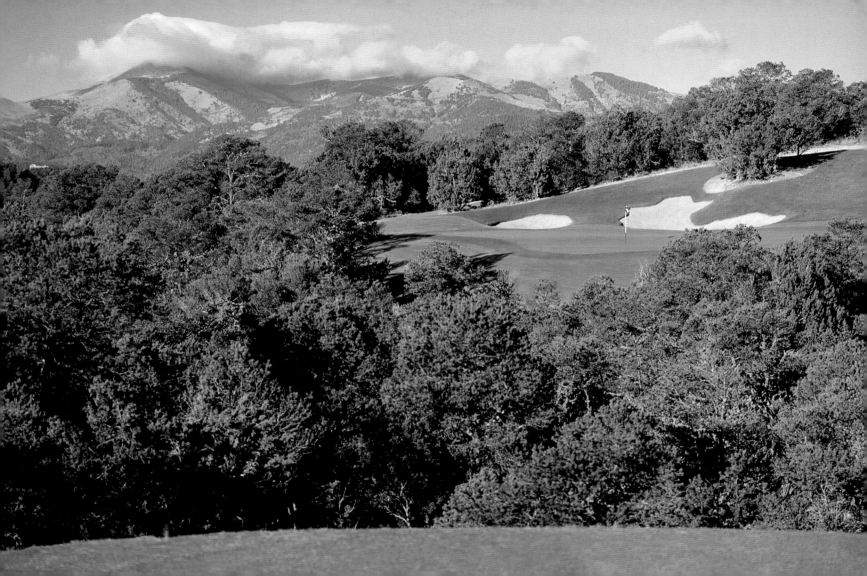

Black Mesa Golf Club is a stunning course that streams through the New Mexican high desert on the Santa Clara Pueblo 30 minutes north of Santa Fe. Opened in 2003, Black Mesa was designed by Baxter Spann of the firm of Finger Dye Spann, whose partner Ken Dye is responsible for two other New Mexico gems, Piñon Hills and Paa-Ko Ridge.

Spann did not try to alter the terrain, but instead fitted swirling fairways and dollops of green between crowns of sandstone and rocky gullies cut by ancient arroyos. Spann created big pinwheeling bunkers and oversized greens in the natural depressions that are surrounded by wiry wild grasses and juniper bushes.

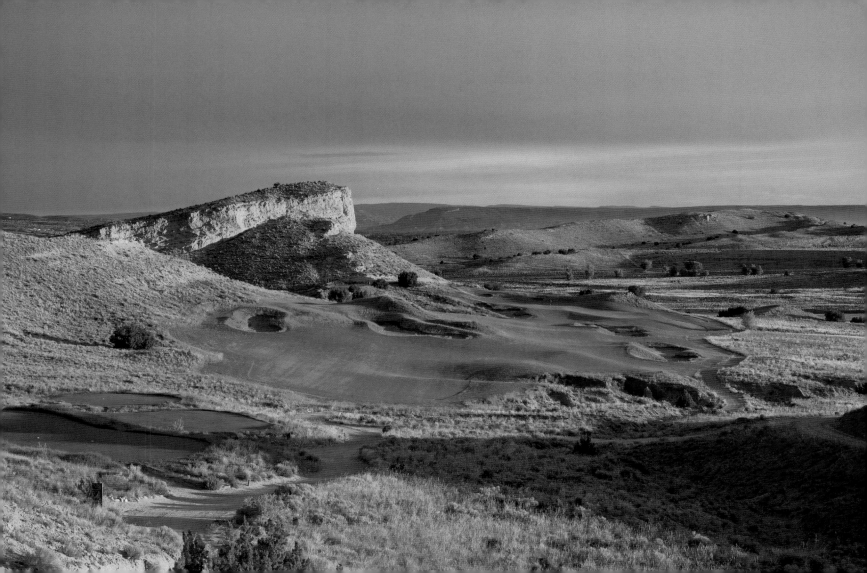

Cougar Canyon Golf Links is located in Trinidad, in southeastern Colorado, once a rough-and-tumble coal mining town of saloons and gunslingers, where legendary lawman Bat Masterson served as town marshal in 1882. The golf course, designed by Jack Nicklaus, lets the rugged setting do the talking, with the sandy, boulder-clogged arroyo carved by Gray Creek serving as the dominant design feature. A whopping 7,700 yards, the course gradually climbs in elevation, surrounded by the Spanish Peaks and Sangre de Cristo Mountains. Fisher's Peak, the 9,600-foot high basalt-capped mesa that towers over Trinidad, comes into view on the sixth hole, a split-fairway par-five. The par-three 16th is a Wild West showpiece, with a pedestal green mounted above the arroyo to form an island green. With such robust natural obstacles, there was little need for artificial hazards. There are only 33 bunkers at Cougar Canyon and, in a nod to Cougar Canyon's coal mining heritage, they are filled with black-lava sand from Capulin, an ancient volcano 60 miles to the south in New Mexico.

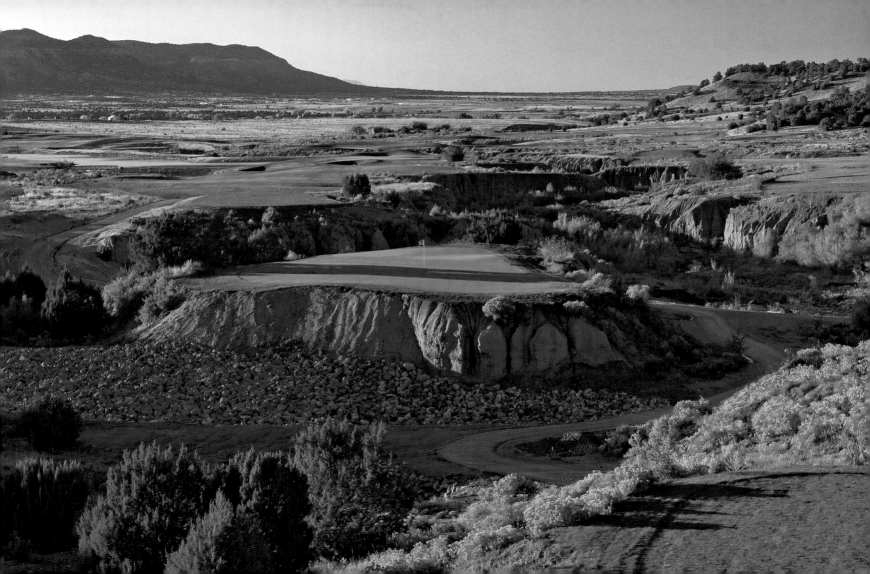

Four Mile Ranch Golf Club is located outside Cañon City in southern Colorado's sunny and temperate "banana belt." Opened in June 2008, the course is part of the 1,640-acre Four Mile Ranch residential community. The course is the work of Jim Engh, known for his muscular designs on tempestuous western landscapes. True to form, Four Mile Ranch features sharp doglegs and roiling greens designed around ridges and dips, with the fairways playing chutes and ladders through a landscape of juniper, piñon, and the defining white-shale hogsbacks. Engh dispensed with sand bunkers, letting the natural contours and hogsbacks serve as hazards. He also threw in a blind one-shotter on the 14th modeled after the Dell Hole at Lahinch. From the course there are views out to Cañon City and the Sangre de Cristo Mountains in the distance. Established in 1859 as a base for gold miners in the Rockies, Cañon City straddles the Arkansas River just across from the mouth of the Royal Gorge, which is traversed by the world's tallest suspension bridge.

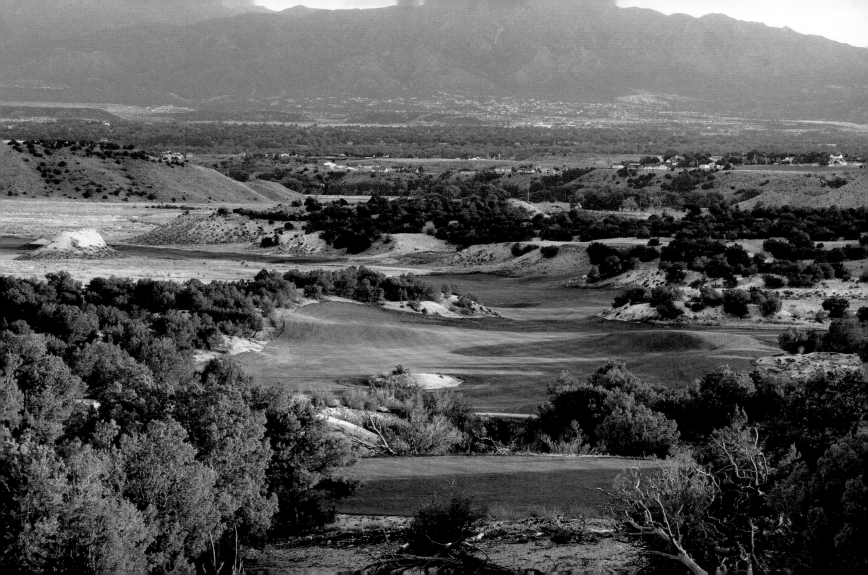

The Broadmoor in Colorado Springs has been an American golfing landmark since the original Donald Ross–designed course opened in 1918, together with the resort. The Broadmoor was created by Spencer Penrose, a Philadelphia entrepreneur who developed the Pikes Peak region into a major tourist destination. From the 1880s until Penrose arrived on the scene in 1916, the site was a dairy farm at the foot of the Cheyenne Mountains. James Pourtales, a Prussian count who had gone West to seek his fame and fortune, invested in the struggling dairy and built the Broadmoor Casino in 1891 in an effort to develop the town of Colorado Springs. The Casino and its hotel were a financial failure and Penrose bought the property. He hired the premier architectural firm of Warren and Wetmore to design the main complex, with its famed pink stucco façade, in a grandiose Italian Renaissance style, bringing in artisans from Italy to carry out the work. The Broadmoor's East Course is a combination of nine of the original holes designed by Ross, the leading architect of the period, and nine holes designed by Robert Trent Jones in 1952. The East Course has hosted many major tournaments, including the 1959 U.S. Amateur won by Jack Nicklaus and the 1995 U.S. Women's Open at which Annika Sorenstam captured her first major title. It will host the U.S. Women's Open again in 2011. The Broadmoor's West Course also combines holes by Ross and Jones, and at 6,800 feet is even higher in elevation than the East Course. The Broadmoor's third 18, the Mountain Course, was renovated by Nicklaus and reopened in 2006.

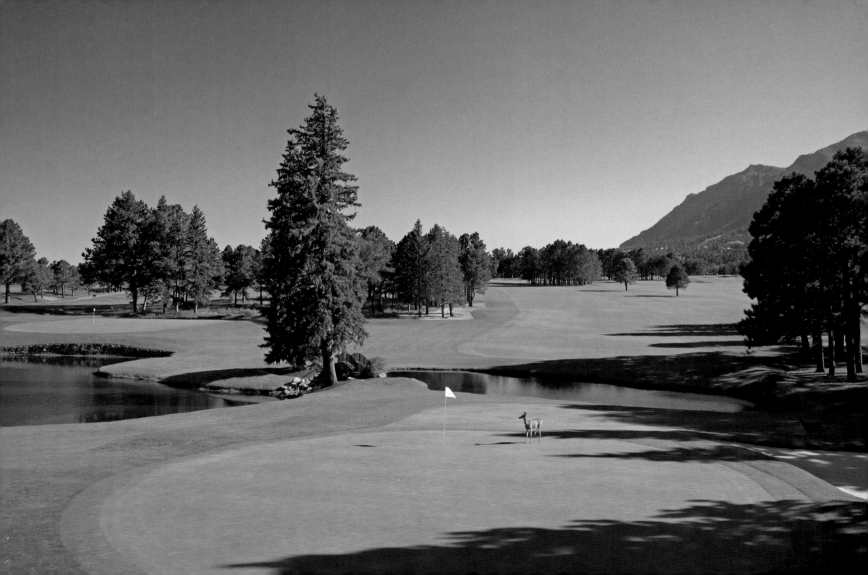

Arrowhead Golf Club in Littleton, Colorado, is the cream of public golf in the Denver area and one of the most photogenic and most photographed courses in the world. Located in Roxborough State Park, the course is routed through and around the immense red sandstone flatirons, which the course's architect, Robert Trent Jones II, referred to as the "cathedral-like conglomerate rocks jutting up from the rolling terrain at the foothills of the Rockies." The course has plenty of elevation changes, narrow fairways, undulating greens, and one dramatic view after another of the vermilion wonderland, with the fourth hole demanding an approach that is all carry over a pond. The short par-four tenth and the 11th and 12th all play around the 60-foot high parapets of red rock forged 300 million years ago. Opened in 1974, there are five mesmerizing par-threes at Arrowhead, but the 13th hole is the real rock star, with a pulpit tee 80 feet high playing down to a green framed by flatirons with the lake behind.

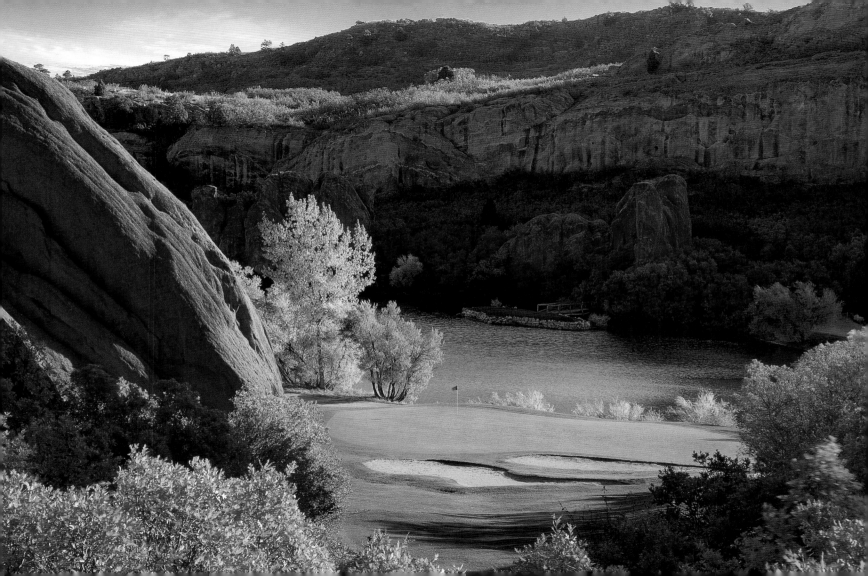

MAY 20 | RED SKY RANCH & GOLF CLUB—COLORADO, U.S.A.

Red Sky is a private membership club with two championship courses located in Colorado's Vail Valley between Vail and Beaver Creek and separated by a mountain ridge that serves as a wildlife migration corridor for deer and elk. The Tom Fazio Course, which overlooks Vail's Back Bowls, is spread-eagled over open, sage-covered hills and runs through dense aspen forest and around a highland lake. To preserve the natural landscape, Fazio's team moved more than 23,000 native plants into nurseries, later replanting them throughout the course. The Greg Norman Course, extending to 7,580 yards, shimmies through rock outcroppings, tangles of scrub oak, and wildflower meadows facing the Gore Range and Castle Peak. Red Sky also offers playing privileges to guests at partner lodging properties.

RIGHT: Tom Fazio Course

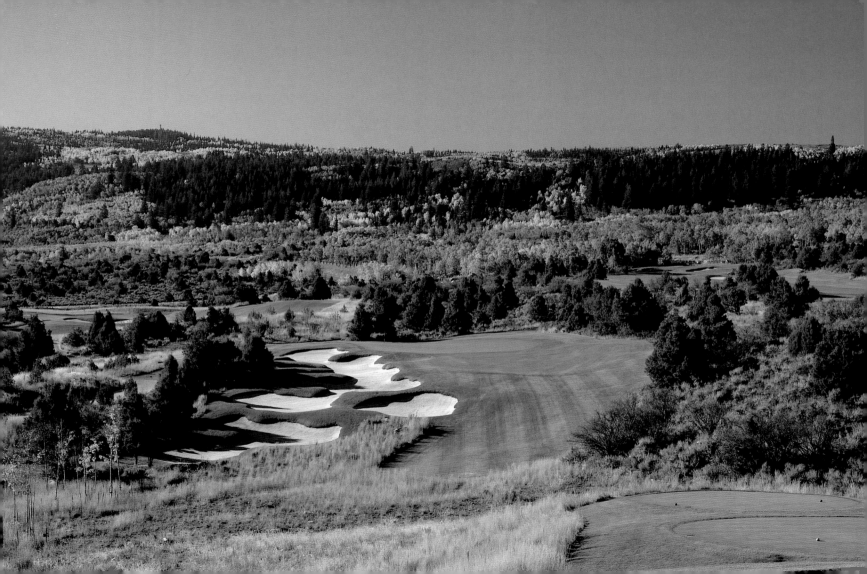

Cherry Hills Country Club is a traditional and elegant parkland course outside Denver. Opened in 1923, it was designed by William Flynn, the Philadelphia architect of the golden era whose portfolio includes Shinnecock Hills and the Cascades Course in West Virginia. More than any other course, Cherry Hills is associated with the stardom of Arnold Palmer. It was here in the final round of the 1960 U.S. Open that Palmer famously drove the green on the 346-yard first hole for an easy birdie, and kept on making birdies for a 30 on the front nine. Eventually, Palmer passed 14 golfers who were ahead of him going into the last round to win the championship. The 1960 Open was also a crossroads in golf history, marking the emergence of a young Jack Nicklaus, who finished second as an amateur, and the last hurrah of an aging Ben Hogan, who was in contention until he found the water that rings the island green of the par-five 17th hole. The U.S. Open was last held at Cherry Hills in 1978, when Andy North was the victor. The newly lengthened course will host the U.S. Amateur in 2012.

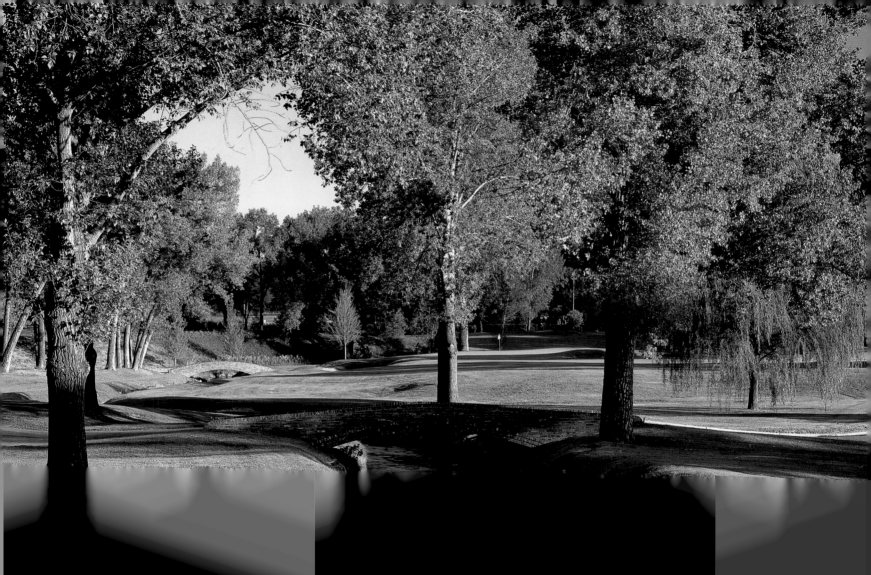

Ballyneal is a superb inland links, sequestered from the world and dedicated to the essence of the game, which opened in 2007. The course is located just south of the little town of Holyoke on the high plains of northeast Colorado, a dozen miles from the Nebraska border. Ballyneal is not in the middle of a cornfield like the baseball diamond in *Field of Dreams*, but in the middle of thousands of acres of cornfields in a swatch of sand dunes known by the locals as the chop hills, that are knotted with yucca plants and sunflowers. The course is the vision of a young local golfer named Jim O'Neal, who is now the head pro at the Meadow Club north of San Francisco. O'Neal enlisted the aid of his older brother Rupert to build an authentic links to complement the family-owned hunt club. The O'Neals hired minimalist architect Tom Doak to design their course, and he scoured the dunes from 2002 to 2004 to find the 18 holes—like the sculptor searching for the angel in a block of marble. The result is a pure, walking-only links with gallivanting fairways, raggedy, unkempt bunkers, closely mowed chipping contours, and greens full of shelves and slides. There are three hunting lodges at Ballyneal, offering access to 4,000 acres of upland game bird hunting, with dozens of varieties of birds, including the trophy Chinese ring-neck pheasant.

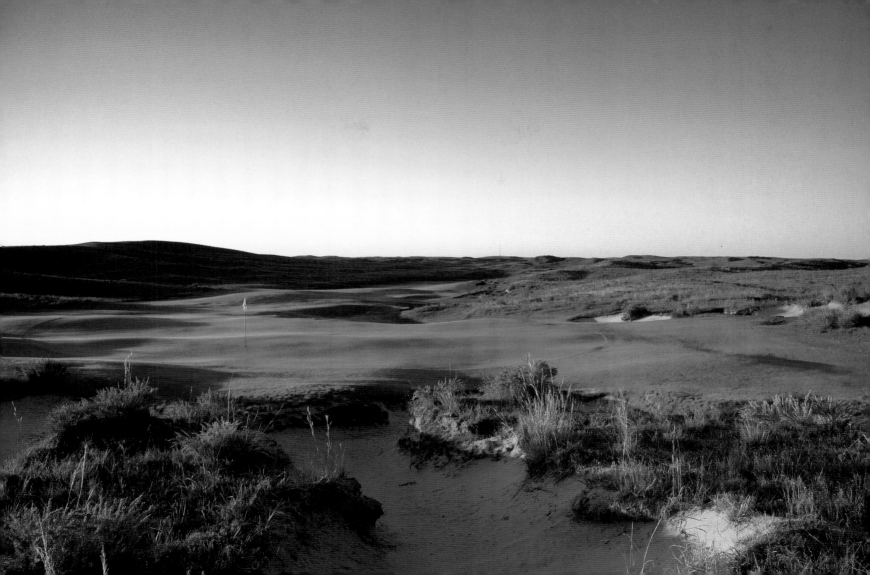

Prairie Dunes Country Club is the great inland links of the American heartland, and the masterpiece of its designer, Perry Maxwell. Prairie Dunes was established by the four sons of Emerson Carey, who had founded the Carey Salt Company after vast deposits of sodium chloride were discovered in Hutchinson, the remnants of what had once been a great saltwater sea covering central Kansas. Dedicated golfers, the Careys hired Maxwell in the mid-1930s to design a course on 480 acres northeast of Hutchinson. Maxwell immediately recognized the potential offered by the rolling sandhills. His son Press, who became a successful golf course architect, recalled: "It seemed to him, as it did to many others, that this part of Kansas looked just like parts of Scotland. He thought that the area would be a wonderful site for a Scottish-type course in the valleys of the sandhills." Maxwell designed 18 holes through the crests and dips of the dunes and the lovely old cottonwood trees, with fairways brushed by wild plum bushes, yucca plants, bluestem, sunflowers, milkweed, and crowfoot grass. Only nine of the holes were built in 1937, with the additional nine completed by Press Maxwell nearly two decades later in 1956. The wildly tossing greens are known as the Maxwell rolls. In 2002, Juli Inkster shot a sizzling final-round 66 at Prairie Dunes to capture her second U.S. Women's Open.

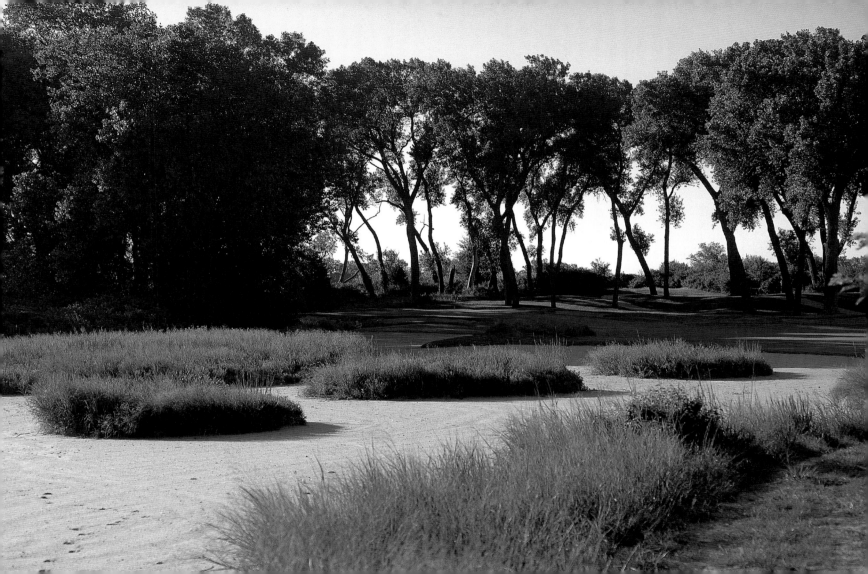

Sand Hills Golf Club lies amidst the vast sand hills of central Nebraska near the village of Mullen—golf's ultimate fulfillment of the credo "build it and they will come." Sand Hills has been lauded as a masterpiece of the highest order, and is ranked by *Golfweek* as the No. 1 course opened in the United States since 1960. The course was developed as a private club by Omaha-based Dick Youngscap and his partners on a thousand acres of boundless inland dunes left by receding glaciers. Youngscap hired Ben Crenshaw and Bill Coore, the leading practitioners of old school, lay-of-the land golf course architecture, to design the course. They were presented with the dilemma of such an astonishing site that it offered literally hundreds of different options for laying out holes among the dunes. Through countless hours of inspecting the property, they gradually arrived at an ideal routing in which they "found" 18 superb and unique holes lying in the sandhills blanketed with blood-orange and brown native grasses. Virtually no earth was moved in laying out the course, completed in 1994, but Coore and Crenshaw in their typical fashion paid meticulous attention to the contours of the greens, allowing for shots to run onto the putting surfaces, and created enormous, raggedy-edged bunkers that look like they are part of the landscape.

Sutton Bay Club, which lies in the flyspeck town of Agar, 40 miles north of Pierre, is a transcendent golf course in an out-of-the-way place. The course takes its spiritual inspiration from Sand Hills Golf Club, the field-of-dreams prairie links in central Nebraska, which harkens back to Prairie Dunes in Kansas, the first of the great American inland links. While Sand Hills paved the way by proving that a private national club with an other-worldly layout could exist at a seemingly unreachable destination, Sutton Bay is unique in many respects. The course was designed by Graham Marsh, an Australian playing on the Champions Tour, who was shown the property by Mark Amundson, the director of his U.S. design office and a native of South Dakota. Both men were thrilled by the site, which was part of the Sutton family ranch of several thousand acres that dates back to 1896. Opened in 2003, the course is laid out over wind-blown dunes created by glaciers, while the back nine is also flanked on the left by a vast mesa. The fairways bubble and spill through the endless sierras of coffee-colored grasses. Unlike at Sand Hills or conventional links courses, the soil is not sand-based but consists of shale, with thousands of boulders pitting the landscape. This landlocked links also comes with a bay view. The course overlooks Lake Oahe, the immense lake that was formed when the Missouri River was dammed in the 1960s, measuring three miles wide and 230 miles long, and visible from every hole.

The Powder Horn Golf Club is a semi-private development located at the base of the Bighorn Mountains in Sheridan, 80 miles south of where Custer made his last stand at the Little Big Horn. The course consists of three nines designed by Dick Bailey—Mountain, Stag, and Eagle. The Mountain nine features exposed, links-style golf, right down to a replica of the Swilcan Burn Bridge at St. Andrews on the first hole. The Stag nine runs through groves of cottonwoods and incorporates a number of stream crossings and beaver ponds, with the holes revolving around an old red barn. The par-three 15th plays diagonally across Little Goose Creek with the two-tiered green set in what had once been the corral of the old barn behind.

Three Crowns Golf Club opened in Caspar, Wyoming, in 2005 on the brownfield site of the former Amoco Oil Refinery along the North Platte River. The course is closely associated with the history of the refinery, built in 1912, taking its name from Amoco's old symbol of crowns of gold, white, and red for its three grades of gasoline. The construction of the course and surrounding parks was a major and fascinating feat of reclamation, beginning with the removal of 3,000 miles of pipe and 400,000 yards of concrete, with the contaminated soil then capped with a six foot layer of clean dirt. Architect Robert Trent Jones, Jr., created lakes that were dug using high tech maps to identify places where the soil was uncontaminated to lower depths. The fill from the excavation was then used to shape mounds that were planted with prairie grasses and serve to isolate the holes from one another. Eight blue water lakes come into play on 14 holes, with an intricate system that tests the water's quality before it is returned to the adjoining Platte River. Three Crowns's bluegrass fairways are offset by native grasses and 81 white sand bunkers. Golfers can relax after a round at the course's restaurant, aptly named The Filling Station.

Jackson Hole was named for fur trapper Davey Jackson in 1829, but Laurance Rockefeller was a pioneer of a different kind when he purchased the Jackson Hole Golf & Tennis Club back in 1967. In 1973, Rockefeller hired Robert Trent Jones II to undertake a major remodeling of the original Bob Baldock design, and ever since then the Jackson Hole Golf Club has been rated one of the top tracks in Wyoming. Over 30 years later, in 2004, Jones was brought back for a renovation that included adding 500 yards in length, restoring the 66 bunkers, and redesigning the first and 15th holes. The revamped course opened on June 30, 2006. The Gros Ventre River and several ponds provide water hazards on 11 of the 18 holes set in the valley, or hole, beneath the staggered rims of the Tetons.

3 Creek Ranch is a residential golf and fly-fishing community just a few minutes from the center of Jackson Hole in northwest Wyoming. Rees Jones designed the course on 710 acres of western rangeland that takes full advantage of the Spring Gulch, Cody, and Blue Crane Creeks from which the layout takes its name. The first six holes play through the wetlands in the central valley beneath the Gros Ventre Mountains to the east and the majestic crags of the Tetons to the north. The midsection of the course features a number of lakes and water features as the fairways climb through native grasslands and tall cottonwoods, with the finishing holes staring out at the Tetons with two buttes in the foreground. Since 3 Creek Ranch opened in 2005, golf has continued to expand in the Jackson Hole area, with the Tom Weiskopf–designed Snake River Sporting Club completed in 2006 and Shooting Star, designed by Tom Fazio, opened in 2009.

Rock Creek Cattle Company is a working 80,000-acre cattle ranch near the remote Montana town of Deer Lodge, but it is also a high-end private club with a world-class prairie links course designed by Tom Doak. Originally part of the Grant-Kohrs Ranch that covered 10 million acres of southwestern Montana in the 19th century, Rock Creek Cattle Company was purchased by entrepreneur Bill Foley in 2004. Foley, who grew up on his family's cattle ranch in the Texas panhandle and was looking for a spread in Montana, became a megamillionaire by founding Fidelity National Financial Corporation and growing it into a Fortune 500 company. Foley preserved Rock Creek as a working ranch but also had a clear and determined vision for creating a rustic but first-class outdoor community. Foley selected Doak, known for his handcrafted, lay-of-the-land approach, to design the course on 350 acres in the Deer Lodge Valley, framed by the peaks of the Flint Creek Range and worked around a creek flowing out to the Clark Fork River. The fairways riff through natural bowls surrounded by sagebrush pocked with ponderosa pines and fringed by the prairie fescues that turn purple and brown as the summer progresses. Doak created huge, abraded blowout bunkers that mirror the shape of the land and the severe green slopes. Opened in 2008, the course finishes with a 598-yard par-five that plays from a rock cliff overlooking the trout stream out to the Flint Creek Range in the distance.

The Banff Springs Hotel and Golf Course was developed by the Canadian Pacific Railway as a resplendent playground in Banff National Park in the Canadian Rockies, 80 miles west of Calgary, Alberta. The golf course, which opened in 1928, was designed by Stanley Thompson, the legendary Canadian architect of the golden era of golf course architecture. The course is laid out in the Bow Valley along the confluence of the Bow and Spray Rivers. The arching fairways trace the serpentine of the Bow, with the granite faces of Mount Rundle, Sulphur Mountain, and Tunnel Mountain flanking the course. Blasted from the bedrock and carved from an immense fortress of evergreens, Banff Springs is reputed to have been the first course to cost over $1 million to build. The most famous hole is the Devil's Cauldron, a 170-yard par-three from an elevated tee across a glacial pond to a green at the base of Mount Rundle. The 800-room Banff Springs Hotel, which officially opened on June 1, 1888, rises like a vast baronial palace above the course.

BELOW: Banff Springs Hotel

Tobiano Golf Club, located just outside the town of Kamloops, opened in July 2007 and showcases the stupendous landscape of the badlands of south central British Columbia. Canadian course architect Thomas McBroom maximized the views by laying out the course on the ridgelines overlooking Kamloops Lake, which is visible from every hole. The fairways float above the arid, largely treeless terrain of fissured valleys and rocky chimneys—known as hoodoos—all framed by the mountains. McBroom created a challenging test with five par-fives, including the number one handicap eighth hole, and five par-threes, with oversize greens and splashed bunkering offsetting the mocha and mustard-colored native grasses. Tobiano, which was once the site of the Six Mile Ranch, is named for the painted horses of the American southwest and is part of a planned resort community on 1,000 acres along the lake. The modern, 10,000-square-foot clubhouse is also distinctive, with a soaring, butterflied roof design of fir beams, heavy masonry wall, and large windows.

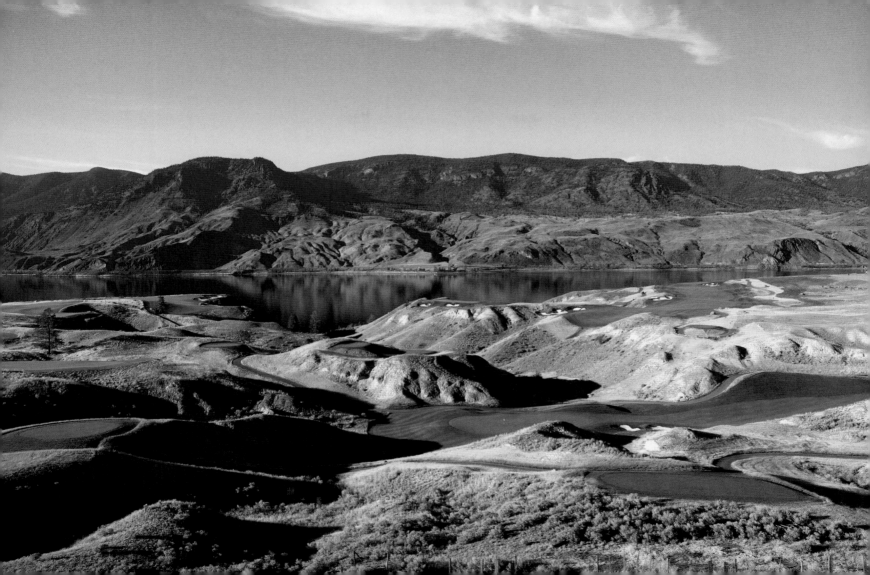

JUNE 2 | GREYWOLF GOLF COURSE AT PANORAMA RESORT—CANADA

Greywolf Golf Course is one of the golfing wonders of western Canada, an acrobatic layout that vaults through the Purcell Mountains with Tobey Creek crashing through the valley below. The course is part of the Panorama Mountain Village Resort in Panorama, British Columbia, one of Canada's top ski resorts. Opened in 1999 in an area that attracted prospectors for silver and gold a century ago, the course is located at an elevation of 4,000 feet and displays a breathtaking 500 feet of elevation changes over its routing. Greywolf was designed by Canadian course architect Doug Carrick and continues the tradition of Stanley Thompson, the virtuoso architect of the 1920s and '30s, who created mountain masterpieces at Banff, Jasper, and Capilano. Each of the par-threes at Greywolf is memorable, but the 6th, called Cliffhanger, is the never-to-be-forgotten golfing high wire act around which Carrick shaped the front nine. The tee shot, measuring 175 to 200 yards from the regular tees, must carry across Hopeful Valley to a green mounted on a granite precipice, with a sheer vertical drop on three sides.

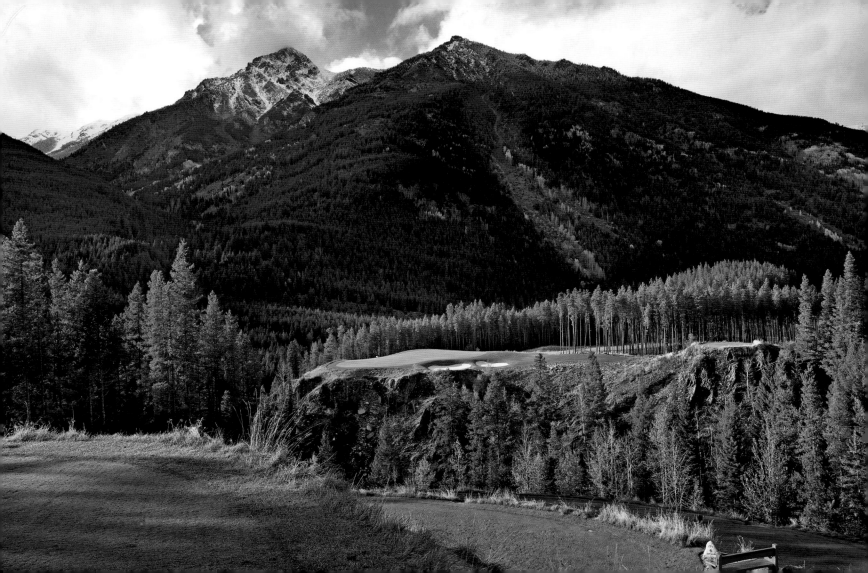

Since it opened in June 2007, Washington State's Chambers Bay has caused a bigger stir in the world of golf than any other recently opened course, having been selected to host the 2015 U.S. Open as well as the 2010 U.S. Amateur Championship. Located in University Place on the shores of Puget Sound, Chambers Bay was actually an immense reclamation project carried out by architect Robert Trent Jones, Jr., and his associates Bruce Charlton and Jason Blasi, on a former sand and gravel quarry operated by Pierce County. Jones used the sand piles to form a system of massive dunes and transformed a series of sedimentation ponds into low-lying waste areas, one of which covers seven acres running along the right side of the fourth hole. The result is a 7,500-yard swirling links course framed by the Olympic Mountains.

There is one lone pine tree on the site, spared because it was the home of a bald eagle's nest. Many of the firm and fast fairways are exceptionally wide, requiring proper position to negotiate second and third shots to the swooping greens. There is a wonderful variety of long and short holes, with few that play straightaway, and sweeping views of the water and mountains, particularly on the 14th. The 18th plays slightly uphill, with the remnants of the concrete sorting bins from the quarry located above the tee. Chambers Bay, which is a municipal course, represents a number of firsts, including the first time the U.S. Open will be played in Washington State, the first time in modern history that such a new course has been selected for the Open, and an unusual foray by the USGA into British Open–style links golf.

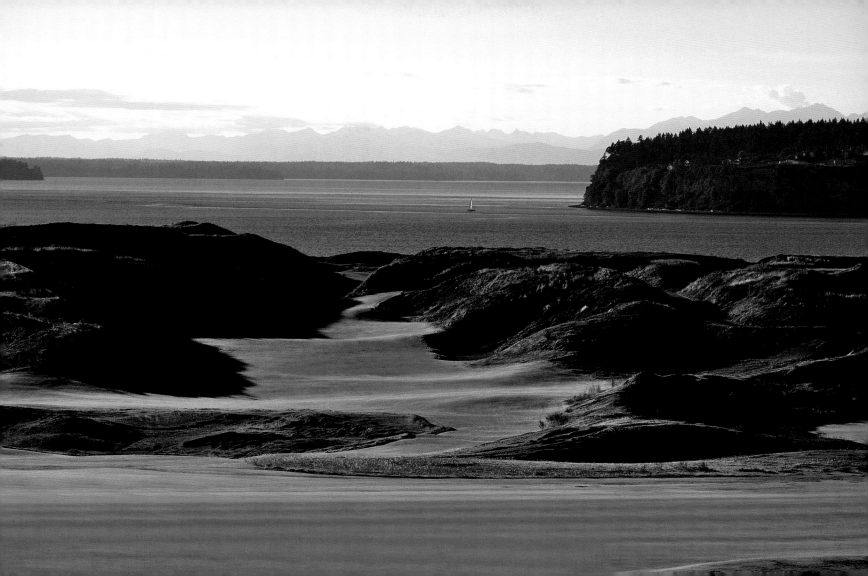

Bandon Dunes, the resort on Oregon's remote southwest coast just north of the town of Bandon, has become a world-renowned golf destination, with both the Bandon Dunes and Pacific Dunes course set in the tempestuous dunes with their tiaras of yellow flowering gorse high above the Pacific. Bandon Dunes is the brainchild of Michael Keiser, who was determined to build a low-key resort with out-of-this-world golf, and after looking at sites throughout the U.S., found his golfing nirvana when he acquired 1,200 acres adjoining Bullards Beach State Park that had been mainly used by dirt bikers. Keiser, who had made his fortune in the greeting-card business, took a leap of faith in hiring a young, unknown Scottish golf course architect, David McLay Kidd, to design Bandon Dunes, the first of what are now four courses at the resort. Kidd designed a swash-buckling course where each nine loops out to the coast and back, with deep, sod-walled bunkers and broad, supple fairways creating different angles of play. Bandon Dunes was followed by Pacific Dunes in 2001, Bandon Trails in 2005, and Old Macdonald, a course that pays tribute to Charles Blair Macdonald that officially opens in June 2010.

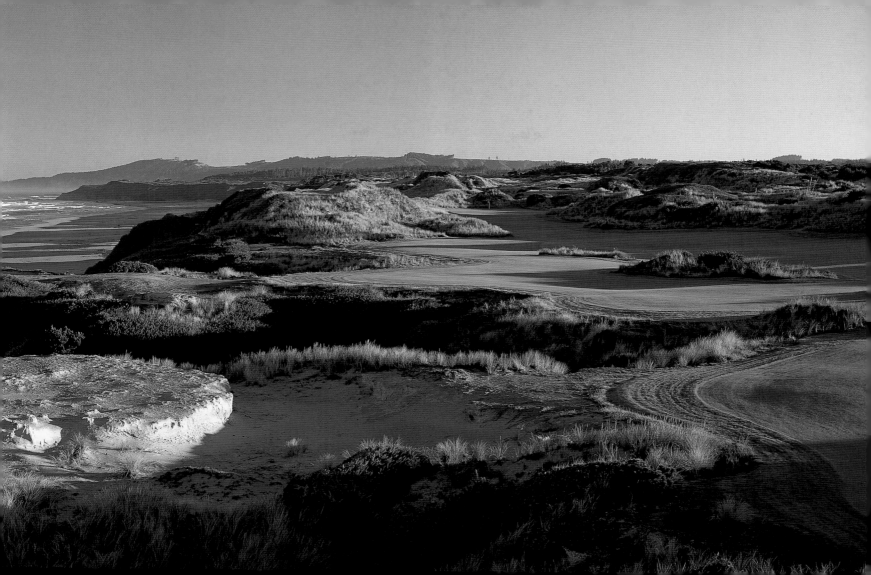

The Bandon Dunes Resort burst onto the golf scene in 1998 when it unwrapped an honest-to-goodness, Scottish-style seaside links on the rough and tumble dunes high above the Pacific in southern Oregon. Michael Keiser, the developer of the resort, commissioned Tom Doak, an intrepid believer in the virtues of classic design principles, to design the resort's second course. Doak had a tough act to follow but Pacific Dunes, opened in 2001, is, if anything, even more stunningly picturesque and varied in its artistry. Doak was able to lay out holes on the cliffs above the windswept beaches with their sculpture gardens of gargantuan driftwood. Other holes run through blowout sand ridges and across swaths of huckleberry bushes and red fescues, while everywhere there are wildflowers and ferns and splashes of yellow gorse. As much as the setting, it is the strategic options, thrilling shots, and challenging green complexes that have lifted Pacific Dunes near the top of most golf course rankings. The no-frills resort is dedicated to golf, while the quaint old village of Bandon offers seafood restaurants overlooking the Coquille River, vintage stores, and the Cranberry Sweets candy store.

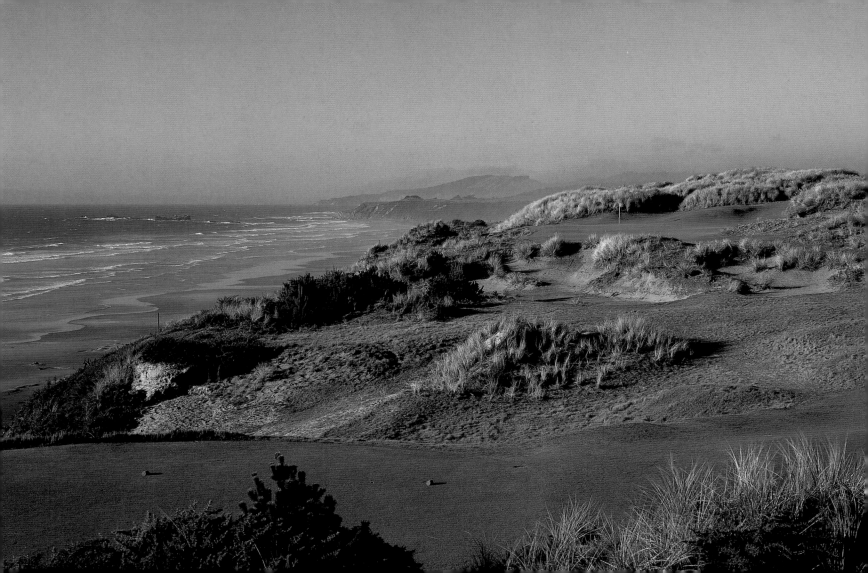

The Pronghorn Club is part of a golf residential community located in the high desert terrain outside Bend, in central Oregon, that is home to courses designed by both Tom Fazio and Jack Nicklaus. The courses amble through junipers and chaparral on a 640-acre site that was acquired from the Bureau of Land Management. Pronghorn is surrounded by thousands of acres of protected wilderness, with imposing views of the Cascades, including the volcanic peaks of Mount Bachelor, Broken Top, and Three Sisters. The Nicklaus Course is a stern test, with the 511-yard par-four sixth playing uphill into the prevailing summer wind. Lava rock outcroppings pop up throughout the design, particularly on the par-five 15th, with its unparalleled view of the Three Sisters. The Fazio Course features the downhill, par-three eighth, its green fronted by a subterranean tube of petrified lava that was exposed during construction. The green itself is hooded by 25-foot high walls of volcanic rock.

RIGHT: Nicklaus Course

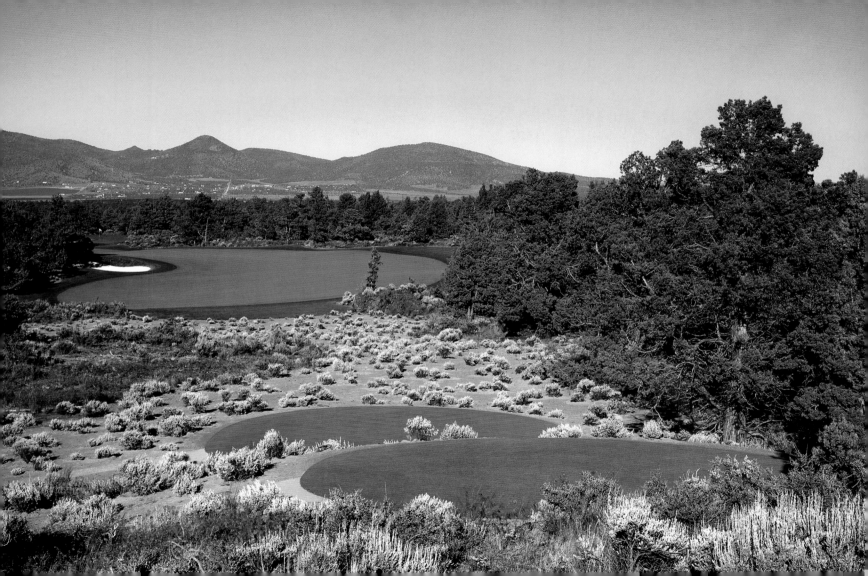

Tetherow Golf Club is part of a 700-acre golf residential community in Bend, a resort town in central Oregon that has become a golfing haven thanks to its rich array of courses set in the high desert landscape and sheltered by the Cascades, allowing for year-round play. Opened in 2008, the course was designed by David McLay Kidd, who ten years earlier was a young, unknown Scottish course architect when he was selected to design Bandon Dunes on Oregon's southern coastline, a staggering links courses that gained him international acclaim. Kidd's recent designs range from the Castle Course at St. Andrews, Scotland, to the TPC San Francisco at Stonebrae, to Nanea in Hawaii. At Tetherow, he created a distinctive Scottish heathland-style course with broad, mounded fairways frescoed with free-form waste areas that are a colorful tangle of manzanita, bitterbrush, and native grasses. The severely sloping fescue greens add to the challenge. The site had been denuded of most of its trees by a forest fire in the early 1990s, but Kidd took advantage of the isolated surviving pines to create fairway landmarks. There are also water hazards lined with colored desert rocks, while the 182-yard par-three 17th plays across an old pumice quarry to a small green.

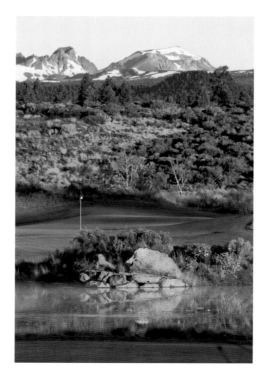

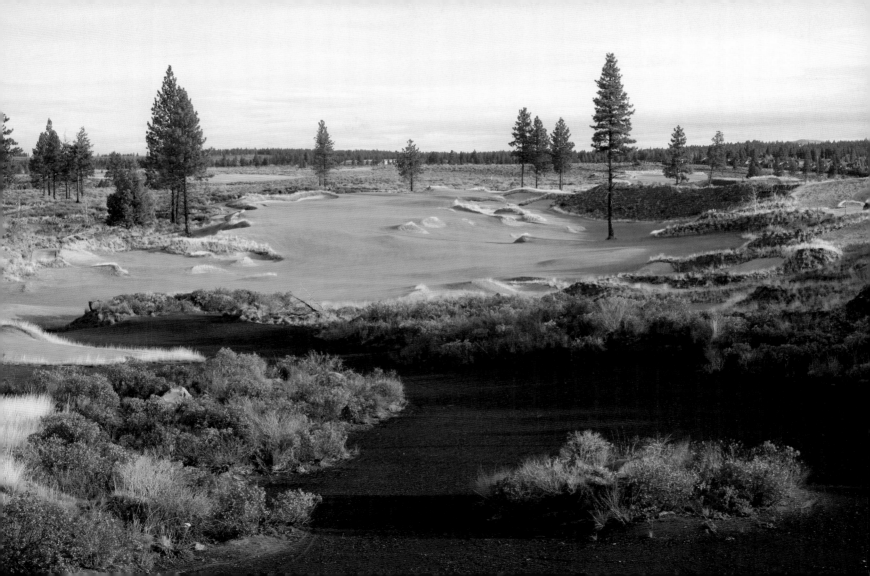

Palouse Ridge was created by Washington State University on 315 acres at the east end of its Pullman campus, in the southeast corner of the state, and is the home course of the Cougar men's and women's PAC-10 golf teams. The course occupies a distinctive terrain of tented silt dunes known as the Palouse, created by thick layers of volcanic sediment and glacial till during the last Ice Age. The University hired Tacoma-based architect John Harbottle III, who trained with Pete Dye, to design the course over the restless and fertile hills covered with checkerboard fields of wheat, lentils, and dry peas. Harbottle introduced sweeping bluegrass fairways with a perimeter of native prairie grasses and pine-peppered ridges; a pair of ponds and low-lying wetlands attract water fowl. Environmental considerations also play an important role at Palouse Ridge, with a riparian corridor flanking the third, fourth, and fifth holes, protected by a hedgerow of alder, hawthorn, and fescue grasses. From the course there are also long views out to the surrounding buttes and the distant mountains of Idaho and Oregon. Palouse Ridge opened on August 29, 2008.

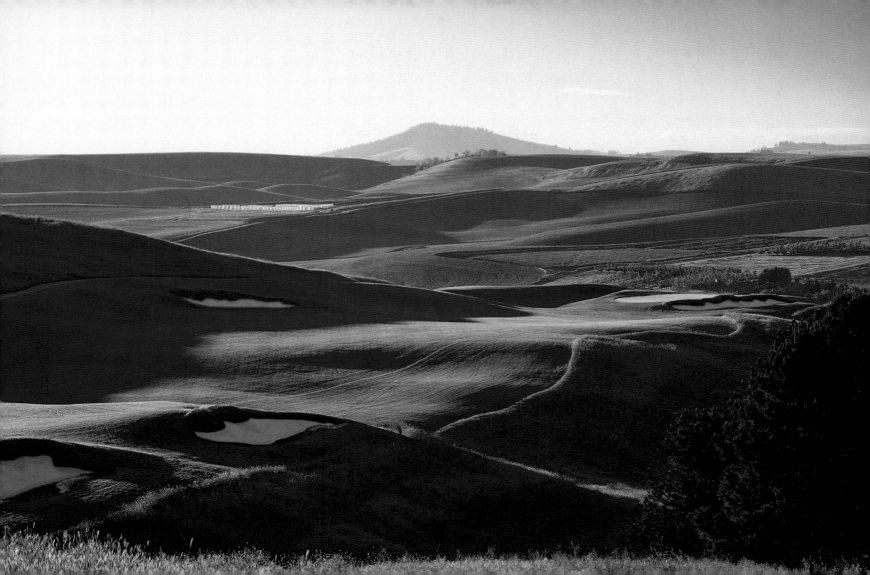

JUNE 9 | CIRCLING RAVEN GOLF CLUB—IDAHO, U.S.A.

Located in Worley, Idaho, Circling Raven is owned and operated by the Coeur d'Alene Tribe and is part of the Coeur d'Alene Casino and Resort that is tucked into the vast reservation spanning 45,000 acres of mountains, lakes, forest, and farmland at the western edge of the Rocky Mountains. The Schitsu'umsh Indians were named Coeur d'Alene or Heart of the Awl by the early 19th-century French fur trappers who first met them. The course is named for a great chief and prophet of the Coeur d'Alene, who according to legend was guided by a raven on his spiritual quest. Designed by Gene Bates and opened in 2003, the course is a quest through the tall Palouse grasses, wetlands, and old-growth pine, aspen, cottonwood, and birch that frame the bluegrass fairways. Wetlands affect play on 13 of the 18 holes, with all four of the par-threes playing over 200 yards from the gold tees, topped by the 253-yard 13th. With the dynamic course and broad views of the Big Sky wilderness, the Coeur d'Alene Tribe has transformed what started out as a small bingo operation into a golf destination.

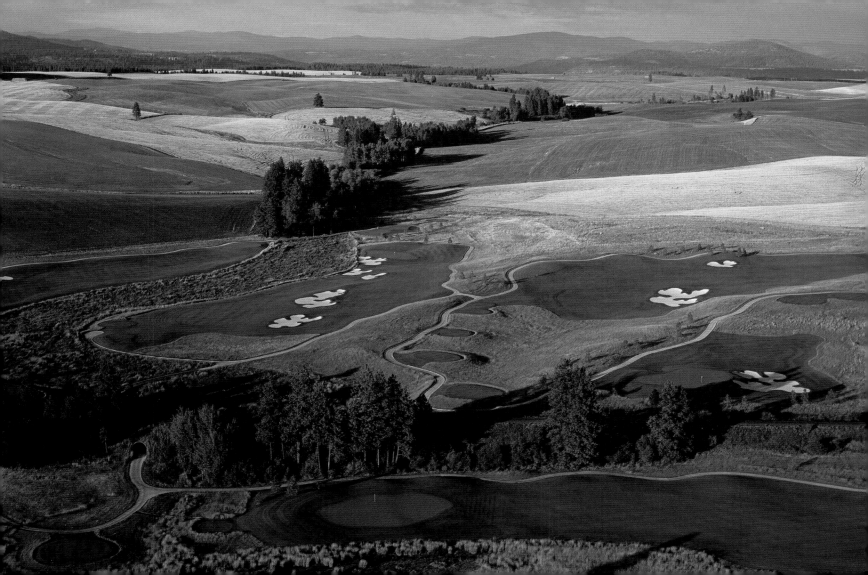

Gozzer Ranch Golf Club provided course architect Tom Fazio with an inspiring landscape on the black basalt bluffs above the eastern shores of Lake Coeur d'Alene in northern Idaho, near Harrison. The course spotlights views of the lake, which *National Geographic* named one of the five most beautiful in the world, particularly on the par-four 15th, with its long vista over water to the mountains. The course is carved through the hunky basalt formations, with stand-alone pole pines marking greens and fairways, and scooped-out, frayed bunkers. The par-three third plays sharply downhill along the lake on the left to a green beneath a basalt cliff on the right, while the 12th is a short but daunting par-four with the fairway split by black rock. Gozzer Ranch's three 1950s-themed comfort stations offer a smorgasbord that includes jerky, crab dip, apples, and root beer floats. Completed in 2007, Gozzer Ranch was awarded *Golf Digest's* Best New Private Course for 2008.

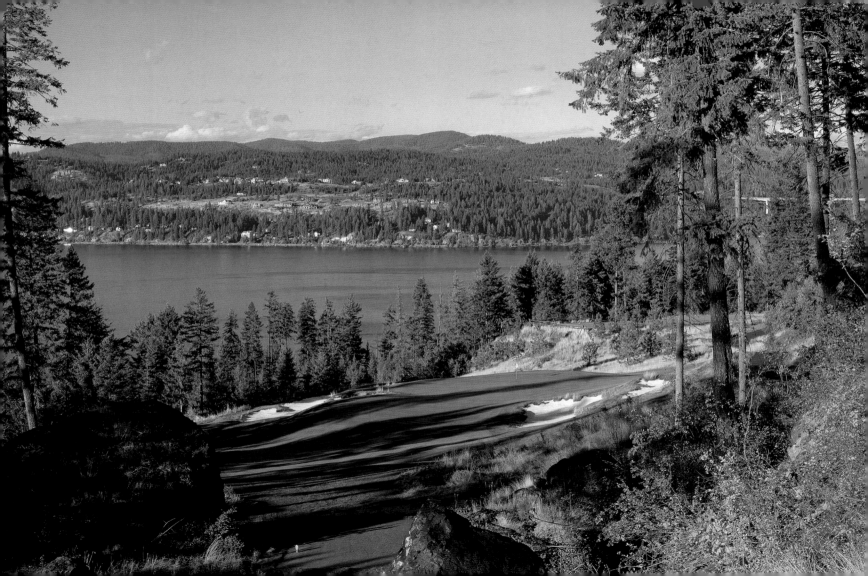

JUNE 11 | THE CLUB AT BLACK ROCK—IDAHO, U.S.A.

The Club at Black Rock is part of an 1,800-acre residential community on Lake Coeur d'Alene in Northern Idaho, 90 miles from the Canadian border. Designed by Jim Engh, the course takes its name from the black basalt rock formations and escarpments rising above the shores of the lake. The course sits high above the water, its fairways seamed through the immense Idaho pines. The 150-yard par-three 13th runs along a curtain wall of black rock, with five waterfalls spilling through the rock fissures. The green of the par-four 11th is guarded by knobs of basalt, with two more waterfalls raining down the rock face. The course was named Best New Private Course by *Golf Digest* in 2003. Black Rock's second course was designed by Tom Weiskopf.

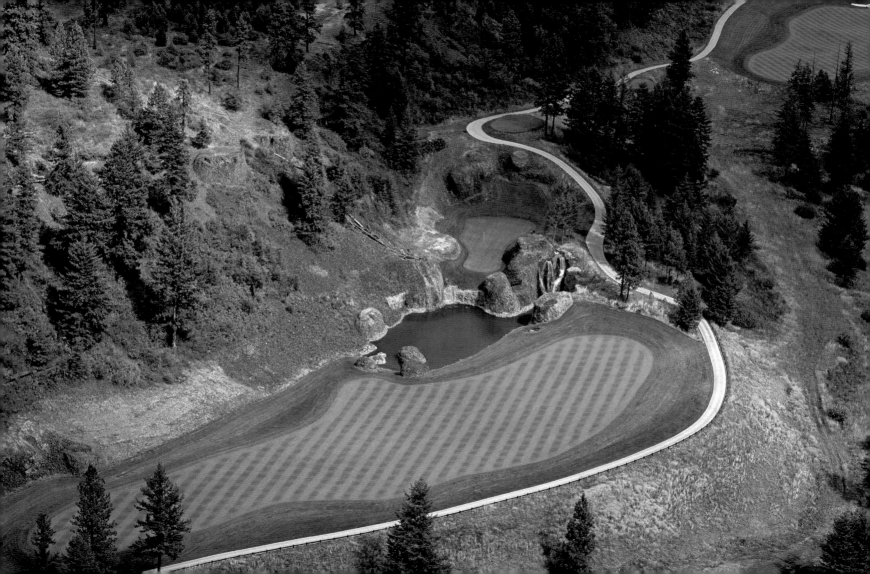

Spanish Peaks is a 3,500-acre private residential community in the Big Sky area of Montana, nestled in the Gallatin River Valley 18 miles from Yellowstone National Park as the crow flies and about 50 miles from Bozeman. The community's developer, Jim Dolan, gave his friend and Montana neighbor, Tom Weiskopf, first dibs on selecting 400 acres for the golf course. Weiskopf then rode the land on horseback to devise the routing and design. The result, opened in August 2007, is an uncontrived, walkable course spread out over the sym-phonic Big Sky landscape of meadows of range grasses and wild flowers, ridges of blue spruce, aspen, and lodge pole pine, and limpid reflecting ponds. Weiskopf designed the course to show off the scintillating 360-degree views of the Spanish Peaks, the Gallatin Range, Lone Peak, and the Absarokas in Yellowstone. Elk, deer, and moose wander the course, with bald eagles, hawks, western meadowlarks, and bluebirds over-head. The ski and golf clubhouse features exposed spruce log beams, rusticated stonework, and a grand log staircase.

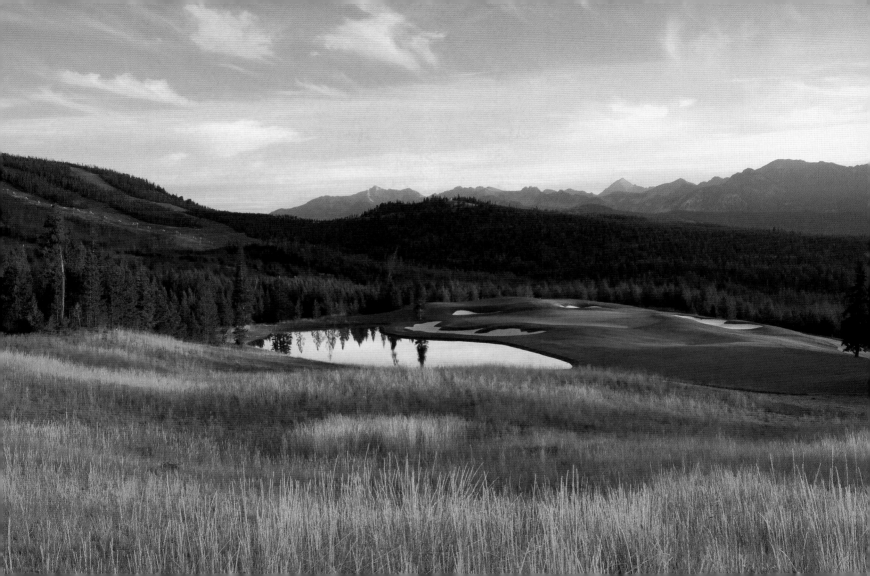

Bully Pulpit, which opened in 2005, is located just south of Medora, North Dakota, moseying along the Little Missouri River before venturing into the Badlands. Medora was founded in 1883 by the Marquis de Mores, a young French nobleman who named the town for his wife, Medora von Hoffman, daughter of a wealthy New York banker. He built a 26-room home overlooking the town, the Chateau de Mores, which is now a state historical site, and sought to develop the area, although his efforts eventually ended in financial failure. Theodore Roosevelt came to the Badlands in 1883 to hunt buffalo, shortly after the arrival of the Marquis. He bought a cattle ranch eight miles south of Medora, which he named the Maltese Cross Ranch and which is now the center of Theodore Roosevelt National Park. Roosevelt returned to Medora in 1884, buying another cattle operation, and came away physically reinvigorated by his time spent in North Dakota. The public Bully Pulpit Course takes its name from Roosevelt's reference to the White House as a platform to influence public opinion. Designed by Michael Hurzdan, the course runs through open prairie and cottonwood trees. The 14th through 16th fairways climb through the striated white sandstone ridges of the Badlands with their fleece of tan and burgundy-colored prairie grasses.

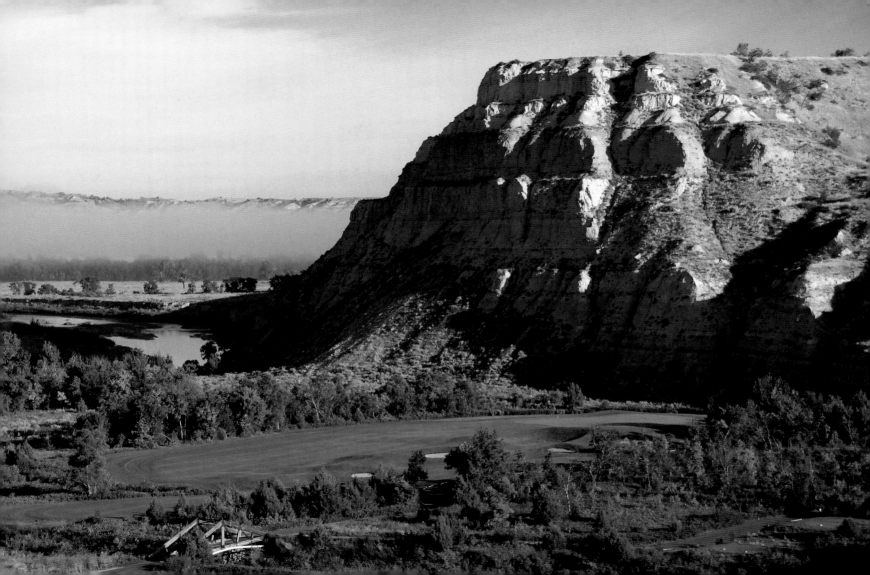

Hazeltine National Golf Club outside Minneapolis had a rocky start as a championship course, but has now earned a reputation as a fair and dramatic test of the game's best players. Opened in 1961, Hazeltine was a brawny creation of Robert Trent Jones featuring many doglegs. Hazeltine was heavily criticized by the pros at the 1970 U.S. Open won by Tony Jacklin, and it was unclear whether the course would again be selected to stage the Open. Jones made substantial changes, including new 16th and 17th holes, and then Rees Jones, Trent's younger son, was brought in to further polish the design before the 1991 Open. The result was a pronounced success. Payne Stewart tied with Scott Simpson in regulation, and came back from two strokes behind with three holes to play to win the 18-hole playoff. Rich Beem was the ebullient winner of the 2002 PGA Championship at Hazeltine, overcoming birdies on the last four holes by Tiger Woods to earn a one-stroke victory. He clinched the title on Hazeltine's marquee 16th hole, which has a fairway shoehorned between a creek down the left and Lake Hazeltine to the right, by rolling in a 35-foot birdie putt. In the 2009 PGA, Hazeltine turned out to be the site of an even more enthralling and unexpected turn of events, when unsung Korean Y.E. Yang caught and passed Woods from behind in the final round in one of the biggest upsets in the history of the game.

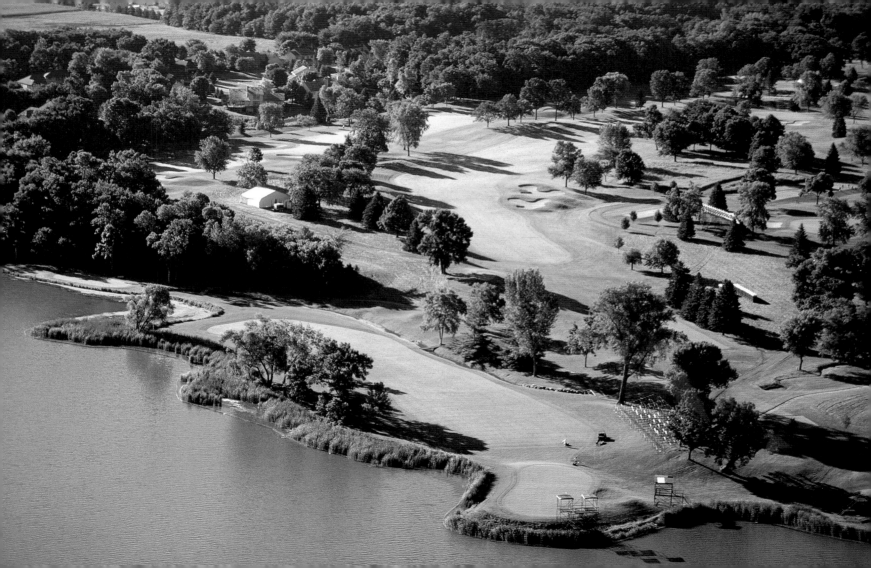

Interlachen is the grand dame of Minnesota golf, and over the years has hosted a cavalcade of major events, from the 1919 Western Open to the 2008 U.S. Women's Open. Most famously of all, Interlachen hosted the 1930 U.S. Open won by Bobby Jones for the third of his four major victories in his Grand Slam season. The club was founded in 1909 with the purchase of two farms, comprising 146 acres, on the suburban streetcar line from downtown Minneapolis, making it the first true country club in the Twin Cities. The original nine holes designed by Willie Watson, opened in 1911, but in 1919 Donald Ross was hired to create a championship course. Ross's design over the rolling, wooded farmland endures, with some modifications by Robert Trent Jones in the early 1960s.

Interlachen has had a particularly close affiliation with the history of women's golf. In 1935, the club hosted the U.S. Women's Amateur championship, where 17-year old Patty Berg, a product of Interlachen, dazzled the field before losing in the finals to Glenna Collett. In 2002, with Berg serving as the honorary chairperson, Interlachen was the site of the Solheim Cup match, which was won by the U.S. team. Most recently, Interlachen hosted the 2008 U.S. Women's Open, where Inbee Park was the victor.

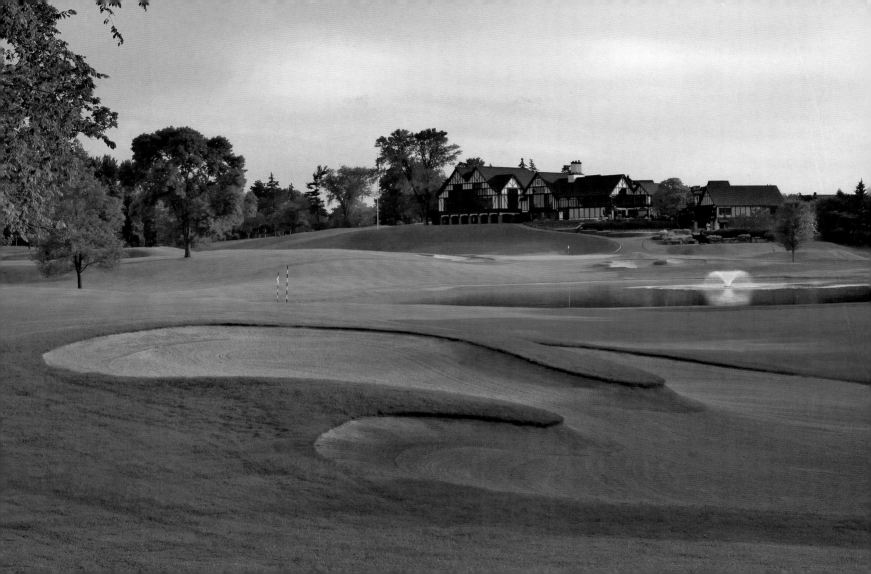

JUNE 16 | DACOTAH RIDGE GOLF CLUB—MINNESOTA, U.S.A.

Dacotah Ridge, opened in 2000, was developed by the Lower Sioux Indian Community in southwestern Minnesota, four miles east of the tribe's Jackpot Junction Casino Hotel in Morton, Minnesota. The surrounding flat fields of corn and sugar beets belie the rolling and varied topography of the golf course. Designed by Rees Jones as a prairie-style links, Dacotah Ridge tacks across 240 acres of creased, windswept countryside laced by the clear waters of Wabasha Creek, a tributary of the Minnesota River. The fairways are separated by sloping bands of prairie fescues, with pockets of native wetlands, a 14-acre lake, and steeply walled, sugar sand bunkers. The long, tiered greens offer another form of hazard, but trees primarily come into play only on the 17th and 18th holes, the latter a 569-yard par-five with the creek running down the left-hand side of the fairway. The Wabasha and wetlands come into play on several holes, with the tee shot on the short, par-three seventh required to cross the creek twice.

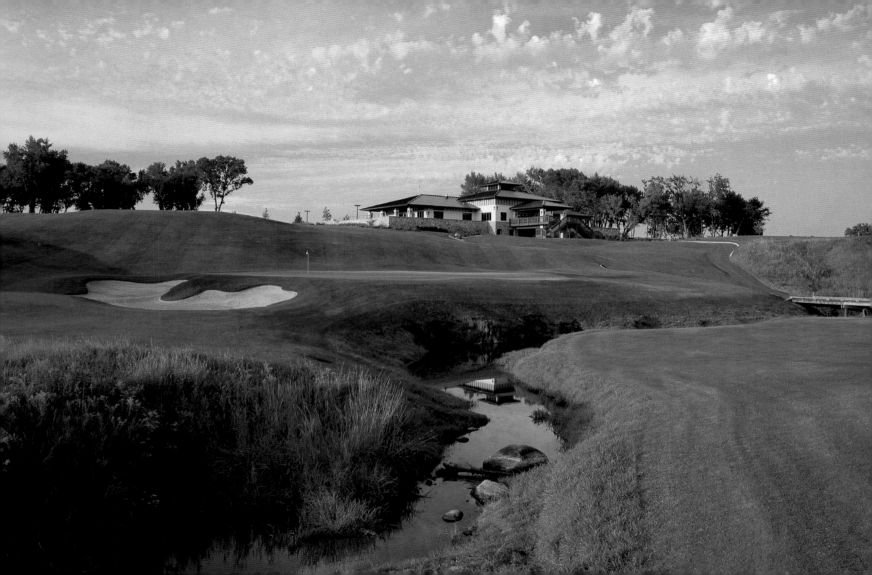

Blue Top Ridge is the golf course at the Riverside Casino, crafted over a 175-acre former livestock farm south of Iowa City. Designed by Rees Jones and opened in August 2007, the course maxes out at over 7,500 yards, making it the longest and toughest track in Iowa. The layout was formed on a canvas of three different landforms. The front nine starts out on a prairie before descending to a river plain on the fourth, with a trio of holes skirting the Iowa River. The back nine is carved into a wooded hillside. Blue Top has some particularly brawny par fives, beginning with the 615-yard third. The 12th only measures 552 yards but plays uphill, with a creek cutting across the fairway. The 16th stretches 665 yards from the back tees, with a creek dissecting the fairway, making it the longest hole in Iowa.

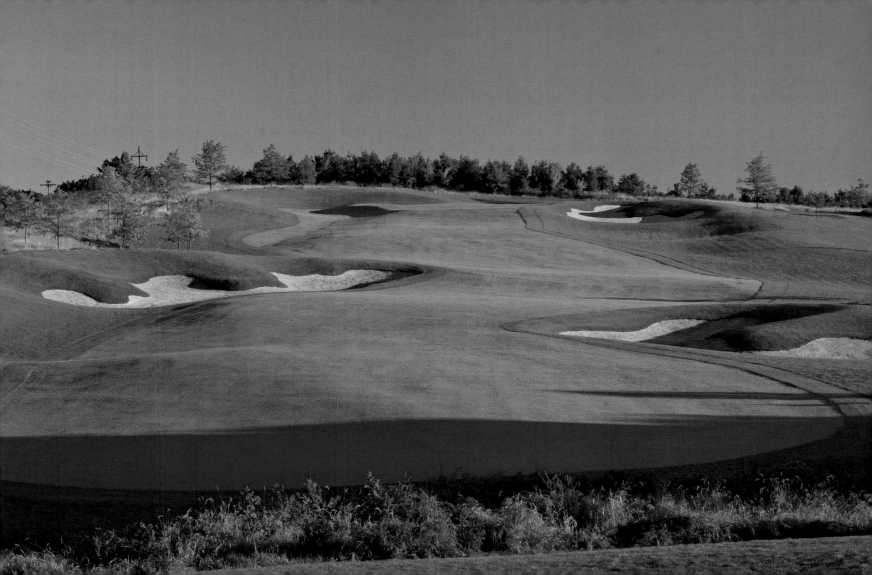

Medinah Country Club's No. 3 Course is the famed championship course of Chicago. With its massive red-bricked and minareted mock-Moorish clubhouse, Medinah was founded in 1928 by the Shriners, who are members of the Arabic Order of Nobles of the Mystic Shrine. The club is named for Islam's second holiest city. The Shriners were started by a New York City Freemason in 1871 after he returned from a trip to Europe, where lavish parties in Arabic costumes were then in vogue. Medinah is a big-shouldered and taxing course, measuring more than 7,400 yards, with nine doglegs. The central feature of the course is Lake Kadijah, named after Mohammed's wife. Medinah's signature holes, the par-three 13th and 17th, both play across the lake, with the glassy greens sloped so that a tee shot hit with too much backspin risks rolling back into the water. In one of the more memorable U.S. Opens, Hale Irwin caught journeyman Mike Donald on the final hole of regulation in 1990 and then won the championship in the 18-hole playoff the next day. Tiger Woods won the PGA Championship at Medinah in 1999 and then repeated there in 2006, becoming the first golfer to win the PGA Championship twice on the same course. Medinah will be the host course for the 2012 Ryder Cup Match.

BELOW: Member's fez

There are many vaunted courses in Chicago's suburbs, but Harborside International Golf Center is an urban original, built within the city limits just 16 minutes from downtown, with stirring views of the skyline. Harborside consists of two municipal courses, the Port and the Starboard, built on 458 acres of industrial landfill and inorganic sludge near Lake Calumet on Chicago's gritty South Side. The transformation of urban wasteland into two verdant links courses was the work of Illinois golf course architect Dick Nugent and his son Tim. The entire site was capped with a thick layer of clay, dirt, and sand, which prevented the growth of trees. The Nugents then applied the same principles used to grow grass on the lava fields of Hawaii. The result is broad, exposed shelves of curvilinear fairways. The signature hole on the Port, named Anchor, is the par-three 15th with an island of green in the shape of a ship's anchor surrounded by sand. Lake Calumet comes into play on the final three holes. Former President Bill Clinton made his first and only hole-in-one on the par-three sixth hole at the Port Course. Harborside also has a red-roofed prairie-style clubhouse that echoes the designs of Frank Lloyd Wright.

RIGHT: Port Course

Olympia Fields has long been Chicago's citadel of golf, with the famed North Course having hosted the U.S. Open in 2003 won by Jim Furyk. The South Course played second fiddle until a renovation completed in 2007 restored its long-lost luster, giving Olympia Fields two courses of the first rank. Olympia Fields originally had four courses, making it the largest private country club in America by the 1920s, and the clubhouse with its 80-foot-high Tudor clock tower remains one of the most famed in the land. Courses 2 and 3 were sold for development in 1945, leaving Course 4, designed by Willie Park, Jr., which became the North Course, and the original Course 1, designed by Tom Bendelow back in 1918, which became the South Course. The club hired architect Steve Smyers to spearhead the second incarnation of the South Course, which was laid out over surprisingly hilly ground for the Chicago area, with knobs and crests and Butterfield Creek running through the property. Smyers combined restoration of original features with new touches sympathetic to the original design and made the course a contemporary challenge by adding 600 yards to stretch the length to 7,200 yards. He restored the deep, grass-faced bunkers, which had become shallow ovals over the years, enlarged the greens to their original proportions, and included the chocolate drop mounding that was popular during the period. The result is that the South Course now stands shoulder to shoulder with the North.

BELOW: The South Course
RIGHT: The North Course

Erin Hills, laid out over 652 acres of heaving former farmland in the small town of the same name, has taken the golf world by storm since it opened in 2006, and is considered the front-runner to secure the 2017 U.S. Open. The course, 35 miles northwest of Milwaukee, was developed by owner Bob Lang, a former junior high school teacher turned home builder, who has doted on every detail in order to create a truly original, lay-of-the-land links course. High fescues wave over fairways routed through the glacial geology of kettle moraines, drumlins, and eskers. Lang even bought and demolished several houses near the entrance of the course in order to preserve the complete sense of isolation on the links, where the only man-made landmark is the Basilica of the Holy See, a monastery that looms on the hilltop to the east.

Erin Hills recently underwent some remodeling and enhancements prior to opening for the 2009 season in order to eliminate a few of its more quirky features, making this public access course more demanding for the pros as well as more manageable for higher handicappers. The changes included the elimination of the blind par-three seventh hole and its replacement with the downhill par-three Bye Hole—an extra hole built to settle ties—that is now the ninth. The arrival of Erin Hills gives Wisconsin a one-two wallop for major championships, with Erin Hills already slated to host the 2011 U.S. Amateur Championship, while Whistling Straits will be the home of the PGA Championship in 2010 and 2015 and will host the 2020 Ryder Cup.

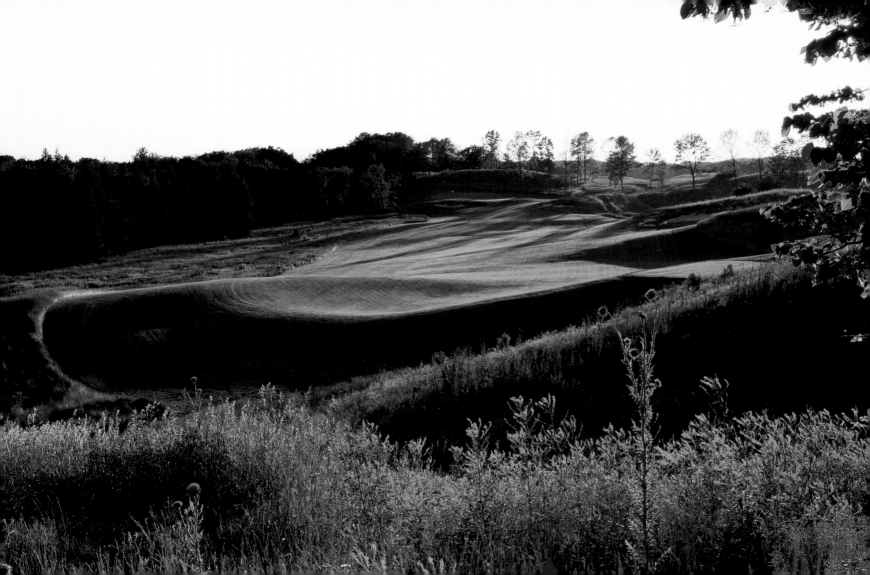

The American Club is a resplendent golf resort founded by Herb Kohler, the paterfamilias of the Kohler Company, now featuring four remarkable, distinct, and challenging Pete Dye courses. Located an hour's drive north of Milwaukee, Kohler was a company town, and the American Club, which is now a hotel with deluxe bathroom fixtures, was originally built in 1918 as a sturdy red-brick and blue-slate dormitory for immigrant workers. In 1988, Dye created Blackwolf Run, named for a Winnebago Indian chief, with two pastoral 18-hole layouts consisting of the River Course, with the shallow silver and blue Sheboygan River curling through an ultra-demanding layout, and the Meadow Valleys Course, which is no pushover itself. The 1998 U.S. Women's Open, won by Se Ri Pak in a playoff over amateur Jenny Chuasiriporn, was played on a composite of the two courses.

BELOW AND RIGHT: Meadow Valleys Course

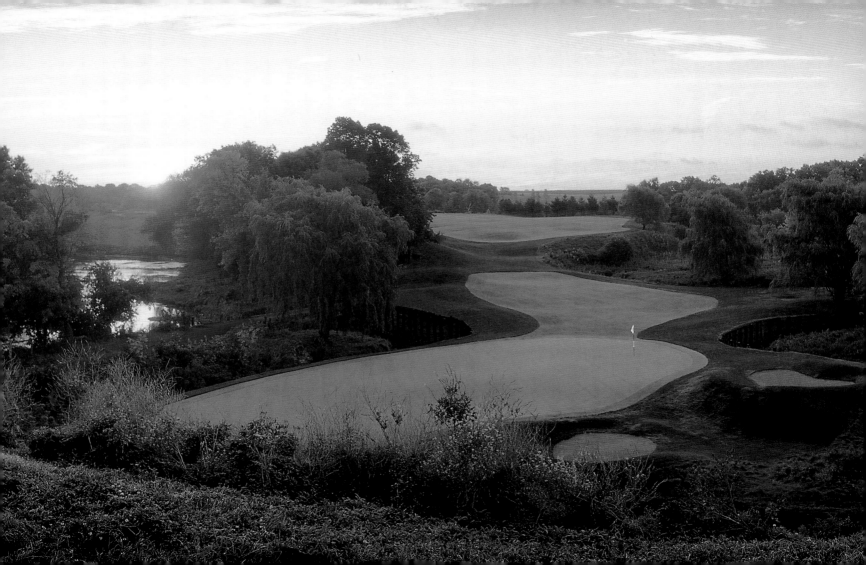

Ten years after he designed Blackwolf Run, Pete Dye returned to the Kohler Resort to design the Straits Course at Whistling Straits in 1998, which earned such rapid acclaim that it was named the site of the 2004 PGA Championship. Whistling Straits, which also includes Dye's Irish Course, is located nine miles east of Kohler in the village of Haven. Dye took a pancake-flat, 560-acre site adjoining Lake Michigan that had been a military encampment and proceeded to create a rock 'em sock 'em seaside links. Dye built huge drifting dunes nubbed with colorful grasses by literally moving mountains of earth, topped off with a liberal dusting of 800,000 cubic yards of sand. The 2004 PGA proved to be a rousing success, with the pros managing to fire sub-par rounds notwithstanding the course's unprecedented visual intimidation, some 1,300 bun-kers give or take a hundred or two, and over 7,500 yards in length from the back tees. When it was all over, Vijay Singh took away the Wanamaker Trophy after a playoff with Justin Leonard and Chris DiMarco. The PGA Championship is returning to Whistling Straits in 2010 and 2015.

BELOW AND RIGHT: The Straits Course

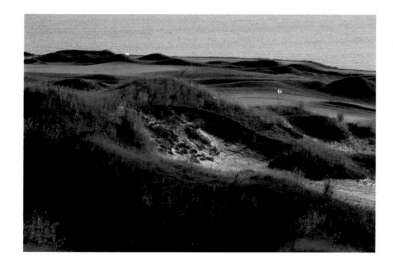

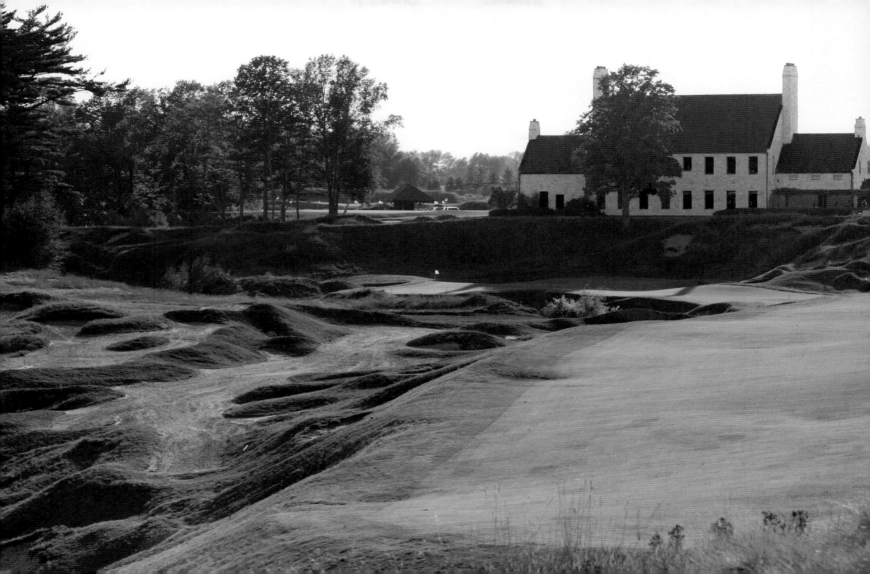

Greywalls opened in 2005, a new edition to the Marquette Golf Club on Michigan's remote Upper Peninsula that lies north of Wisconsin, overlooking Lake Superior, the largest of the Great Lakes. Marquette's original Heritage Course dates back to 1926, with nine holes laid out by golden age architect William Langford and a second nine added by David Gill in 1969. Architect Mike DeVries was hired to design the Greywalls Course over a beautiful but severe site, with a good portion of the 233 acres unusable because of wetlands and the ubiquitous gray granite outcroppings and flatheads from which the course takes its name. DeVries moved very little earth for a project of this magnitude, transitioning the holes through a valley on the 11th through 16th and the plateau that holds that first, ninth, 17th and 18th. Lake Superior is on dis-play on several holes, beginning with the first tee, the highest point on the course, with a nearly 50-mile view over the Pictured Rocks National Lakeshore, and then again on the 7th tee, holes nine through 11, and the 17th and 18th. The fifth is a short par-four, but the tee shot is over the brow of a steep hill, littered with gray rocks, to a fairway that sweeps right to left through dense woods. The green is a featherbed between an anvil of granite and a 60-foot-high rock wall.

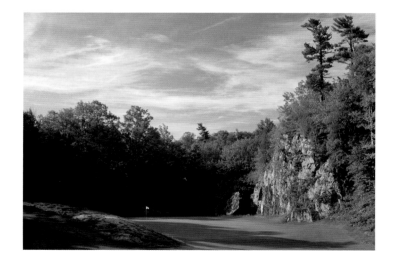

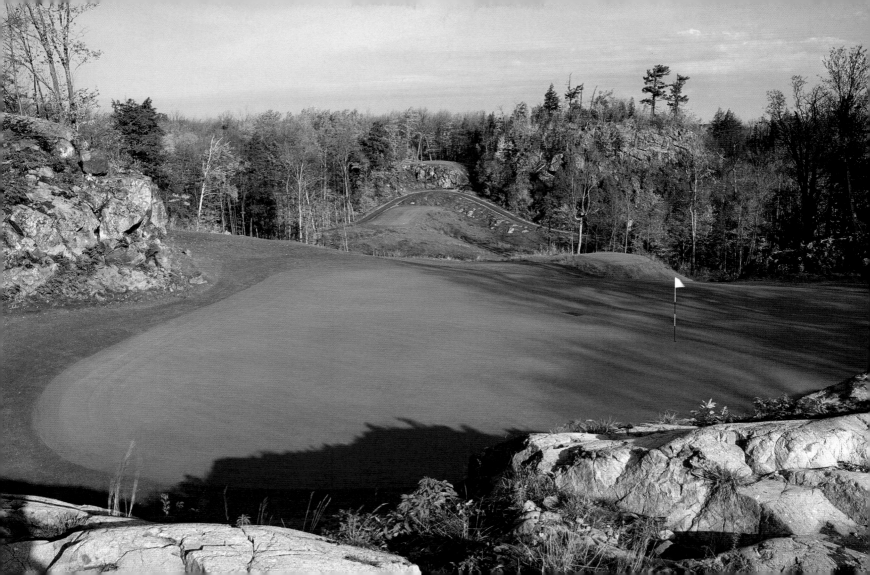

Located in Kingsley, just south of Traverse City in northern Michigan, the Kingsley Club was created as an old-fashioned, unvarnished course that adheres to the fundamentals of good design. The club's founders, Art Preston and Ed Walker, turned to architect Mike DeVries, who had studied Crystal Downs, Alister MacKenzie's Michigan masterpiece, while working on the maintenance staff, and had then worked with Tom Doak and Tom Fazio. DeVries was given a rolling site of hardwoods and white pine with sandy soil, and proceeded to route the holes while moving hardly any dirt during construction. The fairways were planted with seaside fescue grass to promote a fast ground game, and DeVries created shaggy, rough-edged bunkers that are clotted across the furrowed fairways. A great deal of thought and careful shaping went into the greensites and surrounding contours, which are nested among trees and grass dunes, set on hillsides and saddles, or sunk in a punchbowl—as on the fifth hole. Opened in the summer of 2000, the Kingsley Club, with its throwback design and emphasis on traditional golfing values, is a walking course with a strong caddie program and club cottages for national members and their guests.

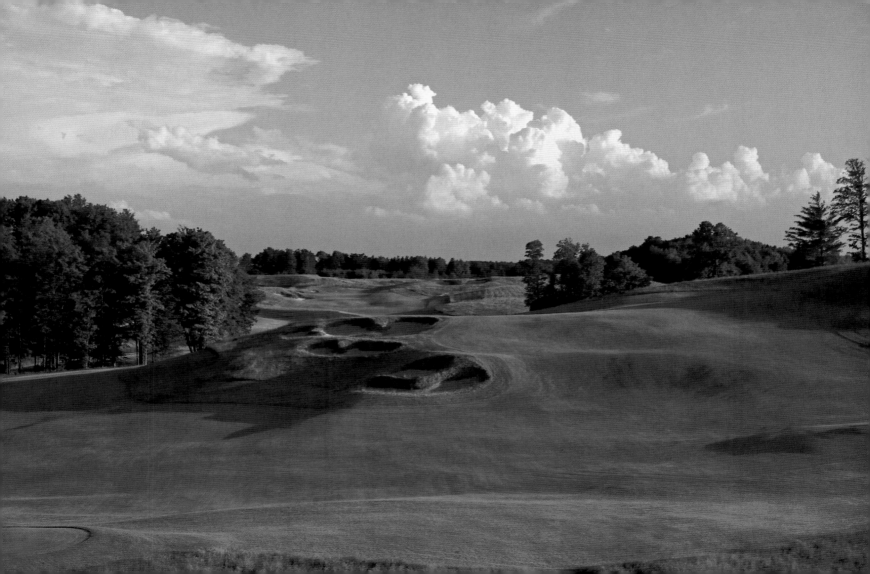

Arcadia Bluffs Golf Club is a true links—that is, a course next to the sea routed through sandhills—overlooking Lake Michigan. Opened in 1998, the course is in the remote town of Arcadia in northwest Michigan, and it is an arcadia for golfers, laid out across 245 windswept acres of sand dunes. The dunes drop 225 feet from the highest point down to the bluff above Lake Michigan, with 3,100 feet of shore frontage. Designed by Warren Henderson and renowned teaching professional Rick Smith, Arcadia Bluffs emulates the great seaside Irish courses. There are wide fairways framed by tall fescue grasses that sway along the lake, 50 sod-walled bunkers, and big rippling greens. The flagsticks are short, three-foot wooden poles specially designed to resist the fierce winds off the lake.

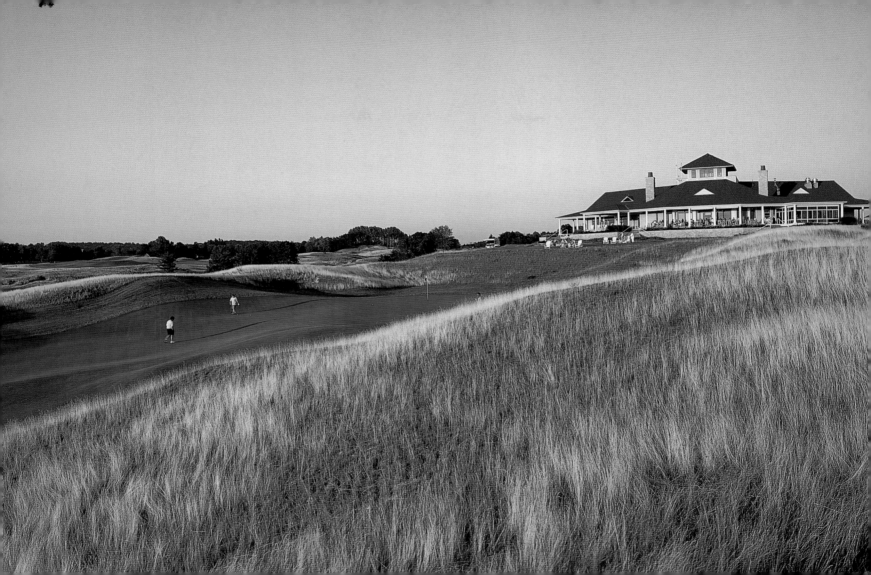

Crystal Downs Country Club, located in the town of Frankfort, and routed around a bluff overlooking Lake Michigan with views of Crystal Lake in the distance, is an almost mythic shrine for worshippers of American golf course architecture. The private course was designed by Dr. Alister MacKenzie, who visited the site in 1926, on his way from Cypress Point in California to his native Scotland, with construction supervised by his design consultant Perry Maxwell, the great architect of the lower plains states. The course is original in many respects. The rolling fairways framed by birch and pine are expansive, providing multiple lines of approach, and the bunkers are strategically placed seams of sand. The most striking feature of the course is the steeply pitched and exceptionally intimidating green surfaces, exemplified by the seventh green, which is shaped like a boomerang.

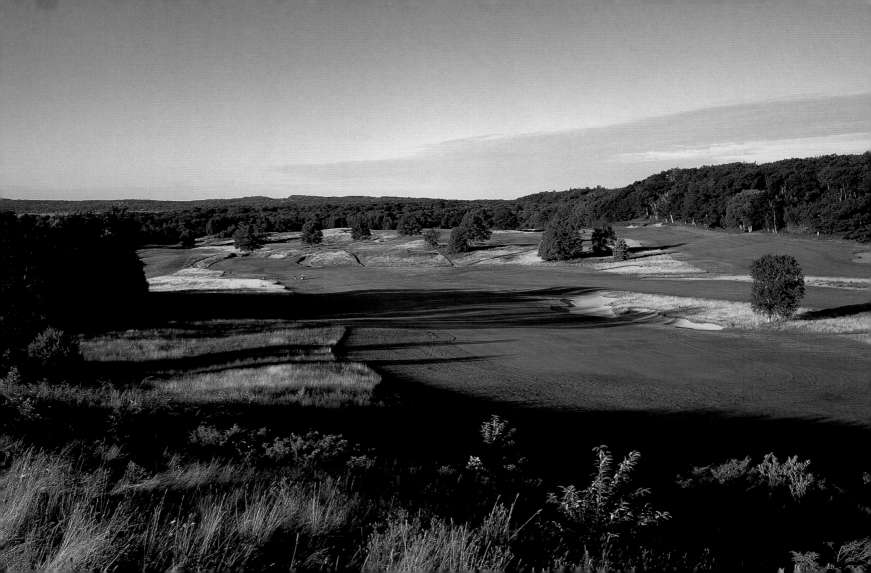

Oakland Hills Country Club's South Course is one of the landmark, quintessentially American courses. Located in Bloomfield Hills, a suburb of Detroit, the course was originally designed by Donald Ross in 1918, but the Oakland Hills of today reflects the heroic style of Robert Trent Jones. Jones was called in to redesign the course in 1950 so that it would humble the game's best players in the 1951 U.S. Open. Ben Hogan shot a final-round 67 to win the Open that year, and famously declared that he had brought "this monster to its knees." Oakland Hills has one of the most arduous and lovely finishing stretches of parkland holes, with the 16th hole playing along and then across the willow-lined pond to the green. In the 1996 U.S. Open, Tom Lehman and Steve Jones came to the final hole on Sunday in a dead heat. Lehman's tee shot kicked into the bunker at the corner of the pinched fairway, and Jones hit a brilliant second shot to the massive, tiered green to earn his victory. In 2004, Oakland Hills was the site of the European team's drubbing of the U.S. squad in the Ryder Cup. In 2008, the club hosted the PGA Championship, with Padraig Harrington winning his second major of that year.

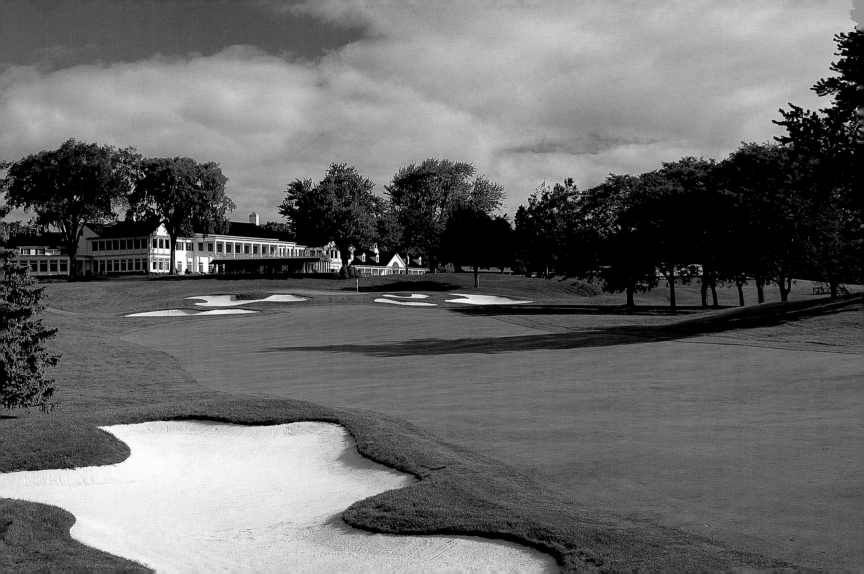

Inverness in Toledo is one of America's most historic championship courses. The club dates back to a nine-hole course built in 1903, when S.P. Jermain, the club's first president, received permission from the Scottish village of Inverness to use its name and crest. In 1919, the club hired Donald Ross to rework those nine holes and add nine more. Several architects have tinkered with Ross's handiwork over the years, most notably George and Tom Fazio, who built four new holes before the 1979 U.S. Open, a change much decried by architectural purists. The club held its first U.S. Open in 1920 when Harry Vardon, almost 50, was on his way to winning until a fierce windstorm descended as he was playing the back nine, causing him to lose the tournament. Jack Nicklaus made his U.S. Open debut at Inverness in 1957, when Dick Mayer defeated Cary Middlecoff in a playoff, and Hale Irwin was the winner of the 1979 Open. The most memorable major tournaments at Inverness, however, have been the 1986 and 1993 PGA Championships. In 1986, Bob Tway unforgettably holed his bunker shot on the final hole to beat Greg Norman. Norman was again the agonizingly hard-luck runner-up in 1993, losing to Paul Azinger on the second extra hole of their sudden death playoff.

Wolf Run, a private club 10 miles north of Indianapolis in Zionsville, is a demanding test that established the reputation of its designer, Steve Smyers, when it opened in 1989. The course is laid out over an attractive 216-acre site that includes meadowlands, a large bluff, and a heavily wooded valley scissored by Eagle Creek. Smyers moved very little earth on the holes along the valley, while shaping the upper holes on farm land, and made clever use of the creek, which perambulates into play on the second, seventh, eighth, and 16th holes. Nests of flash bunkers, which are especially pronounced on the 235-yard par-three 13th, are a distinctive feature. The layout and bunkering so impressed Nick Faldo that he hired Smyers to work with him on the design of Chart Hills Golf Club outside London, completed in 1993. Wolf Run was intended by its founder, Dr. Jack Leer, an Indiana dentist and competitive golfer, as a course that would attract and challenge top players from around the country. Smyers renovated the course in 2003, and it has continued to hold a lofty position on *Golfweek's* listing of America's Top 100 Modern Courses.

When it was built at the turn of the last century, French Lick Springs was a resort of Bavarian splendor in the American heartland of southern Indiana, its visitors coming from far and wide for the mineral springs that were the home of Pluto water. The French Lick Springs Hotel, which opened in 1901, continued in operation, while the palatial, six-tiered West Baden Springs Hotel, with its domed atrium, closed in 1932. The golf course, designed by Donald Ross, debuted as the Hill Course in 1917 and hosted the 1924 PGA Championship won by Walter Hagen.

The two landmark hotels and historic golf course have now all been restored to their bygone glory, the culmination of a 15-year, $382 million project that includes the new French Lick Casino and an eagerly awaited Pete Dye–designed golf course that opened in 2009. The entrepreneur behind the restoration was Bill Cook, Indiana's richest man, who made his millions inventing medical devices. The Ross Course was restored by Lee Schmidt, who started his career with Dye, working off the 1917 blueprints. Schmidt brought back 35 of Ross's original deep-dish bunkers and re-created the old fashioned, oversized rectangular greens. The Dye Course, measuring a bodacious 8,102 yards from the gold tees, is located in the rolling hills near the West Baden Springs Hotel, on some of the highest ground in the state of Indiana, with pillbox bunkers set in conical mounds. The mansion of French Lick's original owner, Thomas Taggart, is to serve as the clubhouse.

BELOW: The Ross Course
RIGHT: The Dye Course

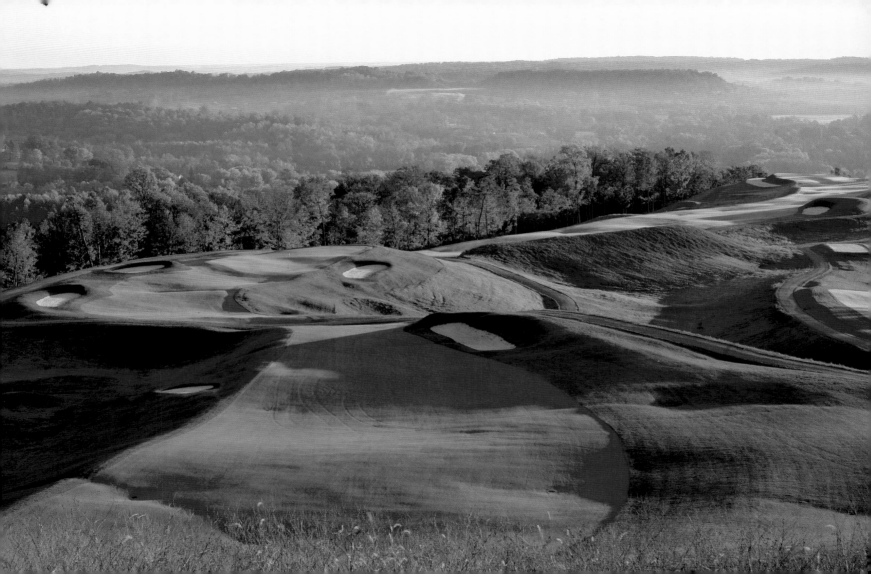

Muirfield Village Golf Club in Dublin, just north of Columbus, had its genesis in a conversation that Jack Nicklaus had with his old friend, Ivor Young, while they were sitting on the clubhouse veranda at Augusta National during the 1966 Masters. Nicklaus suggested that it would be wonderful to have a course in his hometown of Columbus that would convey the same type of golfing ambience as Augusta. Young was in the real estate business and when he returned to Columbus he found 10 or 11 potential sites for a course. Nicklaus and he ended up buying the first one they visited— a 160-acre parcel that Jack used to hunt on when he was growing up. Construction began in 1972, Nicklaus working with his design partner at the time, the late Desmond Muirhead. Muirfield Village, named for the course in Scotland where Nicklaus won the 1966 British Open, is an impeccably manicured tableau of pasture and woodlands, with three intersecting streams on the property trilling through the fairways and coming into play on 11 of the holes. Nicklaus fulfilled his dream of building a great course specifically designed for tournament golf, as Muirfield Village hosts the annual Memorial Tournament, dedicated each year to an individual honoree.

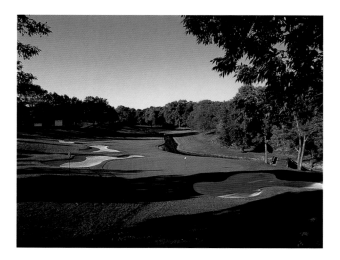

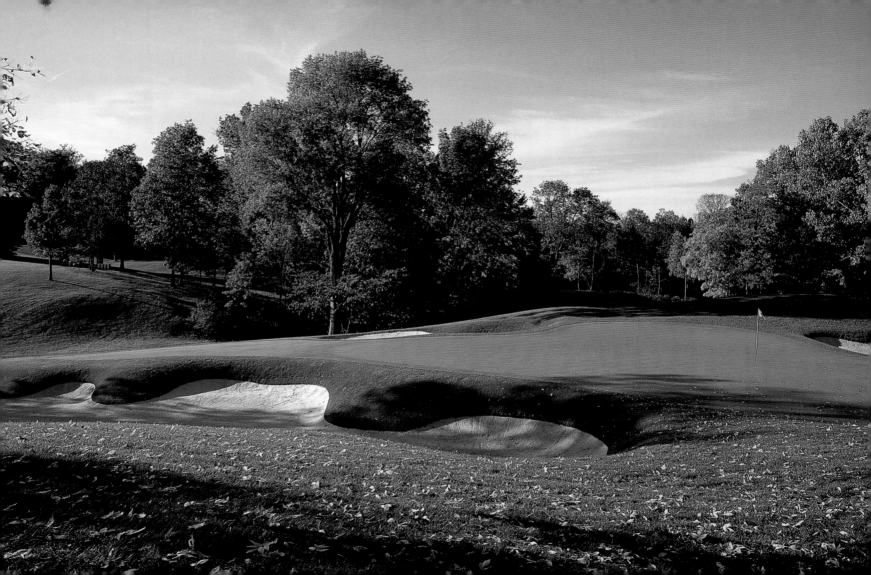

Oakmont is the singular vision of its founder, Henry Clay Fownes, the Pittsburgh industrialist, and his son William C. Fownes, Jr. (who was given the Jr. despite being named after his uncle). Located a dozen miles north of Pittsburgh, the course was planned by Fownes *père* and built by 150 men and 25 mule teams, beginning September 15, 1903, and opening a year later. The Fownes took a strict Calvinist view of golf as a game that was meant to be difficult, and Oakmont reflects the credo of William Fownes that "a shot poorly played should be a shot irrevocably lost." Oakmont's penal bunkers are legendary, particularly the eight rows of the Church Pews that separate the third and fourth fairways. The clay soil did not allow for building deep bunkers, so Oakmont's were filled with heavy river sand and then, starting in 1920, furrowed with specially built heavy metal rakes with two-inch-long teeth. The Fownes had the greens rolled with a 1,500-pound roller that required eight men to pull. The Oakmont rakes are gone nowadays, but Oakmont's greens remain the fastest and wickedest in all of golf, where four-putts are not out of the ordinary and putts have been known to fall backwards into the cup. Oakmont has figured prominently on the stage of championship golf, with Ben Hogan winning the U.S. Open there during his epic season of 1953. In 1973, Johnny Miller fired a blistering 63, which remains the lowest final round in the history of the championship, to win the Open. In 1994, Ernie Els took the title by outlasting Colin Montgomerie and Loren Roberts in an 18-hole playoff that ended in sudden-death. In 2007, Ángel Cabrera was the victor, becoming the first Argentinian to win the U.S. Open.

BELOW: The clubhouse

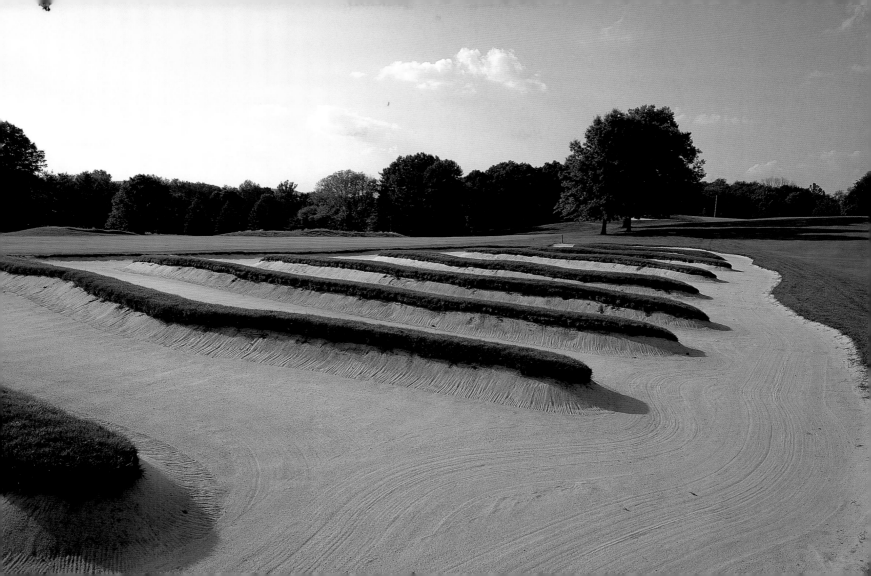

The Omni Bedford Springs Resort is a grand piece of Americana with a recently restored vintage golf course, located in the Cumberland Valley of south-central Pennsylvania beneath the Allegheny Mountains. The resort, which was designated a National Historic Landmark in 1984, only to close two years later, was purchased in 1998 and has been reminted with a $120-million head-to-toe makeover completed in July 2007.

Bedford Springs traces its history all the way back to 1806, when Dr. John Anderson, who had been introduced to the curative powers of the eight mineral springs by the native Indians, acquired the land, and opened a small hotel called the Stone Inn. During the 19th century, Bedford Springs became the most popular resort in the United States, where guests—including several U.S. presidents—came to take the waters. Naturally, the resort required a premier golf course,

and in 1895 Spencer Oldham laid out an 18-holer measuring what was at the time a daunting 6,000 yards. In 1912, the legendary A. W. Tillinghast was brought in to remodel the course, which had been reduced to nine holes, and left behind his Tiny Tim green, which he described in his book *Gleanings from the Wayside*.

In 1923, the great Donald Ross was summoned to revamp the course and return it to 18 holes. He created the long, uphill par-three fourth hole, known as the Volcano. Now the golf course, like the hotel, has been meticulously returned to its 1920s-era high style. The retro rebuild was carried out by Ron Forse, a noted restorer of vintage Ross designs, and the historic collection of holes, including Tiny Tim, now playing as the 14th, the Volcano, and the par-three 10th, named the Gulley, are all on full display.

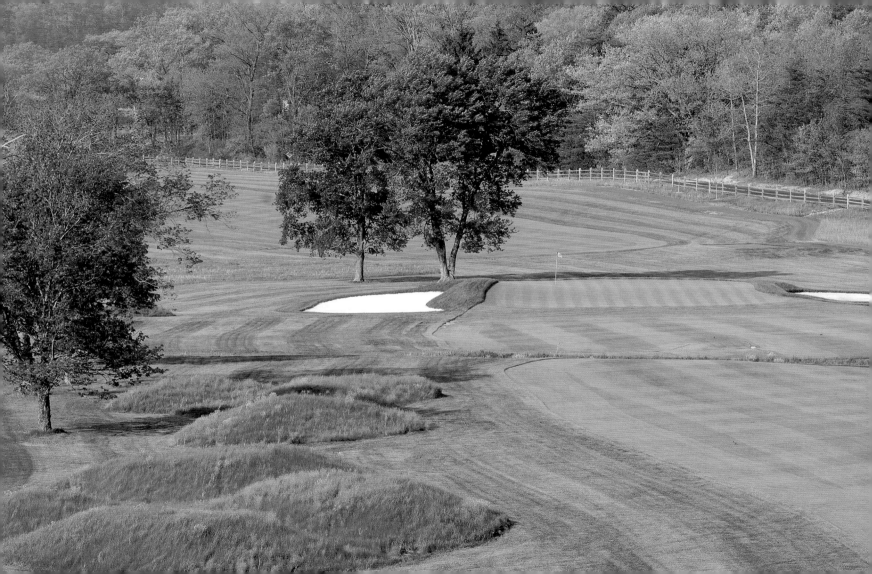

Aronimink Golf Club has played a continuous and important role in the Philadelphia golf scene since 1897, when it was one of the four founding clubs of the Golf Association of Philadelphia. Known at the time as the Belmont Golf Association, its original clubhouse at 52nd Street and Chester Avenue in southwest Philadelphia was a small frame farmhouse previously occupied by an Indian chief of the Lenape Tribe named Arronimink, whose name the club adopted after its golf members broke off from the Belmont Cricket Club. The winner of the club championship in 1897 was 18-year-old Hugh Wilson, who would go on to design Merion.

The club's first pro was John Shippen, whose father was an African American minister at the Shinnecock Indian Reservation on Long Island. Shippen made golf history in 1896 by finishing fifth at the U.S. Open held that year at Shinnecock Hills, becoming the first African American to play in the Open. In the 1920s, the club acquired 300 acres of tumbling land in the Radnor Hunt country in Newton Square, west of Philadelphia, and the illustrious Donald Ross was hired to design the present championship course, completed in 1928. Since then, Aronimink has emerged on the national stage, hosting the 1962 PGA Championship won by Gary Player and the 2003 Senior PGA won by John Jacobs. Aronimink will also serve as the home course of the AT&T National—the PGA Tour event founded and hosted by Tiger Woods—in 2010 and 2011, while Congressional undergoes renovations in preparation for the 2011 U.S. Open.

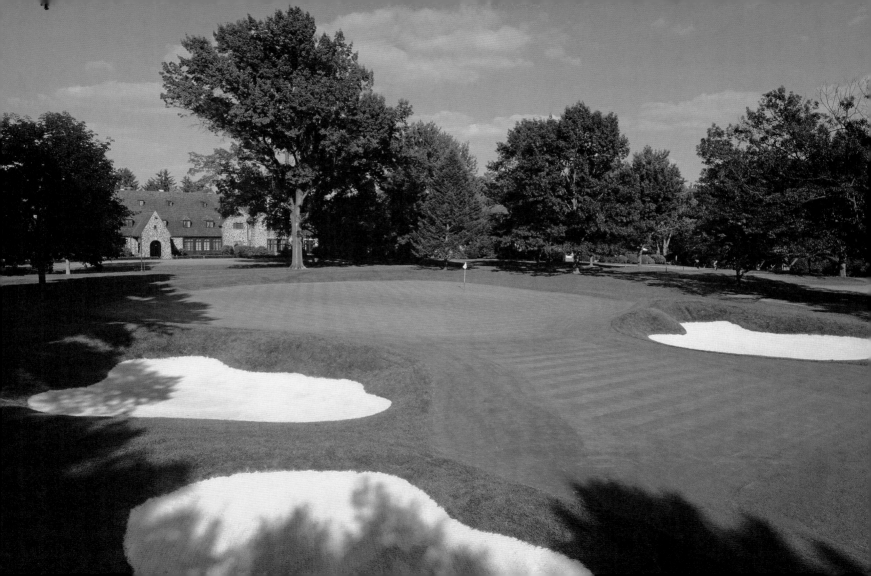

Merion Golf Club in Ardmore, outside Philadelphia, is a classic American course and a hallmark of the Philadelphia school of design. The Merion Cricket Club was founded in 1865, and golf was introduced with a nine-hole course in 1896. The East Course was designed by Hugh Wilson, a member of Merion and a Princeton graduate who was born in Scotland. Wilson was not a professional course architect, but showed an aptitude for design, and was selected by the club to spend seven months studying the great courses of Scotland and England in preparation for his work at Merion, which was completed in 1912. Wilson created a course that is still ranked in the top ten in the United States. He molded 128 bunkers—"the white faces of Merion"—as they were famously described by Chick Evans when he won the 1916 U.S. Amateur Championship at Merion. Merion, with its distinctive red wicker flagsticks, modeled after the crooks of Scottish shepherds, has hosted a number of historic tournaments. Ben Hogan won the U.S. Open there in 1950 in a remarkable comeback after his near-fatal car accident in 1949. Lee Trevino won his second U.S. Open at Merion in 1971, defeating Jack Nicklaus in a playoff. Merion is scheduled to host the U.S. again in 2013, with the course having been lengthened to 6,846 yards since David Graham's victory in the 1981 Open.

JULY 7 | PHILADELPHIA CRICKET CLUB—PENNSYLVANIA, U.S.A.

The Philadelphia Cricket Club is one of the most venerable golf clubs in United States, with the unique distinction of having opened a course in each of the past three centuries. The club was founded in 1854 by a group of cricket-playing young men of English descent who had been students together at the University of Pennsylvania, eventually establishing a home pitch at Chestnut Hill in 1883. When golf became all the rage in the 1890s, the club established a nine-hole course, quickly followed by an 18-hole course designed by Willie Tucker, which hosted the 1907 and 1910 U.S. Open championships. This original course, known as St. Martin's, still survives as a nine-hole layout, but in 1920 the club acquired a large tract of rolling, wooded land in Flourtown. The larger-than-life Philadelphia School architect A.W. Tillinghast was brought in to design the Flourtown course, which opened in 1922 and was rechristened the Wissahickon Course in 2002. Tillinghast's flowing course remains a first-rate test, with eight par-fours stretching over 400 yards and the ninth and 18th both topping 450 yards. In 2002, the Cricket Club unveiled its new Militia Hill Course, designed by Michael Hurzdan and Dana Fry, and laid out over an old Revolutionary War encampment.

RIGHT: Wissahickon Course

Saucon Valley Country Club in Bethlehem has three championship courses—the Old Course, the Grace Course, and the Weyhill Course—plus a six-hole short course, giving it a nifty 60 holes altogether. The history of the club is closely tied to that of the Bethlehem Steel Company. The Old Course, which opened in 1922 and hosted the 1992 and 2000 U.S. Senior Opens, is a classic parkland layout designed by the English architect Herbert Strong on softly sloping terrain that once had been a farm. The Grace Course is named for Eugene Grace, the founder of the club, who after graduating from Lehigh University in 1899, became president of Bethlehem Steel in 1916 and served as president and chairman until his retirement in 1957. The Grace Course, designed by William Gordon and his son David in the 1950s, circles around the Old Course without returning to the clubhouse, pausing at the halfway house named Villa Pazzetti after another Bethlehem Steel executive. The Weyhill Course, also designed by the Gordons and opened in 1968, is the most dramatic of the three, with more severe and sudden changes of elevation. Laid out over what had been a dairy farm named Weyhill Farms, the 14th and 15th play over an abandoned quarry, and Saucon Creek snakes through the property. The Old Course, which was lengthened in 2007 with revised bunkering, hosted the 2009 U.S. Women's Open, with Eun-Hee Ji the surprise winner.

RIGHT: The Old Course

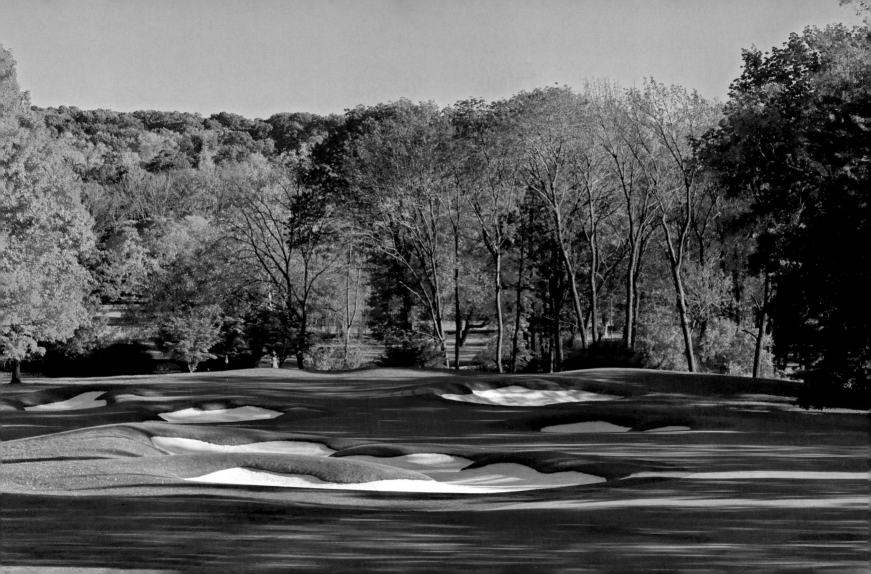

The Auld Grey Toon of St. Andrews on the east coast of Scotland in the Kingdom of Fife is the home of golf, and no course is more closely identified with the history of the game than the Old Course at St. Andrews. The course is laid out along St. Andrews Bay in the shape of a shepherd's crook, with the first seven holes running out to Eden Estuary, followed by a four-hole loop, and then returning to the world's most recognized clubhouse. St. Andrews is a course that golfers learn to love, but it is somewhat unprepossessing and strange at first sight, with broad fairways as rumpled as dirty laundry, lurking bunkers seemingly scattered randomly across the field of play, and immense double greens with rollercoaster surfaces. The earliest documented evidence of golf at St. Andrews dates from January 25, 1552, although no doubt golf had been played there for some time earlier. The Royal and Ancient Golf Club of St. Andrews was founded in 1754 and eventually became the governing body of the game outside of the United States. Many of the early Scottish pros, including Old and Young Tom Morris, hailed from St. Andrews, where they began as caddies. The Old Course has hosted 26 British Opens since 1873, with Tiger Woods winning the claret jug there in both 2000 and 2005 by commanding margins.

It is not every day that there is a new course at the home of golf, so it was big news indeed when in June 2008 the St. Andrews Links Trust opened the Castle Course, the seventh at St. Andrews. The Castle Course joined the Old Course, which dates from the mists of golfing time; the New Course, opened in 1895; the Jubilee, opened in 1897 on the 60th anniversary of Queen Victoria's accession to the throne; the Eden; the nine-hole Baglove Course; and the Strathyrum Course. The prestigious commission for designing the seventh at St. Andrews went to David McLay Kidd. Kidd was presented with a flat site consisting of potato farms on the dramatic head-land of Kinkell Ness, where a fortification known as Kinkell Castle once stood. McLay and his team then proceeded to create a links course, shipping in tons of sand and creating the sinewy fairways full of blind shots, with every hole overlooking St. Andrews Bay. Several holes, especially the sixth, ninth, the 17th—a par-three playing over a cliff—and the 18th peer out at the ecclesiastical spires of the Auld Grey Toon to the northwest across the Kinkell Braes. The Castle Course has come in for its share of criticism, particularly for the extremely severe green slopes and overgrown fairway mounds, and some features were softened slightly in 2009.

Carnoustie is a small and rather remote village that lies on the other side of the Firth of Forth from St. Andrews, but the 1999 and 2007 British Opens left no doubt that it is the fiercest and most unrelenting of all the championship courses of Great Britain. Before 1999, Carnoustie was best known as the site of Ben Hogan's historic triumph at the British Open in 1953, the year the wee ice mon won all three of the majors he entered. Even in ordinary circumstances, Carnoustie is a tough track, but with the rough allowed to grow like the giant's beanstalk and the fairways reduced to narrow corridors, the pros were left crying for mercy in 1999. No golfer can forget Jean Van de Velde's agonizing finish on the 18th hole that year. The Frenchman's pitch from the tall rough found Barry Burn on his way to a triple bogey seven, sending him to a three-way playoff that ended with Paul Lawrie as the last man standing. In the 2007 Open, Ireland's Padraig Harrington almost suffered the same fate as Van de Velde, after hitting two shots into the burn on the final hole in regulation. But after Sergio García just missed his putt for a par on the 18th, Harrington came back to win the playoff. As Patric Dickinson wrote so presciently of Carnoustie back in 1950: "The dénouement is like the climax of an Elizabethan drama: daggers are out by the 16th, a poisoned-cup filled from the Burn and drunk deeply at the 17th; and the 18th green is littered with dead bodies which Fortinbras (fresh from a 72 at St. Andrews) arrives to clear up and cart off, on trolleys . . . but is it really a grand tragedy finish; or is it grand guignol? Or a bit of both?"

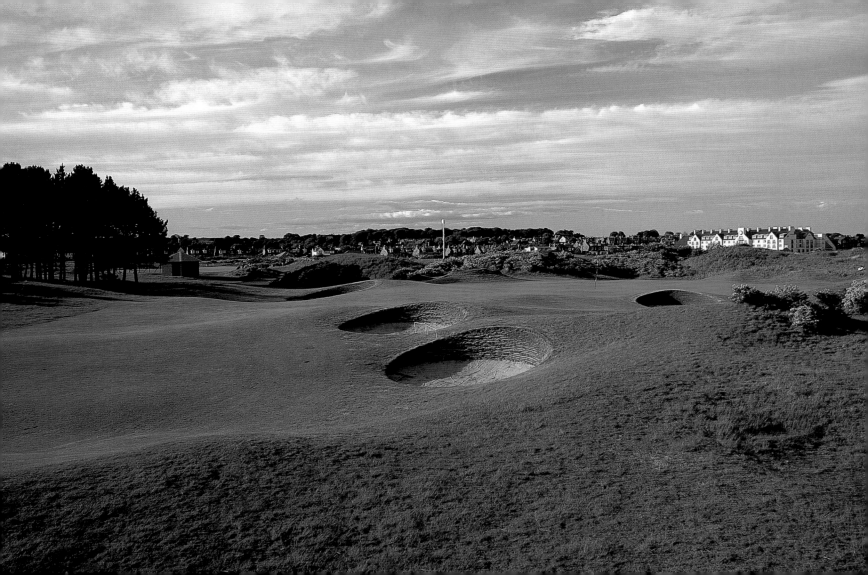

Gleneagles is golf 's version of Brigadoon, although, fortunately for golfers, this pleasure palace created in the Scottish moors is not imaginary. Located between Blackford and Auchterarder, with the Ochil Hills to the south and the foothills of the Grampians to the north, Gleneagles had its genesis in the rivalry between the various British railways before the First World War. Donald A. Matheson, the general manager of the Caledonian Railway, devised the brilliant plan to build the ultimate luxury hotel and two championship courses in the beautiful bower of the highlands. The famous King's and Queen's Courses were both designed by the great Scottish professional James Braid, with work beginning in 1913. Both courses opened in 1919, after construction was halted by the war, and the hotel was finally completed in June 1924. In 1993, Jack Nicklaus unveiled a third course, the PGA Centenary Course, which has been selected to host the 2014 Ryder Cup.

RIGHT: Kings Course

Castle Stuart, one of a clutch of new courses in Scotland that includes Machrihanish Dunes, Spey Valley in Aviemore, Kittocks in St. Andrews, and the Renaissance Club in Gullane, has been widely acclaimed as the fairest of them all. The course is a supreme links in a superb Highlands setting, overlooking the Moray Firth five miles east of Inverness. Opened in July 2009, Castle Stuart was developed and designed by Mark Parsinen, who created the Kingsbarns links near St. Andrews. Parsinen teamed up with architect Gil Hanse, and these two American devotees of links golf poured their hearts and souls into creating a course that combines tremendous flair with all of the subtle virtues of Scottish seaside golf.

Castle Stuart has very broad fairways, designed to create the strategic angles of play that Parsinen so admired at the Old Course at St. Andrews, and heaps of chunky, raw-edged bunkers railed with tall fescues. There are views of the Moray Firth out to the Kessock Bridge on 15 holes, with six of the scooped and crested greenswards lying along the south shore of the firth. The first hole kicks off with a cliff-top drive overlooking the panorama of the firth. The par-three fourth is backed by 400-year-old Castle Stuart—originally built for James Stuart, half brother of Mary Queen of Scots and first Earl of Moray—which is now a bed and breakfast. The 11th is a short par-three out to the water, with the tee facing the Fortrose lighthouse in the distance, while the 18th is a 595-yard par five, whose right side is guarded by a gallimaufry of sand and scrub.

Brora offers all the profound pleasures of links golf in the Highlands of Scotland, located an hour north of Inverness. The club was founded back in 1891, with the current course laid out in 1923 according to the plan of James Braid, the five-time Open champion and pillar of Scottish golf. The course remains as Braid designed it and Brora is also the headquarters of the James Braid Golfing Society, which alone would warrant a pilgrimage. The layout follows the traditional out and back routing, with the outward nine, except for the short sixth, hewing to the coastline along Kintradwell Bay and the North Sea. The inward nine, which finishes with a long par-three, runs along the bordering croft land, with the foothills of Sutherland as a backdrop. Brora barely tops 6,100 yards, playing to a par of 69, but it is much more than a holiday course, with only one par-five and six stout par-fours measuring over 400 yards. A flock of sheep roams the course, requiring fencing around each green—in this case made of electric wire.

Royal Dornoch is the farthest north of the great championship courses of Scotland, located by the village of Dornoch 60 miles north of Inverness on the east coast of Sutherland, and 600 miles north of London. A classic links course festooned with gorse, Dornoch runs out and back along Embo Bay, with seven miles of creamy beach leading to Little Ferry and Loch Fleet to the north and out to the pale blue mountains beyond. The golf club was founded in 1877, although golf has been played in Dornoch since 1616, with Sir Robert Gordon writing in his *History of Sutherland*, published in 1630: "About this toun there are the fairest and largest links of any pairt of Scotland, fit for archery, Golfing, Ryding, and all other exercise; they do surpass the fields of Montrose or St. Andrews." Dornoch's most famous native son was Donald Ross, born in a house on St. Gilbert Street in 1873. In 1898, Ross emigrated to Boston, and was eventually hired by James Tufts to design Pinehurst No. 2, where the crowned and exquisitely sculpted greens reflect Dornoch's influence. Dornoch was a popular resort for the upper crust of English golfers in the early years of the 20th century but then settled into relative anonymity. It has been rediscovered in recent years, with many golfers making the pilgrimage that Herbert Warren Wind described in his 1964 *New Yorker* article, "North to the Links of Dornoch."

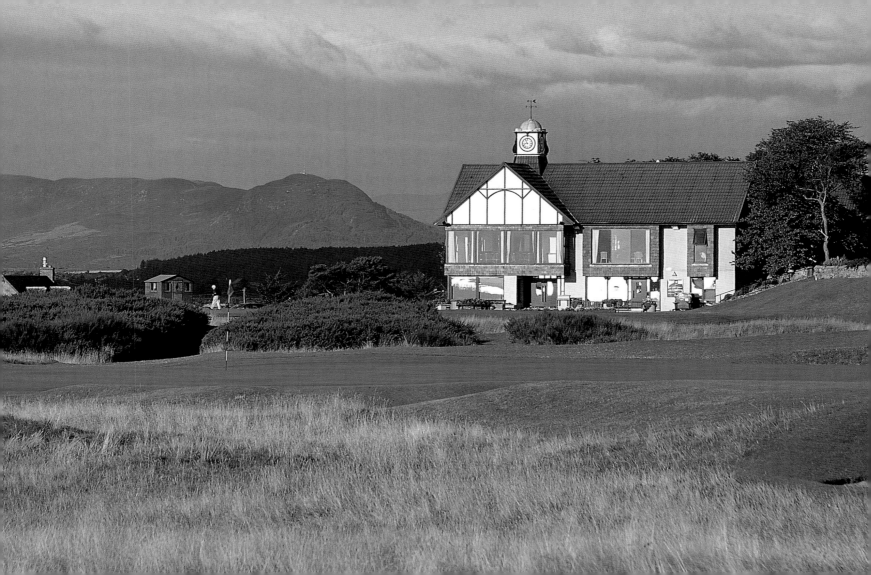

Akernish is a new links course on the island of South Uist, on the distant golfing shore of the Outer Hebrides off the northwest coast of Scotland, its design inspired by the original links course laid out on the island by Old Tom Morris back in 1891. By the mid-1930s, Morris's original layout was lost when the central portion of the links was bulldozed to make way for a military airstrip. David Owen told the story of the modern re-creation of the lost links in his article "The Ghost Course," which appeared in *The New Yorker* in April 2009.

In 2005, Scottish golf course consultant Gordon Irvine visited South Uist on a fishing trip and was regaled with the story of the original Morris links by Ralph Thompson, chairman of Askernish's existing nine-hole course. When Thompson and some of the other members showed Irvine the duneland running along the Atlantic on the island's west coast, known as the *machair* in Gaelic, he became a true believer. Irvine returned with course architect Martin Ebert in March 2006 and, together with the members, sought clues as to where Morris had placed the original fairways and greens. Eventually, using Morris's design principles and the natural contours of the *machair*, they created an 18-hole course that officially opened on August 22, 2008. The seventh through 12th holes run along the Atlantic and the entire back nine barrels through sea grass dunes freckled with poppies and orchids.

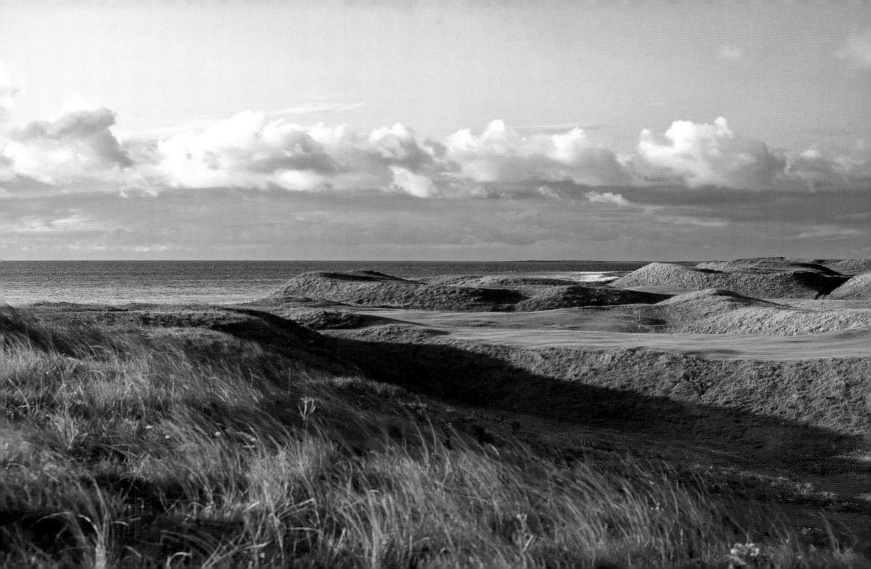

Muirfield is the home of the Honourable Company of Edinburgh Golfers, founded in 1744, ten years before the Royal and Ancient Golf Club of St. Andrews, making it the oldest golf club in the world. The members originally played at the links of Leith, but in 1836 the club moved six miles east to Musselburgh. The course eventually became overcrowded, and in 1891 the club moved further east to Muirfield, where it has been ever since. Muirfield is the blueblood of Scottish golf, not only in its lineage and membership, but in the elegance and fairness of its design. The course is famous for its routing, with the clockwise outward nine encircling the counterclockwise inner nine. Many great champions have won the British Open at Muirfield, beginning with Harold Hilton in 1892, and including Jack Nicklaus in 1966, Lee Trevino in 1972, Tom Watson in 1980, Nick Faldo in 1987 and 1992, and, most recently, Ernie Els in 2002.

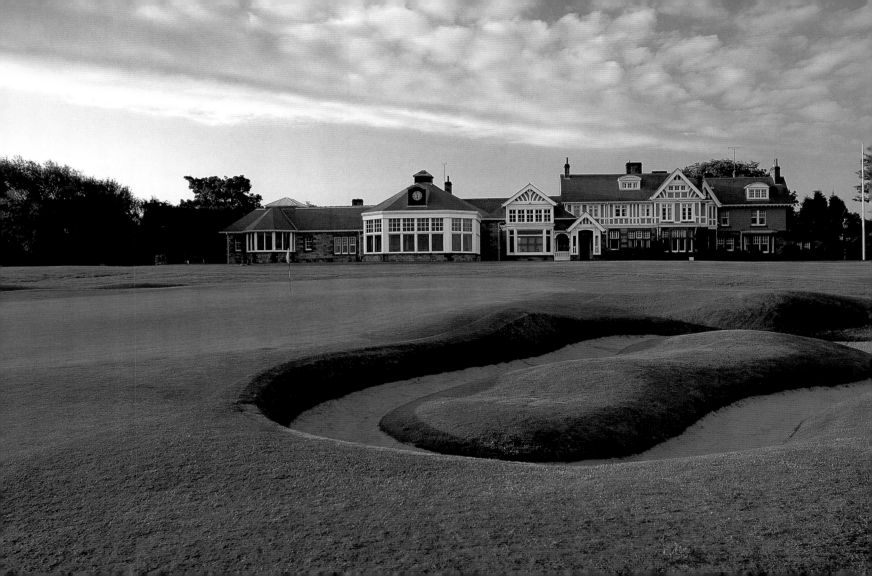

North Berwick is a venerable and much venerated course, full of historic charm, set in the midst of the golfing pageantry of East Lothian. At the turn of the 20th century, North Berwick was the most fashionable of all the Scottish resorts—the place for members of English society to see and be seen. Arthur Balfour, the future prime minister, was a regular on the links and was captain in 1891-92. The original club was founded in 1832, but the New Club dates from 1879. North Berwick is particularly famed for its scenery, with views from the front nine over the Firth of Forth to the brooding Bass Rock with its colony of gannets and the small craggy islands of the firth, including Lamb and Fidra. To the west lie Dirleton and Archerfield Wood, with Muirfield beyond. The first and 17th holes both run out to Point Garry, while the green of the seventh hole is guarded by Eel Burn. The 15th is the famous par-three Redan hole, which takes its name from a Crimean War fortification, and has been copied all over the world, including at the National Golf Links of America and Shinnecock Hills.

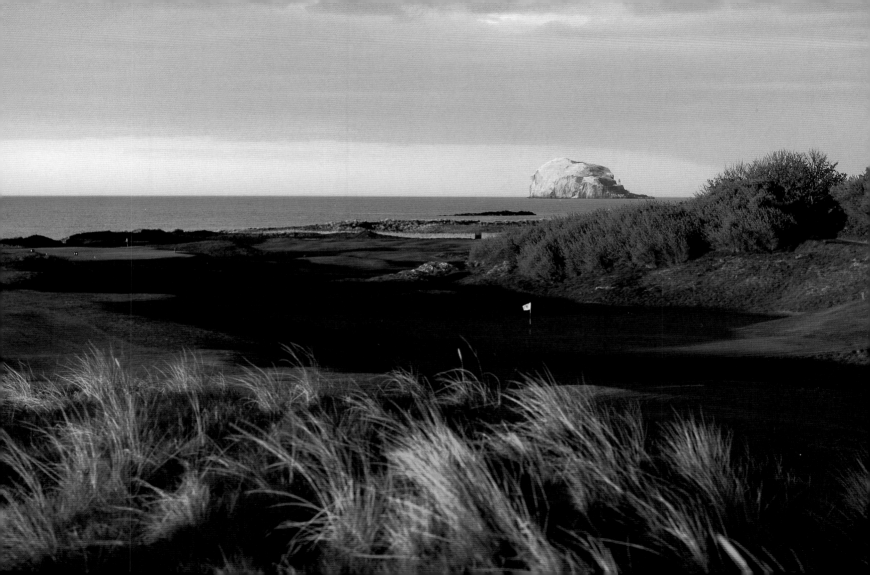

Portmarnock is the golfing pride of Dublin, located across an estuary on a two-mile-long peninsula that juts into Dublin Bay. Like many other early Irish courses, Portmarnock was founded by Protestant businessmen, in this case a Scottish insurance executive named William Chalmers Pickeman, who rowed over to survey the site on Christmas Eve in 1893 with his friend George Ross. The first nine holes opened in 1894, on land owned by the Jameson distillery family, with an outhouse belonging to local resident Maggie Leonard serving as the first clubhouse. The course, which evolved over time, is a low-lying, somewhat understated, and strategic links compared to its more rambunctious cousins on the west coast. The 185-yard par-three 15th that runs hard along the shore of Dublin Bay, with a sprig of palm tree to the front right of the green, features views across the sea to Ireland's Eye and the Lambay Islands. Portmarnock has hosted more championships than any other Irish course, including the 1991 Walker Cup and many Irish Opens.

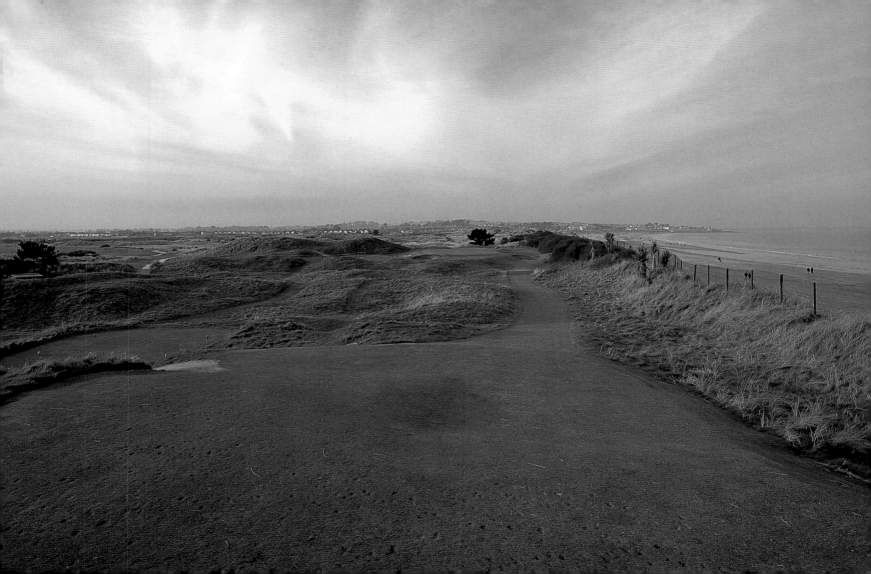

Carton House Golf Club rambles around the grounds of one of the most opulent of Ireland's great estates, located in the old seminary town of Maynooth in County Kildare, 14 miles west of Dublin. Carton Demesne was the ancestral home of the FitzGeralds, who became the Earls of Kildare and then Dukes of Leinster. It dates back to the 12th century. Carton House, the Palladian mansion that overlooks the two courses, was built in 1739 by the 19th Earl of Kildare. His son, the 20th Earl and first Duke of Leinster, married Lady Emily Lennox, who added the Shell Cottage, decorated with seashells from around the world. In 2000, it was decided to develop the estate as a golf resort with a hotel that was added to the main house. In 2002, the O'Meara Course designed by Mark

O'Meara opened, followed one year later by the Montgomerie Course designed by Colin Montgomerie. Both courses are laid out over the grounds of what is considered to be the finest example of an 18th-century Georgian parkland landscape in Ireland. The O'Meara course runs through the meadows and old specimen trees, making excellent use of the oxbow of the River Rye on the short 14th and 16th holes and the long par-five 15th. The Montgomerie Course is a tougher and longer test, measuring 7,300 yards, with deep bunkers galore. The Montgomerie Course hosted the Irish Open on the European Tour in 2005 and 2006.

RIGHT: The Montgomerie Course

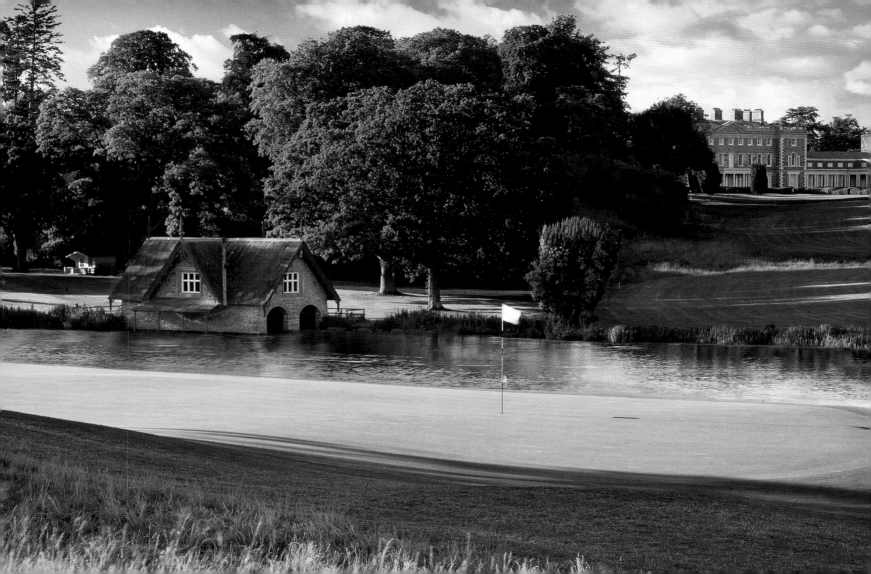

Dun Laoghaire is one of the newest courses in Ireland, but the golf club will celebrate its centenary in 2010. The club was founded in 1909, just outside Kingstown some seven miles south of Dublin. The Earl of Longford was elected its first president. A nine-hole course was laid out in 1910 and quickly extended to 18. Harry Colt was then employed after World War I to create a new course wedged into only 78 acres. By 1922, the year of Irish independence, the club's name was changed to Dun Laoghaire (Kingstown) Golf Club, and subsequently Kingstown was dropped altogether, reflecting the change of the town's name back to the original Irish name in 1921. In 2002, the members approved a plan to relocate the club to 320 acres at Ballyman Glen, near Enniskerry in County Wicklow. Hawtree & Sons were engaged to design the new course, which opened as a 27-hole layout of three nines in August 2007. The new Dun Laoghaire is a parkland course that sits in the secluded valley on the border of counties Dublin and Wicklow under Carrickgollen Hill. From the course there are scenic views of Sugar Loaf Mountain, the emblem of County Wicklow, and out to the Irish Sea.

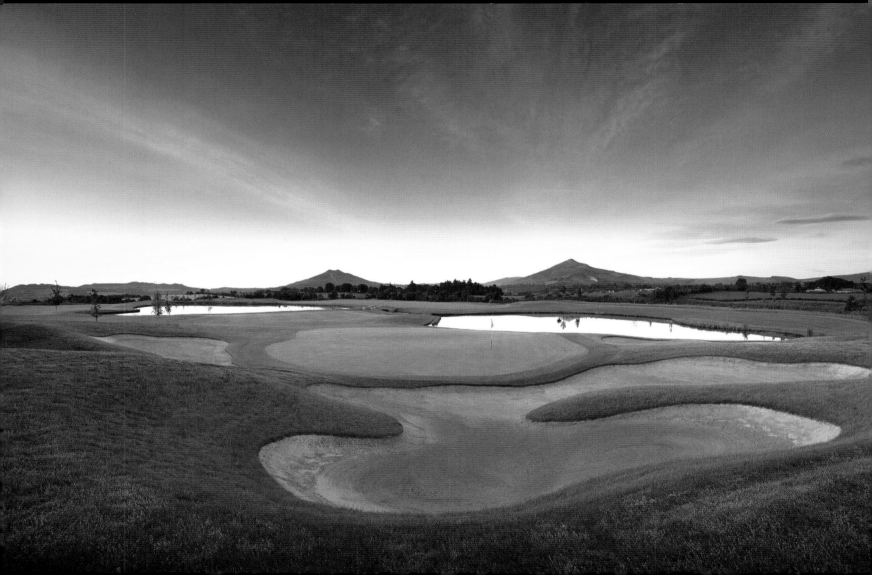

The European Club owes its conception, design, and realization to the vision and determination of Pat Ruddy. Ruddy, who grew up in County Sligo in the west of Ireland, has been something of a one-man band for Irish golf, starting out as the golf writer for the *Evening Herald* in Dublin as a young man and becoming a leading course architect. The European Club is located about 35 miles south of Dublin, overlooking Brittas Bay. In 1987, Ruddy saw an advertisement in the real estate section of a Dublin newspaper for a stretch of seaside property suitable for a golf course. He arranged for a helicopter ride down the east coast to inspect the site from the air, discovering an Elysium of enormous sand dunes that cried out for a golf course. Ruddy was able to raise the funds to buy the property and then essentially built the course himself, with the help of his children, over a five-year period, completing it in 1992. Ruddy created a true blue, natural links that he has continued to refine over the years, but without the blind holes and quirkiness of some of the older links courses.

Old Head Golf Links, opened in 1997, is located seven miles south of the harbor town of Kinsale in County Cork. The course occupies a 220-acre dragon's tongue of land lashed across high sea cliffs above the Atlantic. Old Head, declared Joseph Passov in *Links Magazine*, "is the most spectacular course on earth." Until 1978, the rocky promontory was farmland, but brothers John and Patrick O'Connor, both successful real estate developers, recognized that the site would make for a magical golf course. The O'Connors hired American course architect Ron Kirby to design the course, who teamed up with Ireland's leading architect Eddie Hackett, Waterville pro Liam Higgins, and the legendary Irish amateur Joe Carr. No less than nine of the holes rollick across the rocky cliffs, which rise 300 feet above the ocean, not far from where the Lusitania was torpedoed by a German U-boat in 1915. The symbol of Old Head is the lighthouse at the tip of the promontory built in 1853.

BELOW: Fishing boats along Kinsale peninsula

Tralee Golf Club in County Kerry is a links of high drama that lies on the southwest coast of Ireland overlooking Tralee Bay and the Barrow Strand. For 90 years, the club existed as a nine-hole course near the village of Tralee, but after buying a spectacular piece of seashore duneland at Barrow, the ambitious members engaged Arnold Palmer and Ed Seay to design a world class links that opened in October 1984. Tralee is one of the scenic splendors of Irish golf, with the first, second, 16th, and 17th—which is named Ryan's Daughter—running along the beach where David Lean filmed many of the scenes in his epic 1970 movie. The third, named The Castle, is a 194-yard par-three perched on a rocky thumbnail of land above the sea, with a 14th-century tower sitting stoutly behind the green and looking out at Fenit Island. The fourth bends right, with the green above the sea and a backdrop of the red sandstone mountains of Slieve Mish and the Rose, Crow, and Illaunacusha rocks. The 15th, the shortest par-four on the course, curves around the channel where the Atlantic cuts through the beach to form the inlet that leads to the town of Poulgorm.

Ballybunion Old is the best-known course in Ireland and one of the most famous in the world, although its fame is relatively recent. Like many of the world's most resplendent links, Ballybunion was shaped as much by nature as by an architect, though Irish professional James McKenna was probably responsible for laying out the original course in the immense sand ridges that flank the encroaching Atlantic in County Kerry. Ballybunion traces its origin to 1893, starting out as a 12-hole course that was not fully extended to 18 until 1927. Tom Simpson was given free rein to alter the course in 1936, but recognizing that one should not attempt to repaint the Mona Lisa, he chose only to move three greens and add one fairway bunker, known as Mrs. Simpson. The first hole runs past a graveyard just off the right side of the fairway, while the 18th traverses a vast sandy waste area known as the Sahara. In between, the holes clamber and clatter through the sand dunes. Herbert Warren Wind wrote of his visit in 1971: "Very simply, Ballybunion revealed itself to be nothing less than the finest seaside course I have ever seen." That article and the enthusiasm for Ballybunion of Tom Watson, who first visited the course in 1981 and made it a staple of his British Open preparations, brought the links to the attention of the world. Ballybunion added a second course, the Cashen Course, in 1980. Designed by Robert Trent Jones, it is a creative, controversial, and taxing links of the first order.

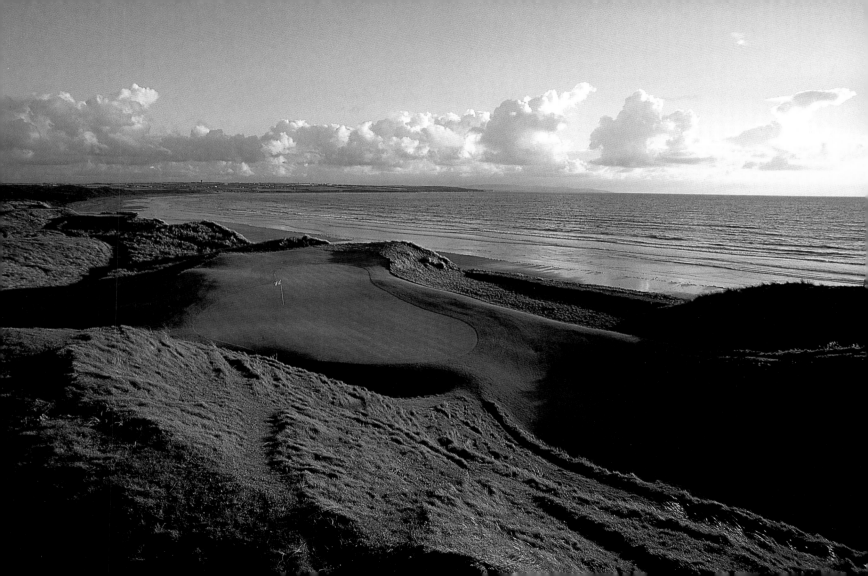

Doonbeg immediately leapt into the ranks of the great links of western Ireland when it opened in 2002. This much bally-hooed course set in the pleated dunes and piled stone walls along Doughmore Bay in County Clare lives up to its billing. Located near the wee village of Doonbeg, the course was developed by Kiawah Development Partners, making Doonbeg the Irish cousin of the Ocean Course at South Carolina's Kiawah Island. Greg Norman made the most of the rare opportunity to lay out a course on sacred golfing ground, making 22 visits over a three-year period to find the holes in the natural folds of the dunes and farmland. A 51-acre portion of the dunes was fenced off as a habitat preserve for the *vertigo angustior*, a small snail, but that still left Norman with plenty of choice golfing ground. From the very first hole, Doonbeg captures the rustic, windswept flavor of Irish seaside golf, with the par-four fifth running out to the beach, and the shoreline hugging the right side of the 18th hole. Doonbeg can rightfully take its place alongside its famous golfing neighbors, Lahinch, Waterville, and Ballybunion.

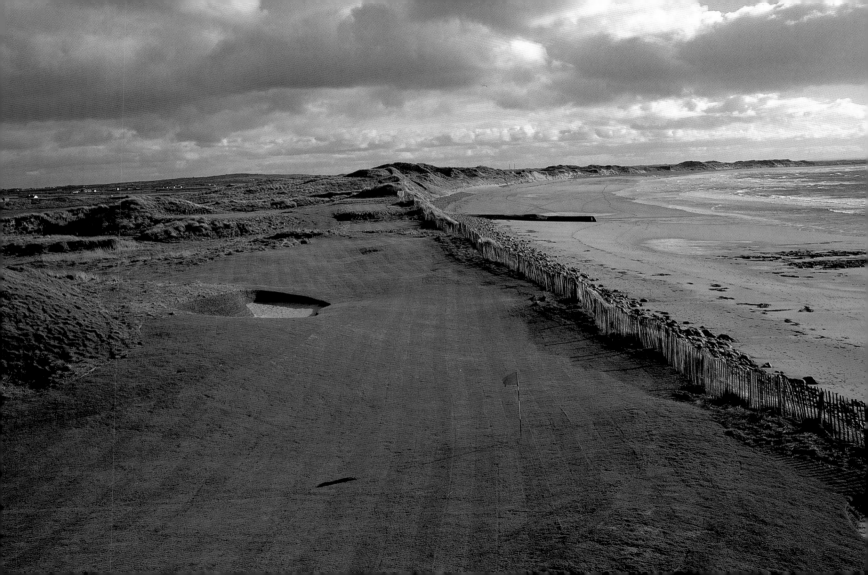

Lahinch is one of Ireland's most venerable links, named for the seaside village in County Clare overlooking Liscannor Bay and the famed razor-sheer Cliffs of Moher. The club was founded in 1892 by a group of well-to-do merchants from Limerick, and in its early years the members came from the Protestant upper class. Lahinch quickly became a leading Irish golf resort, with fashionable golfers arriving from London by ferry and then railway from Dublin. The original course was designed by Old Tom Morris for a fee of £1 plus travel expenses, even less than he charged for his design at County Down in Newcastle. The course was reshaped by Charles Gibson, the professional from Westward Ho! in 1907, and then redesigned by Alister MacKenzie in 1927, just before his work on Cypress Point and Augusta National. While MacKenzie modernized the course, he did not tamper with two of Lahinch's most famous holes, the Klondyke and the Dell, described by Herbert Warren Wind as "two living museum pieces." The Dell is the par three sixth, an original from Old Tom's design that requires a blind shot over a dune to a featherbed of green. Lahinch is also famous for its weather-forecasting goats, which huddle near the clubhouse when rain is on the way.

BELOW: The Strand at Lahinch

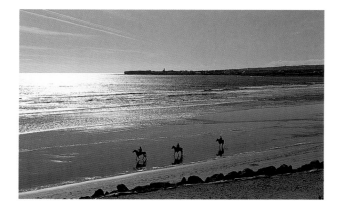

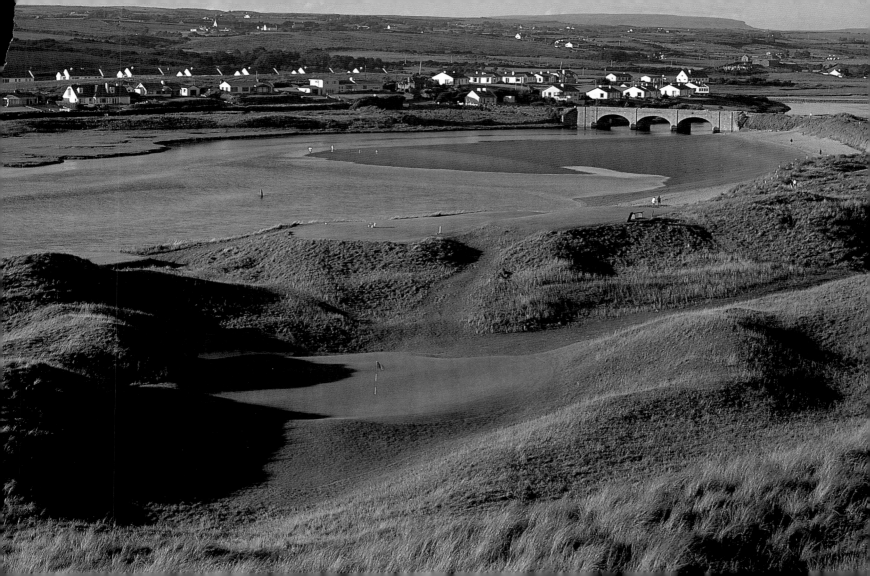

Carne is one of the wonderful, storm-tossed, remote, and not particularly well-known links of northwest Ireland, lying at the tip of the Belmullet Peninsula past the small village of Belmullet and overlooking Blacksod Bay. Opened in 1995, Carne owes its formation to Michael Mangan, who upon returning to County Mayo from London in the early 1980s, purchased a small farm, including a one-seventeenth share of a commonage—that is, shared grazing rights on agriculturally poor land. A couple of years later, when Mangan actually saw the grazing land, he recognized that the magnificent dunescape would make the ideal site for a golf course. Then came the difficult job of persuading each of the farmers who had a stake in the commonage to sell their share and raising the necessary funds to buy them out. Eddie Hackett, the foremost Irish course architect, was brought in when he was nearly 80 years old to design the course, walking the dunes and making drawings each night in his B & B. The result is a bodacious and boisterous links, laid out on a small budget through the cul de sacs and crannies of the massive dunes.

BELOW: View of Blacksod Bay

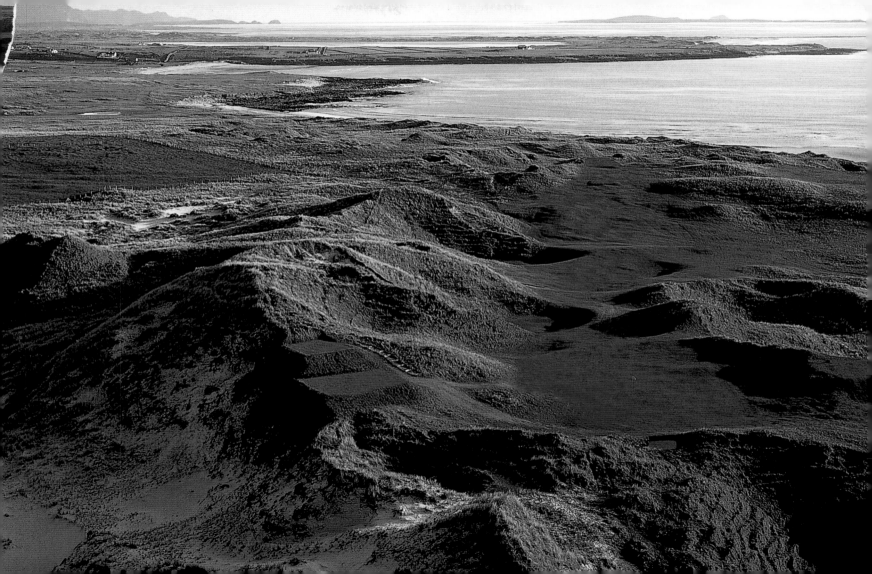

County Sligo Golf Club, or Rosses Point, is the unsurpassed links of northwest Ireland, running through the lyrical landscape made famous in the poetry of William Butler Yeats. The course lies at the tip of Rosses Point, the five-mile sliver of land that runs out to the sea and along the channel that leads to Sligo Town and its harbor. Across from the quaint, black and white Tudor clubhouse lies the original Coney Island. The club was founded in 1894 by British army officers, with the original nine holes laid out by George Combe, who played a leading role at Royal County Down. The present design owes much to a week-long visit by the great English architect, Harry Colt, in June 1927. Rosses Point has been described as golf's magic stepladder and from the high ground there are sweeping panoramas over Sligo Bay and to the interior mountains, with the green summit of Knocknarea where the mythic warrior Queen Maeve is reputed to be buried. Above the course as it loops inland looms "bare Ben Bulben's head," the flat-topped mountain for which the 10th hole is named, with Drumcliff Estuary running below. Yeats is buried in the Drumcliff churchyard, its steeple visible from the course, under the plain limestone tombstone that bears his epitaph:

Cast a cold Eye
On Life, on Death.
Horseman, pass by!

BELOW: The clubhouse

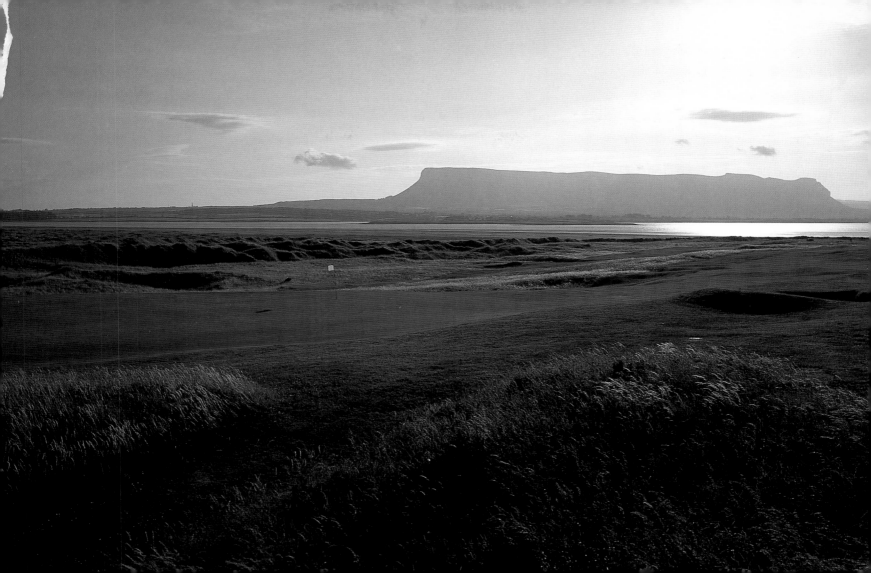

Donegal is the great northwest or so-called Alaska of Ireland, and each of its peninsulas, with awe-inspiring sea cliffs and wild moors, is home to an outstanding links course. The old Portsalon Golf Club, remodeled by Pat Ruddy, lies on the Fanad Peninsula overlooking Ballymastocker Bay and Lough Swilly. Sandy Hills, the new links at the Rosapenna Golf Resort created by Ruddy in 2003, is further west, on the Rosguill Peninsula overlooking Sheephaven Bay. Ballyliffin, the most northerly of them all, lies on the western edge of the Inishowen Peninsula overlooking the Atlantic. Ballyliffin has two buoyant links floating through the rows of rugged dunes and colored coastal sands.

Founded in 1947, the club's Old Course actually only dates from 1973, having been laid out by two of the members on a less than shoestring budget of £5,838, with advice from the late Eddie Hackett. Nick Faldo was smitten with Ballyliffin when he discovered it in the 1990s and sought, as it turned out unsuccessfully, to purchase the Old Course. Faldo oversaw some renovations to the course in 2006, prior to its hosting the 2008 Irish Seniors Open. Ballyliffin's new course, named the Glashedy Links after the massive rock dome that emerges out of the Atlantic, opened in 1995. Designed by Ruddy and his partner Tom Craddock, the course is a robust, unabating links with mighty par-fours, large greens, and deep pot bunkers set in the high dunes.

RIGHT: Glashedy Links

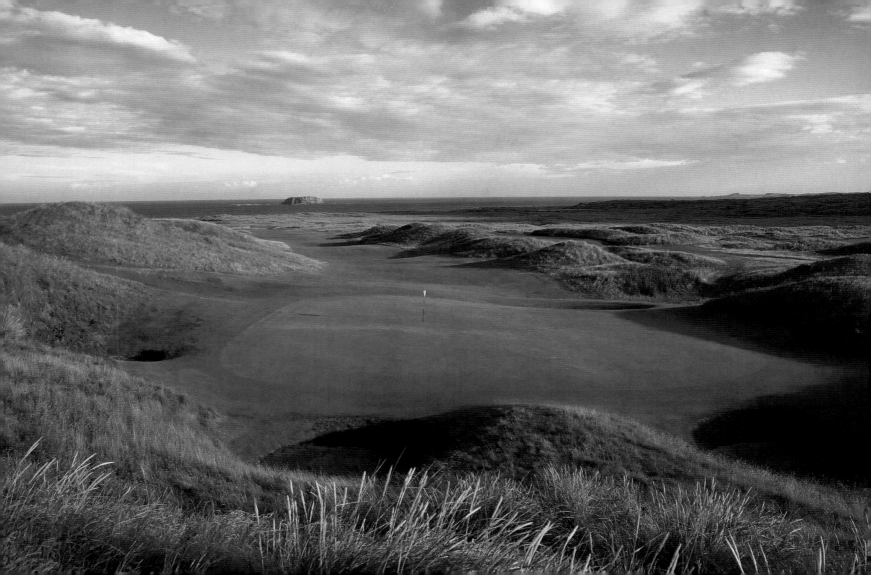

Castlerock Golf Club is less well known than its neighboring links of Portrush and Portstewart on Northern Ireland's Causeway Coast, but it is a course of considerable charm. Located just a short stroll from the center of the seaside holiday town of Castlerock in County Londonderry, the course overlooks the mouth of the River Bann, with its sandbars and sea birds. The club's 18-hole Mussenden Course stretches out beneath the ruins of Downhill Castle on the hilltop above, the classical 18th-century estate of the Earl of Bristol (later the Anglican Bishop of Derry) that once housed the finest art collection in Ireland. The club was founded in 1901, with the original course laid out in 1908 by Ben Sayers, the spry golfing wizard of North Berwick, and has been revised over the years. The most famous hole is the 200-yard, par-three fourth, named Leg O'Mutton, with the green squeezed by the burn on the left and railway tracks on the right. The real character of the course comes from the middle holes, with the tees and green cosseted in the high, rumpled dunes. The green of the par-three 16th is the high point of the course, overlooking the Bann and across the sea to the green hills and smoky blue mountains of Donegal's Inishowen Peninsula. The short par-four 18th faces Mussenden Temple, once the library of the Bishop of Derry, which was designed after the Roman temple of Vesta at Tivoli and stands at the edge of a cliff above the sea.

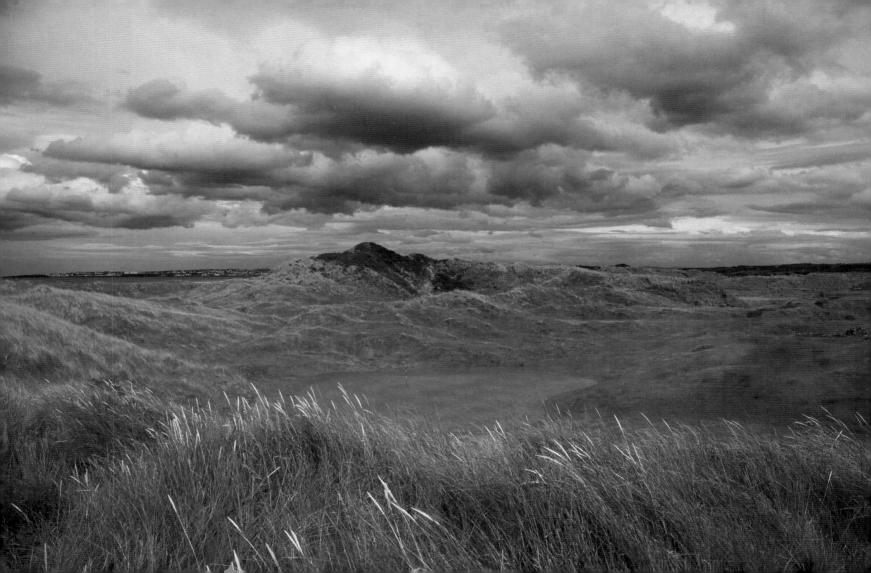

Royal Portrush is one of the most historic links in Ireland, unraveling through the shaggy dunes of Northern Ireland's Antrim Coast, not far from the Giant's Causeway, the thousands of stone pillars that form a natural esplanade to the sea. Founded in 1888, Portrush was a fashionable seaside resort drawing droves of golfers by the turn of the century. The present course is the inspired work of the English master Harry Colt in the early 1930s. Portrush is inevitably compared to Royal County Down, the other great links of Northern Ireland, but the temperaments of the courses are quite different. Portrush's narrow, angled fairways ripple through the dunes on the white chalky cliffs high above the Atlantic, while County Down lies at sea level beneath the Mourne Mountains. Instead of the yellow gorse that blankets County Down, Portrush is famous for its thick rough of sea grasses adorned with wildflowers and thickets of sea roses. The championship course at Portrush is named Dunluce after Dunluce Castle, the 16th-century fortress of the warrior chieftain Sorley Boy MacDonnell, its ruined shell tottering on the seaside cliff in view from the course. The Dunluce Course has the distinction of being the only course outside of Scotland and England to have ever hosted the British Open, with Max Faulkner winning the championship there in 1951.

BELOW: Ruins of Dunluce Castle

Many knowledgeable golfers consider Royal County Down in Newcastle, Northern Ireland, to be the greatest golf course in the world. It is certainly one of the most surpassingly beautiful, with the course following the crescent of Dundrum Bay and looking across the spire of the Slieve Donard Hotel and the town to the Mountains of Mourne, with their chameleon's coloring of smoky purples, blues, and greens. The fairways glide along galleons of yellow-flowering gorse and clusters of eyebrow or bushy-topped bunkers. County Down was founded in a meeting at Mr. Lawrence's Dining Rooms, Newcastle, in 1889, and Old Tom Morris was brought over from St. Andrews, Scotland, to design the course for a fee of £4. By 1902, only six of the original holes remained, with George Combe, an early captain, carrying out the alterations, and further refinements were overseen by Harry Colt in the 1920s. The splendor of Royal County Down was best summed up by Bernard Darwin: "It is perhaps superfluous to say that it is a course of big and glorious carries, nestling greens, entertainingly blind shots, local knowledge, and beautiful turf . . . the kind of golf that people play in their most ecstatic dreams."

BELOW: Slieve Donard Hotel

Turnberry's Ailsa Course is one of extravagant and unforget-table beauty, with a sweeping view across the links from the terraced lawns of the grandiose, red-roofed hotel. The hotel and the two original courses were developed by the Glasgow & South Western Railway, which took over the private 13-hole course of the third Marquis of Ailsa in 1907. During World War II, the Ailsa Course and its sister course, the Arran, were turned into concrete runways used by the RAF. It seemed like golf might be finished at Turnberrry, but eventually, through the perseverance of Frank Hole, the managing director of the hotel, the Scottish course architect Philip Mackenzie Ross was commissioned to resurrect and redesign a new Ailsa Course, completed in 1951. In 1977, Turnberry hosted its first British Open, won by Tom Watson by one stroke over Jack Nicklaus in their famous duel in the sun, and the glory of Ross's design was revealed to the golf world. The ninth hole, with the tee perched precariously on a promontory and with the emblematic whitewashed lighthouse to the left, vaunts over and along the cliffs, with views across the Firth of Clyde to the Isle of Arran with its steep, slumbering mountains, the Ailsa Craig bubbling out of the sea, and all the way west to the Mull of Kintyre in the distance. In 2009, Watson was on the verge of a miraculous victory at the Open on Turnberry, but a cruel bogey on the 72nd hole cost him the victory, and he lost in the ensuing playoff to Stuart Cink.

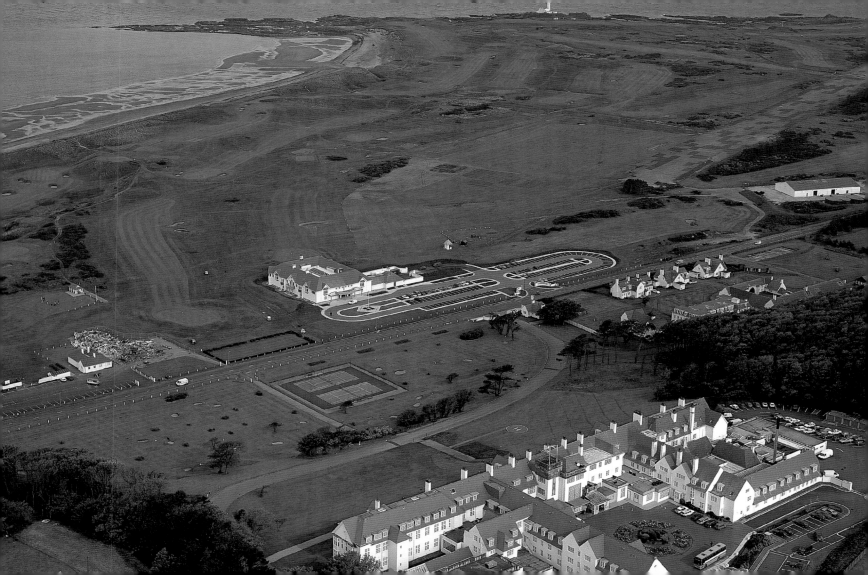

Prestwick by contemporary standards is a particularly unusual links, but one that exults in its eccentricity. The course is located on the Ayrshire coast of western Scotland, separated from Troon by the Pow Burn that dominates the fourth hole. Prestwick is inextricably tied to the history of British golf, for the first 12 Open championships were held there beginning in 1860, when the course consisted of only 12 holes. The last Open to be held at Prestwick was in 1925, but the famous old links remains full of vitality. The third hole features the vast Cardinal bunker, fortified by an irregular ridge of wooden sleepers or railroad ties. The blind, par-three fifth is played over the sandhills known as the Himalayas. The drive at the 16th must avoid the bunker named Willie Campbell's Grave, with the second shot over the Alps to the green guarded by the Sahara bunker. The railway line runs hard along the right side of the first hole, another distinctive feature of many of the old Scottish courses that is present at Prestwick.

BELOW: Clubhouse interior

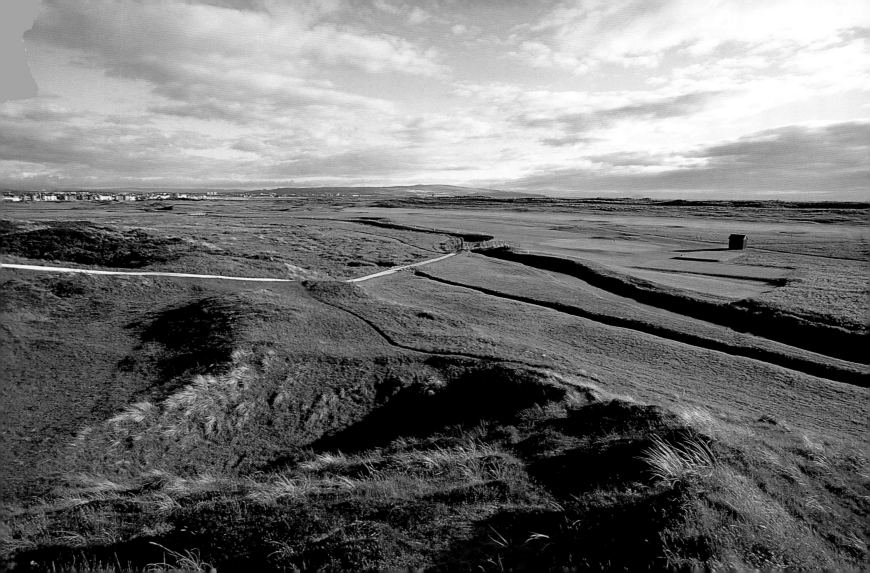

Royal Troon is one of the most highly acclaimed of the daisy-chain of fine links courses that stretch along the Ayrshire coast south of Glasgow. The first six holes straddle the shoreline before the course climbs into the sandhills at the seventh, with the next six holes running through the higher ground. The sixth is the longest hole in British championship golf at 601 yards while the eighth, the famous and fiendish "Postage Stamp Hole," with its tiny green, is the shortest at 123 yards. In the 1973 British Open, Gene Sarazen hit a punched five-iron into the cup for a hole-in-one on the Postage Stamp, 50 years after he missed the cut at the Open at Troon. Founded in 1878, the course was added to the Open rota in 1923, when Sarazen made his maiden voyage and Arthur Havers won the championship. The course is known for its unrelenting back nine, which can become a torture track when it plays into the wind. Arnold Palmer won the Open at Troon in 1962, while underdog Todd Hamilton took home the claret jug in 2004 in a playoff with Ernie Els.

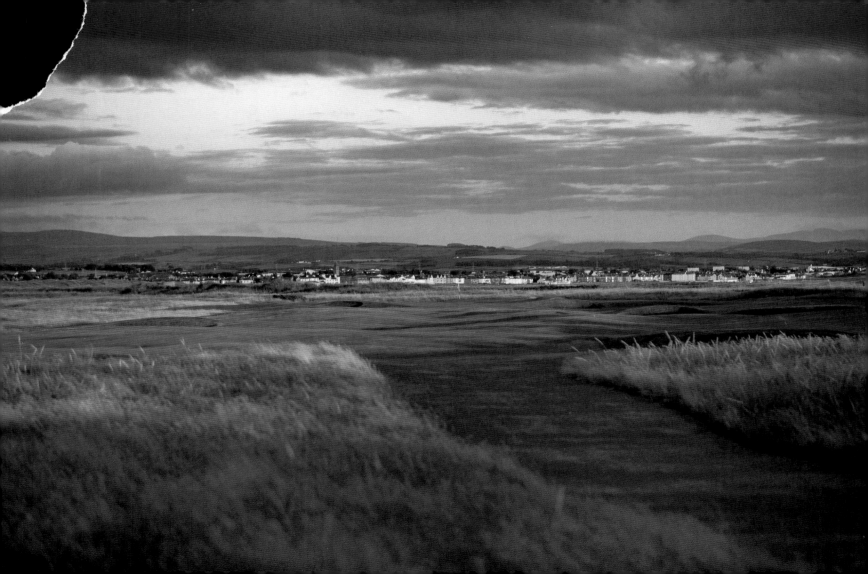

Western Gailes is one of the great links courses of Scotland, but it is somewhat under the radar compared to its neighbors on the golfing Riviera of the Ayrshire coast—Royal Troon, Turnberry, and Prestwick. The farthest north of the four, the course is threaded, two-fairways wide, between the sea and the railway, with Barrassie, Glasgow Gailes, and Dundonald on the other side of the tracks. The first four holes run north along the railway tracks and then the course turns south, with holes five through 13 all channeling through the coastal dunes that run down the right side along Irvine Bay. The greens are folded in dells and bowls in the broken sandhills, with three burns curlicuing across the fairways. The closing five holes turn back to the north and along the railway line, which is very much in play. Founded in 1897, the course changed little over the years until Fred Hawtree revised several holes in the 1970s. As Donald Steel wrote of Western Gailes: "In the great galaxy of the Ayrshire courses, it shines as brightly as its more famed neighbours. None can match the historical connections of Prestwick, the scenic splendour of Turnberry or the royal patronage of Troon. All have their advocates, but there are those that like Western Gailes best of the four and their allegiance is perfectly understandable."

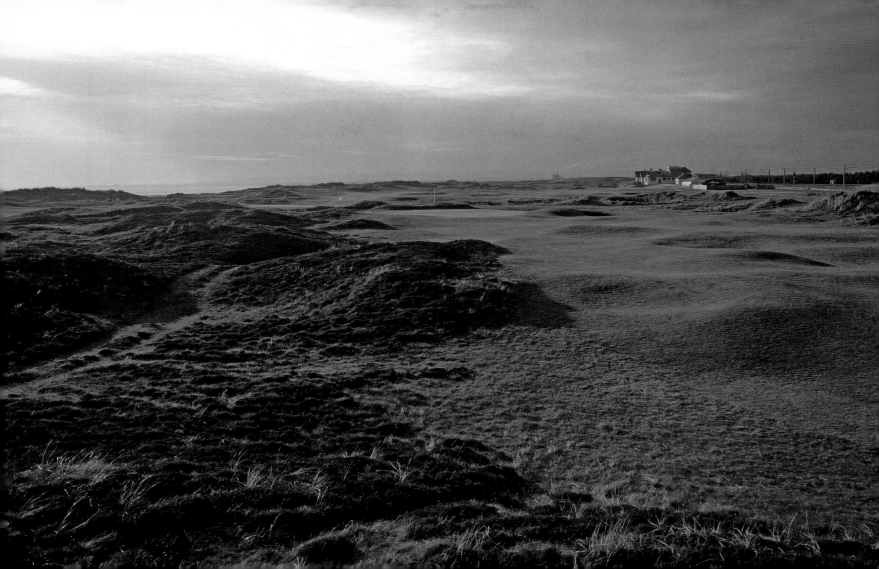

AUGUST 7 | MACHRIHANISH DUNES GOLF CLUB—SCOTLAND

Machrihanish Dunes officially opened on July 21, 2009, the first 18-hole links course created on the west coast of Scotland in 100 years. The course rattles through the sandhills at the southern tip of the Kintyre Peninsula near Campbeltown, next to the old Machrihanish Golf Club, one of Scotland's most remote championship links, laid out by Old Tom Morris in 1876 overlooking the sea out to Gigha Island and the Hebrides. Machrihanish Dunes is also the first course ever to be built on a Site of Special Scientific Interest, which entailed some very restrictive limitations. The course's developer, Brian Keating, is an Irish-born Australian entrepreneur living in England, who had fallen in love with the Mull of Kintyre while playing golf on the old course. Keating was willing to let environmental considerations take precedence and hired Scottish architect David McLay Kidd to design the course. Kidd laid out the holes as he uncovered them in the pyramidal dunes, moving earth on only seven acres of the 276-acre site. No heavy machinery was permitted during construction, no pesticides or chemicals could be used, and there was no irrigation, except for the tees and greens, while all of the grass seed was produced from local varieties to match the existing turf. The course was routed to avoid disturbing the rare species of orchids and gentians that grow in the dunes, and a flock of Hebridean Black sheep was introduced to maintain the rough.

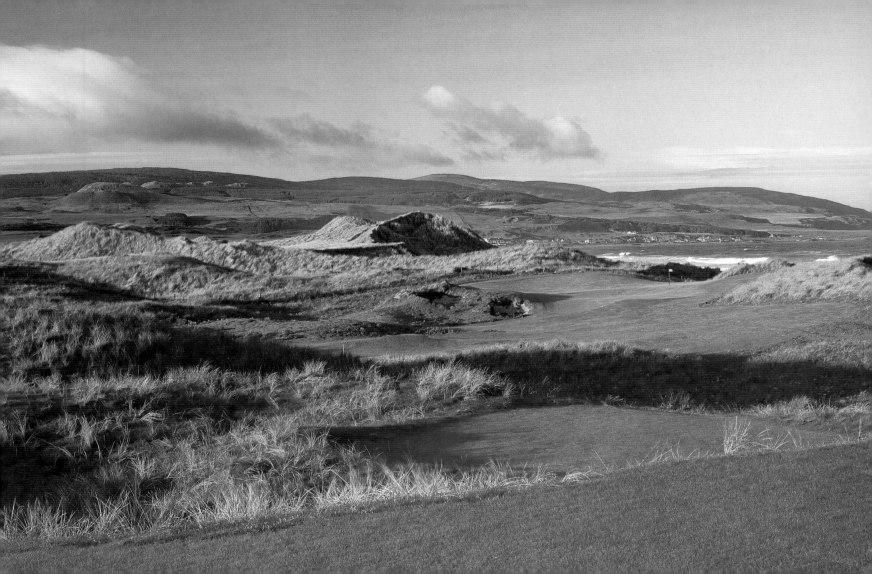

Scotland is famed for its seaside links courses, but Loch Lomond is the paradigm of the parkland course, and there could be no lovelier rendition than this course that does indeed run along the banks of the bonniest loch of them all. The course is laid out on land that was once held by Clan Colquhoun, and the palatial Georgian mansion built by Sir James Colquhoun in 1773 and known as Rossdhu House serves as the clubhouse. Loch Lomond was designed in 1993 by the American duo of Tom Weiskopf and Jay Morrish. Weiskopf, recognizing that this course would be his lasting testament, labored long and hard on every detail, spending two summers at the site while living in the garden cottage by the third tee. The gentler front nine clings more closely to the loch, which first comes into view on the third green, and runs down the entire right side of the 625-yard, par-five sixth, named Long Loch Lomond. The back nine plays inland, closer to Ben Lomond and the distant mountains at the gateway to the Highlands, and through a marshy bog. Behind the three-tiered 18th green lie the remnants of the 15th-century Rossdhu Castle, where Mary Queen of Scots supposedly wrote her love letters. Loch Lomond is a private club with an international membership. The course is the annual site of the Barclays Scottish Open and hosted the Solheim Cup match in 2000.

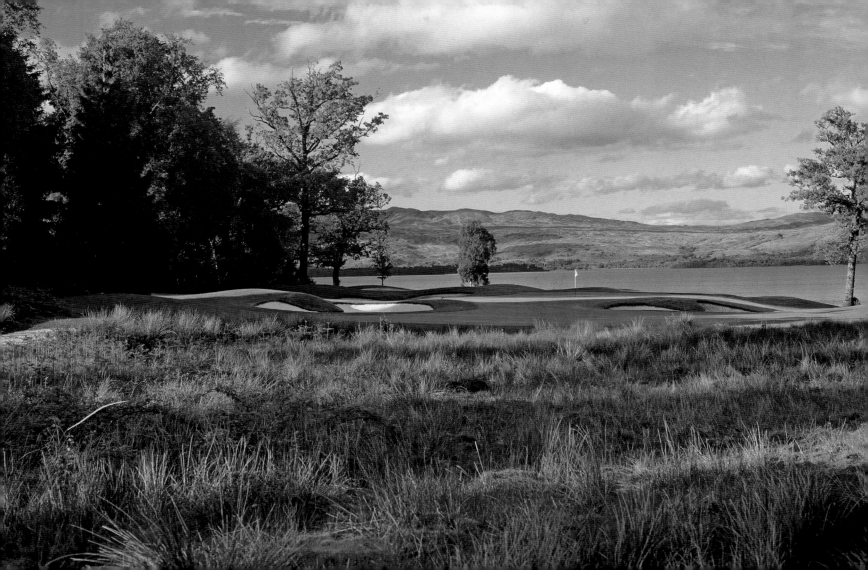

The Lübker Golf Resort, which was selected Best International Golf Course in 2008 by *GOLF Magazine,* is located in the small farming village of Nimtofte in the heart of Jutland or Djursland, midway up Denmark's east coast and close to Denmark's second city of Aarhus. Designed by Robert Trent Jones, Jr., and Bruce Charlton, the course comprises three nines—Sand, Sky, and Forest—laid out near a Viking grave-yard. Lübker is a paean to the Danish countryside, routed through gently rolling terrain around existing ponds and expanded wetland areas. The sandy subsoil allowed the designers to carve out large, grassy-fingered waste areas framed by stands of lofty birch, maple, and pine. The resort was developed by former UBS executive Poul Anker Lübker, who raised funding for the project through a share offering on the Copenhagen Stock Exchange and the sale of home sites on the property. A five-star lodge is planned.

BELOW: The clubhouse

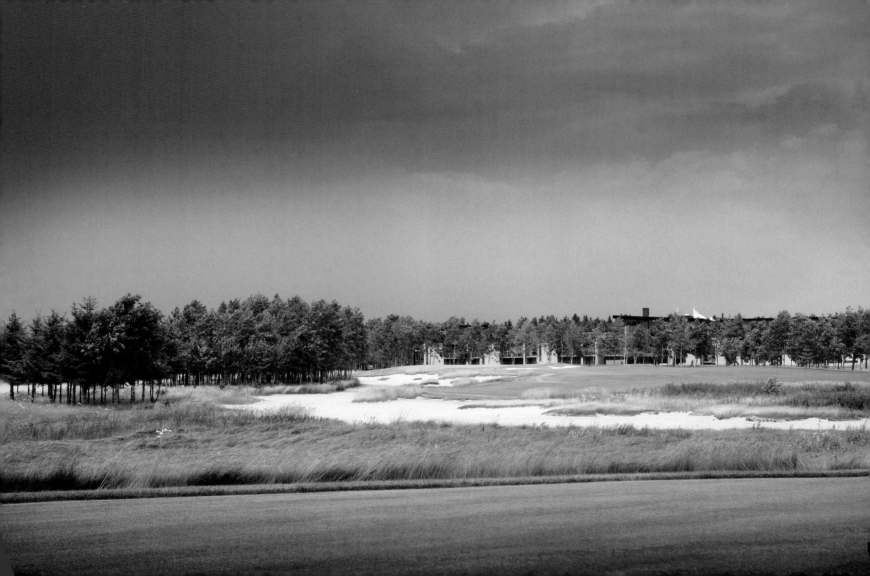

In 2007, the Trent Jones Course opened at Skjoldenæsholm Golf Center in Jystrup, thirty miles from Copenhagen. The Jones Course, like the Old Course that opened in 1992, is laid out over open countryside that was once part of the Skjoldenæsholm Estate, which dates back to the 14th century. Its Neoclassical manor house, built in 1766, now serves as a hotel. The design incorporates a centuries-old stone wall that crisscrosses several holes. The 13th through 15th holes run along a national scenic highway, which prevented the landscape from being altered through the introduction of sand bunkers and led to the creation of grass defenses in the form of hollows and knobs. The course is also the site of the Skjoldenæsholm Tramway Museum, which houses a collection of vintage Danish trams from Copenhagen, Aarhus, and Odense that operate on two tracks running alongside the third, fourth, and fifth holes. Skjoldenæsholm is south of Ledreborg, the site of the Nick Faldo–designed Ledreborg Palace Course, a links-style layout that also opened in 2007 and borders the 18th-century rococo Ledreborg Palace.

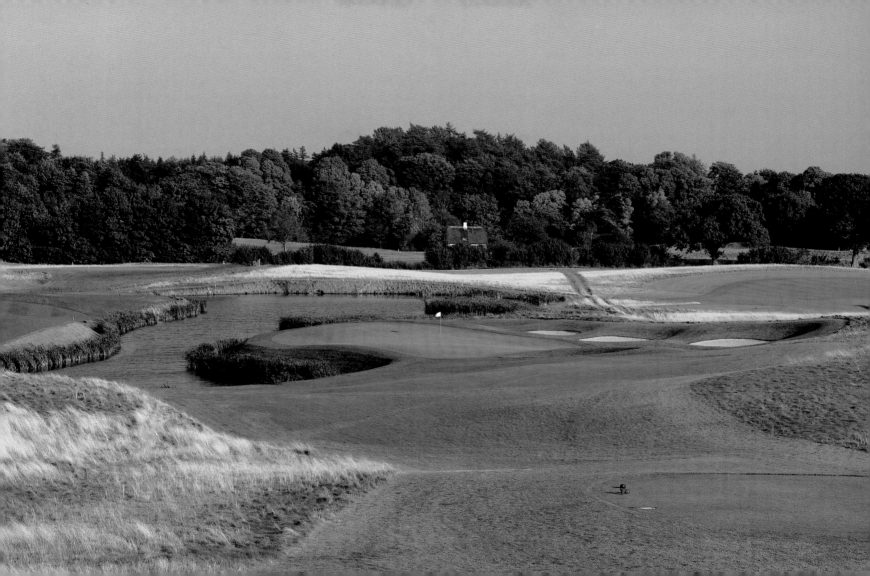

Falsterbo Golf Club is one of the great links of Europe, located by the little seaside resort of Falsterbo, 21 miles south of Malmö, Sweden's third city. The course, which dates from 1909, is spread over a small spear of ground that forms Land's End—the southernmost point of Sweden—with the Baltic on one side and the North Sea on the other. While a true links, with the fairways angled at different directions against the wind, several of the holes play over ponds and wetlands. The green of the demanding 427-yard fourth is tucked behind the marsh and the par-three 11th plays across a pond to an island green. The back nine sweeps around the somber, old domed lighthouse. The green of the 16th hole marks the tip of Sweden, with the view over the Oresund to Denmark and of the second-longest suspension bridge in the world that links Malmö to Copenhagen. The 17th and 18th run along the narrow ridge of dune separating the course from the Baltic and back to the clubhouse.

BELOW: Falsterbo lighthouse

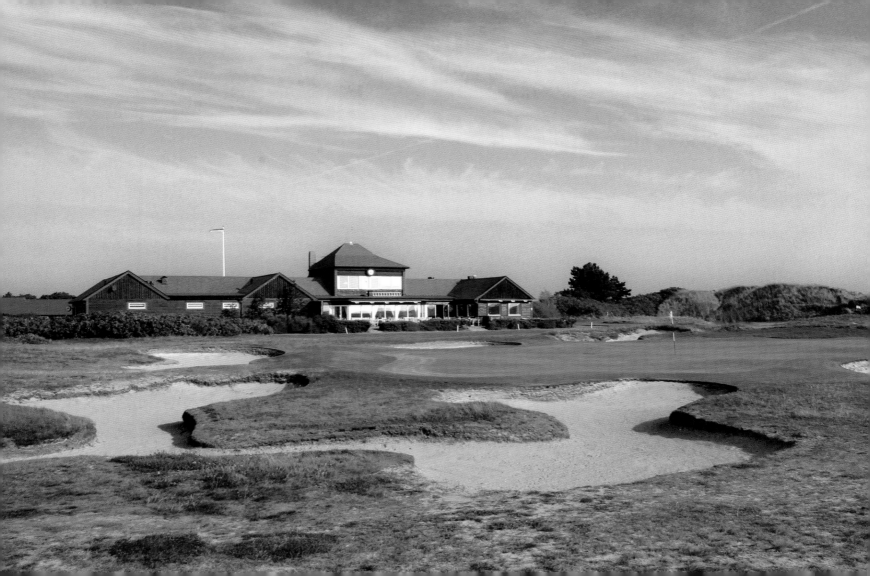

AUGUST 12 | BARSEBÄCK GOLF AND COUNTRY CLUB (OLD COURSE)—SWEDEN

Barsebäck Golf and Country Club, located about 30 miles up the western coast of Sweden from Malmö, has two superb 18-hole courses. The Old Course, designed by the late Ture Bruce, opened in 1969, while the New Course designed by the English architect Donald Steel opened in 1989. The heart and soul of Barsebäck is the stretch of holes on the Old Course that play along the leaden sea through the rushy grasses and offer links golf at its finest. The New Course is sculpted through an imposing forest of pines. Barsebäck hosted the 2003 Solheim Cup, in which the European team led by Annika Sorenstam soundly defeated the U.S. The U.S. team gained its revenge when the competition returned to Barsebäck in 2007.

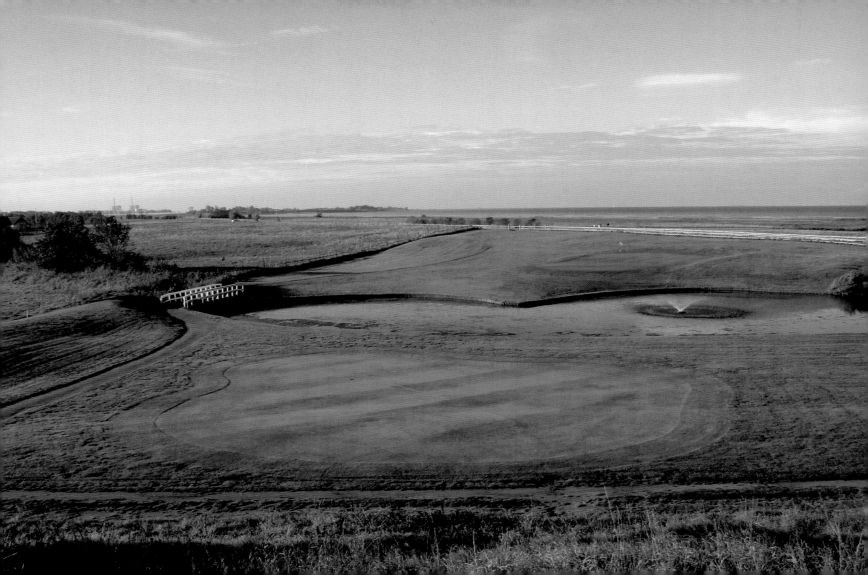

Robert Trent Jones has played a prominent role in course design in Scandinavia, particularly in Norway. Miklagard Golf Club in Oslo, which opened in 2002, was the country's first international tournament-caliber course. Most recently, in 2006, he completed Holtsmark Golf, which is a public course in Sylling, just south of Oslo, with wooded fairways routed along the top of ridges that fall off into a series of ravines. In 2005, Jones created Bjaavann Golfklubb in Kristiansand, located at the southern tip of Norway. The course is routed around Lake Bjaavann, a fjord that extends inland from the North Sea, and on its journey the layout negotiates rock outcroppings, a rock island, natural springs, and an alpine stream. The fairways overlooking the lake are outlined with stands of birch and pine. Several holes on the back nine play through a peaty bog, requiring Jones to install a lining of geotech fabric beneath the layers of light fill and rich soil in order to stabilize the land. The finished product is a serene course that wheels around the lake and wetlands.

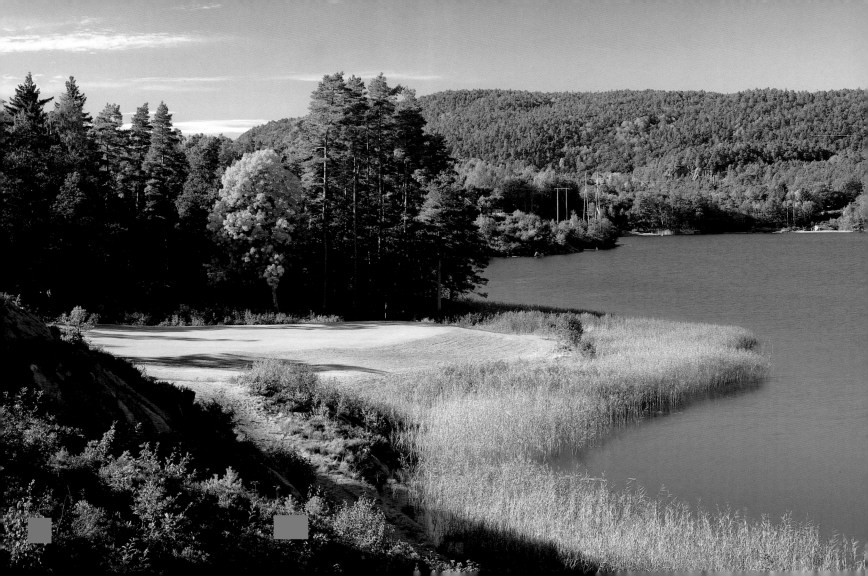

Bro Hof Slott, the Swedish Stadium Course 20 miles north of Stockholm, has skyrocketed to the top of the European golf world since it opened in 2007. The owner, Björn Örås, spared no expense in developing the property, and the course designed by Robert Trent Jones, Jr., and Bruce Charlton, with its fairways pirouetting around the pristine waters of Lake Mälaren, is a technical as well as aesthetic tour de force. During construction, the site was capped with a layer of sand beneath the creeping bentgrass fairways to provide for optimal drainage, and the greens were built with underground ventilation systems to allow for a longer playing season. In 1888, Count Johan Sparre built the domed castle that was acquired and impeccably restored by Örås to serve as the clubhouse. Stretching to almost 8,000 yards and designed as a stadium course that can hold up to 300,000 spectators, Bro Hof Slott has been selected as the site of the Scandinavian Masters from 2010–17 and is a leading candidate to host the 2018 Ryder Cup. A second course, known as the Castle Course, opened in the summer of 2009.

BELOW: The castle that is now the clubhouse

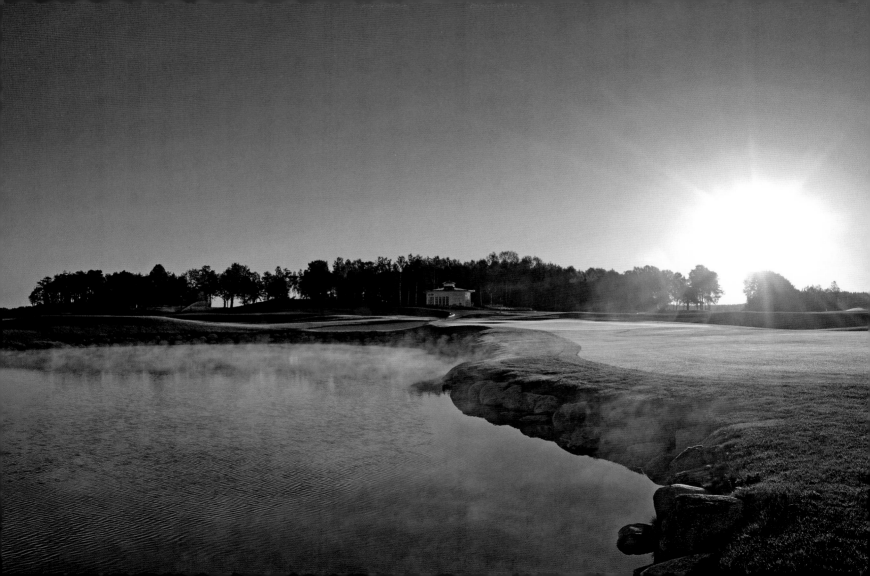

Paltamo Golf Club, also known as Midnight Sun, is located in the small village of Paltamo, overlooking Oulu Lake in northern Finland. Designed by Americans Ronald Fream and David Dale of Golfplan, the course opened in 1991, with the final five holes completed in 2000. The course is girded by the lake, one of the largest in Finland, and ringed with Arctic birch. The town of Oulu, 100 miles to the west, is the capital of northern Finland, and is the home of the Oulu Golf Club founded in 1962. The current 27-hole Oulu Course, also designed by Golfplan, opened in 1992, with the third nine completed in 2004. From the beginning of June to the middle of July, the midnight sun allows golfers to play all night long.

Ozo Golf Club, the only golf course in the Baltic republic of Latvia, was founded by its namesake, National Hockey League star Sandis Ozolinsh, the greatest player to come out of Latvia. Ozolinsh took up golf shortly after he was traded from the San Jose Sharks to the Colorado Avalanche during the 1995-96 season, when the Avalanche won the Stanley Cup. After the Avalanche were eliminated from the playoffs in 1999, Ozolinsh took Latvia's leading sports journalist Armands Puce to play a round at Castle Pines in Denver. Afterwards, a casual conversation in the backyard of Ozolinsh's home about how nice it would be to have something similar back in Latvia hatched the idea for what was to become Ozo. When Puce returned to Latvia, he began looking for land for the course and found a site that had been used as a dumping ground just 10 minutes from the center of Riga. Ozolinsh hired Denver-based architect Rob Swedberg to design the course and Puce became the club's general manager. Ozo Golf Club opened on May 29, 2002, two years after construction began, and hosted its first professional tournament in the summer of 2003, the Hansabank Baltic Open.

Pestovo Golf & Yacht Club opened 20 miles north of Moscow in the summer of 2006. The course is laid out in the shape of a figure eight on land that was the estate of Prince Serebryany, an opponent of Ivan the Terrible and the hero of Alexey Tolstoy's 19th-century romantic novel. The opening holes are carved from birch forest before emerging onto open ground that sweeps around a series of lakes. Designed by British Ryder Cup player Dave Thomas and his son Paul, Pestovo hosted the 2008 Russian Senior Open, an event on the European Senior Tour. The 70-slip marina and yacht club are located on nearby Pestovskoye Reservoir, one of the largest man-made lakes along the Moscow canal system. Pestovo gives Moscow a second championship caliber course, joining the Moscow Country Club designed by Robert Trent Jones, Jr., which opened in 1994.

BELOW: The Russian Open Matrioshka Doll trophy on display at Moscow Country Club

RIGHT: Jeff Hall in action during the 2008 Russian Senior Open at Pestovo Golf & Yacht Club

AUGUST 18 | KRAKOW VALLEY GOLF CLUB—POLAND

Krakow Valley is located at the village of Paczoltowice, 45 minutes west of Krakow in the direction of Katowice, in a rural area where farmers with horsedrawn wagons are still the order of the day. Opened in 2004 and developed and owned by Zbigniew Lis, the site was previously a Communist collective farm growing wheat and barley. American golf architect Ron Fream created an open, prairie links-style look, taking advantage of the native grasses and wildflowers. The groves of trees around the perimeter of the course have been protected, with tall beech bordering some holes. Krakow itself offers the contrast of the 500-year-old town center with the Soviet-style architecture of the outer ring. The old barn adjoining the course has been refurbished into the 16-room Hotel Villa Pacoldi with a restaurant and bar.

Karlštejn Golf Resort is located 18 miles southwest of Prague on the grounds of Karlštejn Castle in the protected area of Čský-kras. Opened in 1993, with an additional nine holes added in 2007, Karlštejn is one of several courses to open in the Czech Republic with the resurgence of interest in the game following the fall of the Iron Curtain. Designed by the Canadian duo of Les Furber and Jim Eremko, the course hosted the Czech Open in 1997, where Bernhard Langer was the victor. The layout slopes through the surrounding forest, with a pair of lakes, limestone outcroppings, natural ravines, and 86 bunkers coming into play. Looming above the fairways is the gothic fairy-tale castle with its Great Tower built between 1348 and 1368 by Charles IV, the King of Bohemia and Holy Roman Emperor. Within the Castle, the walls of the chapel of the Holy Cross are encrusted with semiprecious stones and paneled with paintings of 127 saints. The same King

Charles founded the famous Bohemian spa town of Karlovy Vary, or Carlsbad, also named for him, where the first course in then Czechoslovakia, Karlovy Vary Golf Club, was founded in 1904 and continues to thrive.

BELOW: View of Karlštejn Castle

Pannónia Golf Course is located in Mariavölgy, about 40 minutes from the center of Budapest, on land that was a weekend retreat of the Hapsburgs during the 19th century. The course, opened in June 1997, was designed by Austrian architect Hans-Georg Erhardt in collaboration with leading Canadian course designer Doug Carrick. There is an imperial-looking clubhouse, approached through a lane of old sycamores. Erhardt and Carrick also teamed up to design Fontana, outside Vienna, the home of the Austrian Open. Erhardt recently completed work on the Royal Balaton Golf & Yacht Club, in Tihany, overlooking the north shore of Hungary's Lake Balaton.

BELOW: The clubhouse

Fontana Golf Club is a low-lying, open layout located 18 miles south of Vienna in Baden bei Wien. The course is dominated by a 50-acre man-made lake, with water and rock formations constantly coming into play. Opened in 1996, Fontana became the host course for the Austrian Open in 2006, raising its profile as one of the top tracks in Europe. Built as the hub of a residential community and sports club, the course was designed in tandem by Austrian course architect Hans-Georg Erhardt and Canadian architect Doug Carrick. Fontana has a decidedly Floridian flavor—the designers used the fill excavated from the 30-foot-deep groundwater lake to create sinuously sculpted fairways, bunkers up to 15 feet deep, and the long, sandy beach running down the right side of the 18th fairway to the peninsula green that juts into the lake.

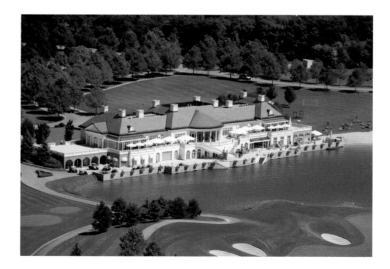

BELOW: The clubhouse

AUGUST 22 | EICHENHEIM GOLF COURSE—AUSTRIA

Eichenheim Golf Course is located near the ski village of Kitzbühel, surrounded by the Tyrolean cloud-topper peaks of the Wilder Kaiser, High Tauern, and Hahnenkamm, the latter the site of the famous annual World Cup alpine ski races. Designed by California-based Kyle Phillips, best known for his work at Kingsbarns in Scotland, the green torrents of fairway rush across the slopes. The elevated tees enhance the views of the *Sound of Music* scenery, while deciduous woodlands, natural streams, and gullies flank the fairways. The Grand Tirolia Golf & Ski Resort opened in July 2009, giving Eichenheim a trendy five-star hotel with a Green & Aveda Spa that offers après-golf Tyrolean herbal steam baths.

BELOW: The clubhouse

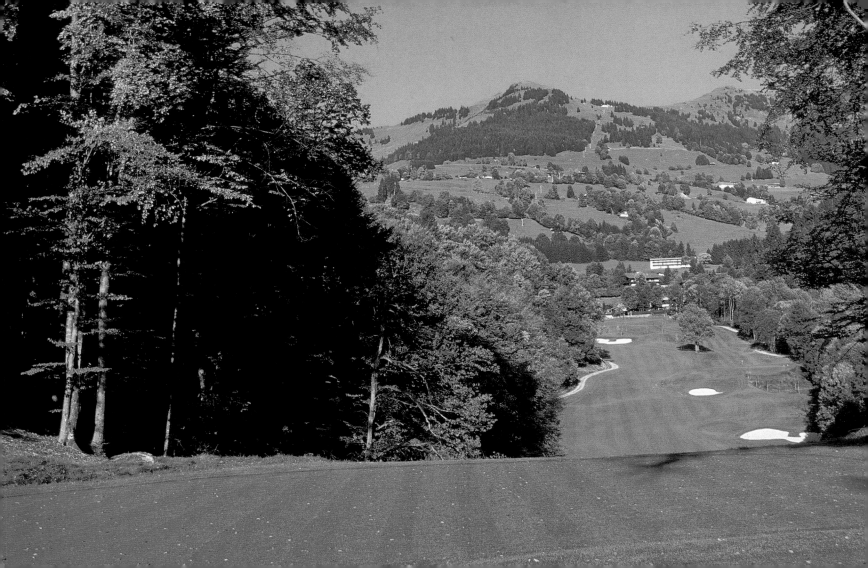

Crans-sur-Sierre is synonymous with golf in the Swiss Alps. The original course was laid out in 1905 by Sir Arnold Lunn, an early pioneer of downhill skiing and the proprietor of the famed Palace Hotel at nearby Montana. When the English golfers who formed the course's clientele disappeared during World War I, the course was abandoned. After the war, two local hoteliers, Elysée and Albert Bonvin, took the initiative in creating a new course, with the full 18 holes completed in 1929. The present course covers a gently contoured plateau 5,000 feet above the fir-clad Rhône Valley. There are breathtakingly sublime views across the valley to the snow-covered majesty of the Matterhorn and Monte Rosa. Crans-Sur-Sierre has hosted the Swiss Open, now known as the European Masters, since 1939 and it is a favorite stop for the players on the European Tour and their families.

BELOW: Jean-François Lucquin holds the winner's trophy after the 2008 Omega European Masters at Crans-sur-Sierre

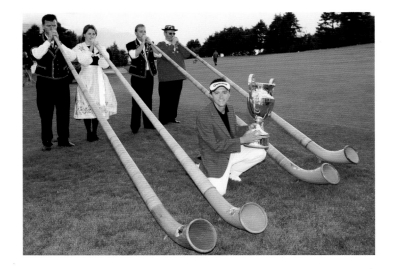

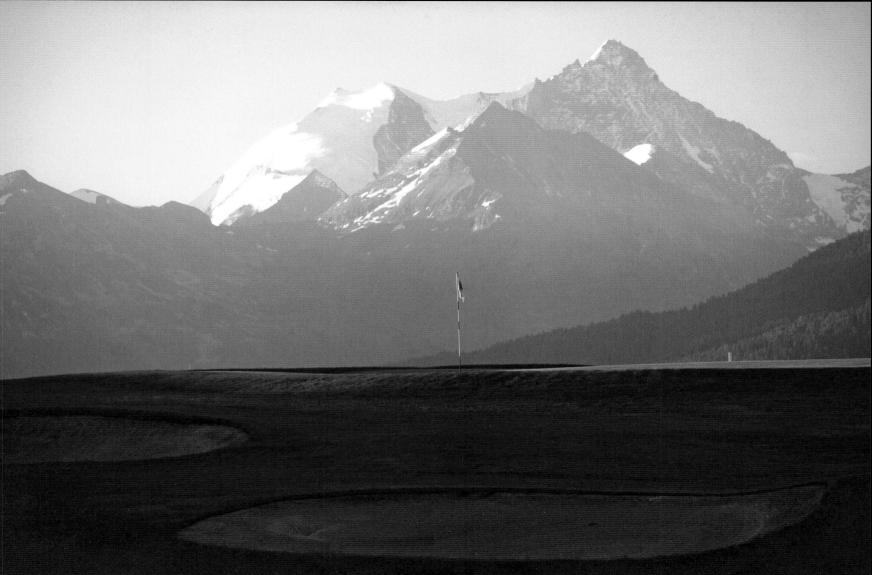

Berlin Sporting Club is 150 miles from the Baltic Sea, but the Nick Faldo Course has the features and feel of a seaside links. The club is located outside the town of Bad Saarow near the shore of the Scharmutzelsee lake. Working with Stan Eby, Faldo took great care in creating subtle drapes of fairway on a flat site. The strategic challenge comes from the sunken, grass-walled bunkers—130 in total—that are folded into the land. The course, which opened in 1997, hosted the 2000 World Amateur Team Championship to great acclaim and was the site of the 1999 and 2000 German Open. The Sporting Club Berlin also has a fine course designed by Arnold Palmer, opened in 1995, with the back nine playing through a forest, and a shorter course designed by Eby, opened in 2002.

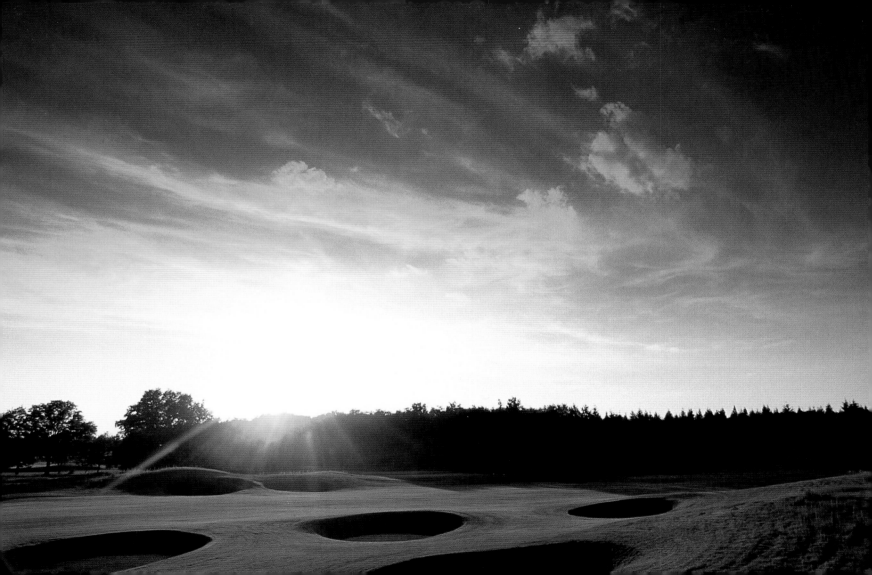

AUGUST 25 | GOLF & COUNTRY CLUB SEDDINER SEE (SOUTH COURSE)—GERMANY

Seddiner See's South Course is one of the premier new courses in Germany, located along the shores of Seddiner Lake some 25 minutes south of Berlin, near the towns of Neuseddin and Wildenbruch. The only course in Germany designed by Robert Trent Jones, Jr., the South Course opened in 1994, followed by the North Course in 1997. Built at a cost of over 20 million euros, no expense was spared, with a lavish clubhouse and impeccably conditioned fairways and greens. The course is relatively flat, but Jones defined the fairways with curved water hazards, hives of large swirling bunkers, and borders of birch and tall flaxen grasses.

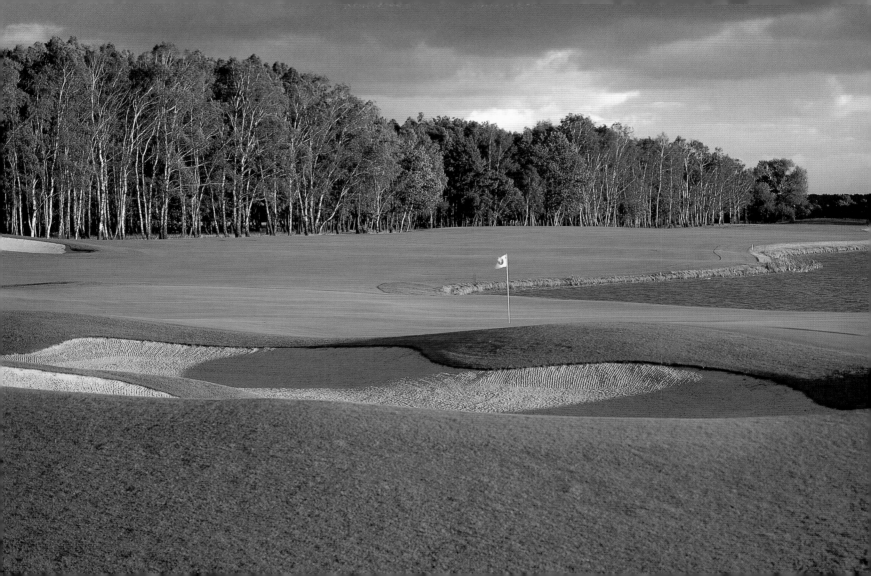

Hamburger Golf Club, generally known as Falkenstein, remains one of the very best German courses, even though in recent years the ranks have been considerably strengthened by such newcomers as Berlin Sporting Club and Seddiner See. While the club traces its history back to 1906, the present course was completed in 1930, and is located six miles from Hamburg near the Elbe River. Designed by the outstanding English team of Colt, Alison, and Morrison, the course would be right at home in the heathbelt of Surrey outside London. The fairways are carved from stands of pine and silver birch over moderately rolling terrain banded with heather. When the German Open was held at Hamburger in 1981, Bernhard Langer thrilled the crowd by becoming the first native German to win the event since its inception in 1912.

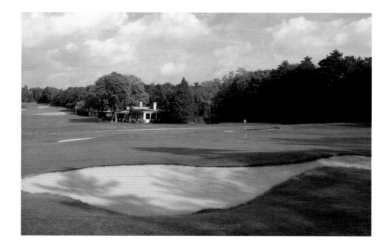

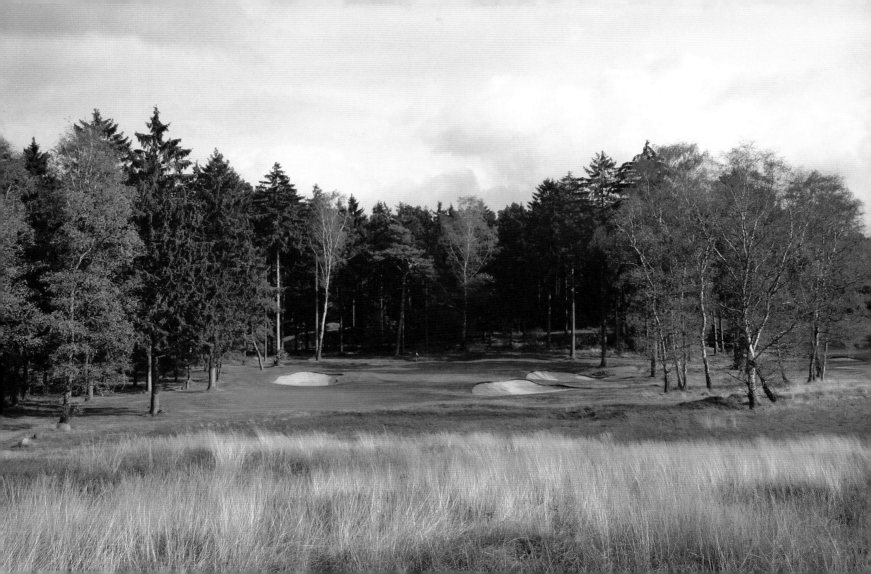

Club zur Vahr's championship course is situated 12 miles north of the Hanseatic city of Bremen in Garlstedt, on the road to Bremerhaven. Golf has been played in Bremen since 1895, when the Freudenberg family brought the game back with them from Ceylon to start a course on the city's race course in the suburb of Vahr. The Garlstedter Heide Course, part of Club zur Vahr's extensive sports complex, opened in 1970. August Weyhausen, the driving force behind the course, brought in Germany's foremost course architect, Bernhard von Limberger, who had won the German Amateur Championship at the nine-hole Vahr course in 1921, to design the new layout. A notably tough test, the numerous doglegs running through large pines and thick rough, with fairways punctuated by patches of heather, left little need for bunkers. The course is renowned for its six par fives, particularly the second and sixth, both of which offer alternative routes around the trees and over a stream to the green.

BELOW: Rain shelter

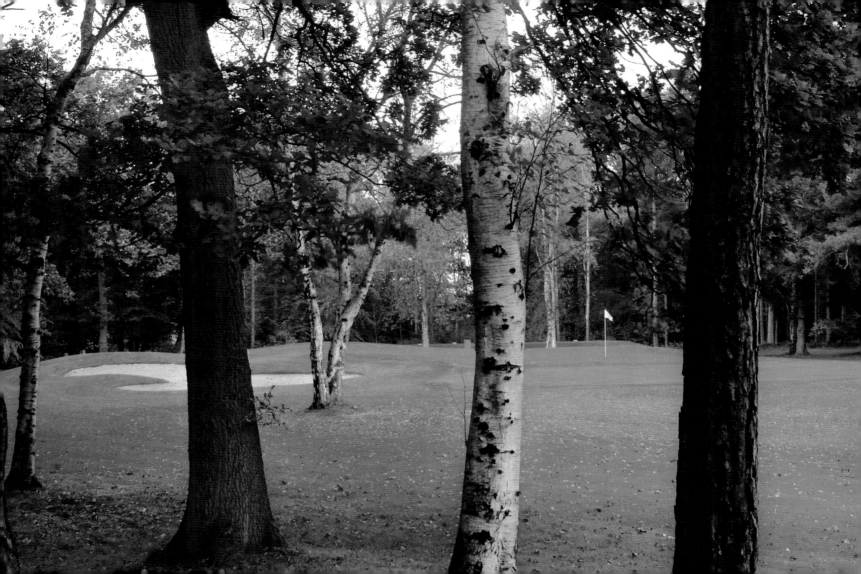

The Royal Hague Golf Club, or Haagsche, located in the beautiful old wooded suburb of Wassenaar, is the oldest golf club in the Netherlands, having been founded in 1893. Like several other Dutch courses, the original course was badly damaged by the German army during World War II and had to be rebuilt. Haagsche has an aristocratic air about it, and it shares the pedigree with several of the fine heathland courses outside London of having been designed by Harry Colt. The course is an entrancing hybrid, for it is not literally a seaside course and yet it is hard to imagine more billowing fairways, with rolling green waves of turf that crest so high it is impossible to see over them from the troughs. The holes are artfully arranged and framed by a palette of greens that range from the yellowy-green river birch to the bottle-green firs. The clubhouse has a traditional thatched roof and red-and-white shutters with a grass patio that runs out to the 18th green.

AUGUST 29 | ROYAL GOLF CLUB DE BELGIQUE—BELGIUM

Golf in Belgium has long enjoyed royal patronage, with royal status conferred on each of Belgium's leading courses, including Royal Antwerp, Royal Zoute, Royal Waterloo, and Royal Golf des Fagnes. Royal Golf de Belgique, known as Ravenstein, is located at Tervuren, six miles from Brussels. Ravenstein was built in 1905 by order of King Leopold II to enable visiting British businessmen to play golf in Belgium. The course was designed by the English architect Tom Simpson, who was also responsible for the revision of Royal Antwerp. Château de Ravenstein, which serves as the clubhouse, is a national monument, and was built by the Infanta Isabella of Spain in the 17th century after the 15th-century hunting lodge of Philip of Cleves that originally occupied the site burned down. The château is also the headquarters of the Fédération Royale Belge de Golf.

Sunningdale's Old Course is the grande dame of the great heathland courses built in the sand belt southwest of London at the turn of the last century. Twenty-five miles from London, the course occupies land that had once been part of the Benedictine nunnery of Broomhall, abolished by Henry VIII, and since 1524 the site has been owned by St. John's College, Cambridge. The course, designed in 1901 by Willie Park, Jr., and revised by Harry Colt, two of the greatest luminaries of British golf course architecture, is enchantingly beautiful. The fairways are lapped and crossed by pools of heather and each hole is encased by burly conifers. The Old Course has hosted the 1987 Walker Cup, the 1992 European Open (won by Nick Faldo), and three Women's British Opens in the past decade. The New Course, designed by Colt in 1922, is more open and a truly outstanding course in its own right. There is a picturesque clubhouse and the halfway house is famous for its sausage sandwiches.

BELOW: The clubhouse

The Addington is one of the crown jewels of English inland golf, and the utterly original creation of its architect, J.F. Abercromby, who served as the club's longtime benevolent despot until his death in 1935. Old Aber designed the course in 1914, just south of London in Croydon, on a wooded preserve dating back to the 13th century, on land that King John granted to the Aguillon family. The course has changed little since Abercromby routed the firm fairways braided with heather through the forest of silver birch, English oak, beech, cedar, sweet chestnut, and the orange-tinged trunks of mountain ash. The holes carry across a series of ravines flush with ferns and bracken that are traversed by several rather rickety looking wood trestle bridges. In 1958, the course was acquired by one of the members, a solicitor named J.W. Bennett, whose daughter, Mrs. Moira Fabes, inherited the club in 1963 and presided over it for many years. Abercromby had a penchant for par-threes and there are six of them at The Addington, their greens nestled in the trees above the purple and russet brown pits of the ravines. Many prominent members of the English golfing fraternity have been members of The Addington over the years, including the great golf writer and commentator Henry Longhurst. Longhurst described the famous 225-yard, par-three 12th as "with the exception of the fifth at Pine Valley, near Philadelphia, the greatest one-shot hole in inland golf. To see a full shot with a brassie perfectly hit and preferably with a new ball, sail white against the blue sky, pitch on the green and roll up towards the flag, is to know the sweetest satisfaction that golf has to offer."

Walton Heath's Old Course is one of the earliest and certainly one of the finest of the heathland courses around London, located less than 20 miles from the city center. The course, site of the 1981 Ryder Cup Match, is laid out over a vast and solitary expanse of heath and gorse, and is renowned for its crisp turf and purple mounds of heather. The club largely owes its inception to Henry Cosmo Bonsor, chairman of the South Eastern Railway Company, who also happened to be the brother-in-law of William Herbert Fowler, a scratch competitive golfer and keen student of golf course design. Given the commission to create the course, Fowler explored the site on horseback in 1902 and his design was completed by the spring of 1904. An inventive and daring architect, Fowler went on to design such notable courses as Saunton East and The Berkshire, as well as the New Course at Walton Heath that opened in 1907, and was expanded to 18 holes in 1913. The club was particularly popular with politicians and members of the press from the outset. David Lloyd George and Winston Churchill were not only political rivals, but played matches against each other at Walton Heath, where Lloyd George was a member from 1907-1945 and Churchill from 1910–1965. James Braid, a towering figure in the history of the game, was enlisted as the first professional, and the Sage of Walton Heath held the position for 45 years until his death in 1950.

Royal Ashdown Forest, located in East Sussex an hour's drive south of London, is the most natural of courses—so natural that there is not a single bunker—laid out at the edge of the ancient forest where Winnie the Pooh and Christopher Robin found their adventures. The club was established in 1888 as the Ashdown Forest & Tunbridge Wells Golf Club, with royal patronage conferred by Queen Victoria in 1893. The same year, the rambling clubhouse was constructed using local brick and clay tiles, with a large clock placed under the gable to remind golfers of their starting times. The original charter of the Royal Forest prohibits alterations or excavations, thereby ruling out sand bunkers. Instead, the considerable hazards come in the form of grassy pits, streams, generous swaths of heather, bracken, and ferns, and the surrounding silver birch on the hilly terrain. The 125-yard sixth, the most famous hole on the course, finds a long green guarded front and left by a stream. The 8th through 12th play across the drier uplands, with views of the rolling Sussex countryside known as the North Downs. It seems fitting that Royal Ashdown Forest had no designer as such, although the club's founder, Archdeacon Scott, was involved in the layout of the course.

Shinnecock Hills Golf Club owes its founding to a visit to the Biarritz golf course in southwest France by William Vanderbilt and his party in the winter of 1890-91. Vanderbilt witnessed an exhibition by the Scottish pro Young Willie Dunn at the famous Chasm Hole and decided then and there that the game should be introduced in the United States. Shortly thereafter, Vanderbilt and his friends enlisted the aid of Samuel Parrish, another member of their wealthy Southampton circle and the founder of the Parrish Art Museum. That summer, Parrish brought another Scottish pro, Willie Davis of Royal Montreal, to design a 12-hole course through the sandhills and underbrush overlooking Shinnecock Bay, using a crew of Shinnecock Indians from the nearby reservation. The original course underwent a couple of redesigns, the second by C.B. Macdonald, who designed the neighboring National Golf Links, but an almost entirely new course was created in 1931 by William Flynn and Howard Toomey (with a young Dick Wilson as construction engineer) after a highway was routed through the old course. The course has a striking links look, with its soaring and swooping ribbons of fairway spread out through the windblown sierras of wild fescue grasses. Shinnecock hosted the second U.S. Open in 1896 and the event did not return again for 90 years. The 1986 Open at Shinnecock was an immense success, with Ray Floyd the winner, and the Open returned again in 1995 and most recently in 2004, when Retief Goosen was the victor. The understated and symmetrical shingled clubhouse, designed by the legendary Stanford White, was completed in 1892. The first clubhouse in America, it is a landmark in its own right.

BELOW: The first golf clubhouse in America

The National Golf Links of America, located in Southampton, was the first great American golf course and the enduring masterpiece of Charles Blair Macdonald, the patriarch of golf in the United States. A native of Chicago, Macdonald attended St. Andrews University in Scotland as a teenager in the 1870s and fell passionately in love with the game. Macdonald, who is credited with inventing the term golf course architect, was determined to build a course in the United States that would be the equal of the great courses of Scotland. He combed the Eastern seaboard in search of ideal terrain, and found it on Long Island in the 200 acres of sandy scrub knitted with bayberry and blackberry bushes adjoining Shinnecock Hills and overlooking Peconic Bay. Macdonald studied firsthand and also obtained detailed maps of famous holes in Scotland, after which he modeled several holes at the National. He also created originals that showed great ingenuity. Macdonald and his protégé, local engineer Seth Raynor, went on to design many superb courses, but the National, opened in 1909, remained his most treasured creation and he continued to dominate the club and refine his design through the rest of his life. The National is a very private club and has hosted only one prominent event in its history, the first Walker Cup competition in 1922.

Sebonack Golf Club lies on America's most hallowed golfing grounds, overlooking Peconic Bay at the northern end of a continuous stretch of linksland with Shinnecock Hills and the National Golf Links of America, on Long Island's South Fork. Sebonack is the fulfillment of the dream of its owner, Michael Pascucci, to create an iconic championship course. In 2001, after four years of searching, he succeeded in acquiring Bayberry Land, the 300-acre Gatsby-era estate of Wall Street financier Charles H. Sabin, with its Arts and Crafts–style manor house built in 1919 and its sunken gardens. After Sabin's death, his widow, Pauline Sabin Davis, the Morton Salt heiress, sold the estate to the International Brotherhood of Electrical Workers, which used it as a summer camp. Pascucci acquired the property from the Union for $45 million and, much to the dismay of preservationists, tore down the manor house to make way for a new clubhouse. Sebonack sits adjacent to the National, where Charles Blair Macdonald built his dream course a century earlier and launched a new era in American golf course architecture but in an even more ideal setting running along the bay. With such a high stakes project, Pascucci, who made his fortune in the automobile leasing business, was able to persuade both Jack Nicklaus and Tom Doak, two stellar golf architects with disparate styles, to collaborate on the design. Doak was primarily responsible for the routing, which bobs along Peconic Bay on the first hole, returning on the 11th and 12th, and then again on 17th and 18th, while Nicklaus focused on the strategic aspects of the design. The course finishes with a 570-yard par-five that runs hard and fast along the bay, with a big bunker crossing the fairway on the site of the old estate's swimming pool. Sebonack opened to critical acclaim in 2006 and has already been selected to host the U.S. Women's Open in 2011.

SEPTEMBER 6 | FRIAR'S HEAD GOLF CLUB—NEW YORK, U.S.A.

Friar's Head opened in 2003 near Riverhead on Long Island's North Fork. From the road that runs by the course, the site appears to be an unprepossessing piece of farmland that was sold by the Talmadge family, who were among the first settlers of the East End, to the course developer, Ken Bakst. The far end of the 350-acre property, however, opens on the sand dunes above Long Island Sound, which are anchored by a dwarf maritime beech-oak forest that dates back 10,000 years. Bakst, a leading amateur golfer who won the 1997 U.S. Mid-Amateur, hired the team of Bill Coore and Ben Crenshaw to design the course. Crenshaw and Coore quickly recognized the need to meld the very disparate topography of the site.

Over time, they did just that, developing an ingenious routing in which Nos. 2, 7, 11, and 14 serve as transition holes between the sandy moraine and the former potato farm. The coastal holes feature great swirling ridges of sand drizzled with sea grasses, and the broad fairways of the farmland holes are punctuated by the irregularly edged bunkers that have become a hallmark of Coore and Crenshaw's work.

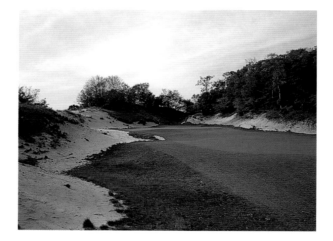

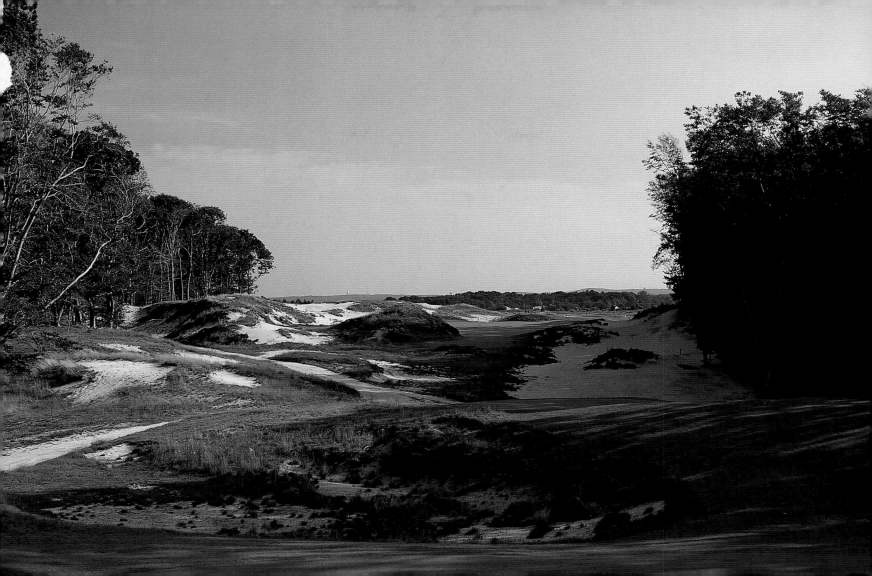

Bethpage State Park's Black Course on Long Island is the pearl of public golf in the United States. The Black and its sister courses, the Red and Blue, were built beginning in 1934, during the height of the Depression, as a Work Relief project, employing as many as 1,800 men (at the same time, an existing course was redesigned to become the Green Course).The entire project was overseen by the legendary golf course architect A.W. Tillinghast, who would shortly move to California to become an antiques dealer in Beverly Hills, having been driven out of business by the Depression. Tillinghast intended the Black to be a man-eater and he designed some of the biggest, baddest, and most carnivorous bunkers in captivity on the rolling, sandy site, with fescue grasses rippling through the waste areas. In 1996, the USGA selected the Black Course to host the 2002 U.S. Open, the first municipal course ever to stage the event. Rees Jones, the Open Doctor, was called in to restore the course and burnished it into a glorious test for the game's best. Tiger Woods won the inaugural Open at Bethpage. The event proved such a success that the Open returned in 2009, this time with unheralded Lucas Glover holding off his challengers. Bethpage can trace its history back to 1695, when an Englishman named Thomas Powell purchased a large tract of land on the road near Jericho and named his property based on the passage from the book of Matthew (21:1): "And as they departed from Jericho, a great multitude followed Him, and when they drew nigh unto Jerusalem and were come to Beth'phage unto the Mount of Olives."

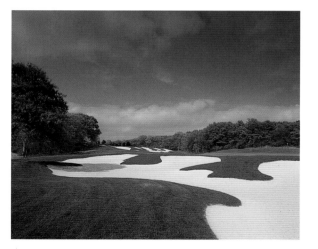

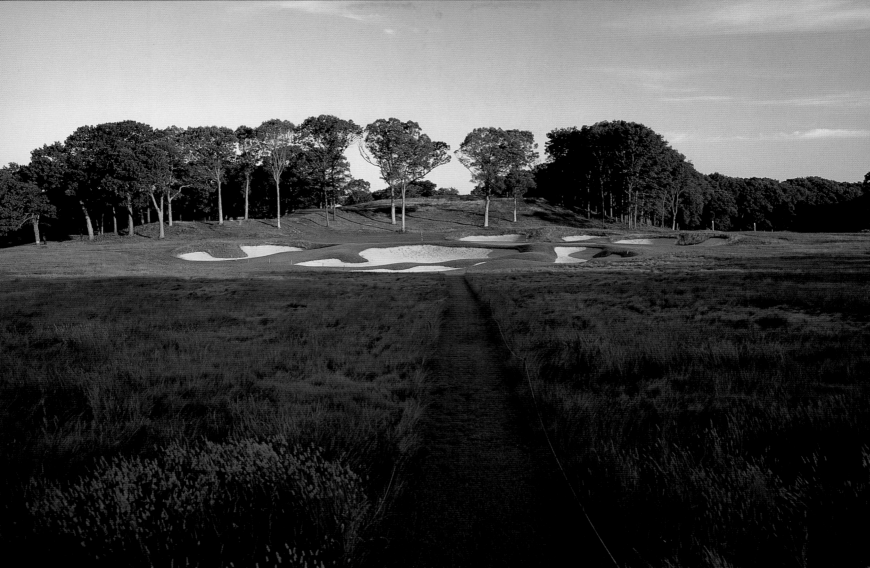

The Creek Club in Locust Valley on Long Island's tony North Shore holds back its pleasures for a few holes, and then, on the sixth tee, all is revealed. The fairway plunges steeply downhill to a butterflied green, with a broad view of the skeins of fairways and sea grasses that sweep down to Long Island Sound and across to the Connecticut coast. Members are still able to arrive via the Sound by boat near the 10th hole, with the fairway squeezed between a tidal lagoon and a strip of sandy beach. The 11th requires a brave carry to a pontoon of green in the lagoon. The club was founded in 1922 by a committee of 11 leading Long Island sportsmen, including Vincent Astor, Marshall Field, J.P. Morgan, Harry Payne Whitney, and Charles Blair Macdonald, who was enlisted to design the course with Seth Raynor. They named their club after Frost Creek, an inlet of the sound that loops around the 13th and 14th holes.

In 2009, the Otesaga Hotel and its Leatherstocking Golf Course, located on the shores of Lake Otsego in Cooperstown, New York, celebrated their 100th anniversary. Built in the Federal style with a soaring colonnaded portico, the Otesaga dominates the south shore of the lake that is the famed Glimmer-glass of James Fenimore Cooper's *The Leatherstocking Tales*. Cooper, one of the most popular 19th-century American authors, was born in 1789 in New Jersey, but his family moved to Cooperstown, then known as Otsego, after his first birthday. The village was subsequently named for his father, a local judge and congressman. The course, designed by high society architect Devereux Emmet, glides along the western shore of the lake. The middle holes play along elevated fairways, providing panoramic views of the lake and the grounds of the Fenimore Art Museum and Farmer's Museum. The 18th is a par-five with an island tee box on Lake Otsego that doglegs around the water, its green located in front of the hotel's veranda. The main attractions at Cooperstown are of course the Baseball Hall of Fame and the Glimmerglass Opera, but with Leatherstocking, one of the highest-rated public courses in the state, golf does not get the short end of the stick.

Bayonne Golf Club is the realization of a mind-boggling vision of a full-blooded, windswept seaside links of cratered fairways and spiraling sandhills located in the blue collar industrial town of Bayonne, just across New York Harbor from downtown Manhattan. This astounding course is a testament to the perseverance and ingenuity of its developer and designer, Eric Bergstol, who has built a number of courses in the greater New York metropolitan area. Bayonne was an immense reclamation project carried out on a flat 145-acre industrial site overlooking the New Jersey waterfront. Bergstol, who likes to say that he paints with a bulldozer, shaped 7.5 million cubic yards of sludge dredged from the harbor into fairways that bound through 100-foot-high dunes with views of tankers, container vessels, and cruise ships coming into the harbor through the Kill Van Kull. Many of the holes sport features of Scottish and Irish links, like the redan green at the third and the troughed, Biarritz green at the 13th. Bergstol hired Richard Hurley, an agronomy professor at Rutgers, to oversee the planting of different varieties of coastal grasses and shrubs found on links courses, including whiskery sedges, wild raspberry, potentilla, and blueberry bushes. Bayonne is a high-end private club with a dock behind the 16th green to welcome members arriving from Manhattan by ferry and its own heliport. The gleaming white clubhouse sitting on a crown at the center of the course is as impressive as the linksland, with a lighthouse-style tower and a huge American flag on a 150-foot-high flagpole waving over the harbor.

BELOW: The clubhouse

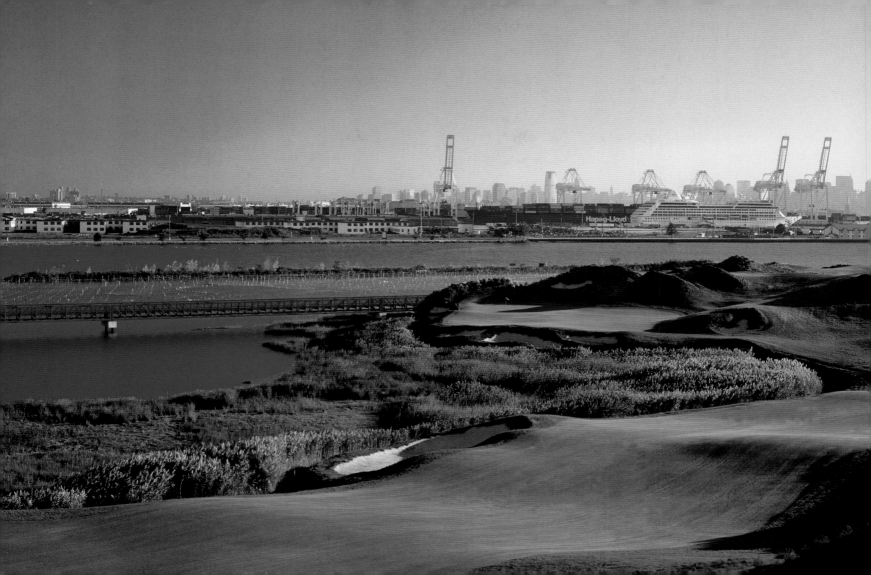

Liberty National Golf Club in New Jersey is a spectacular reclamation project from whose second fairway Lady Liberty can be seen just a few hundred yards away. Designers Bob Cupp and Tom Kite worked on the plans and the permits necessary for the site in Jersey City starting in the early 1990s, but the club really owes its existence to Paul Fireman, the golf-obsessed CEO of Reebok, who thrilled at the prospect of creating a world-class layout in the shadow of the Manhattan skyline. The course was built on 140 acres of defunct oil refineries, a toxic waste site that it took 200 trucks carting clean dirt and sand for almost two years to cover. The surface was raised by almost 60 feet.

Liberty National frequently draws comparisons to Bayonne Golf Club, the herculean reclamation project four miles to the south, but the two courses are very different. Liberty National is not a true links course but features tight fairways, five lakes and creeks, with three acres of salt marsh set aside as a preserve for terrapins. The cart paths are paved with Belgian block, and thousands of mature oaks, willows, evergreens, and many specimen trees were planted. Liberty National, which fittingly opened on July 4, 2006, is an ultra high-end club popular with Wall Street high fliers, whose members include Rudy Giuliani, Eli Manning, Phil Mickelson, and LPGA star Cristie Kerr. At 7,400 yards, the course was designed to challenge the pros and hosted the Barclays tournament on the PGA Tour in 2009, with Heath Slocum the upset winner.

New York's beautiful Mohawk Valley is the site of Turning Stone, a resort and casino founded by the Oneida Indian Nation 30 miles east of Syracuse in Verona. Flaunting three topnotch layouts, it has become the lodestar for golf in upstate New York. The Atunyote Course was designed by Tom Fazio, the Kaluhyat Course by Robert Trent Jones, Jr., and the Shenendoah Course by Rick Smith. The Shenendoah Golf Club, opened in 2000, was the first course at Turning Stone, with broad corridors running through hardwood forests and forced carries over wetlands. Kaluhyat, the Oneida word for the other side of the sky, has more elevation changes and six lakes spread around the course.

Atunyote, which is the Oneida word for eagle, is Turning Stone's headliner course and hosts an annual PGA Tour event, the Turning Stone Resort Championship, that is part of the Tour's Fall Series. The course, which can be elongated to a brutal 7,749 yards, has a variety of water hazards. The largest lake, measuring 13 acres, runs along three fairways, including the right side of the par-five 18th. The entrance gate to the Atunyote Course is a fanciful wrought iron sculpture of intertwining foliage and the wildlife found on the course. Each tee box also has a plaque describing the native wildlife.

Midvale Country Club, located a few miles east of Rochester, New York, is the first course designed by legendary golf course architect Robert Trent Jones, opening for play on July 4, 1931. Jones, who died in 1999, was born in Ince, England, on June 20, 1906, and emigrated with his family to Rochester when he was five. He caddied at Rochester Country Club and became interested in golf course design after watching Donald Ross create Rochester's famed Oak Hill Golf Club. He then studied landscape architecture, agronomy, and horticulture at Cornell University to prepare himself for a career as a course architect. Midvale had its beginning when a group of businessmen from the Rochester area met at the Blarney Stone Inn in Webster, New York, on September 23, 1929, to organize a golf club. Several farms on the Fairport-Penfield line, an area known as Midvale, were purchased to form a 144-acre tract, and the young and unknown Jones was hired to design the course. Jones recounted many years later that the construction was mainly carried out using horse-drawn earthmovers and manual labor. The seventh through 11th holes were routed through a large apple orchard, many of whose trees still stand. Although their sequence has been changed, the original holes remain largely as Jones created them.

SEPTEMBER 15 | GLEN ABBEY GOLF CLUB—CANADA

Glen Abbey Golf Club, located in Oakville, 35 minutes west of Toronto, is Ontario's premier public course and was commissioned by the Royal Canadian Golf Association to serve as the host course of the Canadian Open. Opened in 1976, Glen Abbey was the first solo design of Jack Nicklaus, assisted by Jay Morrish and Bob Cupp. Nicklaus describes the layout as a spoke-and-wheel design around the clubhouse, conceived to allow optimal viewing of Canada's national championship.

The front nine is wider than the back, which features a particularly demanding stretch of five holes that run through the valley, beginning on the 11th. Tiger Woods played one of the most spectacular shots of his career to win the 2000 Canadian Open at Glen Abbey, a six-iron second shot from 218 yards from the right fairway bunker over the lake guarding the par-five 18th hole. The Canadian Golf Hall of Fame is located in the Leonard E. Shore Building attached to the clubhouse.

Devil's Pulpit Golf Association consists of two courses—the Devil's Pulpit and the Devil's Paintbrush—built in the Caledon Hills 35 miles northwest of Toronto. Both courses were developed by Chris Haney and Scott Abbott, the inventors of the Trivial Pursuit board game. Although only three miles apart and both designed by Michael Hurzdan and Dana Fry, the courses have entirely different characters, representing the yin and yang of golf course architecture. The Devil's Pulpit, opened in 1990, is a highly sculpted, more traditional parkland course. Hurzdan and Fry moved 1.7 million cubic yards of earth to create the course, including 300,000 cubic yards on the first hole alone, where a pond was built to create a dramatic tee shot from the elevated tee. The Paintbrush, on the other hand, opened in 1992, is laid out on an exposed, treeless bluff, its rumpled fairways fringed with brown native fescue grasses. An authentic Scottish-style links, there are plenty of blind shots, sprawling, shapeless bunkers lined with wooden slats, and an eighth hole that features the stone ruins of an old barn and a 17-foot-high sod wall bunker. The Devil's Pulpit is named after a rock formation seen from the seventh tee. The Devil's Paintbrush is a small flower found on the course, commonly named orange hawkweed.

RIGHT: The Devil's Paintbrush

The Muskoka region north of Toronto is a popular summer haven known for its rustic lakes and rugged mantle of granite. In recent years it has become Ontario's leading golf destination. Taboo Golf Club, located at the Taboo Resort just north of Gravenhurst, Ontario, takes full advantage of the rocky counterpane that is known as the Canadian Shield, with fairways literally sculpted from the gray and pink granite. Designed by Florida-based course architect Ron Garl on a site with over 380 acres of hemlock, red and white pine, maple, birch, and balsam, the course opened in June 2003. There is a pair of par-threes, the third and the 11th, that play over vast sand-strewn waste areas, while the par-three 15th funnels through jumbled rocks on both sides. The 563-yard par-five 18th is a rollicking finish through hills, valleys, and more chunks of granite. Taboo is the home course of Canadian golf's leading man, Mike Weir.

Highlands Links is a natural wonderland situated in the Cape Breton Highlands National Park on the northern extreme of Nova Scotia's 4,000-square-mile Cape Breton Island. The course was built by the National Park Service of Canada in 1939 as a public works project with the goal of stimulating tourism. Stanley Thompson, the great Canadian architect, who had triumphed over difficult terrain at Banff Springs and Jasper Park in Alberta, was brought in to design the course. Thompson wove the holes through a variety of spellbinding scenery, all the while maintaining the broad, rolling character of the course. Carved through virgin forests of fir, spruce, and birch, the massive swales on several of the fairways were created by piling up rocks and boulders and covering them with soil from river silt. The course overlooks Ingonish Bay and the Atlantic with Whale Island across the channel, while holes such as the 10th and 14th that run inland face the green cloak of Mount Franey. The Clyburn River runs through the middle holes, accompanying the golfer on the 480-yard stroll from the 12th green to the 13th tee. Some of the most notable holes, each of which has a Gaelic name, are the back-to-back par fives Mucklemouth Meg and Killiecrankie. The white clapboard Keltic Lodge, famed for its lobster dinners, was built at the same time as the Highlands Links to provide visiting golfers with first-rate accommodations.

The Mont Tremblant Resort is set in the Laurentian Mountains of Quebec. While the resort is best known for skiing, it has two superb golf courses, Le Géant (the Giant) and Le Diable (the Devil). Le Diable, opened in 1998, was designed by Michael Hurzdan and Dana Fry, and features flamboyant red-tinged waste bunkers on the course carved from the pine forest. In 1999, Le Diable hosted the Canadian Skins Game with Mike Weir, Fred Couples, John Daly, and David Duval competing. Opened in 1995, Le Géant was designed by Canadian architect Thomas McBroom, with fairways cradled by the surrounding Laurentians.

BELOW: Le Géant
RIGHT: Le Diable

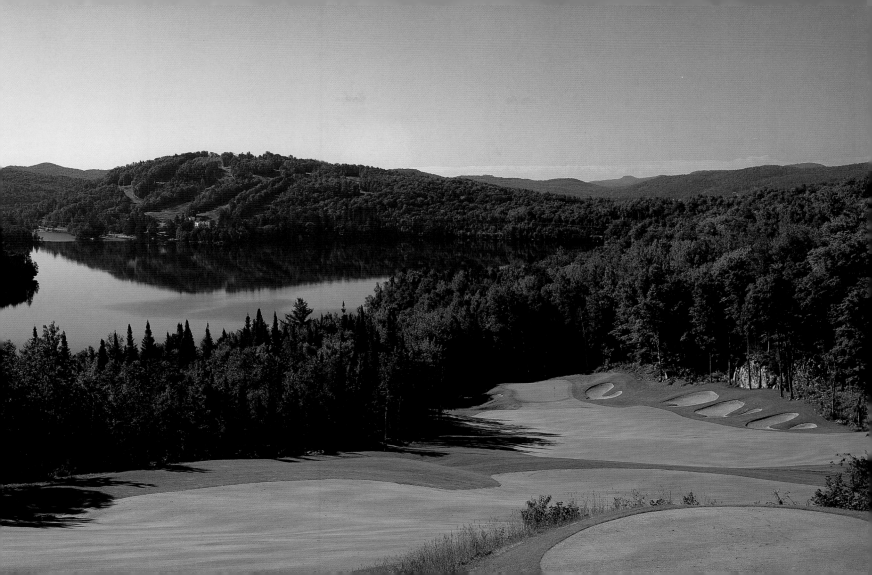

Sunday River is a public course five miles from Bethel, Maine, encased in the hardwood forest of the Sunday River Valley. Opened in 2005, with 400 feet of elevation change throughout the property, the course is built on a hillside with views across the valley to Goose Eye Mountain and Speck Mountain in the Mahoosuc Range. Architect Robert Trent Jones II, who also designed Sugarloaf Golf Course, Maine's other mountain stunner, used stone retaining walls to create broad pavilions of fairway shaped to mimic the surrounding terrain. He created hazards using rock outcroppings, wetlands, and Merrill Creek. The demanding, uphill 496-yard 17th, the No. 1 handicap hole, leads to the highest point on the course, the 18th tee, at an elevation of 1,550 feet. From there it's a downhill plunge to the fairway and the wilderness lodge clubhouse below.

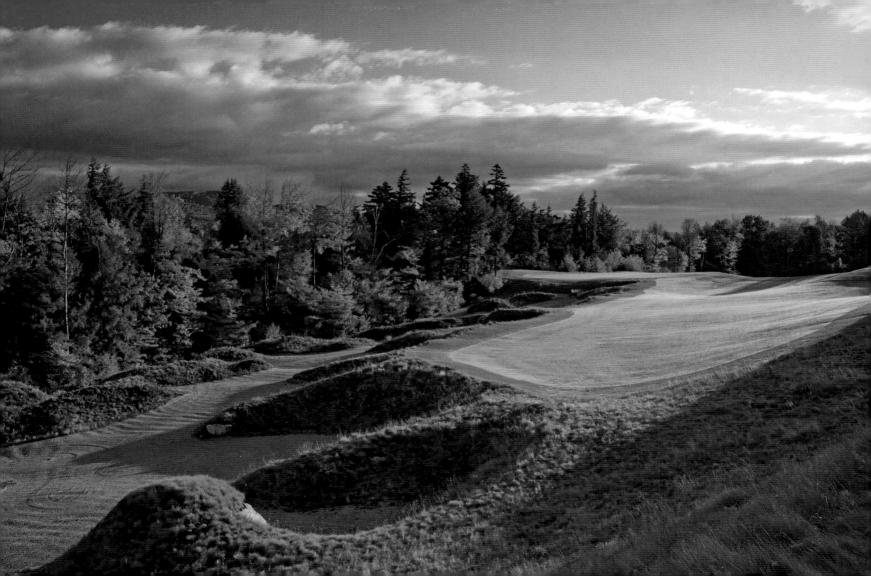

The Mount Washington Course is part of the Mount Washington Resort & Spa in Bretton Woods, the Spanish Renaissance–style hotel from a bygone era that rises in the shadow of the White Mountains in northern New Hampshire. As at other grand resorts of the era, a Donald Ross–designed course was *de rigeur*. Opened in 1915, Mount Washington has recently been restored to its original glory by New Hampshire–based architect Brian Silva and was officially reopened on Memorial Day, May 25, 2009. Silva, who has been responsible for a number of highly touted Ross restorations, including Seminole in North Palm Beach, Biltmore Forest in Asheville, North Carolina, and Augusta Country Club in Georgia, worked from Ross's original design plans. He restored the original fairway bunkers and unearthed the lost Principal's Nose bunker on the fourth, as well as removing trees to enhance the vistas of the peaks of the Presidential Range. Silva also made use of the gentle swales of the old riverbed to place tees, fairways, and greens, in keeping with Ross's original intent. The course restoration was part of an overall $50 million refurbishing of the resort, with the addition of a new wing and a 25,000-square-foot spa.

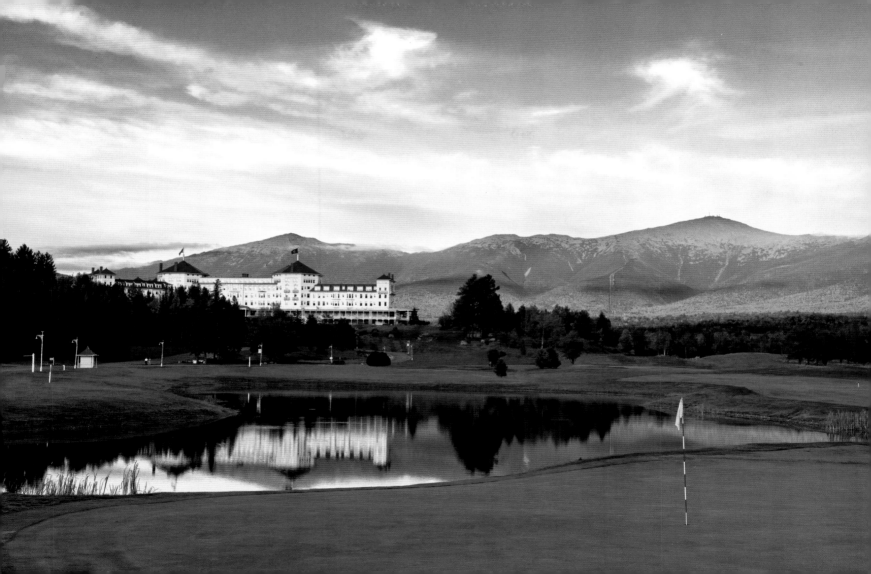

Vermont National Golf Club in South Burlington is spread out over 400 acres on a high site, with scattered stands of sugar maple, butternut, and ash trees. The course, opened in 1998, offers diverse topography and a range of stunning views of the neighboring Green Mountains and the calm surface of Lake Champlain. The front nine is a green broadcloth of fairways running through meadows and valleys, while the back nine is a steeper test with rock outcroppings and ledges. Architect Jack Nicklaus and son Jack also spent considerable effort devising a routing that would show off the vistas of Mount Mansfield, Vermont's highest mountain, and the Camel's Hump, the state's third-highest peak, which can best be appreciated from the 10th hole. The finishing hole from the elevated tee offers a sweeping view of the Adirondacks rising to the southwest.

The Gleneagles Golf Course at the Equinox Resort lies at the base of the Green Mountains in Manchester and has long been a New England beauty. The rugged layout with steeply canted greens and panoramic views across the valley and over the steeple of the First Congregational Church to 3,816-foot Mount Equinox was designed by Walter Travis in 1926. In the early 1990s, Rees Jones, who has distinguished himself with his sensitive restorations of a number of classic American courses in preparation for the U.S. Open, reworked and revitalized the course. Guinness, the Irish brewery that acquired the Equinox Resort in 1992, also refurbished and upgraded the historic hotel, which dates to 1769. Ethan Allen and the Green Mountain Boys were regulars at the hotel's Marsh Tavern. Several presidents have been guests at the Equinox, and Mary Todd Lincoln spent summers at the resort with her two sons both before and after the assassination of President Lincoln.

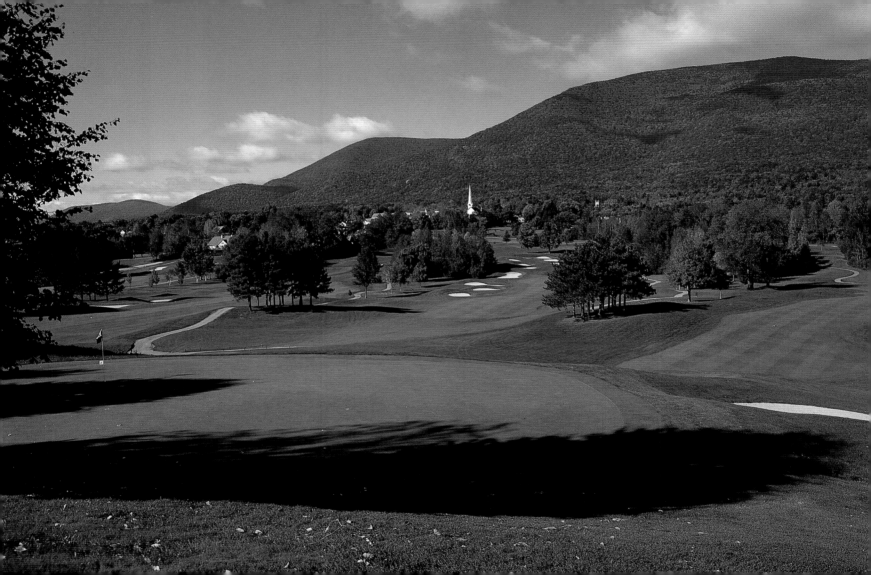

The Country Club in Brookline, Massachusetts, just outside downtown Boston, is the original American country club. With its canary yellow and white clapboard clubhouse, it remains a beautiful enclave of rolling fairways with rocky outcroppings through the stately oaks and maples. The Country Club has been the site of some of golf's most epic battles, beginning in 1913, when Francis Ouimet, a 20-year-old unknown amateur who grew up on Clyde Street across from the club, won the U.S. Open by defeating the English stars Harry Vardon and Ted Ray in a playoff. In 1999, the course was the setting for the historic come-from-behind win by the U.S. squad in the Ryder Cup Match. The Country Club began as a retreat for pursuits like riding, shooting, and horse racing before golf was introduced thanks to a figure described as a young girl from Pau. The girl in question was Florence Boit, the daughter of wealthy Boston expatriates, who brought her clubs from France on a visit to her uncle Arthur Hunnewell's estate in Wellesley in 1892. Hunnewell, together with Laurence Curtis and Robert Bacon, then took the lead in establishing golf at The Country Club. Florence Boit and her three sisters are the subject of John Singer Sargent's masterpiece in the Boston Museum of Fine Arts.

BELOW: Ryder Cup

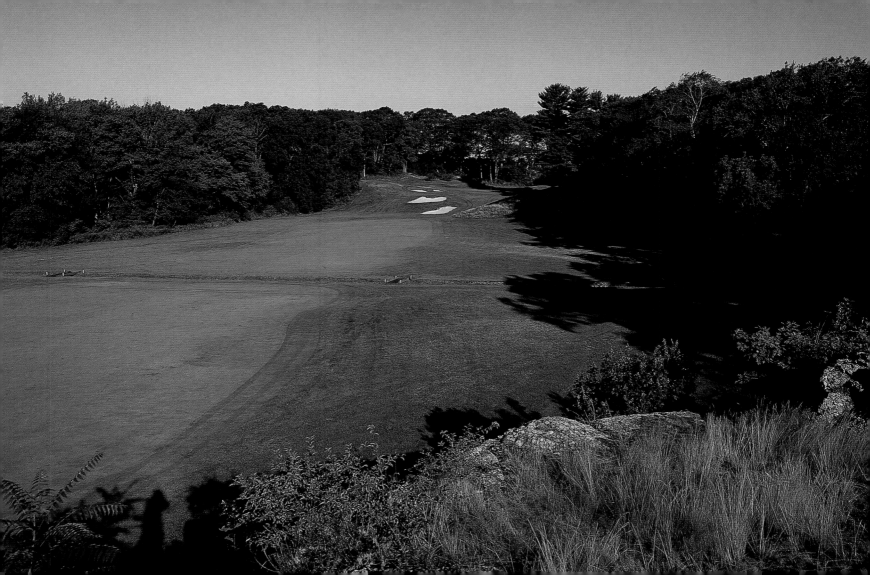

The Kittansett Club lies across from Cape Cod on the mainland side of Buzzards Bay, ten miles northeast of New Bedford. Laid out on a hook of ground where English settlers landed in 1639, the course has a links-like feel because of the views across the sea grasses and the sandy coast but is routed through scrub oak. Built in 1922, Kittansett was designed on paper by the great architect William Flynn, but the course's design also owes a great deal to the owner of the property, Fred Hood, who closely supervised the construction. One of the interesting features Hood was responsible for was grassing over rock formations and piles of debris to form mounds. Many of the original design features were lost over the years, so the club hired architect Gil Hanse to carry out a restoration. Hanse removed hundreds of trees that had covered over the original mounds, rebuilt the bunkers to their original large size, and opened up the dramatic view across Buzzards Bay from the 16th green.

The Golf Club of Cape Cod is laid out on rolling coastal woodland in Falmouth, on some of the highest ground on Cape Cod. Architect Rees Jones created a traditional New England course with lanky-fingered bunkers and large, undulating greens that comfortably fit across the sandy glacial terrain of ridges, kettle holes, and granite boulders.

Many of the holes play downhill from the tee and then back uphill to raised greens, including the short par-four second, the par-four 10th, and the par-five, 559-yard finishing hole. Water comes into play on the back nine. From the clubhouse on the high ground there are views out to Martha's Vineyard and Buzzards Bay.

Sankaty Head Golf Club is an old-fashioned links whose fairways flutter at the southwestern elbow of Nantucket in Siasconset, Massachusetts, surrounded by the Atlantic, with the Sankaty Head Lighthouse standing tall above the front nine. The course dates from 1923, designed by Emerson Armstrong, a member at the nearby Old Siasconset Golf Course that was founded back in 1894. The brick and granite lighthouse was built in 1850 on the 90-foot high bluff at Sankaty Head, which takes its name from the Indian word *sankoty*, meaning highland. The members of Sankaty have been loyal supporters of the Francis Ouimet Scholarship Fund, and the club maintains one of the last remaining caddie camps in the world, Camp Sankaty Head. The camp, which is located just off the 11th hole, is home each summer to 60 caddies who are selected through an application process from around the United States and abroad.

Newport Golf Club was founded in 1893 by Theodore A. Havemeyer—the "Sugar King"—head of American Sugar Refining Company and one of the founders of the United States Golf Association. When the club opened on July 4, 1893, the cream of American society was on hand, with more than 300 members of the Social Register present. On October 2, 1895, Newport held the first USGA-sponsored Amateur Championship, won by Charles Blair Macdonald. Two days later, it hosted the first U.S. Open, won by Horace Rawlins, but the Amateur was considered a bigger deal in those days. In 1995, the U.S. Amateur returned to what is now Newport Country Club for its centennial, with Tiger Woods winning the Havemeyer Cup that is still awarded to the Amateur champion. The original Newport course was laid out on Rocky Hill Farm by the Scottish pro Willie Davis, with more work done by Donald Ross in 1915. The current course, however, is the creation of A.W. Tillinghast, who redesigned nine of the existing holes and added nine new ones in 1923–24. The clubhouse, overlooking Hazard's Beach and opened in 1895, was designed by the young Whitney Warren in the French Beaux-arts style. Warren later founded the firm of Warren & Wetmore, which designed New York's Grand Central Station.

Shelter Harbor Golf Club is located in Charlestown, Rhode Island, not far from the coast of Block Island Sound. When the course opened in 2006, it was the first new private club to open in Washington County in a century. Architects Michael Hurzdan and Dana Fry created a traditional par 71, 7,000-yard layout on a generous 600-acre property that has shifting elevations, as well as room for a nine-hole, par-three layout. The site proved to a difficult one for constructing a course because, in addition to the protected wetlands, it was riddled with thousands of boulders, some the size of small barns. The finished product features rock outcroppings and rock walls running through the course, with clusters of old-fashioned eroded bunkers. The superb greens of velvet bent benefit from the sandy soil and ocean breezes. There is also an 18th-century cemetery to the right of the second green, from which golfers get a free drop should their approach shot happen to stray.

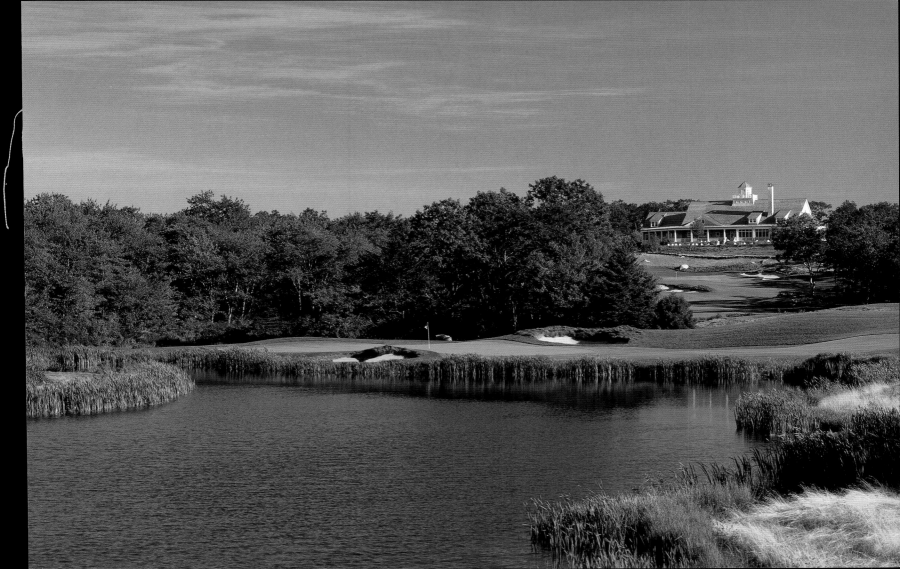

Donald Ross achieved fame as the architect of Pinehurst No. 2 in North Carolina, where he lived nine months of the year, but what is less well known is that Ross spent his summers in Little Compton, Rhode Island, at a house owned by his wife's family, and maintained an office there. Rhode Island has the good fortune to be the home of a trove of Ross courses, including Rhode Island Country Club, Wannamoisett, Sakonnet—where he was also a member—Metacomet, Point Judith, and the public Triggs Memorial in Providence. Misquamicut Golf Club was founded in 1895 in the summer colony of Watch Hill as a nine-hole course with an old corn crib converted into the clubhouse. The present course, however, was laid out by Ross in 1922 and is one of his more charming creations. It is short by modern standards, playing to a par of 69 with five par-threes, but the fairways are well bunkered and water comes into play on eight holes. The front nine is considerably hillier than the back and offers superb views of Block Island Sound. There is a rambling shingle-and-fieldstone clubhouse, with an oversized hipped roof, designed by Grosvenor Atterbury in 1900, and a tennis clubhouse built in 1979 that is a whimsical small-scale adaptation of McKim, Mead & White's Newport Casino.

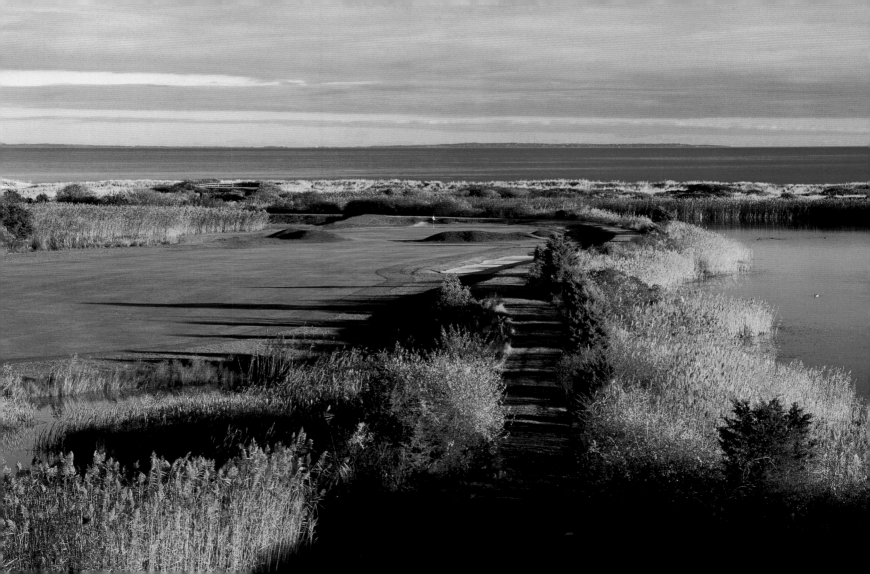

In 2005 the Foxwoods Resort and Casino in 2005 opened two courses that hop, skip, and jump across the tranquil 90-acre Lake of the Isles in North Stonington, just west of the Rhode Island border in eastern Connecticut. The Lake of the Isles North Course is public, while the South Course is private. Both were designed by Rees Jones and run through 900 wooded acres of white pine, red maple, hemlock, red and white oak, and yellow birch across from the Foxwoods Casino, which is owned and operated by the Mashantucket Pequot Tribal Nation. Each course features an island green 11th hole and long forced carries over sleeves of wetlands from the back tees—including a 270-yard bash from the tips on the 18th hole of the North Course. Starting as a high stakes bingo hall in 1986, Foxwoods has grown to become the largest casino in the world, rising like Emerald City from the Connecticut woods. The Casino attracts 40,000 guests a day, with accommodations including the Grand Pequot Tower and a new MGM Grand Hotel that opened in 2008. The Pequot Museum and Research Center, near the resort, is the most comprehensive Native American museum in the world.

RIGHT: The North Course

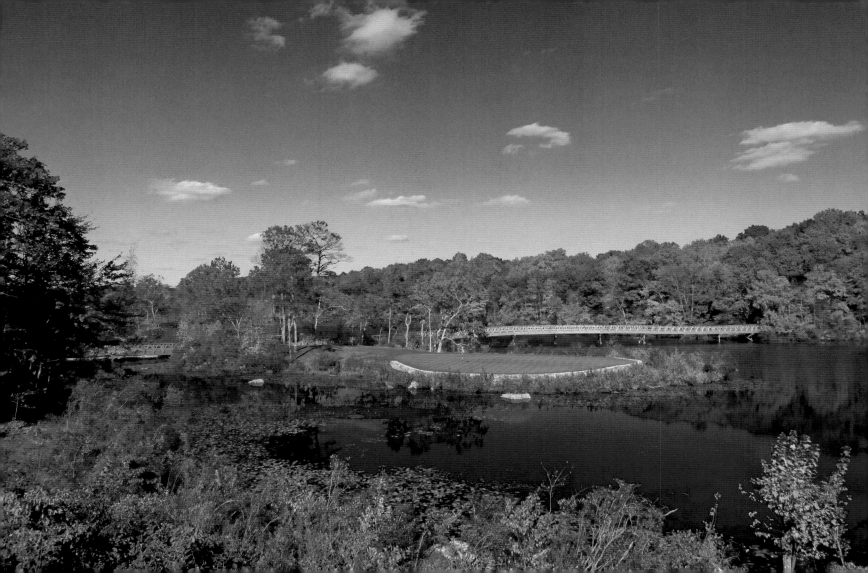

Hudson National Golf Club in Croton-on-Hudson occupies a lofty 260-acre eyrie above the Hudson River on the second-highest elevation in Westchester County. When Henry Hudson sailed up the river in 1609, the land was occupied by the Kitchawank Indians. During the Revolutionary War, the 450-foot-high bluffs provided a key lookout for Washington's army as the British fleet sailed north. The golf course, designed by Tom Fazio, opened in June 1996. Fazio made the most of the rugged topography by not overdoing it, laying out a straightforward, big boned course with commanding views and old stone walls sprinkled around the fairways. In the 1920s, a nine-hole course named Hessian Hills was built on the property, but when the clubhouse burned down in 1932, the course was disbanded and allowed to return to nature. The ruins of the old clubhouse overlook the fifth tee. Hudson National's new clubhouse is an imposing four-story stone manor house.

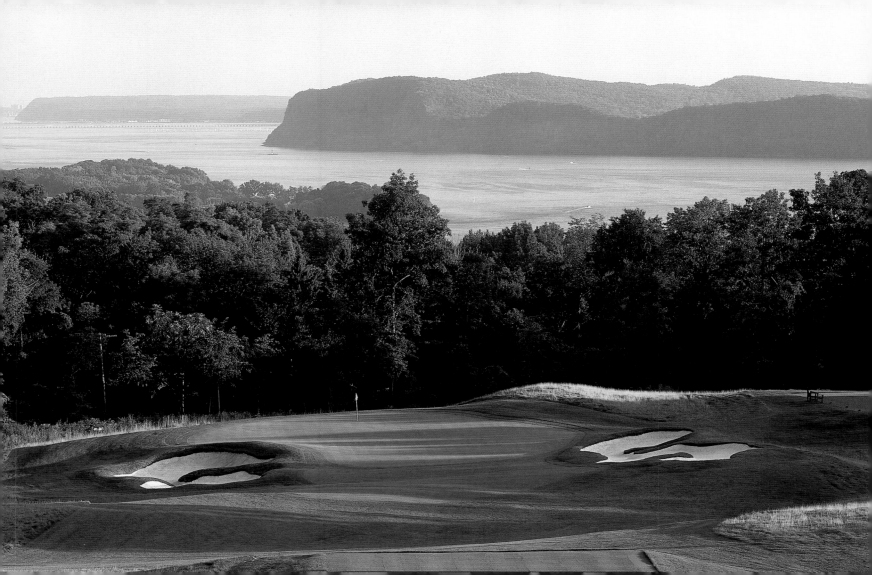

OCTOBER 3 | **SLEEPY HOLLOW COUNTRY CLUB—NEW YORK, U.S.A.**

Sleepy Hollow Country Club is located in Scarborough-on-Hudson in the hills of Westchester made famous by Washington Irving in *The Legend of Sleepy Hollow*. Irving's headless horseman, supposedly the ghost of a Hessian soldier, threw his head at Ichabod Crane at the foot of the haunted bridge that now links tee to green on Sleepy Hollow's third hole. The club was very much a millionaire's playground, founded in 1911 by the likes of William Rockefeller, John Jacob Astor, and Oliver Harriman. The clubhouse is one of the most impressive in the world, having originally been built as the estate of Colonel Elliott Fitch Shepard and his wife, who was from the Vanderbilt family.

Designed by Stanford White, it is a 75 room Italianate villa constructed of limestone and orange brick with a rococo interior of marble and mahogany. The golf course was designed by Charles Blair Macdonald during the summer of 1911, with A.W. Tillinghast contributing seven holes—the first, the 18th, and the 8th through 12th, in the late 1920s. The par-threes at Sleepy Hollow are particularly outstanding. The 10th plays to a low-lying green lapped by a pond, while the 16th plays across a gully to an elevated green perched triumphantly above the Hudson River.

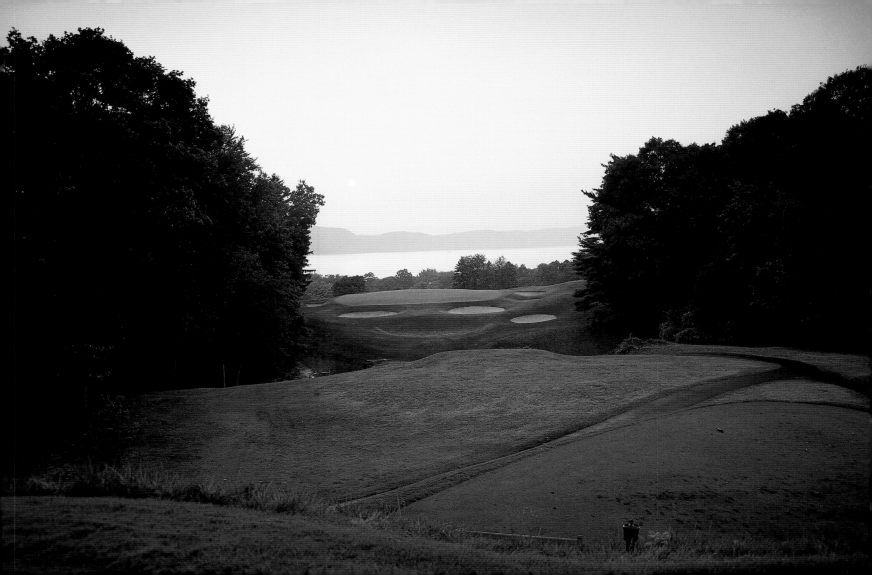

The West Course of Winged Foot Golf Club in Mamaroneck is Westchester's great championship course, although the club actually boasts another excellent course in the East Course. Both were designed by the incomparable A.W. Tillinghast at the peak of his career. Winged Foot was founded by members of the New York Athletic Club in Manhattan, who adopted the NYAC's winged foot symbol as their name. In 1922, the club acquired 280 acres of land that once was home to the Mohican Indians and adjoined the house of James Fenimore Cooper, author of *The Last of the Mohicans*. Both courses were completed by June 1923, with Tillinghast overseeing a massive construction project that included removal of 7,200 tons of rock, which was used to build the distinctive clubhouse designed by Clifford Wendehack. The West Course is considered Tillinghast's greatest masterpiece. Even though Tillinghast worked with more dramatic sites, the combination of deep, steeply banked bunkers built into the tiered, pear-shaped greens makes the course an immensely arduous challenge. As Tillinghast put it: "A controlled shot to a closely guarded green is the severest test of a man's golf." Trees are a defining element of the Winged Foot experience, though the club recently removed some that encroached too much on play. The property is a magnificent arboretum with more than 20,000 trees from 50 different species, including flowering magnolias, dogwoods, crab apples, and Kwanzan cherries. Winged Foot has hosted five U.S. Opens, beginning with Bobby Jones's win in 1929 and the 1997 PGA Championship won by Davis Love III. In 2006, Australia's Geoff Ogilvy won the most recent U.S. Open played at Winged Foot, after Phil Mickelson and Colin Montgomerie both collapsed on the final hole.

BELOW: The clubhouse

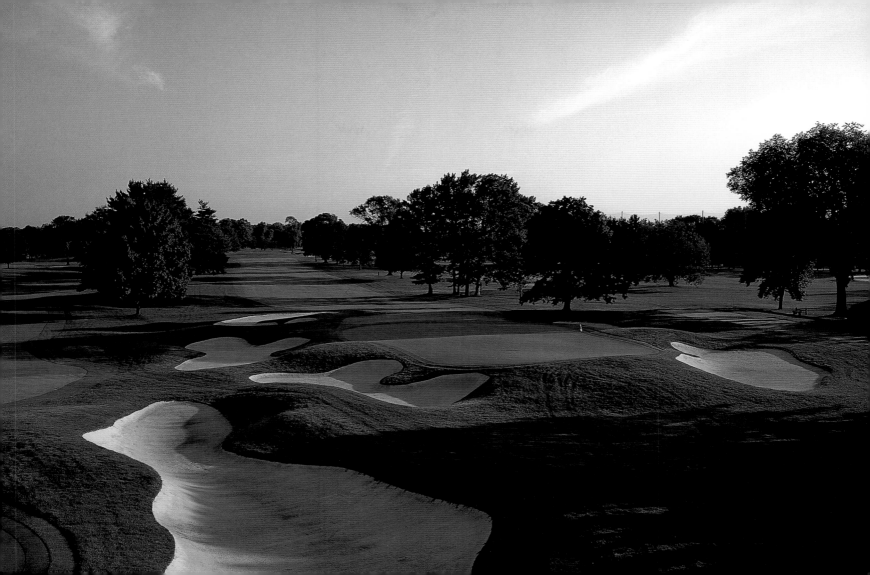

Baltusrol Golf Club's Lower Course has been one of the USGA's favorite venues for the U.S. Open, although the hillier, heavily wooded Upper Course is an outstanding layout in its own right. Both courses were designed after the First World War by A.W. Tillinghast, two of Tillinghast's earliest and greatest in a line of great courses. The club had been founded in 1895 by Louis Keller, the reclusive publisher of New York City's Social Register. Keller had acquired 500 acres at the foot of Baltusrol Mountain in Springfield, named after Baltus Roll, a farmer who lived in a small house on the mountain where he was murdered by thieves on the night of February 27, 1831. Robert Trent Jones was brought in to strengthen the course before the 1954 U.S. Open, when he designed the famous par-three fourth hole that plays across a pond to a double-tiered green. When some of the members criticized the hole, Jones took them to the tee and played a four-iron shot that rolled in the cup for a hole-in-one. "Gentlemen," he remarked, "I think the hole is eminently fair." Baltusrol's majestic Tudor clubhouse, one of the grandest in golf, faces the fourth hole. Among the memorable tournaments hosted by Baltusrol, including a record seven U.S. Opens, were the 1967 and 1980 U.S. Opens, both won by Jack Nicklaus. Most recently, the club hosted the 2005 PGA Championship, at which Phil Mickelson captured his second major win.

Somerset Hills Country Club is in Bernardsville, not far from the USGA's headquarters in Far Hills. The club dates to 1896, when it was formed as the Ravine Land and Game Association with an early nine-hole course. In 1916, the club purchased 194 acres from the estate of Frederic P. Olcott, which included a private racetrack, and the great architect A.W. Tillinghast was hired to create what turned out to be one of his more unusual designs. Completed at the end of 1917, the course does not bear much resemblance to Tillinghast's other famous layouts, such as Winged Foot and Bethpage Black, but instead, the holes reflect the variety and subtlety of the terrain. The front nine is laid out over the old Olcott racetrack on open ground with large, odd-shaped mounds created by Tillinghast known as the Dolomites. The back nine runs through wooded terrain with a rocky stream and a pond that guards the peninsula green on the par-three 12th. Somerset Hills is an exclusive club, but it has hosted various USGA events over the years, including the 1990 Curtis Cup.

Pine Valley Golf Club is perennially ranked and is generally considered the greatest golf course in the world. There are many incongruities in Pine Valley's lofty stature. The course is located in the pine barrens of southwestern New Jersey near Clementon, which would not spring to mind as the site for the world's greatest course, and Pine Valley was designed not by a well-known professional architect, but by a dedicated—some would say crazed—amateur. Pine Valley was the all-consuming passion of its founder and creator, George Crump, a Philadelphia hotelier and member of the Atlantic City Golf Club. Crump labored on the course from 1913 until his death in 1918, moving to the site and living first in a tent and then a bungalow. Crump died having finished 14 holes, with Hugh Wilson, the architect of Merion, completing the design. Crump received key advice regarding the routing from the leading English architect Harry Colt, but Crump created a novel course, in which the fairways are islands subsumed by sandy waste areas overgrown with Scotch broom, huckleberry, and wild grasses, and each hole is framed by the statuesque forest of pines, oak, larch, and hemlock. Legends of Pine Valley's difficulty are legion. There is a standing bet that no one can break 80 the first time he or she plays the course. Arnold Palmer won his bet when he shot 68 in 1954 as the U.S. Amateur Champion, and Jack Nicklaus stopped to play the course in 1960 while on his honeymoon, with his wife Barbara waiting for him in the car.

The sandy soil, pines, and marshland of southern New Jersey's pine barrens region are particularly conducive to crafting superlative golf courses, as artistically illustrated by Tom Fazio at Galloway National. The club, founded by Vernon Hill, the chief executive officer of Commerce Bank, opened in 1994. Hill and his partner acquired a parcel of sandy pineland mixed with hardwoods near Reeds Bay, just north of the Seaview Marriott golf resort outside of Atlantic City, for the site of the course. The par-five 16th plays through a chute of pines to a fairway that is actually shaped in the image of the state of New Jersey, with the course's largest lake, Lake Lauren, pinching the left side. The 17th is a long par-three through a funnel of pines, with a view across the estuary to the skyline of Atlantic City. The finisher is a 486-yard dogleg that swings uphill to the right with fescue-fringed waste areas running the length of the hole.

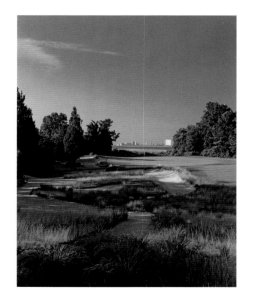

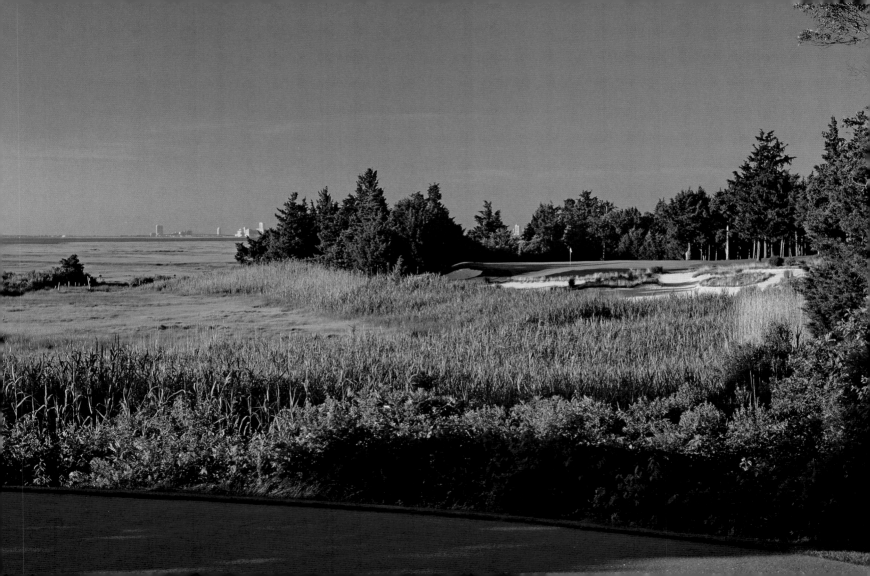

OCTOBER 9 | BAYSIDE RESORT GOLF CLUB—DELAWARE, U.S.A.

Bayside is a master-planned resort community located four miles west of Fenwick Island in southern Delaware, with a Jack Nicklaus signature golf course. The course, which tops out at 7,545 yards, presents long views out to the shores of Assawoman Bay. Nicklaus designed the course to reflect the variegated landscape of salt marsh, meadows, and woodlands. Located on 867 acres, the resort community consists of four resort villages and includes a carousel park. Bayside is a semi-private course that is open to members and guests at the resort; public play is also now available.

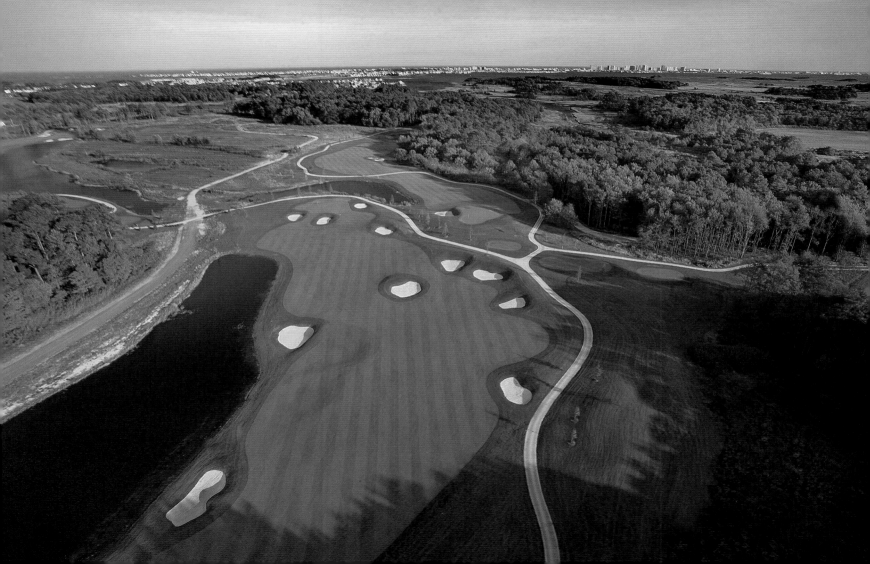

Congressional Country Club, located in Bethesda, Maryland and inaugurated in 1924, has long reigned supreme when it comes to golf in the Washington, D.C. area. The club was founded by Congressmen Oscar E. Bland and O.R. Lubring of Indiana, and the championship Blue Course was designed by the patrician architect Devereux Emmet. The second course, known as the Gold Course, was completely overhauled by architect Arthur Hills in 2000. The Blue Course will once again take center stage when it hosts the 2011 U.S. Open, the third time the championship has been held at Congressional. Robert Trent Jones redesigned the course prior to the 1964 U.S. Open won by Ken Venturi, and the contemporary course reflects the extensive work of his son, Rees Jones, known as the Open Doctor.

Rees Jones was first called in prior to the 1997 U.S. Open, at which Ernie Els prevailed. He regraded the fairways, creating saddle shapes and plateaus for better viewing, and rebuilt all of the greens. As originally designed, Congressional finished with a par-three, which proved to be somewhat anticlimactic at the 1997 Open since the water guarding the green did not threaten the pros. Most recently, Jones created a new par-three that plays as the tenth, while the testing 17th, where Tom Lehman's chances met a watery grave during the 1997 Open, now plays as the dramatic finishing hole. Over the years, Congressional has been the golfing home of many of Washington's political elite, including several Presidents, among them notable First Golfers William Howard Taft and Dwight Eisenhower.

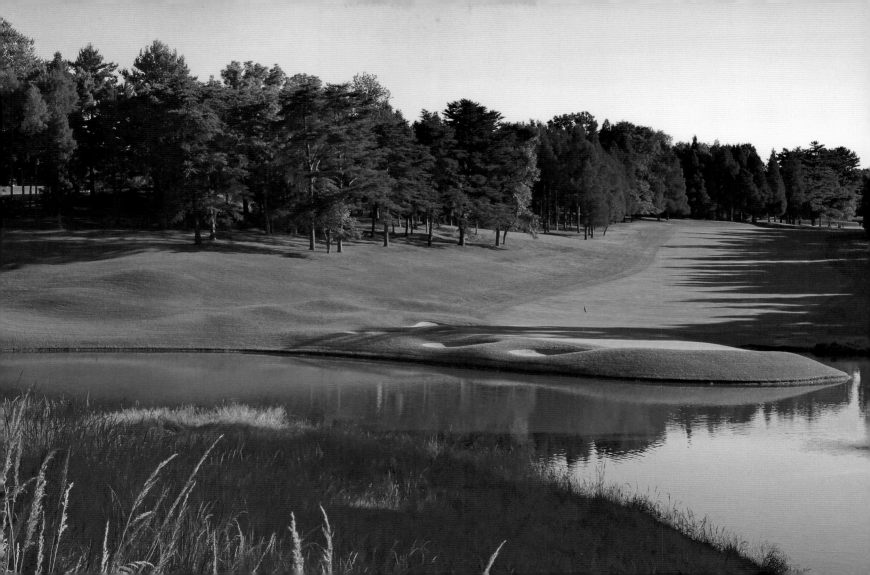

The Mid Ocean Golf Club is the crown jewel of golf in Bermuda, designed by the first great American golf course architect, Charles Blair Macdonald, in 1924. Located in Tucker's Town, the course begins and ends by the ocean, but the character of Mid Ocean is that of a striking inland layout rather than a traditional Scottish links. The course is laid out through coral hills forested with cedars, casuarinas, pines, oleander, hibiscus, and bougainvillea, with forced carries over marshy wetlands. The most famous hole is the fifth, which is one of the world's great Cape holes, that is, a hole where the golfer is challenged to bite off as much of the diagonal carry across the hazard as he or she dares. In this case, the golfer drives from an elevated tee across Mangrove Lake, with the elongated green tucked back against the corner of the lake.

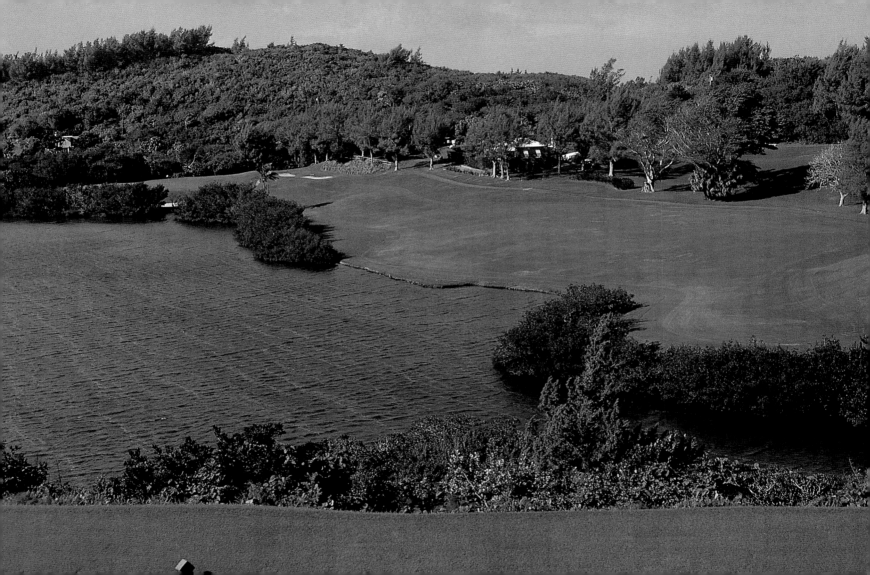

Royal Lytham and St. Annes is one of Britain's most incongruous championship courses, for it embodies all the characteristics of seaside golf, including odd bounces on the lumpy fairways and phalanxes of pot bunkers, but the links is surrounded by the red brick rowhouses of urban England. Lytham lies about a mile from the coast, with a railway line running along the course's seaward side and homes built by the St Annes-on-Sea Land Building Company, founded by a group of Lancashire businessmen in 1874, on the other. The club was founded in 1886 by Alexander Doleman of Musselburgh, Scotland, a talented golfer who had opened a school in the then fashionable resort of Blackpool. In 1897, the club moved to its present site, with the course laid out by George Low and subsequently refined by Herbert Fowler, Harry Colt, and C.K. Cotton. Bobby Jones won the first British Open held at Lytham in 1926, and the mashie he used for his miraculous escape from sandy perdition on the 17th hole hangs in the clubhouse. Seve Ballesteros was the winner in both 1979 and 1988, while Tom Lehman became the first American professional to win the Open at Lytham in 1996, followd by David Duval in 2001.

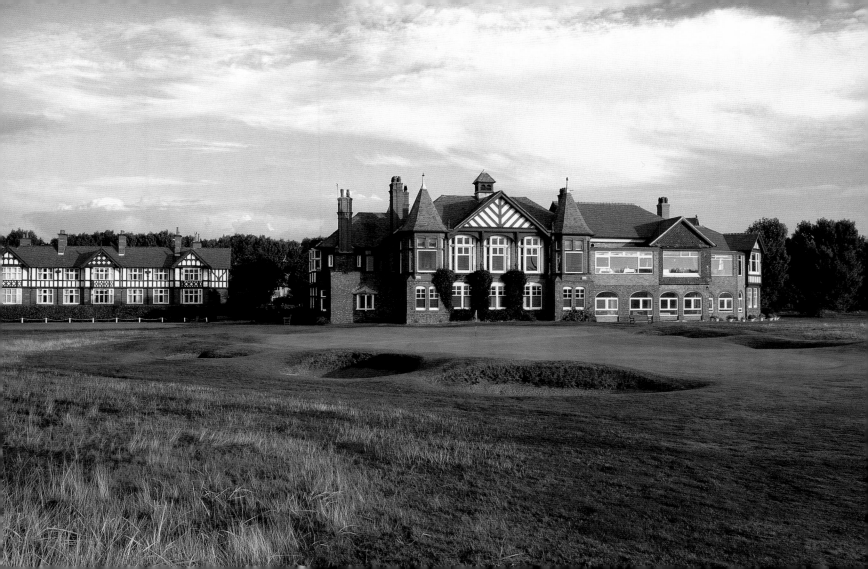

The Lancashire coast of northwest England running north from Liverpool to the town of Southport offers an abundance of outstanding links courses, including Southport & Ainsdale, Formby, Hillside, and West Lancashire, but none feature more majestic dunes than Royal Birkdale. Birkdale is also considered an exceptionally fair links, which helps to explain its popularity for championship events, having hosted eight British Opens since it became part of the rota in 1954, as well as two Ryder Cup matches and the Walker Cup. The original course opened in 1889, but the club moved to its present site in 1897, and the course was revamped by Fred Hawtree and J.H. Taylor in 1931. The futuristic clubhouse, resembling a white, curvilinear ocean liner, was also built in 1931. The holes ripple through the sandhills, with the greens sequestered between the dunes. Birkdale has had an illustrious list of Open champions. Arnold Palmer won his first British Open title at Birkdale in 1961, overcoming a gale that ripped through the course on the second day of the tournament, while Peter Thomson, Lee Trevino, Johnny Miller, Tom Watson, Ian Baker-Finch, and Mark O'Meara have also won at Birkdale. Most recently, in 2008, Padraig Harrington won his second consecutive Open championship at Birkdale.

BELOW: The clubhouse

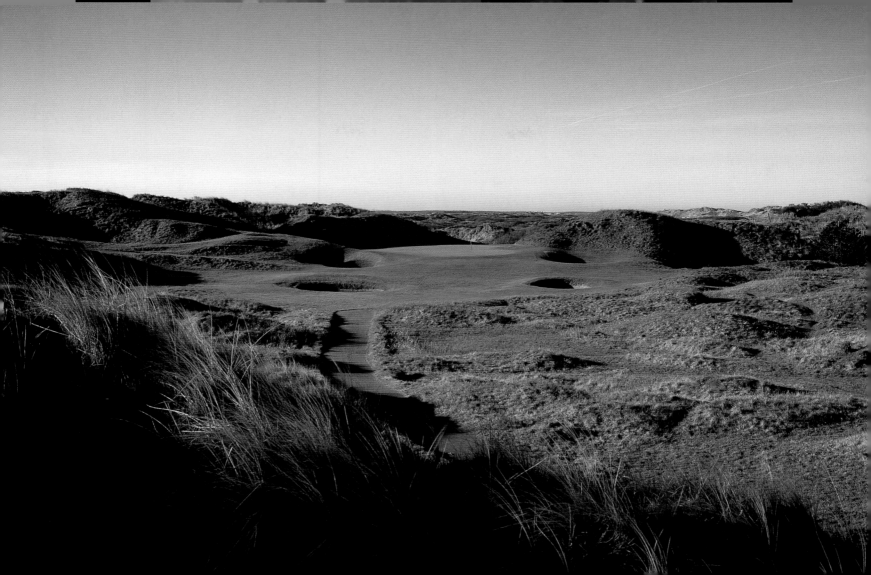

Formby Golf Club lies on the Lancashire coast, a course of rich turf nestled in the sandhills and piney woods, just 14 miles north of Liverpool and five miles south of Southport. The club was formed when 10 gentlemen met at the Reverend Lonsdale Formby's reading room on December 11, 1884, and resolved to name it the Formby Golf Club. Nine holes were then laid out over the rough, sandy terrain of a rabbit warren, expanded to 18 by 1893, with the imposing clubhouse opened by Lord Derby in 1901. The present course is largely the work of Willie Park, Jr., carried out in 1907. The opening holes are laid out on the flat ground, with the railway line running along the first, before the course begins to funnel through the formidable sandhills. Unlike most seaside links, Formby is bordered on three sides by forests of firs, creating a strong sense of seclusion. The threat of coastal erosion caused the club in the early 1980s to replace the old seventh through 10th holes with holes that run through the woodlands. Formby has hosted three British Amateurs, including 1984 when José María Olázabal beat Colin Montgomerie in a memorable final. As Frank Pennink once wrote: "It is easy to fall in love with Formby at first sight, for it has that rare trait of real charm to a very high degree."

West Lancashire is a links course of the first league, although it is less well known than its royal neighbors in the northwest of England— Birkdale, Liverpool, and Lytham & St. Annes— each of which is an Open venue. The club was founded by members of Royal Liverpool (Hoylake) in 1873 at Blundell-sands, north of Liverpool, making it one of the ten oldest clubs in England. The designer of the original links is unknown, but Ken Cotton and Fred Hawtree revised the layout, which is routed in two loops from the clubhouse, in the early 1960s. West Lancs is a classic links course of sand ridges and deep bunkers, set at the edge of the Irish Sea close to the shipping channel out of the port of Liverpool; the more sheltered inland holes run close to the railway line. There are sweeping views of the Mersey estuary, of Anglesey and the Welsh hills to the west, and across the Crosby Channel to Birkenhead peninsula and Liverpool Bay to the southwest.

Conwy Golf Club is an inviting links laid out on the Morfa Peninsula on the coast of North Wales against the backdrop of the Conwy Mountains. Several of the holes on the front nine play hard-and-fast along the Conwy Estuary, with views over the bay to the Great Orme, the limestone headland above Llandudno, and Anglesey beyond. The back nine skirts beneath the mountains before heading into the banks of gorse on the finishing holes. Conwy has hosted the Wales Seniors Open in recent years, an event on the European Senior Tour, and the European Amateur Team Championship in July 2009. The Club was founded in 1890, with the original course designed by a group of members from the Royal Liverpool Golf Club (Hoylake), so it was fitting that Conwy became the first Welsh club to hold the Final Qualifying for the British Open when the championship returned to Hoylake in 2006. The clubhouse displays the three classic paintings of the course by Douglas Adams from the 1890s, reproductions of which are found in golf clubs around the world.

Pennard Golf Club, which has been called the links in the sky, has a strong cult following among lovers of uninhibited links golf. The course is located in a sublime setting on the seaside cliffs of the Gower Peninsula near the village of Southport, eight miles west of Swansea, overlooking Oxwich and Three Cliffs Bays some 200 feet below. Pennard offers all the quirky delights of links golf and then some, with firm fairways filled with humps and hollows, and ridges of dunes running through the course. While the club traces its history back to 1896, the course owes much of its character to the routing created by the great Scottish golfer James Braid in 1908, with significant revisions made by C.K. Cotton in 1965 and further alterations by Donald Steel in 1991. One of the most scenic and memorable holes is the seventh, playing from a high tee out to the sea, past the ruins of Pennard Castle, built by Edward I as one of the iron ring of fortresses intended to subdue the Welsh. The 16th is another showstopper, a par-five from an elevated tee to a green snug against the cliff, with the vertical folds of the headland beyond.

Royal Porthcawl, located on the Glamorgan Coast between Cardiff and Swansea, is the championship course of Wales. Without the barrier of sand dunes found on so many links courses, the sea is in plain sight from every single hole at Porthcawl. Indeed, the first three holes all run directly along the seashore, with views south to Somerset and Exmoor, and northwest across Swansea Bay to the Gower Peninsula. The 18th slopes downhill, playing into the prevailing coastal winds, with the second shot across a deep grassy hollow to a green at the edge of a wide beam of beach along the Bristol Channel.

Porthcawl is foremost among Welsh courses in hosting leading amateur events, including the British Amateur Championship six times, the 1964 Curtis Cup, and the 1995 Walker Cup, when the U.S. team led by Tiger Woods went down to defeat. The club was founded in 1891 by a group of Cardiff businessmen, and Charles Gibson, the professional at Westward Ho!, was hired to lay out the original nine-hole course. The club moved to its present location in 1895, adding nine holes, and three years later the original nine holes at Lock's Common were abandoned and the present 18-hole layout established.

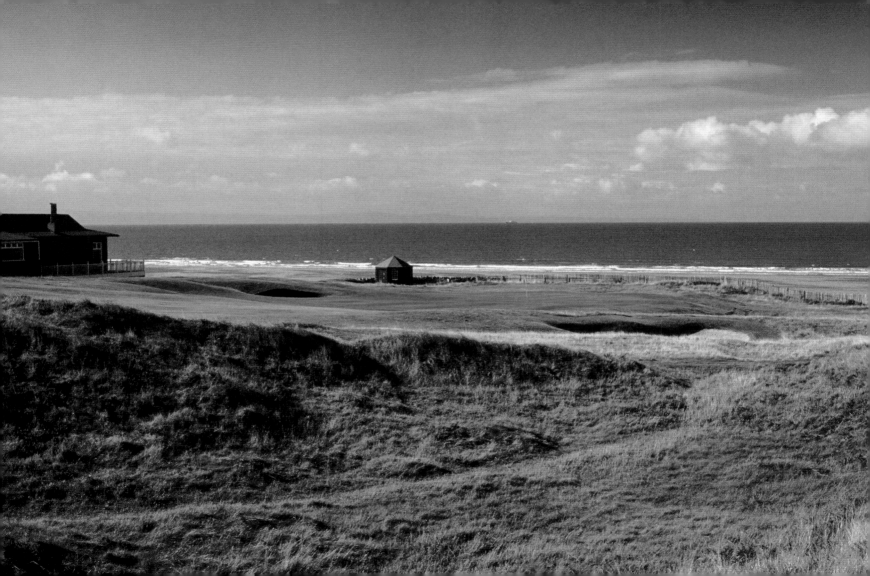

The Celtic Manor Resort, located in Wales's Usk Valley near Severn Bridge, is a golfing stronghold that features three courses—the original Roman Road Course designed by Robert Trent Jones, the Montgomerie Course, and the Twenty Ten Course that was specifically constructed as the dramatic stage for the 2010 Ryder Cup Match. Celtic Manor is the brainchild of Welsh-born telecom billionaire Sir Terry Matthews, who created the resort from the dilapidated 19th-century manor house-turned maternity hospital where he was born. A punishing 7,493 yards, the Twenty Ten Course is actually an amalgam of nine holes from what had been the Resort's Wentworth Hills Course designed by Robert Trent Jones, Jr.—which were extensively remodeled—and nine brand new holes consisting of the first through fifth, 14th, 16th, 17th, and 18th.

The course sweeps along the broad floor of the Usk Valley, with the middle holes playing along and across horseshoe-shaped lakes and the final four flanked by a giant ridge. The Twenty Ten is no mere mortal of a course, but was created by European Golf Design to challenge the pros from both sides of the Atlantic when Wales hosts the Ryder Cup for the first time. The Montgomerie Course was designed by 2010 Ryder Cup captain Colin Montgomerie to incorporate the starting and closing holes of Wentworth Hills as the front nine with a new back nine. The Roman Road Course, which opened in 1995 and is named for the many Roman roads that once ran across the site, overlooks the Severn Estuary. The course hosted the Celtic Manor Wales Open in 2005–2007, which is now played on the Twenty Ten Course.

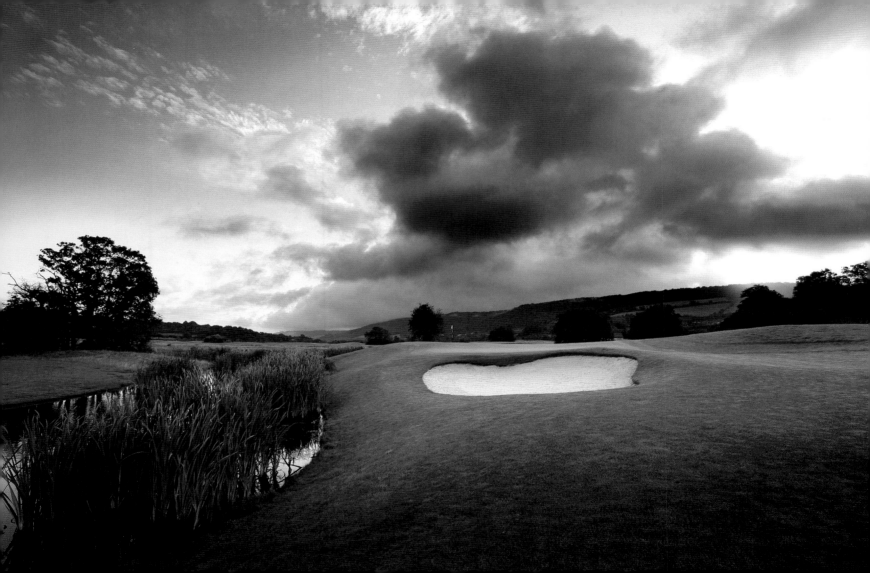

St. Enodoc Golf Club is in north Cornwall, lying above the tiny village of Rock and overlooking the estuary of the River Camel, which is crossed by ferry from Padstow. This quaint seaside course features some of the most stupendous sandhills in all of golf with lyrical views across Daymer Bay. The sixth hole, named the Himalayas, requires a second shot over the mountain of dune with its cratered bunker that dwarfs even the Alps at Prestwick and the Maiden at St. George's. The 10th hole turns inland, hugging Brea Hill, with a series of holes around the ancient St. Enodoc Church. Sir John Betjeman, the poet laureate who wrote much verse about playing at St. Enodoc, lies buried in the little church. The club was founded about 1891, although golf had been played in the dunes even earlier, with the full 18-hole course laid out by James Braid in 1907.

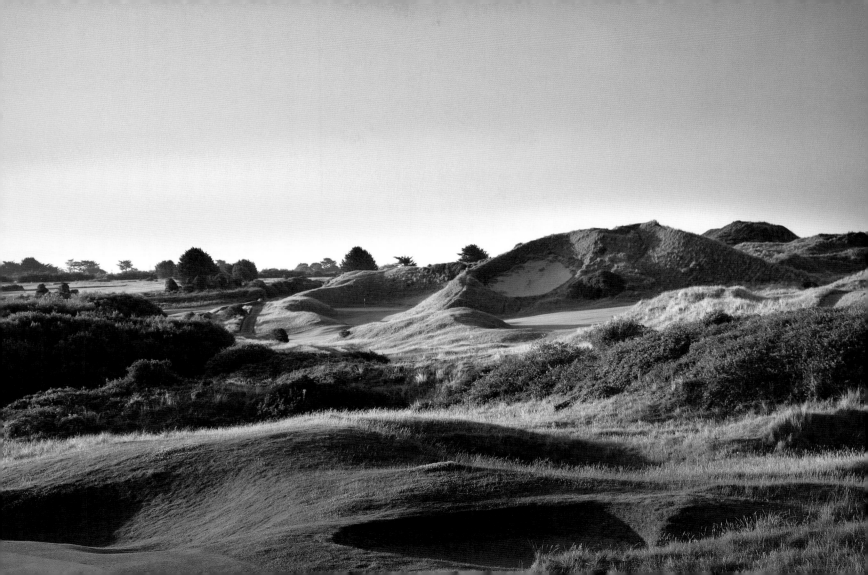

Saunton Golf Club, with its East and West Courses, represents the cream of English links golf, located on the remote southwest coastline in North Devon. The courses are laid out on the Braunton Burrows, the Himalayas of England's sand dunes, bordered by the Taw estuary, with the links of Westward Ho! on the other side, overlooking Bideford Bay and the Saunton Sands. Golf at Saunton began in 1897 with a nine-hole course—extended to 18 in 1908—but the current East Course is the work of the indomitable Herbert Fowler, creator of Walton Heath, and was carried out in the 1920s. Fowler returned to design the West Course, a slightly shorter and hillier layout that gives the East a run for its money, in 1935. The courses were used for battle training in preparation for D-day and were badly damaged, with the East Course not reopening until 1952. The fairways of the East Course glide through the barrier dunes, which are home to over 500 species of flora, including many rare varieties, and have been designated a biosphere reserve by UNESCO. The course moves to flatter, marshier ground for a series of holes beginning with the sixth. The links then builds to a crescendo of a finish with the dogleg 16th, named for Fowler, swinging around the dunes, followed by a long, downhill par-three named Goodban after the club's captain and historian John Goodban. The 18th rounds the corner of another mesa-like dune, with the second shot aimed at the clubhouse clock.

Westward Ho! or Royal North Devon Golf Club was founded in 1864, making it the first links course in England, with the existing design largely the work of W. Herbert Fowler in 1908. This wild and entrancing links, a kind of golf time capsule, was laid out on the open land known as the Burrows just south of the Torridge estuary in the town of Westward Ho! Cattle, horses, and sheep freely graze over the course since it lies on common land. The course runs along the pebble ridge that protects the land from the waters of Bideford Bay, although in recent years the ridge has been breached by the sea. The middle holes play around giant sea rushes, up to six feet tall, with bayonet-like tips that are mildly poisonous. The highest point on the course is the sixth tee, which provides a stirring view across the estuary to the villages of Appledore and Northam up the hillside, where Westward Ho!'s most famous son, J.H.Taylor, the five-time British Open champion, was born and lived out his life. The club and the town both take their name from the popular 19th-century novel by Charles Kingsley.

Broadstone Golf Club is an unblemished heathland golf course set in the tranquil, tessellated Dorset countryside of southwest England. With its fairways framed with porphyrous banks of heather and rhododendron, and separated by pine, chestnut, and silver birch, Broadstone is the archetype of the English heathland course. Bernard Darwin described it as "the Gleneagles of the South." The club, originally named the Dorset Golf Club, was founded by Ivor Bertie Guest, first Baron of Wimborne, in 1898. The original course was laid out by Tom Dunn, but in 1914 the great Harry Colt was called in. Colt shifted the parkland holes on 10 through 16 to create a full-scale heathland layout. Further refinements were made by Willie Park, Willie Park, Jr., Herbert Fowler, and by Colt on a second visit, with the course remaining essentially as he left it in 1920, with its glorious views from the elevated back nine across the Purbeck Hills and Poole Harbour.

Rye is a course steeped in the tradition of English golf. It is located on the southeast coast and entered through the medieval Land Gate at the end of the small village of Rye, one of the ancient Cinque Ports. The club, which is very private, was founded in 1894 and was the first course designed by Harry Colt. Colt, who was only 25 years old at the time and working as a solicitor, was elected the first captain and would go on to become the greatest of English course architects. The current course, however, is in good part the work of Tom Simpson in 1932 and Sir Guy Campbell in 1938. Rye is an unusual course, and one that elicits fierce devotion from its members. Barely measuring 6,300 yards and playing to a par of 68, Rye is nonetheless renowned for its challenge, with filaments of twisting fairway, uneven lies, and constant crosswinds. The only par-five comes at the first hole, and there are nine punishing par-fours that measure over 400 yards each, while the course is famed for its quintet of par-threes. Rye is also the home of the President's Putter, the match play event that has been held every January since 1920 between members of the Oxford and Cambridge Golfing Society. The members of Rye over the years comprise a Who's Who of English golf, including the illustrious golf writer Bernard Darwin, who moved into the old Dormy House at the club in 1954 after the death of his wife. Of Rye, Darwin wrote: "Surely there can nowhere be anything appreciably better than the golf to be had at this truly divine spot."

There are few more joyous places to play golf than Royal St. George's in Sandwich, with the larks trilling above the links overlooking Pegwell Bay. The course is on the Channel Coast, with Prince's adjoining to the north and Royal Cinque Ports in Deal just to the south. The overwhelming feature of St. George's is the immense sand dunes, with the fairways running through the cloistered valleys. St. George's was founded by Dr. Laidlaw Purves, an eye specialist from Edinburgh, who first gazed upon the chain of giant sandhills when he and some friends climbed to the top of St. Clement's Church in Sandwich. The course opened to great acclaim in 1887, was chosen as the site for the British Amateur in 1892, and then became the first course in England to host the Open Championship two years later. From 1894 to 1949, Sandwich held the Open nine times. The par-five fourth displays one of the most cavernous bunkers in the United Kingdom, while the par-five 14th is crossed by a small stream known as the Suez Canal. St. George's again began hosting Opens in 1981, and has been the scene of two of the more remarkable recent Opens, with Greg Norman sailing to victory in 1993, and Ben Curtis, the darkhorse from Ohio, pulling off his stunning upset in 2003.

BELOW: Starter's hut

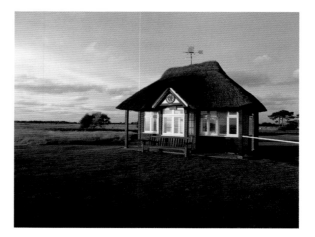

Royal West Norfolk, better known as Brancaster, is often compared with Hunstanton, for they are the two superb links of East Anglia. Brancaster is the more uneven, old-fashioned, and romantic of the two, laid out on the narrow strip of land between the dunes of the Norfolk coast that run down to the harbor of Brancaster Staithe and the saltmarsh called Mow Creek. The eighth and ninth holes are the heart and soul of the course, renowned for what Bernard Darwin termed their "overpowering lonely gorgeousness." Both holes leapfrog with forced carries across the marsh, with a particularly menacing example of the many deep, sleepered bunkers strewn along the course guarding the ninth green. During unusually high tides, the marsh floods and the club-house is cut off from the rest of the course. Brancaster was the favorite course of the late Dai Davies, the golf correspondent for *The Guardian*, and he wrote of his final round there: "The day was still bright as we played the 8th and 9th holes where the marsh intervenes to set the golfer stern challenges, leavened by the sheer beauty of the place. There are tee views over marsh and inlet to Brancaster Staithe and to Scolt Head, and an immense panorama of sea and sky that is almost overwhelming."

Sheringham Golf Club is an outstanding example of a rarity in English golf, the cliff-top ocean course. Nearby Royal Cromer provides another fine illustration. Sheringham is located on the Norfolk coast just outside the town center, with fairways canted across the sheer chalk cliffs hived with gorse and buffeted by winds above the North Sea. The club was founded in 1891, with Tom Dunn laying out nine holes, which he expanded to a full 18 in 1898. The course reaches the tops of the cliffs on the uphill, par-four third, with the next four holes wandering over the dramatic heights. The back nine occupies slightly flatter ground through the gorse, with the vintage steam trains chugging by on the preserved North Norwalk Railway offering a pleasant distraction. It was here in 1920 that 18-year-old Joyce Wethered won the English Ladies Championship, the first of her major victories, sinking the long, winning putt on the 17th hole just as the 4:20 train out of Sheringham station passed by. As Bernard Darwin described the scene: "It was by the way near the 17th green that there first appeared the traditional railway train which puffed and snorted loudly as Miss Wethered putted out and of which she was so unaware, that, on being congratulated on her imperturbability, she is alleged to have asked, 'What train?'" Ever since, the 17th at Sheringham has been named "What train?"

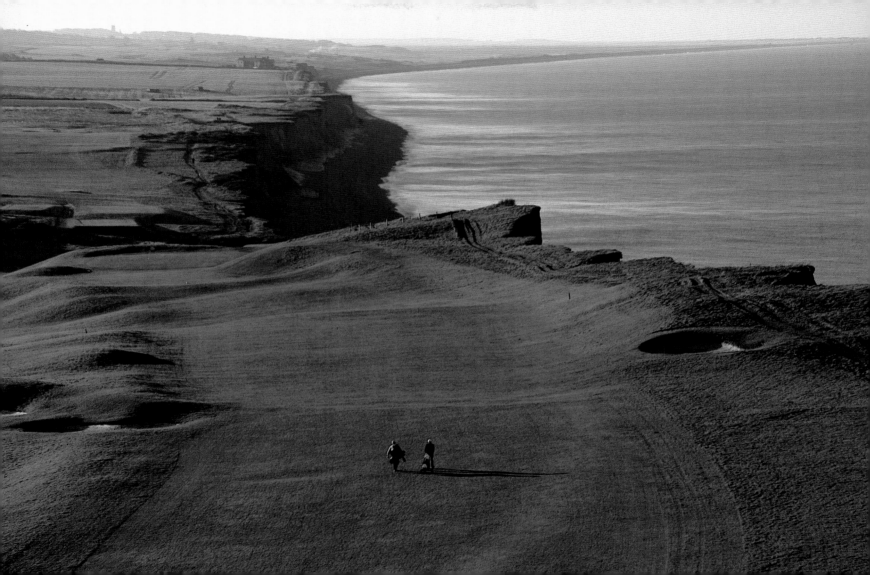

Woodhall Spa is the exemplar of that particularly British genus of golf courses, the heathland links. Unlike the better-known seaside links of Scotland and England, Woodhall Spa is tucked away amidst the farmland of Lincolnshire in northern England. Its fairways are surrounded by fields of heather that burn like purple embers in the summer with accents of yellow gorse set against a layered backdrop of oak, fir, and silver birch. The Hotchkin Course takes its name from Stafford Hotchkin, or Col. S.V. Hotchkin, who came to own Woodhall Spa in the 1920s. Hotchkin substantially redesigned the existing course that had originally been laid out by Harry Vardon in 1905 and revised by Harry Colt, creating the cavernous bunkers carved from the sandy soil for which the course is known. Woodhall Spa itself is a resort village that owes its existence to the discovery of mineral waters in the early 19th century. The resort flourished in the early 1900s, with guests coming for the bromo-iodine waters, golf, and the summer pastoral of woodlands and rhododendrons. The tower on the moor, the emblem of the village, dates from the 1440s and is located behind the third green. In 1995, the English Golf Union acquired Woodhall Spa, where it has its headquarters, and built a second course named The Bracken.

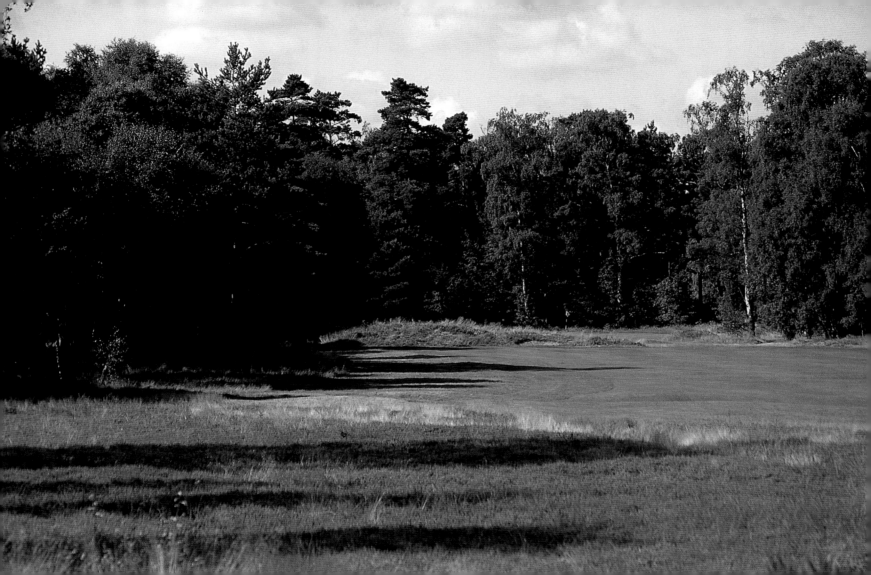

Golf flourished in France at the turn of the 20th century at the famous seaside resorts of Normandy—Dieppe, Étretat, Cabourg, Grandville, and Deauville. Golf d'Étretat lies atop the spectacular white limestone cliffs that make this France's Alabaster Coast. Like many of the courses along the Channel Coast, Étretat was started by visiting British golfers. Founded in 1908, the course was laid out by Monsieur Chantepie, the designer of La Boulie outside Paris, with advice from Arnaud Massy, the only French golfer ever to win the British Open (he did it in 1907). The white cliffs of Étretat and its harbor attracted many of the great Impressionist and landscape artists, including Corot, Boudin, and Monet. At the far end of the cliffs from the course is the monument to the aviators Charles Nungesser and François Coli, who were last seen over Étretat in 1927 during their unsuccessful attempt to fly from Paris to New York in their biplane, the White Bird.

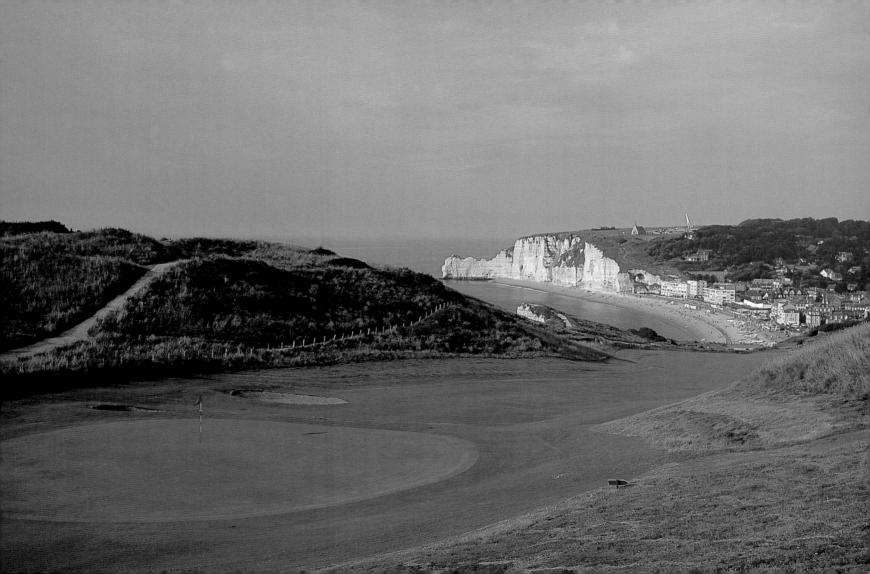

Morfontaine is the heathland masterpiece of Tom Simpson, one of the high priests of golf course architecture during the golden age of the 1920s. The Club is located outside Paris, in Senlis, but would fit right into the Heath Belt of Surrey outside London, which is home to so many of the outstanding inland British courses from which Morfontaine takes its inspiration. Simpson was hired to lay out the course in 1927 on the estate of the 12th duc de Gramont, 30 miles north of Paris. The course was intended as a private playground for the duke and his entourage, but within three years it became a private club; the understated ivy-covered clubhouse remains a gathering place for France's golfing elite. The course is a secluded journey through the sylvestre or Scotch pines, a par-70 with five par-threes, quilted with purple heather and fern beds. There have been some minor touch-ups by American architect Kyle Phillips in recent years, but Morfontaine remains the beau ideal of its British master.

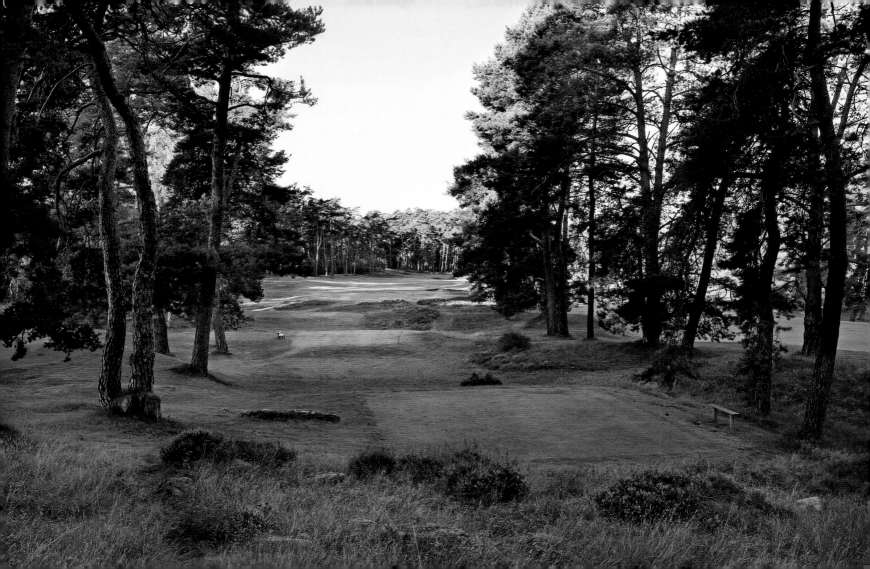

Saint-Nom-la-Bretèche is one of the big four traditional clubs of Parisian golf, together with Chantilly, La Boulie, and St. Cloud, and has made a major contribution to the development of golf in France. The two courses, the Red and the Blue, are set in the rolling, wooded countryside of La Tuilerie, 15 miles to the west of Paris, in the village that takes its name from the ninth-century co-bishop Saint Nonne and from La Bretesche, a medieval wooden stronghold at the edge of the old oaks of the Forest of Cruye, now known as the Forêt de Marly. The genesis of the courses came about when the Ferme de le Tuilerie, a large farm, was put up for sale in 1954.

The courses, designed by the English architect Fred Hawtree, opened on the site in 1959 and burst on the international scene in 1963 when the club hosted the Canada (World) Cup played over the Red Course, with Jack Nicklaus and Arnold Palmer the winners. A few years later, one of the prominent members, Gaëtan Mourgue d'Algue, approached the chairman of the Lancôme Company about sponsoring a professional tournament to promote the sport in France. The Trophée Lancôme, played at Saint-Nom-la-Bretèche from 1970 through 2003, became one of the most fashionable and prestigious events on the European Tour. The restored 18th-century buildings of the old farm provide the club with one of the more magnificent clubhouses in Europe.

NOVEMBER 1 | LE GOLF NATIONAL (L'ALBATROS)—FRANCE

L'Albatros or the Albatross Course at Le Golf National ushered in a new era in French golf when it was created in 1991 as the home course of the French Open, and it has proved a worthy stage for the championship. Designed by Robert von Hagge and Hubert Chesneau over what had been farmland, the course exemplifies the stadium course, target style of design popularized by American architects in the 1980s, particularly Pete Dye's TPC Stadium Course at Sawgrass in Florida, which became the international standard. Located at Guyancourt, 20 miles southwest of Paris, L'Albatros features spectator mounding, Floridian-sized water hazards, large, tumbling greens, and an island green 15th hole. In 2004, Jean-François Remésy captured the French Open at Golf National, becoming the first Frenchman to claim victory since Jean Garaïalde 35 years earlier. Remésy was the repeat winner the following year, out-dueling countryman Jean Van de Velde in a playoff. Le Golf National also has a second course, named L'Aigle, as well as a nine-hole layout, L'Oiselet.

There is a passel of superb parkland courses in the environs of Paris, the first of which was La Boulie, opened in 1901, followed by Fontainebleau in 1908, and Chantilly a year later. These clubs, which also include Morfontaine and St. Germain, are frequently compared to the splendid and better-known courses around London, because they share similar terrain and several were also designed by the leading old-school English architects. In the early 1920s, the English architect Tom Simpson was engaged to redesign the existing holes at Chantilly to create the championship course known as Le Vineuil. The course is set in the great forest of the Île-de-France, 25 miles north of Paris, and there is a serene spaciousness to many of the holes despite the dense woodlands. Near the course are the famous stables that make this the French thoroughbred country. Chantilly opened on September 28, 1909, with an exhibition match between French champions Arnaud Massy and Jean Gassiat, and five years later it hosted what was to be the first of many French Opens. Over the years, Henry Cotton, Roberto de Vicenzo, Peter Oosterhuis, and Nick Faldo all have won the French Open at Chantilly.

NOVEMBER 3 | PARIS INTERNATIONAL GOLF CLUB—FRANCE

Paris International Golf Club, which opened in 1991, is Jack Nicklaus's contribution to the French golfing scene. He was given a fine piece of property to work with, located in the hamlet of Baillet-en-France on the estate of the family of Baron Empain, the Belgian railway builder and Egyptologist who created the town of Heliopolis in the desert outside Cairo after his arrival in Egypt in 1904. The two nines are quite distinct, with a more open front nine and the fairways of the back nine forming esplanades through the old oaks and chestnuts, finishing with a par-five, island green 18th hole. The Club has an impressive whitewashed, Norman-style clubhouse.

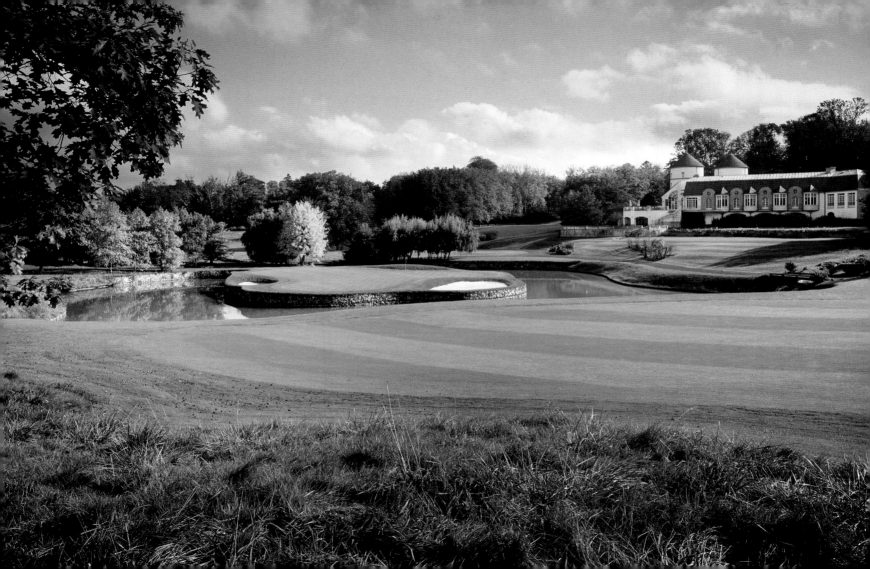

Les Bordes is an exquisite golfing mosaic set in the heart of the Sologne, a region of boggy, untrammeled forest near the Loire Valley that is known for its wild boar, wild mushrooms, and white asparagus. The course was established in 1986 by the late Baron Marcel Bich, inventor of the ballpoint pen that bears the Bic name, on his hunting estate. After the Baron's death in 1994, the course was taken over by his friend and co-founder Yoshiaki Sakurai. Designed by American Robert von Hagge, Les Bordes is the premier course in France and one of the finest in Europe. While its remoteness prevents the course from gaining more acclaim, it adds mightily to the overall ambiance. Von Hagge wove the fairways through the Sologne countryside and there are long rifts of waste bunkers, native grasses, large ponds, and patches of marshland that encroach on the fairways. The rustic clubhouse is very pleasant, and the putting green serves as a sculpture garden. Jean Van de Velde holds the course record of one under par.

BELOW: Putting green sculpture garden

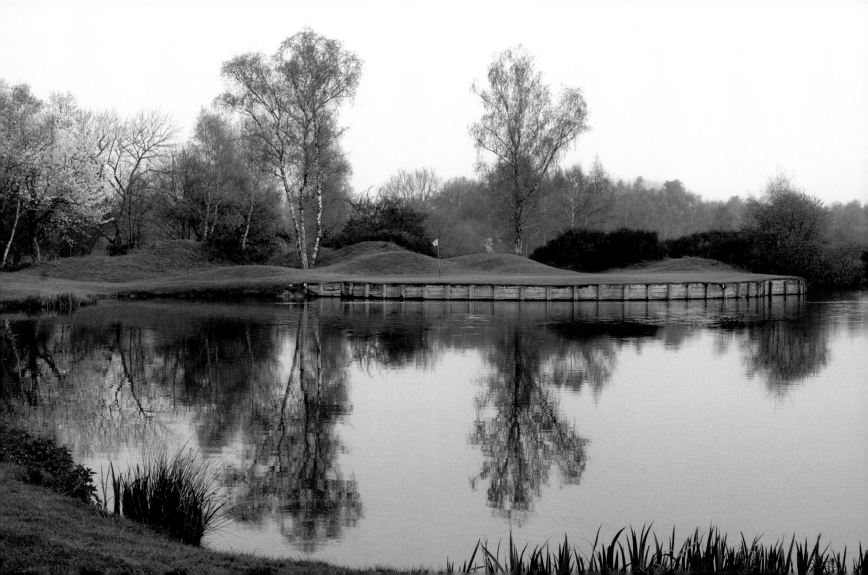

Sicily has warmed to golf in recent years, with a pair of sun-splashed courses set amidst the rolling valley of olive, lemon, and orange groves beside the Mediterranean on the 568-acre estate of the Verdura Golf & Spa Resort. Opened on August 1, 2009, the sleek and elegant earth-toned resort is part of the Rocco Forte Collection and is located in the southwest corner of Sicily, near the fishing port of Sciacca. Agrigento, a little farther down the coastline, is famous for its ancient Greek temple ruins. The Verdura's East and West Courses, as well as a nine-hole, par-three course, were designed by American architect Kyle Phillips. The fairways run from the foothills of the interior mountains through the orange trees and native Sicilian grasses down to the coastline and the royal blue sea. The resort also created a composite championship course of 7,458 yards that combines holes from both courses for tournament play.

Sicily offers other golfing pleasures as well. The Palmerston Etna Golf Resort and Spa, beneath Mount Etna, has a course designed in 1989 by Italian architect Luigi Rota Caremoli through oaks, hazels, and vineyards. Caremoli followed up with his design for Le Madonie Golf Club, on the northern tip of the island overlooking the Tyrrhenean Sea, with five lakes spread through thousands of olive, orange, lemon, and carob trees.

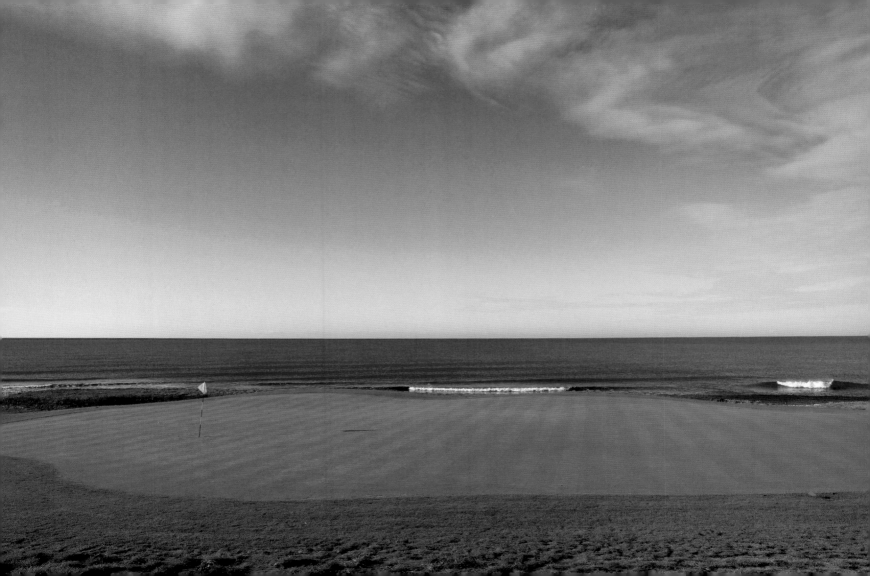

Despite its Olympic heritage and sun-drenched coastline, golf has never been a significant part of the Greek sporting scene, but that is beginning to change. For many years, the best-known course was Glyfada, on the outskirts of Athens overlooking the Saronic Islands. In July 2003, the Crete Golf Club opened on the eastern Mediterranean island that is the largest in the Greek archipelago and birthplace of the ancient Minoan civilization. Developed by local hoteliers, the course is located on the coastline at Hersonissos (Chersonissos), near the capital of Heraklion. Its fairways brushed with olive and carob trees, the course offers unmatched views of Crete's mountainous spine and out to the achingly blue waters of the Aegean coast. Designed by Bob Hunt, the broad fairways are broken with rocky outcroppings, with the par-three sixth playing across a deep ravine to a two-tiered green carved into the foot of a hillside.

NOVEMBER 8 | APHRODITE HILLS GOLF CLUB—CYPRUS

Aphrodite Hills Golf Club captures the essential character of the Cyprian landscape. Opened in 2002, it is a testament to its designer, Cabell Robinson, who first visited the site over 20 years earlier. The fairways are pitched along two stony plateaus, sprinkled with olive, carob, and lentisk trees, separated by a rock-strewn ravine and sheltered by a protective forest. The course is the centerpiece of a luxury resort that includes a hotel, spas, and a golf academy with three additional holes. The eighth and 15th holes offer marvelous views over the Mediterranean, while the seventh is a par-three set in the canyon, with a dramatic carry to the large green. Aphrodite Hills is situated near Paphos on the southwestern coast, where the Temple of Aphrodite, built about 1500 B.C., once stood on a knoll overlooking the sea. Palea Paphos remained the center of the cult of Aphrodite, the Greek goddess of love and fertility, until the Emperor Theodosius banned paganism in the fourth century.

The Korineum Golf and Country Club is located in the Mediterranean village of Esentepe near the ancient coastal town of Kyrenia, and is the first 18-hole course built in Northern Cyprus—the area of the island controlled by Turkey The Beşparmak or Five Finger Mountains, jutting from the alpine greenery, serve as backdrop to the course, its fairways flowing down to the Mediterranean through the natural forest of umbrella pines and olive groves. Kyrenia is a land of Crusader castles, mountain abbeys, and abundant wildflowers, its horseshoe-shaped harbor dominated by a hulking Byzantine-era castle, now a museum.

BELOW: Monastery at Kyrenia

The resort area of Belek has become Turkey's golfing Riviera, with over a dozen courses overlooking the Mediterranean coast of southwest Turkey. Golf first came to the region when the National Golf Club, which remains one of the top layouts, opened in November of 1994. The National was followed in 1997 by the Gloria Golf Resort, now expanded to 45 holes, with its original 18 designed by France's Michel Gaydon. Other noteworthy tracks include the Robinson Club at Nobilis, ambling through a pine forest along the River Acisu, the Antalya Golf Club with its championship Sultan Course, and Nick Faldo's contribution, the Cornelia Golf Club. One of the newest arrivals, opened on September 1, 2008, is the Montgomerie Course at Papillon Golf Club, created by Colin Motgomerie and European Golf Design for the new Papillon beach resort hotel. With its distinctive, puffy parasol pines and sandy waste areas, the course has the flavor of Pinehurst on the Mediterranean. Belek is 30 miles east of Antalya, the capital of southwest Turkey, which was founded in 159 B.C. by Attalos II, King of Pergamon, and subsequently occupied by the Romans, Byzantines, Seljuks, and Ottomans, each of whom left their distinctive architectural stamp on the city.

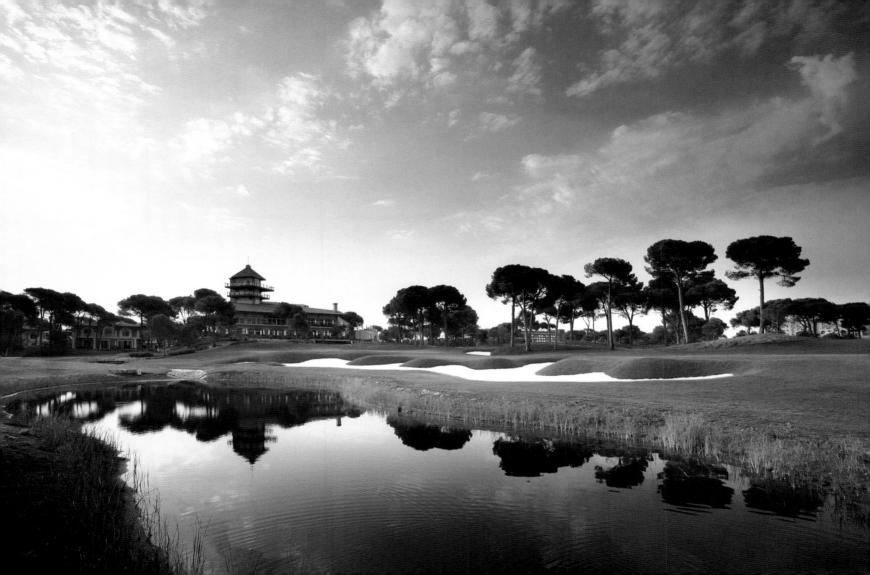

Caesarea Golf Club, the only course in Israel, lies on the Mediterranean coast halfway between Tel Aviv and Haifa. It embarked on a new chapter in its 50-year history on May 1, 2009, when it reopened for play with a course redesigned by America's visionary golf course architect, Pete Dye. The course is located outside the ancient port town of Caesarea, granted by Augustus Caesar to King Herod in 31 B.C., who named the town in his honor. After Herod's death, it became the provincial capital of Judea. The Roman ruins remain, including the amphitheater, which is the site of an annual jazz festival. The golf course was laid out on land that belonged to the Rothschild family prior to the founding of Israel and is the legacy of James de Rothschild, a devoted golfer who dreamed of creating a course at Caesarea after viewing the seaside dunes that reminded him of the Scottish coast. Following his death and the establishment of the Caesarea Edmond Benjamin de Rothschild Foundation, a Golf Club Committee was created in 1958, whose members included Teddy Kollek, the future Mayor of Jerusalem, and Abba Eban. The course officially opened in January 1961, with Lord Victor Rothschild, the Cambridge microbiologist, and Eban hitting the ceremonial first drives before a large assembly of prominent guests. Sam Snead then played an exhibition match, with Lord Cohen, a British judge and member of the Royal & Ancient Golf Club of St. Andrews, serving as referee. Since 1961, Caesarea has hosted a golf competition every four years that is part of the Maccabiah Games, where the gold medalists have included U.S. Senior Open winner Bruce Fleisher in 1969 and U.S. Open winner Corey Pavin in 1981.

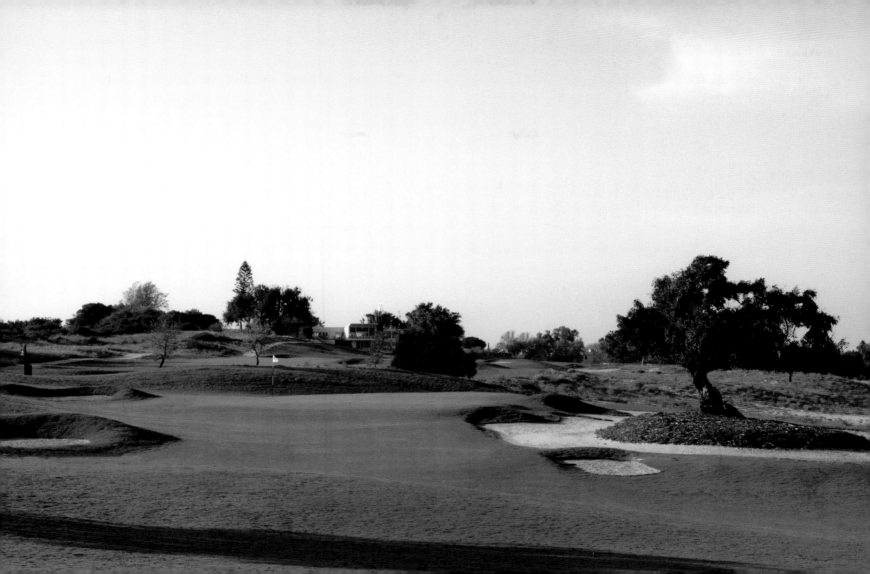

Riffa Views opened in 2008, adding the desert kingdom of Bahrain to the list of Gulf States—together with Dubai, Qatar, and Abu Dhabi—that can boast sensational sand-sculpted courses. Riffa Views is laid out through natural wadis (dry riverbed valleys), including the historic Al Hunaniyah Wadi. Designers Colin Montgomerie, a perennial star on the European Tour, and Robin Hiseman accentuated the desert features by creating ragged natural lines between the surrounding desert and the fairways, and introducing native plants and grasses. The fairway of the par-four fifth is split by a wadi, creating strategic optros on both the drive and approach. The course is part of a luxury development 15 miles outside Manama, Bahrain's capital city, which also sports a Boris Becker tennis academy. To celebrate the completion of the course, Riffa Views hosted an international skins match in November 2008 that featured Montgomerie, South Africa's Retief Goosen, New Zealand's Michael Campbell, and Colombia's Camilo Villegas. Riffa views completely replaced a predecessor course on the site named Riffa Golf Club, which was Bahrain's first grass course when it opened in 1999.

BELOW: Course designer Colin Montgomerie teeing off at Riffa Views in November 2008

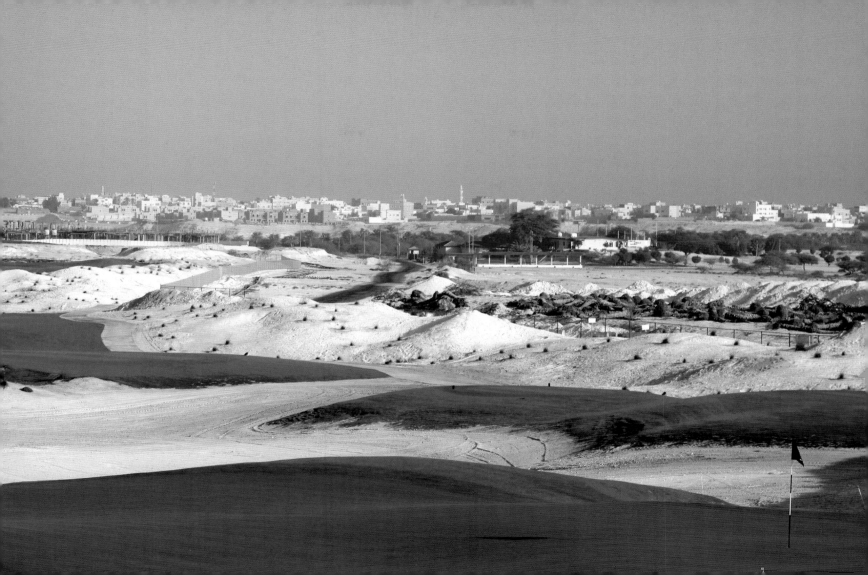

The Al Badia Golf Club, which is part of the Intercontinental resort at Dubai Festival City, is another shimmering golfing oasis in the desert Kingdom of Dubai, whose splendors include the Emirates Golf Club, Dubai Creek & Yacht Club, the Montgomerie Golf Club, and the Els Club at Dubai Sports City. Opened in 2007 and designed by Robert Trent Jones, Jr., the course is named for the Land of the Bedouins. The course was conceived as a watery oasis, with 85 acres of turfgrass. There are 11 saltwater lakes, small streams, and waterfalls that come into play on 12 of the holes. Jones also created what he describes as rivers of sand that add shadows, color, and elevation changes. The dazzling clubhouse is a swirl of blue glass, golden stone, and stainless steel, designed to evoke a golfer's swing, with an atrium filled with palms and water features.

The Els Club at Dubai Sports City is a striking desert links with an impeccably turned out ensemble of blue lakes, milky-white bunkers, and jade green fairways belted by the rippling dunescape. Opened by three-time major winner Ernie Els on January 28, 2008, and topping out at 7,538 yards, the Els Club is the showpiece of an exclusive golf course villa community in Dubai Sports City. In addition to the course designed by Els and his team, the development is also home to the only Butch Harmon School of Golf outside the United States, as well as the Manchester United Football Academy and the David Lloyd Tennis Academy. Conceived of as an integrated sports city with state of the art facilities, Dubai Sports City includes a 25,000-seat cricket stadium, a multipurpose stadium that seats 60,000, and a 10,000-seat indoor arena.

The Emirates Golf Club hosts the Dubai Desert Classic, a popular event with pros on the European Tour. The original Majlis Course, with its lush green fairways, was the first grass course in the Arabian desert, and is now complemented by the Wadi Course. Designed by Karl Litten in 1987, the Majlis Course takes its name from the Arabic for meeting place. Large ponds were excavated and the fill used to create fairways lined with palms and casuarina trees, creating a golf oasis in the bare desert that consumes nearly one million gallons of water a day. The Dubai Creek Golf Club, which opened in 1993, has a course that flows through ship-mast high date and coconut palms along the shores of Dubai's saltwater inlet from the Arabian Sea. The clubhouse of the Emirates Golf Club is designed to resemble a series of Bedouin tents, while Dubai Creek's clubhouse is modeled after an Arab dhow, with soaring white sails.

Not surprisingly, golf in India is rooted in the social history of the British Raj. Indeed, the Royal Calcutta Golf Club was founded in 1829, making it the oldest golf club in the world outside of Britain. Delhi Golf Club in New Delhi is a comparative youngster, tracing its origin to 1928, and it is one of the most interesting and exotic of the Indian courses because it is laid out among the 15th-century tombs of Mughal nobles. The unusual setting was selected by the chief of Delhi's horticulture department, a golfing Scotsman who headed a governmental committee entrusted with establishing a course for the capital city. An amateur archaeologist, he hoped to discover buried treasures while laying out what was originally known as the Lodhi Golf Club in the thick bush between the Mughal Emperor Humayun's tomb and the historic Babarpur *tehsil*, or estate. While no priceless artifacts were discovered, the course is one of the best in India, with the seventh green near the red sandstone Barah Khamba, or twelve pillars, a ruined mausoleum of the Afghan-Lodhi dynasty, and the Lal Bangla mausoleum beside the clubhouse. Expanded in 1950 and renamed the Delhi Golf Club, the Commonwealth War Graves Commission planted more than 200 trees and thousands of flowering shrubs, making the course a sanctuary for many species of Indian wildlife, including the peacocks that wander the fairways.

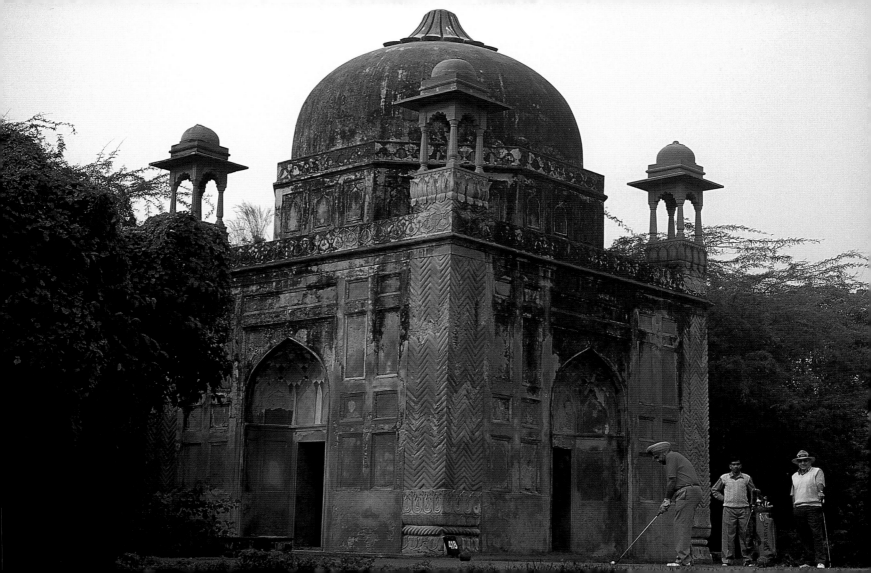

NOVEMBER 17 | GOKARNA FOREST GOLF RESORT—NEPAL

Gokarna Forest Golf Resort is a few minutes from Kathmandu in the Kingdom of Nepal, laid out in a 500-acre remnant forest of medieval Kathmandu Valley. The Himalayas provide the ultimate mountain backdrop for this course at the rooftop of the world, set in the former Royal Hunting Preserve that was once the Forbidden Valley. Opened in 2000, Gokarna was designed by young Scottish architect David McLay Kidd, who captured the golf world's attention with his unabashedly throwback links course at Bandon Dunes in Oregon. Gokarna is routed through groves of silver oaks with creeks and carp-filled lakes coming into play on several holes and spotted deer wandering the fairways. Most of the course runs through hills and valleys, but the sixth hole opens to the plain of the holy Bhagmati River.

Qinghe Bay Golf Club was developed in conjunction with the 2008 Beijing Olympics, and opened in August 2008 to the northwest of Beijing, across the river from the Olympic Village and in view of the Bird's Nest Olympic Stadium. In 1997, there were only 10 courses in the Beijing area, but a decade later the number had increased to about 50, with over 400 throughout China. Qinghe currently has 36 holes, with plans to add a third 18. The West and East courses were designed by Mark Hollinger of JMP Design, who has created several courses in China, including Jian Lake in Shaoxing, Zhejiang Province. The courses were laid out on the far bank of the Qin River, with abundant water hazards. Trees were planted throughout the layout, with semimature Chinese red pines selected as the dominant specimen tree. With its attractive landscaping, one would never guess that Qinghe had previously been a dump site.

Beijing Pine Valley Golf Resort & Country Club is located about 40 miles west of the city's central business district, in Changping District, with striking views of the Great Wall at Badaling and the surrounding corrugated mountains. The original course, designed by Jack Nicklaus in 2001, was complemented in 2007 by the 27-hole Links Course co-designed by Nicklaus and son Jack Nicklaus II. A private club with an opulent marble clubhouse, the course is spacious and well manicured, with several waterways; the par-three 17th plays across a pond to an elevated green with a waterfall on the left. Beijing Pine Valley hosted the 2005 Johnnie Walker Classic won by Adam Scott and the inaugural Volkswagen Masters in 2006. It is currently the home of the Beijing Open. The facilities at Pine Valley include an equestrian center, spa, 118 guest rooms, and even a pet hotel.

The golf course at Weihai Point, which opened in the fall of 2008, scales a hydra-headed peninsula that juts into the Yellow Sea on the northeastern coast of Shandong Province. The second hole, with its tee box above the surf, kicks off a string of half a dozen holes along the promontory that varies from 30 to 100 feet above the sea. Designed by Ron Fream and David Dale of Golfplan, the course was actually built over a previous course. It has been thoroughly remodeled, with a dozen tees positioned closer to the sea cliffs. Weihai only measures a very modest 6,235 yards, but its length is tailored to allow the holes to fit comfortably within the sensational site. There are 14 fairways cabined along the ocean, including the par-five 16th, with its 220-yard carry across the Yellow Sea to a fairway shadowed by cliffs. The resort has a modernist clubhouse, hotel, and villas located near Weihai seaport.

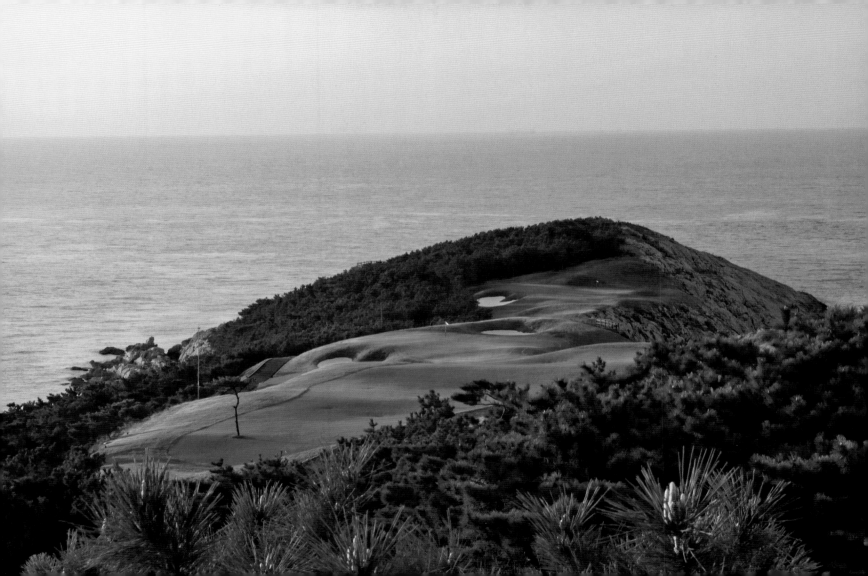

Mission Hills Golf Club & Resort is located just a few miles from Shenzhen in Guangdong Province and offers a sumptuous golf feast of a dozen courses designed by Jack Nicklaus, Vijay Singh, Nick Faldo, Jumbo Ozaki, Ernie Els, Annika Sorenstam, David Duval, José Maria Olazábal, David Leadbetter, and Greg Norman. The granddaddy of them all is the Nicklaus Course, which hosted the 1995 World Cup won by the U.S. team of Fred Couples and Davis Love III.

BELOW: Ozaki Course
RIGHT: Olazábal Course

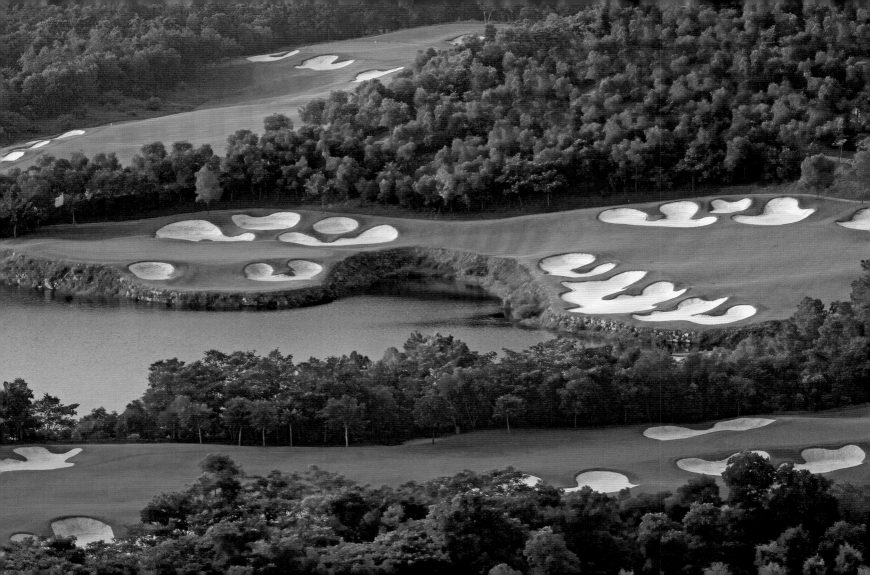

With a dozen different courses, Mission Hills can rightfully boast that it is the world's largest golf resort. The courses are varied, with an island green at the Faldo Stadium Course, the ziggurat tee boxes of the Ozaki Canyon Course, and the lush, riverine look of Els's Savannah Course among the many features. The hotel has 228 rooms overlooking the golf courses. The resort is also the home of the world's largest putting green, a six-acre layout designed by the firm of Schmidt & Curley.

BELOW: Els Course

RIGHT: Valley Course

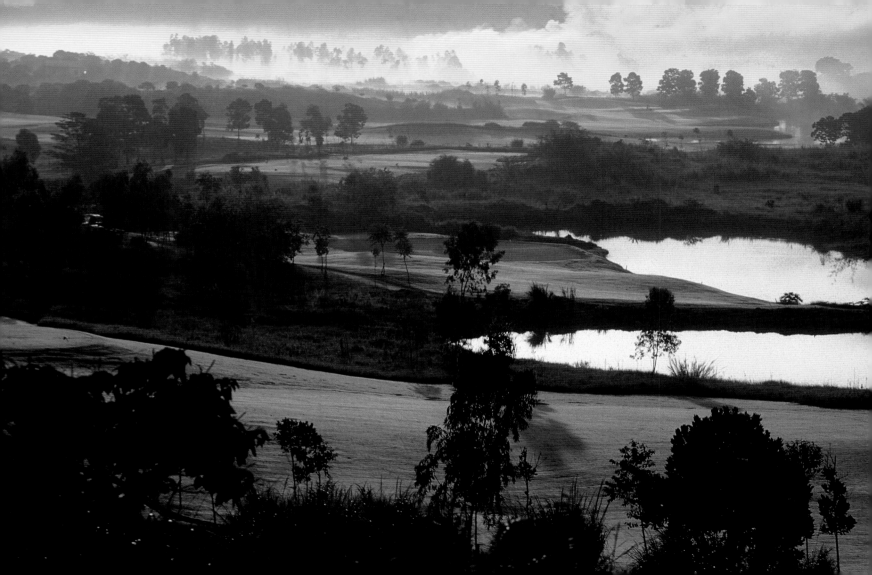

Chung Shan Hot Spring Golf Club opened in 1984, making it the first golf course built in China in the Communist era. It now boasts two of the most highly regarded courses in a booming Chinese golf market, the original course designed by Arnold Palmer, and the second by Jack Nicklaus, opened in 1993. The courses straddle the hills of Shenzen Province, a half-hour drive from the border near Macau. The Nicklaus course, the more challenging of the two, slopes across either side of a 1,000-foot high peak, and like many Nicklaus layouts, it has a roomy, full-cut feel to it, with more than 90 large, terraced bunkers.

RIGHT: Nicklaus Course

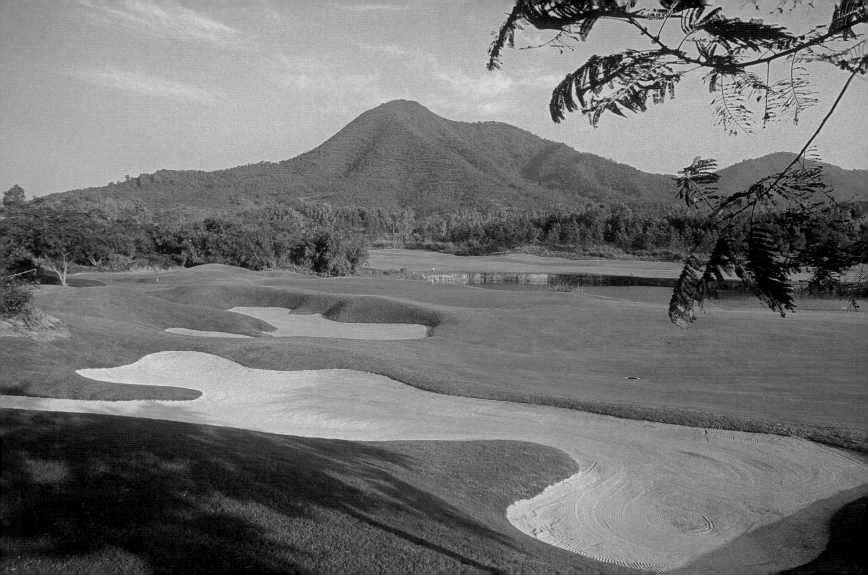

The Jockey Club Kau Sai Chau Public Golf Course, the only public golf complex in Hong Kong, occupies a spectacular aerie above the South China Sea at the northern end of the island of Kau Sai Chau. Opened in December 1995 and built with funds donated by the Hong Kong Jockey Club, Kau Sai Chau has an embarrassment of riches in its three 18-hole courses. The North and South Courses were designed by South Africa's golfing paladin Gary Player, while the more recent East Course is the handiwork of the team of Robin Nelson and Neil Haworth. The courses, which are reached by ferry, overlook the green hills of Hong Kong's Sai Kung Peninsula and the rocky seascapes below, while also serving as a wildlife sanctuary for eagles, egrets, pond herons, and barking deer.

RIGHT: The North Course

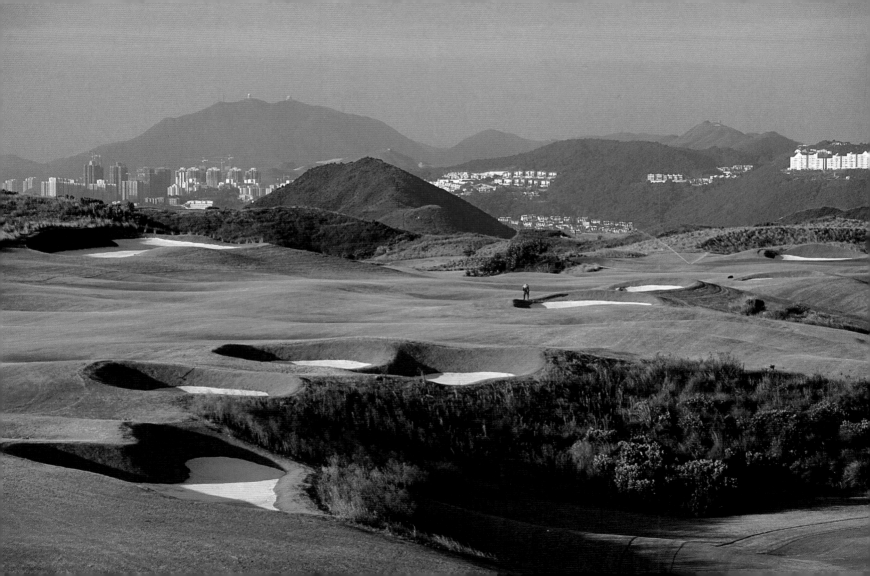

Lijiang Ancient Town Golf Club, founded in March 2005, is only five miles from Lijiang in Yunnan Province in southern China. Lijiang Old Town, surrounded by snow-covered mountains, dates from the Southern Song Dynasty some eight centuries ago. The majority of the local population are ethnic Naxi people, and Lijiang is a center for Dongba culture, the religion of the Naxi. The Old Town is situated on the northwest plateau of Yunnan, along the middle reaches of the Jinsha River. The golf course, designed by American Joe Obringer, is spread across the foot of Mount Wenbi and measures an impressive 7,661 yards. The flatter back nine winds along the shore of Wenbihai Lake, with majestic Yulong Snow Mountain as backdrop. The other course in the vicinity of Lijiang is Jade Dragon Snow Mountain Golf Course, a mountainside layout located at the base of Jade Dragon Snow Mountain, the immense glacier that rises over 10,000 feet and is considered a holy site by the Naxi. The Jade Dragon course was designed by Australian

architect Neil Haworth and opened in 2002. At 8,548 yards, it is the longest course in the world. Lijiang Old Town is famed for its brick and tile buildings, with carved doors and painted windows, which run along a labyrinth of canals crossed by cobblestone bridges.

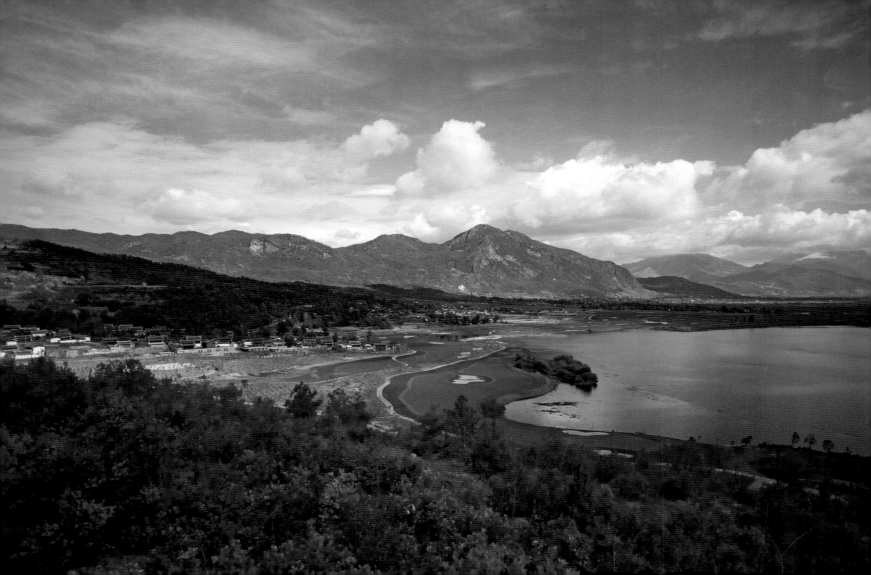

NOVEMBER 26 | SPRING CITY GOLF & LAKE RESORT—CHINA

Spring City Golf and Lake Resort is situated some 30 miles east of Kunming City, the capital of Yunnan Province. The resort is home to courses designed by Jack Nicklaus and Robert Trent Jones, Jr. in 1998. Jones's Lake Course stairsteps around Yang Zong Hai Lake, echoing the neatly stacked ledges of agricultural fields that climb the slopes of the Yunnan hills. The Mountain Course designed by Nicklaus, overlooking the lake with the mountains beyond, runs through pines and rock outcroppings, with water in play on four holes. The area's attractions include the Buddhist Yuantong and Bamboo Temples, a mythical Stone Forest, Lake Dianchi, and the East and West Temple Pagodas.

RIGHT: The Mountain Course

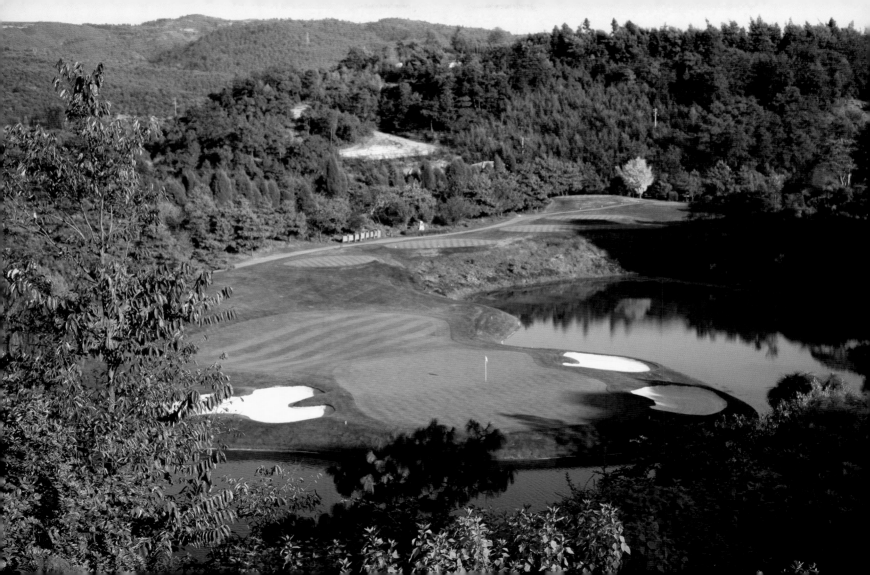

European Tour legend Colin Montgomerie has been putting his stamp on far-flung courses from Ireland to Bahrain and from Turkey to Vietnam. The Montgomerie Links, completed in late 2008, is the first golf course located in central Vietnam. The course overlooks the South China Sea just to the south of Da Nang and 20 minutes north of the old harbor town of Hoi An—which was declared a World Heritage Site by UNESCO in 1999 as a well-preserved example of a Southeast Asia trading port of the 15th to 19th centuries. The course tracks across the duneland above Nam Hai beach, with the Marble Mountains an imposing backdrop. The sand-based fairways, which give the course a links-style feel, are well bunkered and ruffled with feathery casuarinas and pines. There is also a sleek, modern clubhouse comprised of glass-enclosed rectangles.

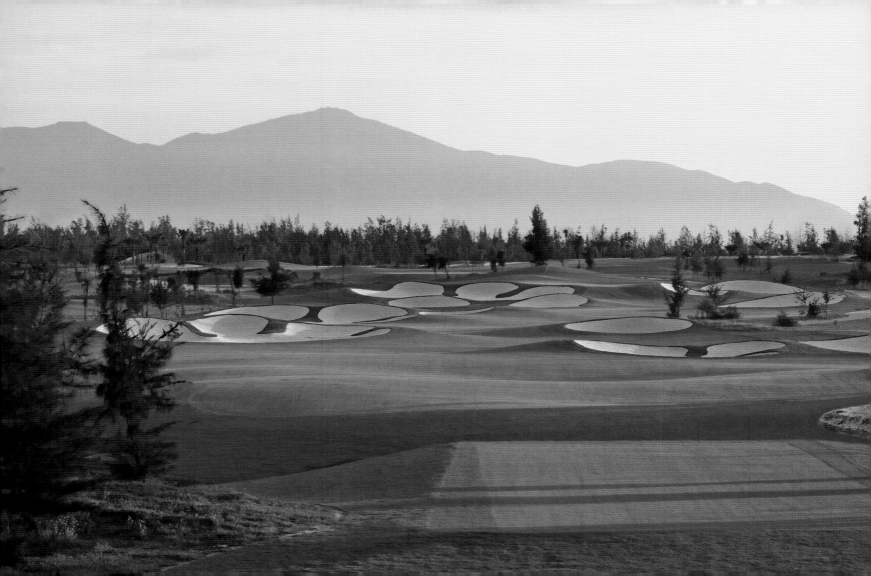

Cambodia now has two international caliber courses, the Angkor Golf Resort and Phokeethra Country Club. Both are located near Siem Reap, the gateway to Angkor Wat—the most wondrous of the Angkor temples—in the cradle of Cambodia's ancient Khmer civilization. Phokeethra opened as Cambodia's first international golf course in early 2007 and is part of the Sofitel Royal Angkor Golf & Spa Resort. The course features broad belts of fairway that gird natural lagoons and swirling, shallow sand bunkers, with an island green 18th hole. The Roluh Bridge, a restored 11th-century stone structure located between the ninth green and 10th tee, was recently declared a World Heritage Site by UNESCO. Phokeethra was soon joined by the Angkor Golf Resort, a first rate course designed by Nick Faldo, who received a blessing from the local monks prior to opening the course in December 2007. Like Phokeethra,

Angkor Golf Resort is intended to tap into the Siem Reap tourist market, including the many South Korean golfers who come to visit Angkor Wat. The part-five 16th plays 588 yards with water left of the green, while the 17th is a long par-three with water to the right of the hole. The 18th is a strong 440-yard finisher, with a lake running down the entire left side of the fairway.

BELOW: Buddhist monks at the Angkor Golf Resort

Alpine Golf Club, located 30 miles north of Bangkok, is one of Thailand's premier courses. It has hosted the Johnnie Walker Classic several times, including the 2000 event captured by Tiger Woods. Established in 1996, the fairways meander through groves of palms, mahogany, and cork, with white sand bunkers large enough to bury an elephant. Built on land that was originally flat rice paddies, American designer Ron Garl created the undulating fairways and the elevation changes that give the course its name. Water comes into play on many holes, particularly the 7th and 11th, each of which plays to an island green.

RIGHT: Tiger Woods teeing off in November 2000 during the Johnnie Walker Classic played at Alpine Golf Club

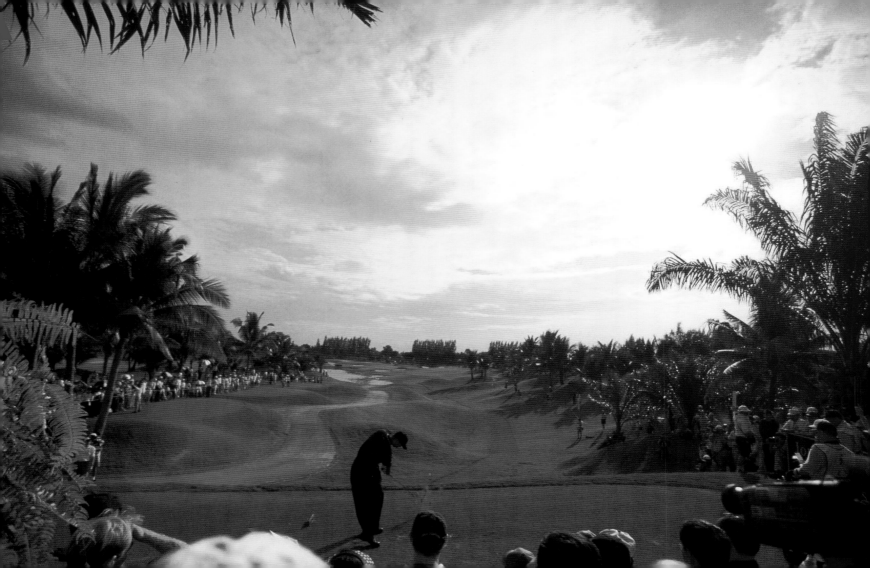

NOVEMBER 30 | SANTIBURI SAMUI COUNTRY CLUB—THAILAND

Santiburi Samui Country Club, part of the boutique Santiburi Resort, was crafted in 2003 by Thai course architect Pirapon Namatra and co-designer Edward Thiele on the northern coast of the island of Koh Samui. The course corkscrews around the hills overlooking an old coconut palm plantation, with views out to Mae Nam Beach and across the bay to the nearby island of Koh Phangan. The routing is tight and challenging, as the fairways climb along the hillside through a tropical landscape of jungle, waterfalls, and tall, spindly palms. The first few holes laze through the coconut groves before ascending the hillside, with two plunging par-threes marking the front nine. The layout reaches its high point on the tee of the par-five 17th, with its blind downhill drive and soaring view over the ocean some two miles away. Koh Samui is located in the Gulf of Thailand, surrounded by 60 other islands that comprise the Ang Thong National Marine Park, and is famed for its white sandy beaches, coral lagoons, and abundance of coconut trees.

DECEMBER 1 | SANTIBURI COUNTRY CLUB—THAILAND

Santiburi Country Club, which was created for Khun Santi Bhirombhakdi, the owner of Thailand's Singha beer, is the premier course of northern Thailand. The course is located in Chiang Rai, in the Golden Triangle between the curtain of mountains that separates Thailand from Myanmar to the west and the Mekong River that flows into Vietnam to the east.

Designed by Robert Trent Jones, Jr., in 1993, the front nine pans around a large, curving lake and runs through the lush, low green hills of Bang Bor, with the mountains of Chiang Rai in the distance. The back nine skidaddles through a steep valley, finishing alongside a chain of three lakes.

Blue Canyon Country Club, considered Thailand's premier club, is located on the northern end of Phuket Island, Thailand's ultimate tropical getaway set in the Andaman Sea. Strangely shaped, sheer stalks of limestone sprout out of the aquamarine waters of Phang Nga Bay, including James Bond Island, which was featured in *The Man With the Golden Gun*, and Koh Pannyi with its floating fishing village. Blue Canyon, opened in 1991, was once an abandoned tin mine and rubber estate. Designed by Yoshikazo Kato, the original Canyon Course hosted the 1998 Johnnie Walker Classic, won by Tiger Woods in a playoff with Ernie Els. The best-known hole, the par-three 14th, plays to a tadpole-shaped island green set in the large lagoon. The Lakes Course, also designed by Kato, opened in 1999. Water comes into play on 17 of the 18 holes, with several water-filled canyons on the front nine created by open cast mining. The back nine gives way to lakes and fairways rustling through the rubber trees, with very large greens.

BELOW: Anton Haig gets the royal treatment after winning the 2007 Johnnie Walker Classic at Blue Canyon Country Club

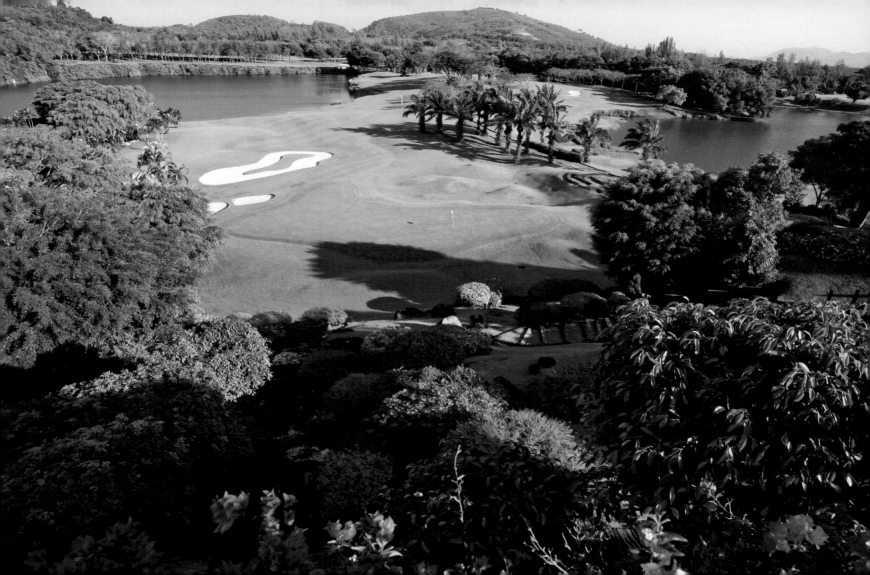

DECEMBER 3 | THE MINES RESORT—MALAYSIA

Golf in Malaysia dates back to the founding of the Royal Selangor Golf Club outside Kuala Lumpur in 1893, and has flourished in recent years. In 1997, one of Malaysia's most spectacular courses opened at the Mines Resort City outside Kuala Lumpur, developed by Malaysian business mogul Tan Sri Lee Kim Yew. Designed by Robert Trent Jones, Jr., the course is a monumental environmental reclamation project, crafted out of an open-cast tin mine that had ceased operation. In 1999, the Mines hosted the World Cup won by the U.S. tandem of Tiger Woods and Mark O'Meara.

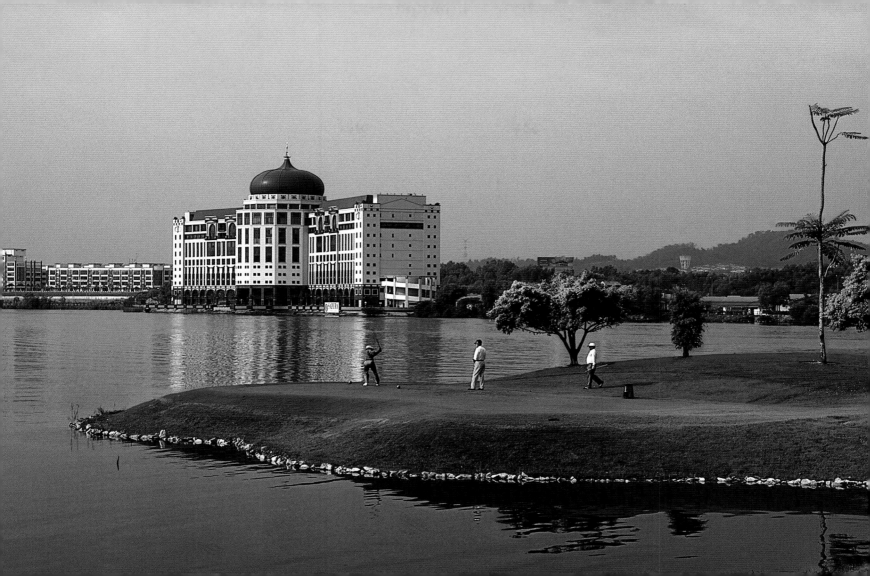

DECEMBER 4 | SENTOSA GOLF CLUB—SINGAPORE

Sentosa Golf Club boasts two superb courses, the Serapong and the Tanjong, encircled by the South China Sea and Singapore's bustling harbor. Set on Sentosa Island, the Serapong Course was designed by Ronald Fream in 1982 and received a major facelift from Bates Golf Design in 2007, which lengthened the course, added new bunkering, and upgraded the Zoysia fairways. The front nine darts around a large, man-made lagoon before flattening out on the back nine, which is starred with palms and separated by a narrow strait from the Singapore skyline. The harbor is an ever-shifting montage of merchant ships and one can see all the way to Batam in Indonesia. The club is a center for the upper echelons of Singapore society and the home of the Barclays Singapore Open, a major event on the Asian Circuit, which is co-sponsored by the European Tour, and attracts a world-class field. Singapore's other memorable courses include Laguna National and Tanah Merah.

BELOW: Simon Dyson at the 2008 Barclays Singapore Open

RIGHT: Padraig Harrington putting at the 2008 Singapore Open at Sentosa Golf Club

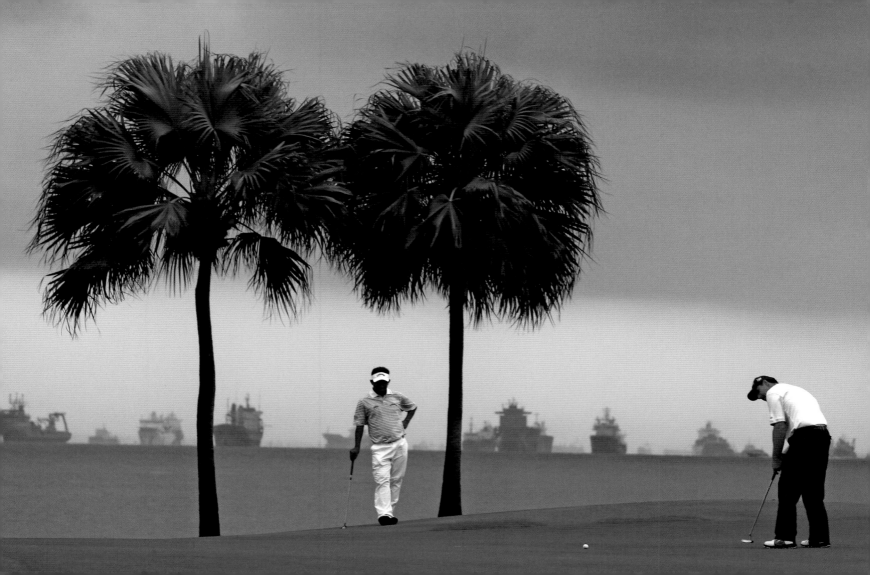

DECEMBER 5 | RIA BINTAN GOLF CLUB—INDONESIA

The Indonesian island of Bintan has become a major golf desti-
nation, with a string of tropical courses running along the
north coast of the kidney-shaped island facing the South China
Sea. Reached by a 45-minute ferry ride from Singapore aboard
a high-speed catamaran, the Ria Bintan Golf Club (part of Club
Med Ria Bintan) has two courses designed by Gary Player, the
Ocean Course and Forest Course. Farther east, the Laguna
Bintan Golf Club, designed by Greg Norman, spans forest,
wetlands, beachfront holes rimmed by boulders, and an aban-
doned quarry. It is part of the Banyan Tree Resort. The Bintan
Lagoon Resort offers the Jack Nicklaus Sea View Course, with
the lovely par-three 12th caressing the South China Sea and
the green of the 13th actually split by a stream, as well as the
hillier Woodlands Course designed by Ian Baker-Finch.

RIGHT: The Ocean Course

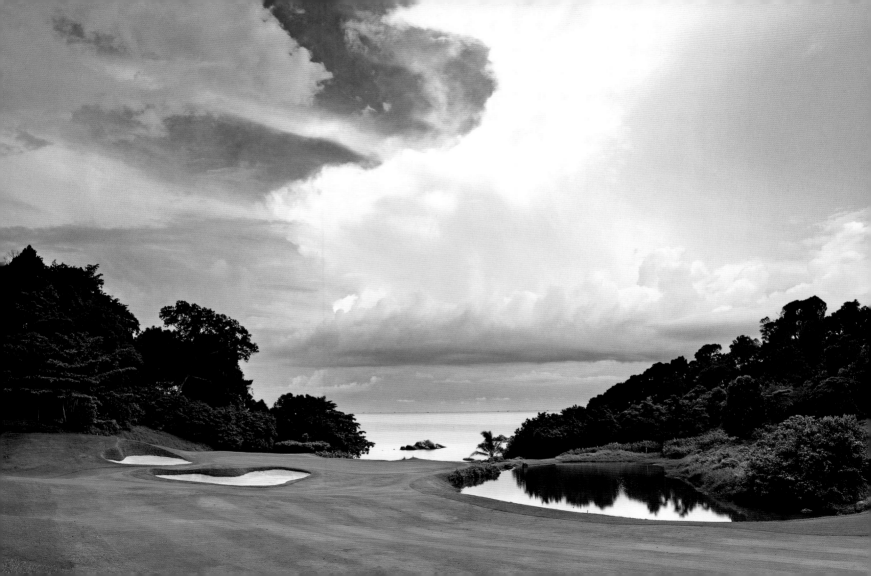

DECEMBER 6 | MOUNT KINABALU GOLF COURSE—SABAH, MALAYSIA

Mount Kinabalu Golf Course traverses the foothills of the highest peak in Southeast Asia, revealing the splendors of the Borneo rain forest and affording soaring views of the surrounding countryside. Located in Kinabalu Park in Kundasang, a World Heritage Site, it is one of the highest-altitude courses in the world, running across the Pinosuk Plateau, at 5,000 feet above sea level. The extravagantly lush lower slopes of the mountain display some of the planet's richest diversity of plant life, including rafflesia, the world's largest flower (blossoms measure three feet in diameter), over 1,000 species of orchids, and nine types of carnivorous pitcher plants. The cooler, upper rain forest is also home to orangutans, gibbons, and anteaters. The course, designed by Californian Robert Muir Graves, is extremely challenging, with steep slopes, rocky outcroppings, and swirling mists, with breathing made difficult by the thin mountain air. The 14th hole, the signature par-three, plays from an elevated tee across the Mesilau East River, flowing in a gorge below, to a small green on the precipice of a cliff.

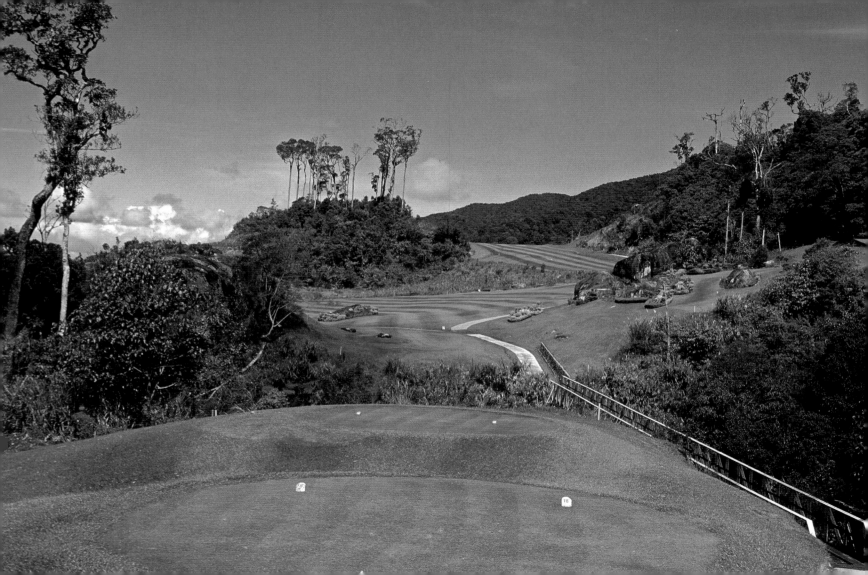

DECEMBER 7 | NEXUS RESORT KARAMBUNAI—SABAH, MALAYSIA

Sabah, the East Malaysian state on the island of Borneo, has a long golfing history, courtesy of the British, with a membership campaign for the still-extant Kudat Club appearing in the British *North Borneo Herald* in 1906. Sabah's golfing revelations include the Jack Nicklaus–designed Borneo Golf and Country Club and the 27-hole Sutera Harbour Golf & Country Club, designed by Graham Marsh and built on reclaimed seaside land outside the capital of Kota Kinabalu. The Nexus Resort Karambunai is located 18 miles from Kota Kinabalu at Menggatal. Designed by California-based Ronald Fream, the course is sandwiched between low hills and the sandy swatch of shoreline, its ponds frilled with flowers. Sabah is a sumptuous landscape of beaches, bays, and rainforests, dominated by the immense rocky crown of Mount Kinabalu, the mountain that is sacred to the Kadazandusun, Sabah's largest ethnic community.

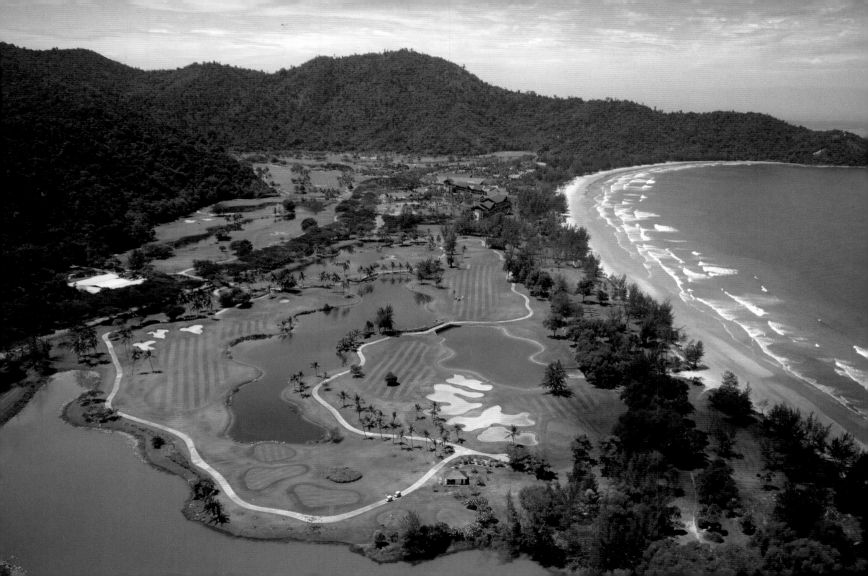

Jakarta and its environs are home to several fine courses carved through the lush Javanese landscape. Some of the more notable layouts are Jagorawi, with its 45 holes hewn from the jungle and rice fields; Emerald One, with 18 holes designed by Arnold Palmer and another nine by Jack Nicklaus for good measure; and Pondok Indah, the Robert Trent Jones, Jr., design that hosted the 1993 World Cup. Bogor Raya, laid out in the garden setting of the tea plantations of the Bogor Mountains to the south, is the work of Graham Marsh. Damai Indah, designed by Nicklaus, skirts the Lisadene River Valley. Cengkareng Golf Club, to the west of Jakarta and near the international airport, was designed by Walter Raleigh Stewart in 1999. The Club hosted the Indonesian Open, an event on the European PGA Tour, in 2005 and 2008.

BELOW: Caddies at the 2007 Enjoy Jakarta Astro Indonesian Open at Damai Indah Golf & Country Club

RIGHT: Cengkareng Golf Club

DECEMBER 9 | NIRWANA BALI GOLF CLUB—BALI, INDONESIA

Nirwana Bali Golf Club is located on the southwest coast of Bali, a 30-minute drive from Kuta. Opened in 1997 and designed by Aussie great Greg Norman and Bob Harrison, the course is the centerpiece of the Nirwana Bali Resort. The layout combines spectacular cliff holes running alongside the Indian Ocean with hazards formed by terraced rice paddies typical of the lush Balinese countryside, beginning with the seven rows of staggered rice paddies that descend down the hill to the left of the first tee. The fantasy hole par-three seventh plays across the inlet of the sea to a green mounted on a vine-draped cliff, facing the sacred Hindu sea temple of Tanah Lot that is perched on a rocky pedestal in the ocean 200 yards farther down the coastline. Nirwana's female caddies come from the neighboring villages and receive an intensive three-month training program.

Bali Handara has long been the holy grail of golf, a tantalizing tropical course cloistered in the central highlands of Bali. The course is laid out in a lush volcanic crater 3,500 feet up the wooded mountainside of Mount Batukaru that rises to a cloud-covered 7,500-foot-high summit, making it a welcome escape from the coastal heat. Designed by Peter Thomson and Michael Wolveridge in 1974, construction was supervised by Guy Wolstenholme, who won the English Amateur. The course is routed through an old dairy farm and the subtropical jungle between two large lakes, near the village of Bedugal. It was built entirely by hand, with a workforce of more than a thousand local laborers, most of them women. The fairways are a mix of Kentucky bluegrass imported from the U.S. and native Bermuda, broken by jigsaw piece-shaped bunkers. There are ponds between the eighth and ninth and 16th and 17th fairways and a jungle stream that crosses the third, fifth, sixth, and seventh holes.

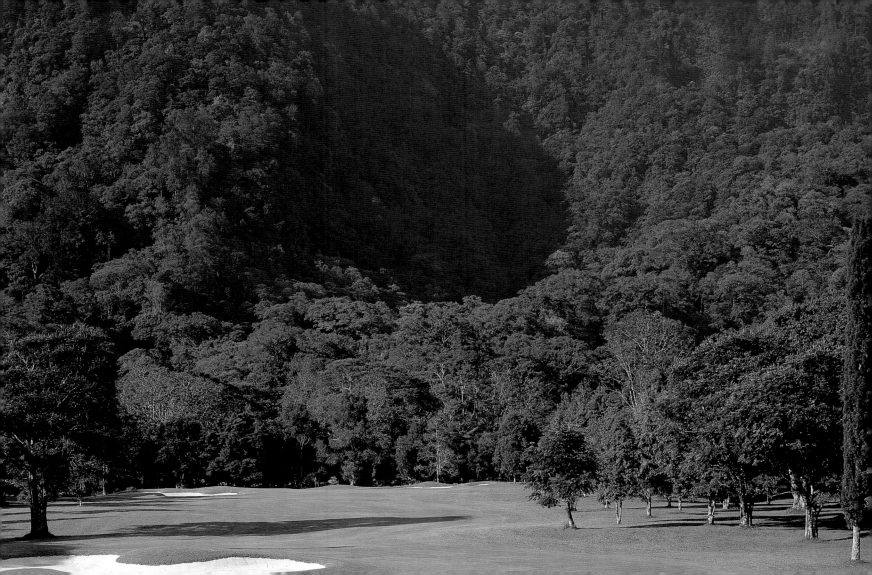

New South Wales, outside Sydney, lies on the northern headland of Botany Bay, with commanding views over the Pacific and along the coastline. Captain James Cook landed on the south side of the bay in the Endeavour on April 29, 1770, dispatching a boat that found fresh water at Captain Cook's Waterhole just below what is now the 17th tee. The course, which was routed and planned by Alister MacKenzie in 1926, lies between Cape Banks, named after Joseph Banks, one of the botanists in Cook's party, and La Perouse, named for Jean-François Galaup de la Perouse, the commander of two French frigates that anchored on January 26, 1788. The course makes two loops along the coast, Nos. 5 through 7 on the front nine, and Nos. 13 through 16 on the back. The sixth hole presents a spectacular tee shot across the rocky ocean that is reminiscent of the 16th at California's Cypress Point, MacKenzie's masterpiece on the other side of the Pacific.

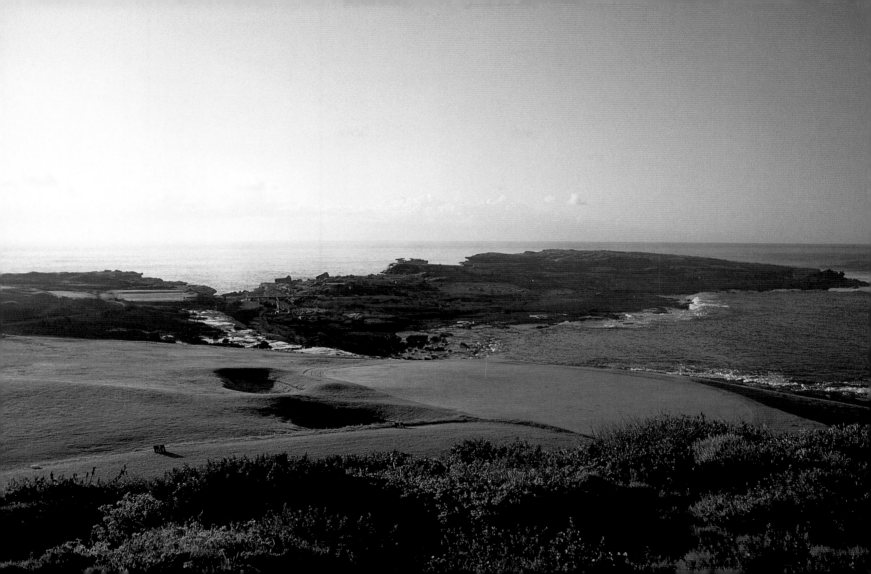

Royal Melbourne Golf Club, the top-ranked course in Australia, is the most illustrious of the series of masterpieces that stretch across Melbourne's famous sand belt, including Commonwealth, Victoria, Metropolitan, and Yarra Yarra. Founded in 1891, it is the oldest golf club in Australia with a continuous existence under the same name. In 1901, the course moved to a location in the rugged heathland by the racetrack in the suburb of Sandringham, marking the birth of golf in the sand belt. In the 1920s, the club moved slightly east to its present location in Black Rock, and hired Alister MacKenzie to oversee the design.

MacKenzie arrived in 1926 to survey the site, the beginning of his historic tour of Australia, and entrusted the realization of his vision for what would become the West Course to Australian Open champion Alex Russell and green keeper Mick Morcom. MacKenzie created a wonderfully strategic design through thickets of ti-trees and mimosa, while the scooped out, scalloped bunkering that blends into the shaved, rolling greens has never been surpassed. Royal Melbourne, which hosted the President's Cup in 1998 when the International team was victorious, will be the home course again in 2011.

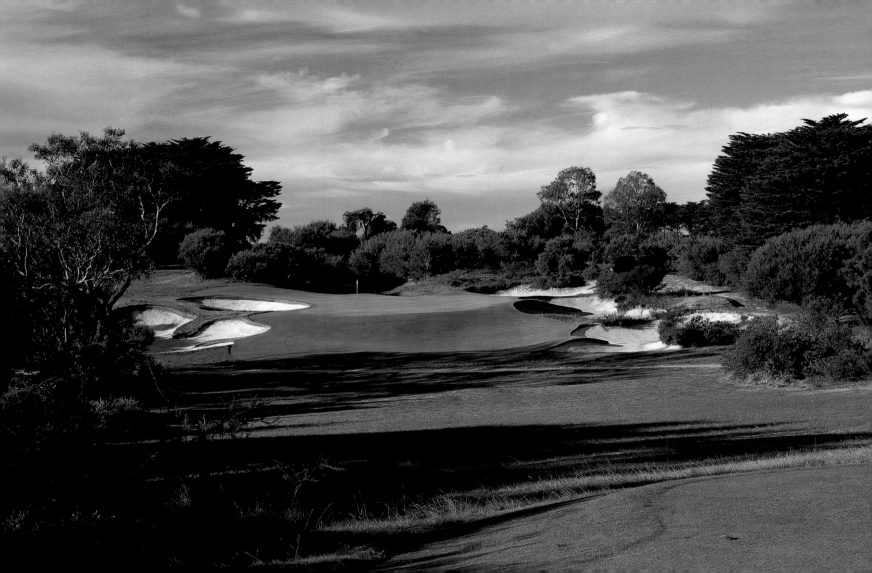

Kingston Heath and Royal Melbourne are the two King Kongs of Melbourne's sand belt. The Heath was designed in 1925 by Dan Soutar, the Sydney professional and winner of the 1905 Australian Open, and constructed by Royal Melbourne's greenkeeper, Mick Morcom. The course measured 6,312 yards at inception, a very long layout at the time, with a par of 82. Three years later, Alister MacKenzie, who had arrived to design Royal Melbourne's West Course, created Kingston Heath's ne plus ultra bunkering. The fairways of couch grass are bordered by eucalyptus and ti-trees, and MacKenzie's bunkers, with their grassy tongues and sandy vortexes, are among the finest in the world. The course finishes with three long, vigorous par-fours, including the blind 17th with its bunkerless green. Kingston Heath has hosted the Australian Open seven times, including in 2000, when Aaron Baddeley was the winner.

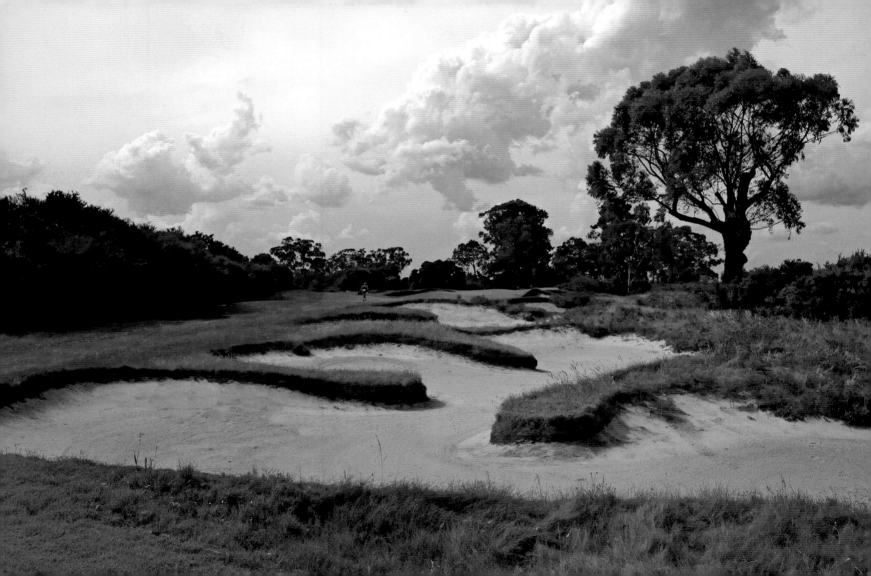

DECEMBER 14 | HERITAGE GOLF & COUNTRY CLUB—AUSTRALIA

The Heritage Golf and Country Club is located about 25 miles northeast of downtown Melbourne, surrounded by the vineyards and wineries of the Yarra Valley region. The club has two courses, the St. John Golf Course, which opened in 2000, and the Henley Golf Course, completed in October 2006. The St. John Course, designed by Jack Nicklaus, follows the contours of the valley, running out to the banks of the Yarra River. The Henley Course, designed by veteran Australian architect Tony Cashmore, whose work includes the Dunes Golf Links on the Mornington Peninsula and 13th Beach fronting the ocean on the Bellarine Peninsula, is on the other side of the Yarra River. A more open, links-style layout than the St. John, the Henley Course weaves through wetlands and the tributaries of the river alongside the Wannadyte state forest. The courses are available for play to guests at the Sebel Heritage Yarra Valley hotel.

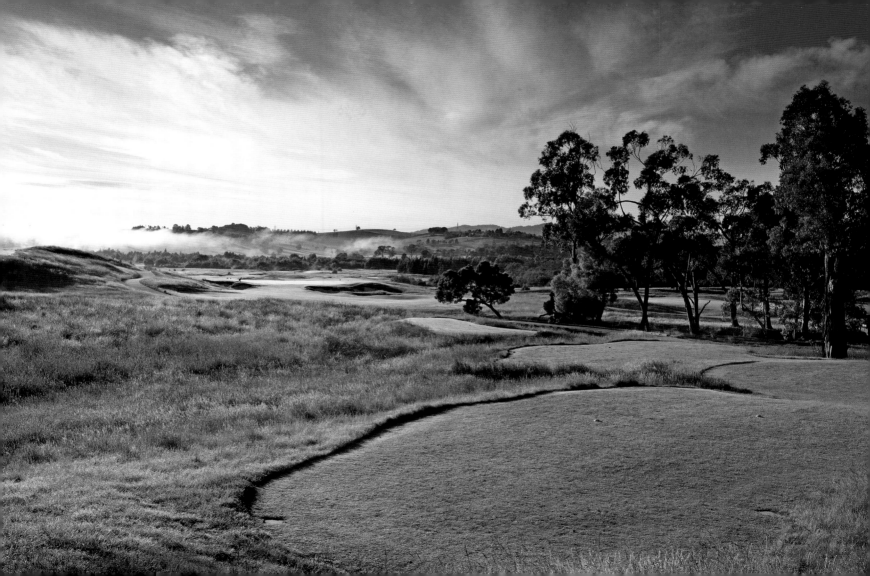

DECEMBER 15 | NATIONAL GOLF CLUB (MOONAH COURSE)—AUSTRALIA

The Moonah Course at the National Golf Club, which opened in 2000, is a breathtaking links that sweeps across the folds of the seaside farmlands and sand dunes of Victoria's Mornington Peninsula. With its broad fairways and swaths of native grasses, framed by the jagged ridges of the Bass Strait Dunes near Gunnamatta Beach, the course is an Australian original. Designed by golf's Great White Shark, Greg Norman, Moonah is one of three courses at the National Golf Club. The original Robert Trent Jones, Jr. course overlooks the Cape Schanck hills, and is now known as the Old Course. The Ocean Course, which also opened in 2000, was designed by Peter Thomson and Michael Wolveridge. The Moonah Course takes its name from the native moonah trees studded across the countryside, which can grow to be 1,000 years old.

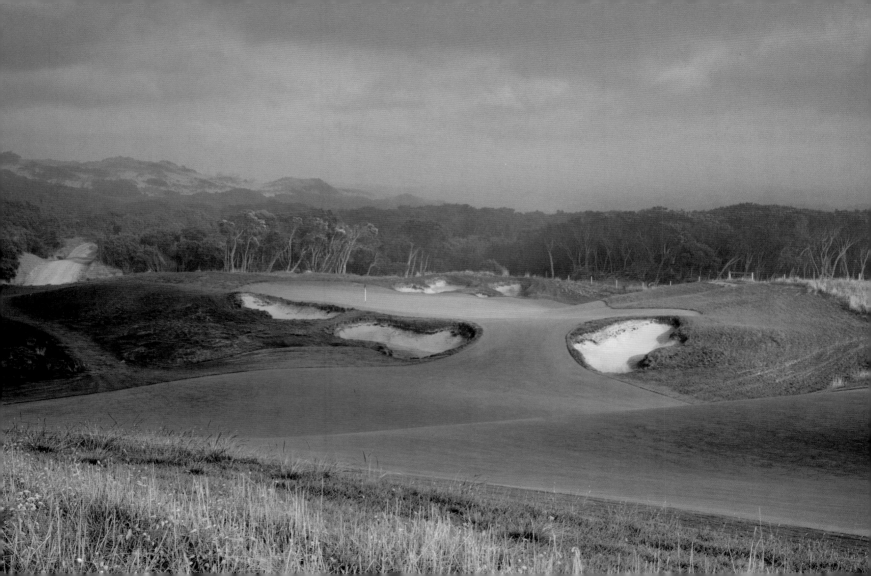

Portsea is an old-fashioned, unpretentious charmer of a links set in the sand dunes at the tip of the Mornington Peninsula, 85 minutes south of Melbourne and adjoining Point Nepean National Park. The course dates from 1924, when nine holes were opened on land acquired by Melbourne businessman Arthur Relph, and golfers arrived by paddle steamer from Melbourne. Additional holes were added in dribs and drabs, including a 10th in 1926, two more in 1930, another in 1934, two more in 1955. The full 18 were finally completed in 1965. The course has benefited in recent years from improvements and tweaking by talented Australian architect Mike Clayton. The links tumbles through valleys frocked with ti-tree scrub and there are a number of tight par-threes. The Portsea Pro-Am, held every year on January 2nd, is a popular event in Australian golf, and there is a nifty, nautical-looking clubhouse.

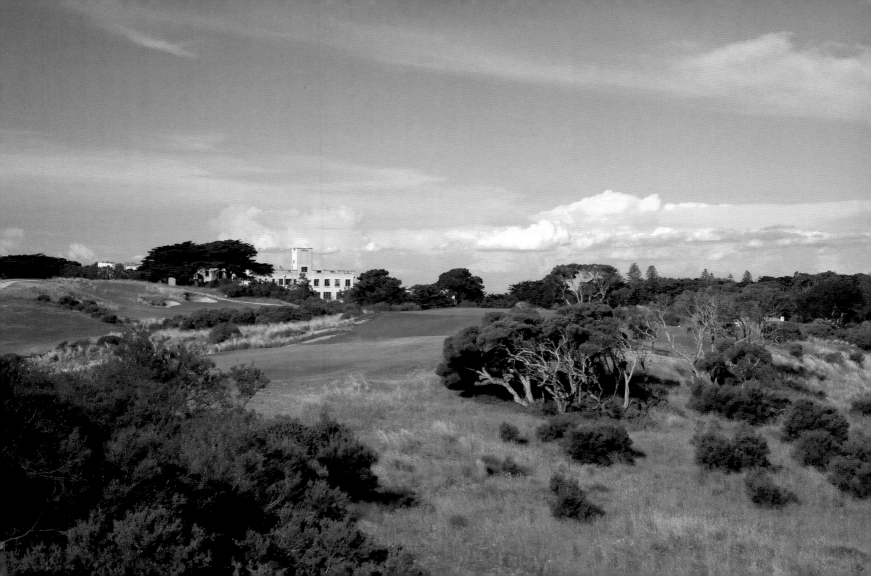

Barnbougle Dunes has placed Tasmania, Australia's Island State, on the world golfing map with a visionary, build it and they will come links that beckons golfers to the small coastal town of Bridport overlooking the barren shoreline of Bass Strait. Ringed by the coast and the estuary of the Great Forester River, the fairways pool and eddy through vast sand dunes layered with marram grass, blasted bunkers, and obelisks of coastal pine that stand exposed to the salty winds.

Barnbougle Dunes started out as the pipe dream of a young and passionate Tasmanian golfer named Greg Ramsey, who suggested to Richard Sattler, a non-golfing farmer, that the dune ridge flanking his 13,000-acre potato and cattle farm could be transformed into one of the world's great seaside links. American architect Tom Doak, whose work Ramsey had admired from afar, and Australian architect Mike Clayton were hired to design the course. Barnbougle Dunes, which opened on October 9, 2004, takes some of its inspiration from Bandon Dunes, a kindred spirit on the Oregon coast developed by Mike Keiser, who also was involved in the creation of Barnbougle. Visiting golfers can stay in one of the brightly colored cottages sheltered in the dunes that are modeled on the beach boxes at Brighton Beach in Victoria. A second course, to be named Barnbougle Lost Farm and designed by Bill Coore, is also planned.

Auckland, known as the City of Sails, overlooks the Waite-mata and Manukau harbors and a diadem of islands glistening in the Hauraki Gulf. Gulf Harbour Country Club, the only course in New Zealand designed by Robert Trent Jones, Jr., is located 20 miles north of Auckland at the tip of the Whang-aparaoa Peninsula. Each of the holes was given a native Maori name. The front nine is more open, with fairways bearded by native grasses, and the seventh through ninth play around an inland lake. The back nine winds its way to the Pacific, with the 11th green offering a vista across the harbor to Auckland. The 15th through 17th, the latter a long par-five named Taniwha or supernatural being, hover on the headland above the ocean, before the course turns inland at the finishing hole. Gulf Harbour hosted the 2005 New Zealand Open and the 1998 World Cup, won by the English team of Nick Faldo and David Carter.

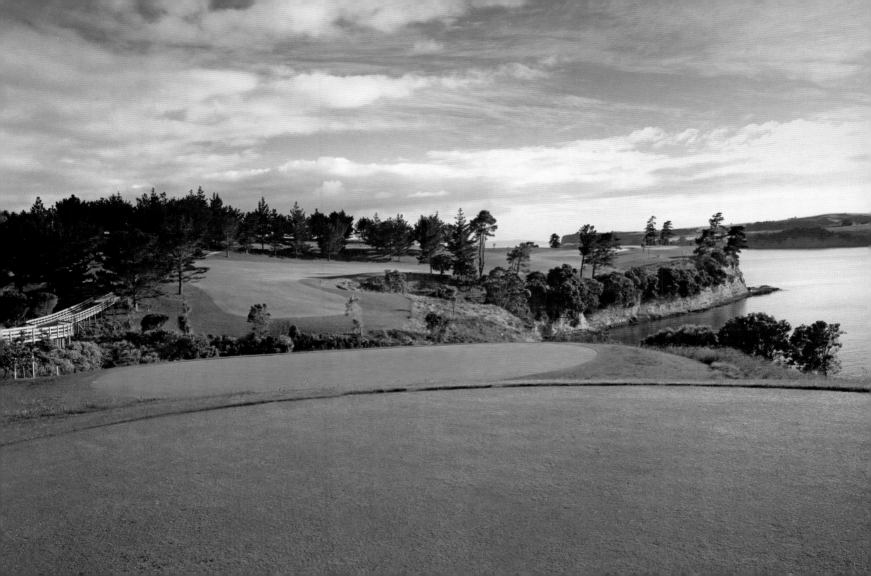

DECEMBER 19 | THE KINLOCH CLUB—NEW ZEALAND

The Kinloch Club is Jack Nicklaus's first design entry in New Zealand, not far from Wairakei Golf Club—where he played an exhibition match when he first visited the country over 40 years ago. Completed in 2007, the course overlooks the clear waters of Lake Taupo in the center of the North Island, where Nicklaus has returned over the years lured by the top-flight trout fishing. With its light volcanic soil loaded with pumice, Nicklaus was able to shape a genuine links course with fast-running, percolating fairways, wild, wavy grasses, and free-form, ragged bunkering. In March 2007, the Great Man returned to Kinloch to play the completed course.

BELOW: Jack Nicklaus teeing off at the course opening in March 2007

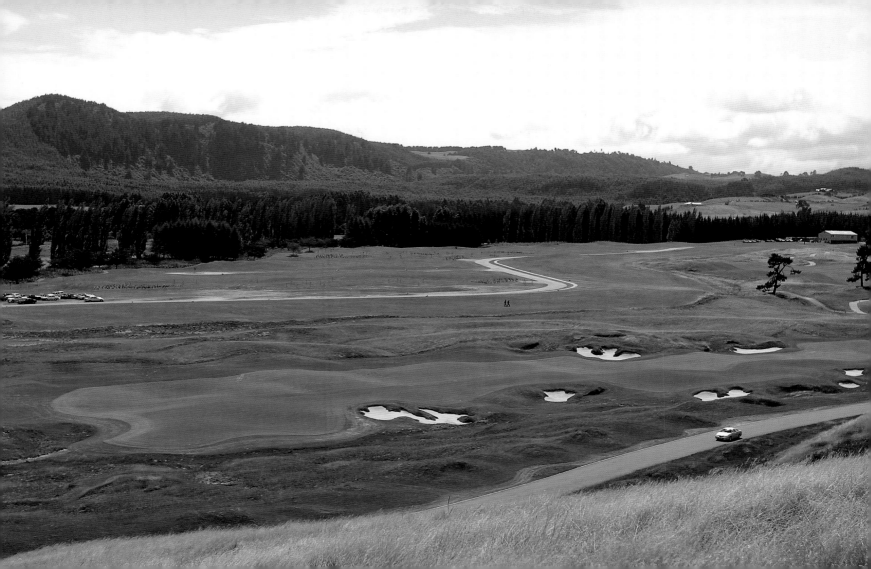

Cape Kidnappers Golf Course near the town of Napier, on the east coast of the North Island, is the second course to be developed on the New Zealand coast by American financier Julian Robertson, whose Kauri Cliffs course 500 miles to the north has earned raves throughout the golf world. Robertson hired American golf architect Tom Doak for the project after playing Doak's acclaimed course at Pacific Dunes in Oregon the second day after it opened. Completed in 2003, Cape Kidnappers was Doak's first design outside the U.S. The setting is awe-inspiring, with the course laid out over a series of tilted ridges that spread like great green talons across the cliffs 500 feet above Hawke's Bay, with views stretching for 70 miles along the entire curvature of the bay. A pulled tee shot on the sixth or 15th holes will find the antipodean abyss, but it will take nearly ten seconds before the ball reaches the ocean below. Cape Kidnappers was named by Captain Cook in 1769 when Maori warriors attempted to rescue his Tahitian translator Tayeto by kidnapping him from the Endeavour. In Maori mythology, the point of land is the fish hook that the god Maui used to pull the South Island from the sea.

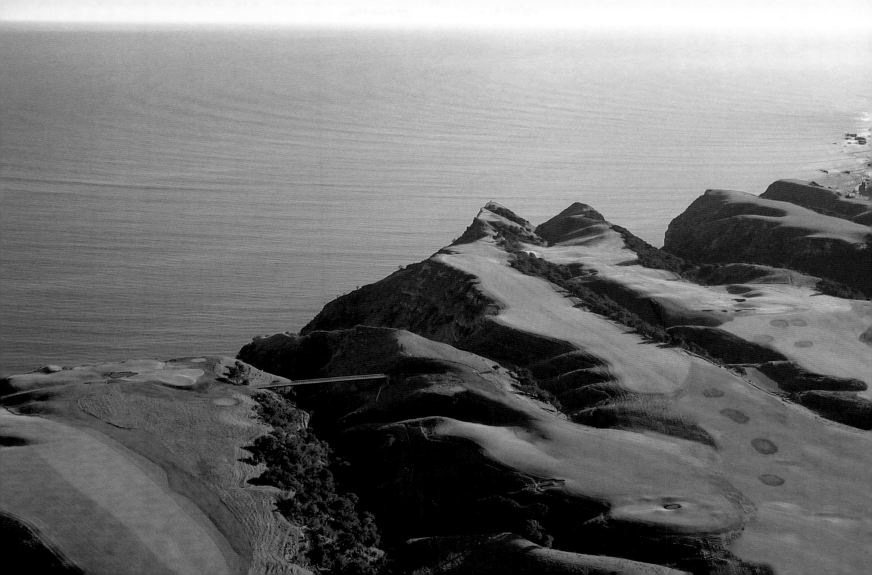

DECEMBER 21 | TERRACE DOWNS GOLF COURSE—NEW ZEALAND

Terrace Downs is set amid the splendor of New Zealand's Southern Alps, in the Canterbury High Country an hour's drive from Christchurch. The course straddles the Rakaia River, under the spectacular snow-capped massif of Mount Hutt. Opened in December 2001, the broad fairways, braided with brown-and-silvery grass tussocks, prance around 70 bunkers and 11 lakes. The 16th hole, a short par-three, plays along the precipice of the Rakaia Gorge, with the river, well known for its salmon fishing, below. The course is part of the Terrace Downs Resort, where activities also include a spa, boating, horse treks, and world-class salmon and trout fishing.

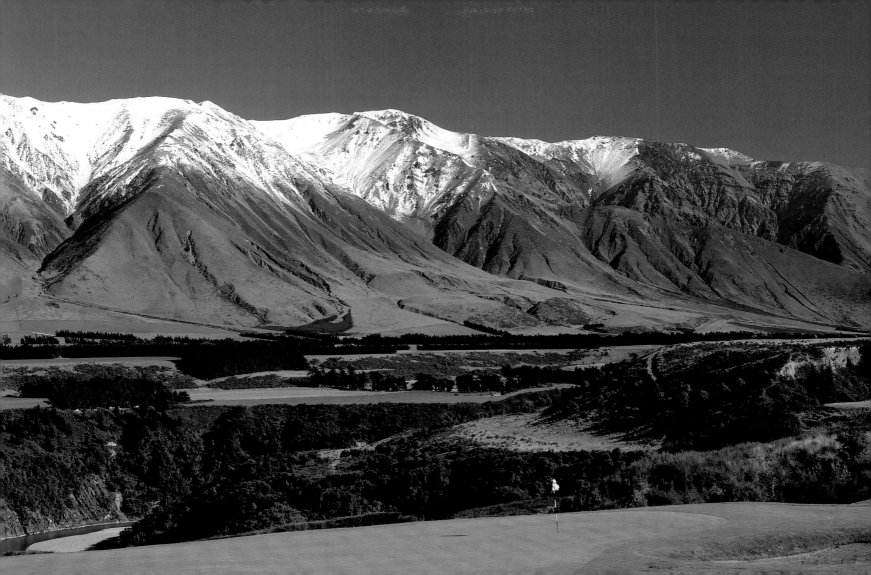

The Hills Course is a magnificent mosaic of waterworks, sand, schist-faced canyons, and fairways embellished with over 50,000 red-and-silver grass tussocks, all of which is encircled by the Remarkables Mountains on New Zealand's South Island. Founded by jewelry entrepreneur Michael Hill, and opened in 2007, the course is a private club laid out over a former deer farm close to Arrowtown in Central Otago. There are 10 lakes and a variety of water features fed by the mill race that runs through the course. The fairways are lined with a mix of native and exotic trees, and the wetland areas have been enhanced by plantings of New Zealand flax, toetoe, cabbage trees, and native beech. With such an inspiring setting, the Hills Course was selected to host the New Zealand Open in 2008, with a return visit in 2009. Designed by New Zealand's Patterson Associates, the ultramodern clubhouse, known as "The Wedge," is also a defining architectural statement. The roof is a 200-ton slab of cantilevered concrete that floats above glass walls, its weight supported by three steel struts, while most of the building is sunken underground. The roof is topped with a layer of live turf, and if a shot happens to land there, the local rule is: Play it as it lies!

BELOW: The clubhouse

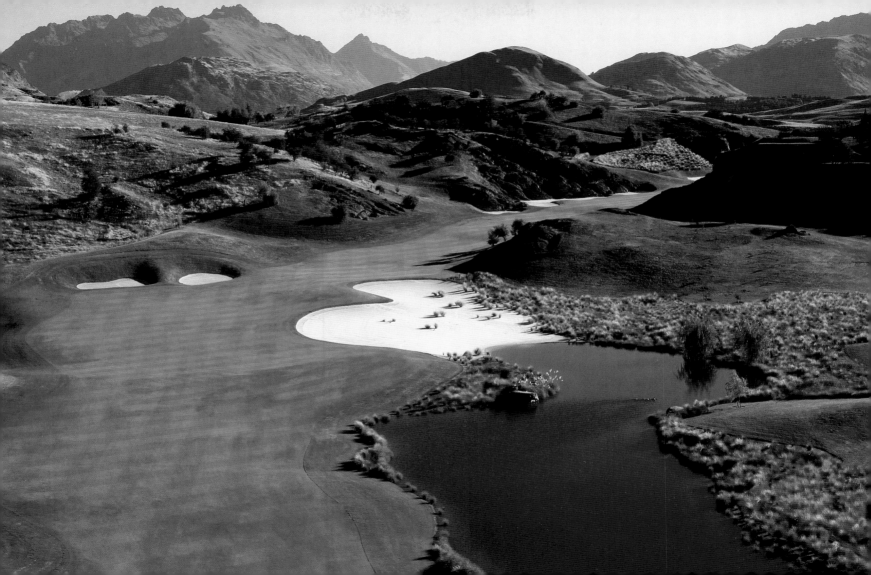

Mount Malarayat, a scenic gem of Philippines golf, is laid out at the foot of the Malarayat Mountain Range in Batangas Province in the southwestern portion of Luzon. The course is near the town of Lipa, at a height of 1,200 feet above sea level, and consists of three nines, each named for a peak in the Malarayat range: Mt. Makulot, Mt. Lobo, and Mt. Malipunyo. Designed by Bob Moore of JMP Design, the first tee of each nine is directed at the peak from which it takes its name. The course is an exotic garden of old growth coconut palms and mangos from the original forest, overlaid with evergreens and ornamental trees planted after construction. Each of the nines is quite short, playing under 6,400 yards as a combined 18, but the tight fairways, bunkers, and abundant man-made lakes create plenty of challenge. The club hosted the Philippine Open, an event that dates all the way back to 1913, in both 2005 and 2009. The club also has a 40-room hotel adjacent to the course.

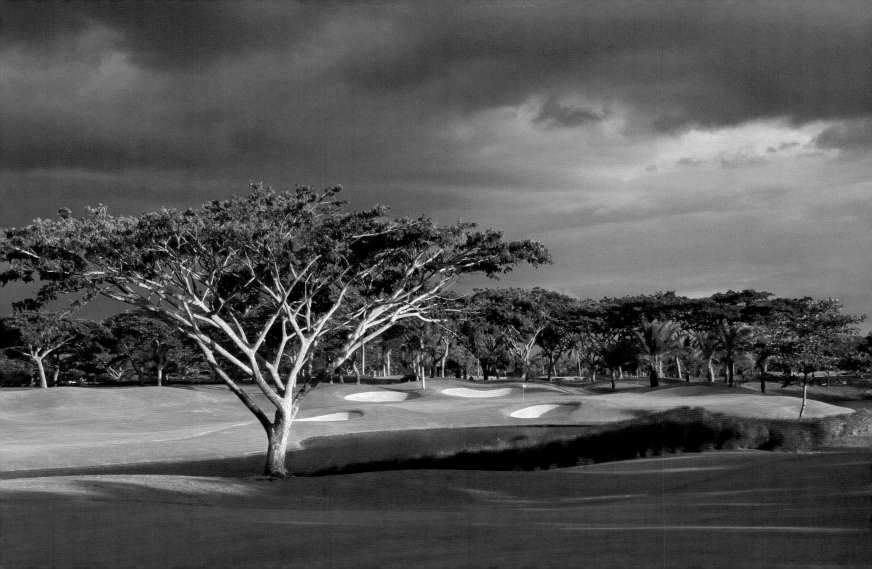

Pine Beach Golf Links, a resort course that opened in February 2009 on South Korea's west coast in Haenam, near Gwangju, is a layout that inevitably—and deservedly—draws comparisons with Pebble Beach. The course is laid out on a series of rocky headlands, with sandy coves below, that extend 200 yards into the sea. With a total of 10 holes toying with the sea cliffs, Pine Beach can more than hold its own with its occidental cousin on the Monterey Peninsula. The fifth green offers a sweeping preview of the seaside holes that lie in store. The eighth is a 190-yard par-three that plays downhill to a green set on the horizon of the sea, while the ninth hugs the coast before climbing to the clubhouse. The 15th is a par-three that plays across the inlet, taking Cypress Point for its inspiration. The 16th is a 430-yard par-four with a cliff-top tee shot catapulting across the Yellow Sea, which runs all along the right side of the fairway. Pine Beach was designed by David Dale of Golfplan, the same firm responsible for the highly rated Nine Bridges Golf Club on South Korea's Jeju Island, as well as the second 18-hole course at Bear River Golf Resort in Iksan, the new home of the Korean PGA.

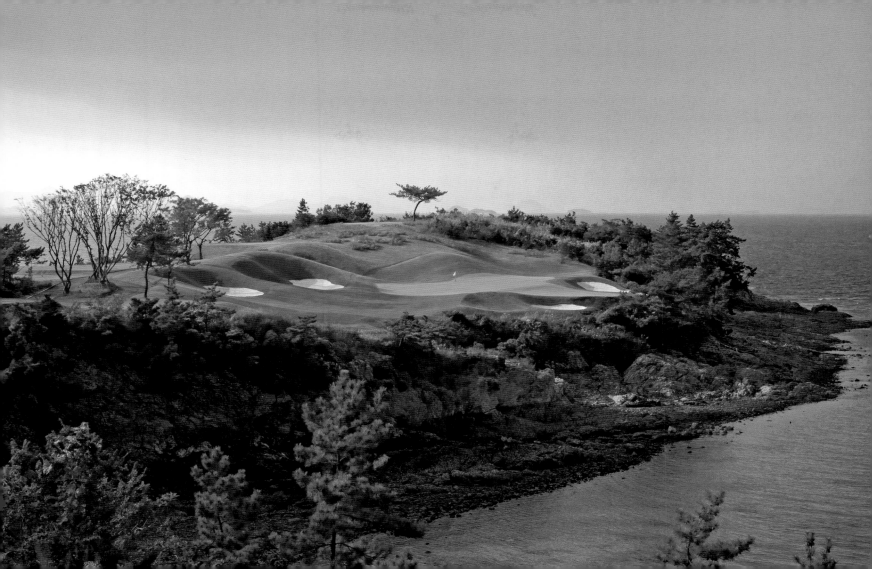

The Club at Nine Bridges is located on Jeju Island, or Jeju-do, the egg-shaped island 60 miles south of the mainland that is referred to as South Korea's Hawaii. Named for the arched stone bridges on the property, the course opened to great fanfare in August 2001. The dazzling highland layout spreads through the piedmont near the volcanic Hallasan, South Korea's tallest mountain at 6,400 feet, which dominates the center of the island and is surrounded by a national forest preserve. Nine Bridges was designed by globetrotting American architect Ronald Fream, and developed by Jay Lee, CEO of the Cheil Jedang Group and the grandson of the founder of Samsung. Fream created broad fairways of bent grass and wide belts of sand through the existing creek beds piled with volcanic stones and lined with oaks. Lakes were created on holes five and seven, and a 50,000-ton water hazard encircles the island 18th green. One bridge that was added connects the 18th green to the clubhouse. The surrounding mountains shelter the course from Jeju Island's fierce winds.

BELOW: The clubhouse

Kasumigaseki is one of Japan's most famous courses, having been revised by English course architect Charles Alison during his three-month trip to Japan. Alison arrived in Tokyo harbor on December 1, 1930, aboard the liner Asama Maru sailing from California, having been sent by his partner, H.S. Colt, to design a new course for the Tokyo Golf Club. On the same trip, Alison produced designs for the Kawana Golf Club's Fuji Course and the Hirono Golf Club. Kasumigaseki's original course, now the East Course, was laid out in 1929 by Kinya Fujita and Shiro Akaboshi, who were introduced to golf as students in the United States. Fujita asked Alison to inspect the course, and he redesigned five holes, introducing the gaping bunkers, particularly on the par-three 10th, that subsequently became known as "Alisons" and were widely copied throughout Japan. A second West Course was added in 1932, designed by Fujita and Seiichi Inoue, who would go on to become Japan's leading course architect. Kasumigaseki is impeccably maintained in the Japanese golfing tradition, with the fairways and white river sand bunkers achieving a highly manicured state. Like some other Japanese courses, Kasumigaseki has two sets of greens, one seeded with fine bent grass that dies off every summer and has to be regrown, and one seeded with hardier korai grass from Korea.

RIGHT: The East Course

Bonari Kogen Golf Club is a course of exceptional beauty crafted from an abandoned sulfur mine in Fukushima, Japan. Designed by American golf architect Ronald Fream and founded by Masanori Tsujita, it took 13 years to transform the mining wasteland, which did not have a single blade of grass, into coiling green fairways scaled with cloverleaf bunkers and rock-lined pools through the ridges of maple and pine. The most spectacular hole is the par-five third, laid out above scarred, reddish-brown cliffs formed by a great gash in the earth with a creek running below. The course is located within the Bandai National Park and is framed by the serene steel-blue peaks of the Adatara Mountain Range, including Mount Bandai.

DECEMBER 28—KAWANA GOLF CLUB (FUJI COURSE)—JAPAN

In 1930, architect Charles Alison arrived on his historic visit to Japan to design the Tokyo Golf Club's new course. He then traveled with Komyo Otani to the retreat of Baron Kishichiro Akura at Kawana on the Izu Peninsula, which is famous for its hot springs, two to three hours south of Tokyo. The son of one of Japan's wealthiest industrialists, Akura had been educated at Cambridge and modeled his 500-acre estate after those he had admired in the English countryside. Akura then set about developing a world-class golf resort and hotel at Kawana. The first course at Kawana, the Oshima Course, was designed by Otani and completed in 1928. It is named for Oshima Island just off the coast, with its still smoldering volcano. Akura then hired Alison to design the Fuji Course, which opened in 1936. The course rises and plunges through the emerald green hills on a promontory above the sea, with cloud-covered Mt. Fuji in the distance rising above an inlet in the Pacific.

Naruo Golf Club, located in the hills near Osaka, is one of Japan's top-flight traditional private clubs. The club has a distinguished pedigree that dates back to 1920, having been founded by British expatriates, and was originally laid out by the Crane brothers, the sons of a British father and Japanese mother. In 1931, the accomplished English architect Charles Alison was hired to remodel the course while on his historic trip to Japan, and the small elevated greens ringed by elegantly tiered and extraordinarily deep, grass-rimmed bunkers bear Alison's unmistakable stamp. Naruo is a steep course, with korai grass greens and narrow fairways that are beautifully shaped through the ornately patterned overhangs of varieties of Japanese evergreens. Indeed, the course is so hilly that the female caddies transport the golf bags on cart trams that run on a mechanized track. There are several notable holes, including the semicircular par-four eighth and the 470-yard 10th, with a long second shot across a ravine. The 15th is a par-three playing 175 yards uphill over the pines to a green guarded by the cavernous, staggered bunkers. Before playing the hole, golfers are fortified by a quick cup of tea in the small teahouse adjoining the tee box.

Hirono Golf Club near Kobe was designed by the English course architect Charles Alison during his tour of Japan in 1930–31 on an idyllic site that was part of the large estate of Viscount Kuki, a former feudal warlord and avid golfer. Opened in June 1932, Hirono is generally regarded as Japan's finest course. While in Tokyo, Alison was approached by Seiichi Takahata, a member of The Addington in London, about the project he was involved with at Hirono. Alison visited the site, finding it tailor-made for golf with its lovely lakes and natural valleys, ravines, and rivulets. After studying the property, Alison retired to his room at the Oriental Hotel near the Kobe train station with notes and contour maps, and after seven days emerged with a detailed plan. Of his work at Hirono, Alison later wrote: "In 1930, wild boar were said to flourish there, but I am thankful to say that my acquaintance with them was made only at the dinner table. On 300 acres available for golf, there was no human habitation, nor view of one. . . . A map of land was prepared by a Japanese surveyor showing the lakes and principal hills and dales. Notwithstanding the trees and in places the dense undergrowth, this proved to be an excellent guide."

The Taiheiyo Club Gotemba Course is located at the eastern foot of Mount Fuji in Shizuoka Prefecture, an hour and 45 minutes drive from central Toyko and 30 minutes from Hakone. Every November, the club hosts the Taiheiyo Masters, one of the marquee events on the Japan Golf Tour and one that attracts a topnotch international field. Winners over the years have included Darren Clarke, Lee Westwood, Greg Norman, and José Maria Olazábal, with Japanese star Shingo Katayama earning victory in 2008. In 2001, the course also hosted the World Cup, won by the South African dream team of Ernie Els and Retief Goosen in a playoff. Gotemba is the crown jewel of the Taiheiyo Club, Japan's largest golf club, which owns 15 courses across the country. Opened in 1977, the course is laid out through mature forest at the base of the mountain. It was designed by leading Japanese architect Shunsuke Kato.

RIGHT: Tiger Woods launches his second shot under Mount Fuji at the 2001 World Cup held at the Taiheiyo Club's Gotemba Course

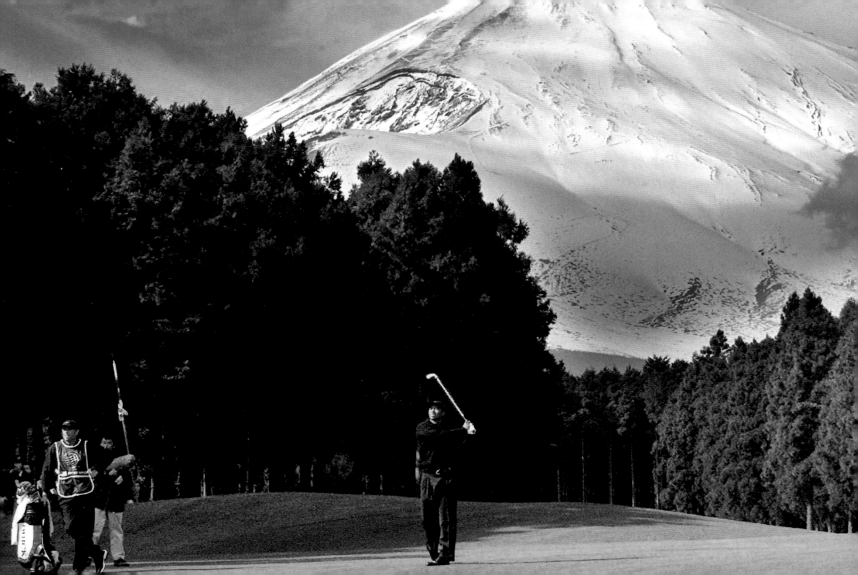

INDEX
OF COURSES

This index includes all of the courses in the book, listed with the date they appear, and arranged geographically by country and by state within the United States. Courses that are open to the public are marked with one star, and those that have limited access to the public are marked with two stars. For both categories, the course's website is listed when available. The limited-access courses are open to the public only during certain days or hours, may include other requirements such as a handicap card, and arrangements generally must be made in advance. Golfers should also note that some of the courses marked as public that are located at resorts might have restrictions on play for nonresort guests. Courses with no stars are private.

www.riversidecasinoandresort.com, 6/17

KANSAS
Prairie Dunes Country Club
 www.prairiedunes.com, 5/23

KENTUCKY
Club at Olde Stone, The
 www.olde-stone.com, 5/2
Valhalla Golf Club
 valhalla.pgalinks.com, 4/30

LOUISIANA
*Gray Plantation Golf Course
 www.graywoodllc.com/gray-woodgolf.php, 5/7

MAINE
*Sunday River Golf Club
 www.sundayriver.com/Golf, 9/20

MARYLAND
Congressional Country Club
(Blue Course)
 www.ccclub.org, 10/10

MASSACHUSETTS
Country Club, The
 www.tcclub.org, 9/24
Golf Club of Cape Cod
 www.tgccc.com, 9/26
Kittansett Club
 www.kittansett.org, 9/25
Sankaty Head Golf Club
 www.sankatyheadgc.com, 9/27

MICHIGAN
*Arcadia Bluffs Golf Club
 www.arcadiabluffs.com, 6/26
Crystal Downs Country Club, 6/27
Kingsley Club, The
 www.kingsleyclub.com, 6/25

*Marquette Golf Club (Greywalls
Course)
 www.marquettegolfclub.com, 6/24
Oakland Hills Country Club (South
Course)
 www.oaklandhillscc.com, 6/28

MINNESOTA
*Dacotah Ridge Golf Club
 www.dacotahridge.com, 6/16
Hazeltine National Golf Club
 www.hngc.com, 6/14
Interlachen Golf Club
 www.interlachencc.org, 6/15

MISSISSIPPI
*Dancing Rabbit Golf Club
 www.dancingrabbitgolf.com, 5/5
*Preserve Golf Club, The
 www.preservegc.com, 5/6

MISSOURI
Club at Porto Cima, The
 www.portocima.com, 5/9

MONTANA
Club at Spanish Peaks, The
 www.spanish-peaks.com, 6/12
Rock Creek Cattle Company
 www.rockcreekcattlecompany.com, 5/30

NEBRASKA
Sand Hills Golf Club
 www.sandhillsgolfshop.com, 5/24

NEVADA
*Bali Hai Golf Club
 www.balihaigolfclub.com, 1/16
**Cascata Golf Club
 www.harrahs.com/golf/cascata-golf, 1/17
**Shadow Creek Golf Club
 www.shadowcreek.com, 1/18

*Wolf Creek Golf Club
 www.golfwolfcreek.com, 1/19

NEW HAMPSHIRE
*Mount Washington Course
 www.mountwashingtonresort.com, 9/21

NEW JERSEY
Baltusrol Golf Club (Lower Course)
 www.baltusrol.org, 10/5
Bayonne Golf Club
 www.bayonnegolfclub.com, 9/10
Galloway National Golf Club
 www.gallowaynationalgolf.com, 10/8
Liberty National Golf Club
 www.libertynationalgc.com, 9/11
Pine Valley Golf Club, 10/7
Somerset Hills Country Club
 www.somersetcc.org, 10/6

NEW MEXICO
*Black Mesa Golf Club
 www.blackmesagolfclub.com, 5/15
Golf Club at Rainmakers
 www.rainmakersusa.com, 5/14

NEW YORK
*Bethpage State Park (Black Course)
 www.nysparks.state.ny.us/golf-courses, 9/7
Creek Club, The
 www.creek.net, 9/8
Friar's Head Golf Club
 www.friarshead.org, 9/6
Hudson National Golf Club
 www.hudsonnational.org, 10/2
*Leatherstocking Golf Course
 www.otesaga.com/LGC, 9/9
Midvale Country Club
 www.midvalecc.com, 9/13
National Golf Links of America, The, 9/4

Sebonack Golf Club
 www.sebonack.com, 9/5
Shinnecock Hills Golf Club, 9/3
Sleepy Hollow Country Club
 www.sleepyhollowcc.org, 10/3
*Turning Stone Resort (Atunyote Golf
Club)
 www.turning-stone.com/golf, 9/12
Winged Foot Golf Club (West Course)
 www.wfgc.org, 10/4

NORTH CAROLINA
Cardinal Golf & Country Club
 www.cardinalcc.com, 4/23
Club at Irish Creek, The
 www.playatirishcreek.com/golf.htm, 4/20
*Pinehurst Resort (Course No. 2)
 www.pinehurst.com, 4/22
Wade Hampton Golf Club
 www.wadehamptongc.com, 4/21

NORTH DAKOTA
*Bully Pulpit Golf Club
 www.medora.com/bully-pulpit, 6/13

OHIO
Inverness Club
 www.invernessclub.com, 6/29
Muirfield Village Golf Club
 www.thememorialtournament.com, 7/2

OKLAHOMA
*Karsten Creek Golf Club
 www.karstencreek.net, 5/10

OREGON
*Bandon Dunes at Bandon Dunes Golf
Resort
 www.bandondunesgolf.com, 6/4
*Pacific Dunes at Bandon Dunes Golf
Resort
 www.bandondunesgolf.com, 6/5

Pronghorn Club, The
www.pronghornclub.com, 6/6
Tetherow Golf Club
www.tetherow.com, 6/7

PENNSYLVANIA
Aronimink Golf Club
www.aronimink.org, 7/5
*Bedford Springs Resort
www.omnihotels.com/FindAHotel/
BedfordSprings.aspx, 7/4
Merion Golf Club (East Course)
www.meriongolfclub.com, 7/6
Oakmont Country Club
www.oakmont-countryclub.org, 7/3
Philadelphia Cricket Club
www.philacricket.com, 7/7
Saucon Valley Country Club
www.sauconvalleycc.org, 7/8

RHODE ISLAND
Misquamicut Golf Club
www.themisquamicutclub.com,
9/30
Newport Country Club
www.newportscountryclub.com,
9/28
Shelter Harbor Golf Club
www.shgcri.com, 9/29

SOUTH CAROLINA
Cliffs at Keowee Falls, The
www.cliffscommunities.com/golf,
4/19
Haig Point Golf Club
www.haigpoint.com/golf, 4/16
*Harbour Town Golf Links
www.seapines.com, 4/15
*May River Golf Club at the Inn at
Palmetto Bluff
www.palmettobluffresort.com/golf,
4/17
*Ocean Course at Kiawah Island Resort
www.kiawahresort.com, 4/18

SOUTH DAKOTA
Sutton Bay Club
www.suttonbay.com/golf.php, 5/25

TENNESSEE
Honors Course, The
www.honorscourse.net, 5/3

TEXAS
*Butterfield Trail Golf Club
www.butterfieldtrailgolf.com, 5/13
Dallas National Golf Club
www.dallasnationalgolfclub.com,
5/11
Whispering Pines Golf Club
www.whisperingpinesgolfclub.com,
5/12

UTAH
*Sand Hollow Resort
www.sandhollowresort.com, 1/20

VERMONT
*Equinox Resort
www.equinoxresort.com, 9/23
Vermont National Golf Club
www.vermontnational.com, 9/22

VIRGINIA
*Homestead Resort, The
www.thehomestead.com, 4/24
Kinloch Golf Club
www.kinlochgolfclub.com, 4/25
Robert Trent Jones Golf Club
www.rtjgc.com, 4/27
*Royal New Kent
www.traditionalclubs.com/royal,
4/26

WASHINGTON
*Chambers Bay Golf Course
www.chambersbaygolf.com, 6/3
*Palouse Ridge Golf Club at Washington
State University
palouseridge.wsu.edu, 6/8

WEST VIRGINIA
*Greenbrier, The
www.greenbrier.com, 4/29
Pete Dye Golf Club
www.petedye.com, 4/28

WISCONSIN
*Blackwolf Run
www.destinationkohler.com, 6/22
*Erin Hills Golf Course
www.erinhills.com, 6/21
*Whistling Straits
www.destinationkohler.com, 6/23

WYOMING
Jackson Hole Golf & Tennis Club
www.jhgtc.com, 5/28
*Powder Horn Golf Club, The
www.thepowderhorn.com, 5/26
3 Creek Ranch Golf Club
www.3creekranch-jh.com, 5/29
*Three Crowns Golf Club
www.threecrownsgolfclub.com, 5/27

INTERNATIONAL

ARGENTINA
* Arelauquen Golf and Country Club
www.arelauquen.com, 2/11
Jockey Club (Red Course)
www.jockeyclub.com.ar, 2/9
*Llao Llao Resort & Hotel Golf Course
www.llaollao.com, 2/10

AUSTRALIA
*Barnbougle Dunes
www.barnbougledunes.com.au,
12/17
**Heritage Golf & Country Club
www.hgcc.com.au, 12/14
**Kingston Heath Golf Club
www.kingstonheath.com.au, 12/13

**National Golf Club (Moonah Course)
www.nationalgolf.com.au, 12/15
**New South Wales Golf Club
www.nswgolfclub.com.au, 12/11
**Portsea Golf Club
www.portseagolf.com.au, 12/16
**Royal Melbourne Golf Club (West
Course)
www.royalmelbourne.com.au, 12/12

AUSTRIA
*Eichenheim Golf Course
www.grand-tirolia.com, 8/22
*Fontana Golf & Country Club
www.fontana.at, 8/21

BAHAMAS
Abaco Club on Winding Bay
www.theabacoclub.com, 2/28
*Blue Shark Golf Club
www.bluesharkgolf.com, 3/1

BAHRAIN
*Royal Golf Club Riffa Views
www.theroyalgolfclub.com, 11/12

BARBADOS
*Green Monkey Golf Course at the
Sandy Lane Hotel
www.sandylane.com, 2/14
*Royal Westmoreland
www.royal-westmoreland.net, 2/15

BELGIUM
**Royal Golf Club de Belgique
www.golf.be/ravenstein, 8/29

BERMUDA
Mid Ocean Golf Club
www.themidoceanclubbermuda.
com, 10/11

BRAZIL
*Commandatuba Ocean Course
www.transamerica.com.br, 2/16
Gávea Golf and Country Club
www.gaveagolf.com.br, 2/12
*Terravista Golf Course
www.terravistagolf.com.br, 2/13

CAMBODIA
*Angkor Golf Resort
www.angkor-golf.com, 11/28

CANADA
*Banff Springs Golf Course
www.fairmontgolf.com/banffsprings,
5/31
Devil's Pulpit Golf Association
www.devilspulpit.com, 9/16
*Glen Abbey Golf Club
www.glenabbey.ca, 9/15
*Greywolf Golf Course at Panorama
Resort,
www.greywolfgolf, 6/2
*Highlands Links
www.highlandslinksgolf.com, 9/18
*Mont Tremblant Golf Resort
www.tremblant.ca/golf, 9/19
Redtail Golf Club, 9/14
*Taboo Golf Club
www.tabooresort.com, 9/17
Tobiano Golf Club
www.tobianogolf.com, 6/1

CHINA
Beijing Pine Valley Golf Resort, 11/19
*Chung Shan Hot Spring Golf Club
www.cshsgc.com.cn, 11/23
*Lijiang Ancient Town Golf Club
11/25
*Mission Hills Golf Club
www.missionhillsgroup.com, 11/21,
11/22
*Qinghe Bay Golf & Country Club, 11/18
*Spring City Golf & Lake Resort

www.springcityresort.com, 11/26
*Weihai Point Golf & Resort
www.weihaipointgolfresort.net,
11/20

COLOMBIA
El Rincón, Club
www.elrincon.com.co, 2/17

COSTA RICA
*Four Seasons Golf Club Costa Rica at
Peninsula Papagayo,
www.fourseasons.com/costarica/
golf.html, 2/8

CYPRUS
*Aphrodite Hills Golf Club
www.aphroditehills.com/cyprus_
golf, 11/8
*Korineum Golf and Country Club
www.korineumgolf.com, 11/9

CZECH REPUBLIC
*Karlštejn Golf Resort,
www.karlstejn-golf.cz, 8/19

DENMARK
*Lübker Golf Resort,
www.lubker.com, 8/9
*Skjoldenaesholm Golf Center (Trent
Jones Course)
www.proarkgolf.dk, 8/10

DOMINICAN REPUBLIC
*Casa de Campo Resort
www.casadecampo.com.do, 2/21
*Legacy Course at Roco Ki
www.rocoki.com/faldo.asp, 2/23
*Playa Grande Golf Course
www.playagrande.com, 2/24
*Punta Espada,
www.capcana.com, 2/22

EGYPT
*Taba Heights Golf Resort
www.tabaheights.com, 3/17

ENGLAND
**Addington Golf Club, The
www.addingtongolf.com, 8/31
**Broadstone Golf Club
www.broadstonegolfclub.com, 10/23
*Formby Golf Club
www.formbygolfclub.co.uk, 10/14
**Royal Ashdown Forest Golf Club
www.royalashdown.co.uk, 9/2
**Royal Birkdale Golf Club
www.royalbirkdale.com, 10/13
**Royal Lytham and St. Annes Golf
Club
www.royallytham.org, 10/12
*Royal North Devon Golf Club (West-
ward Ho!)
www.royalnorthdevongolfclub.
co.uk, 10/22
**Royal St. George's Golf Club
www.royalstgeorges.com, 10/25
**Royal West Norfolk Golf Club
www.rwngc.org, 10/26
**Rye Golf Club
www.ryegolfclub.co.uk, 10/24
*St. Enodoc Golf Club
www.st-enodoc.co.uk, 10/20
**Saunton Golf Club (East Course),
www.sauntongolf.co.uk, 10/21
**Sheringham Golf Club,
www.sheringhamgolfclub.co.uk ,
10/27
**Sunningdale Golf Club (Old Course)
www.sunningdale-golfclub.co.uk,
8/30
**Walton Heath Golf Club (Old Course)
www.whgc.co.uk, 9/1
*West Lancashire Golf Club
www.westlancashiregolf.co.uk,
10/15
*Woodhall Spa (Hotchkin Course)
www.woodhallspagolf.com, 10/28

FINLAND
*Paltamo Golf Club (Midnight Sun)
www.paltamogolf.fi, 8/15

FRANCE
**Chantilly, Golf de
www.golfdechantilly.com, 11/2
*Chiberta, Golf de
www.golfchiberta.com, 11/5
*Étretat, Golf d'
www.golfetretat.com, 10/29
*Evian Masters Golf Club
www.evianroyalresort.com, 4/9
*Golf National, Le (L'Albatros)
www.golf-national.com, 11/1
*Les Bordes
www.lesbordes.com, 11/4
Morfontaine, Golf de, 10/30
**Paris International Golf Club
www.paris-golf.com, 11/3
Prince de Provence, Le, 4/4
Saint-Nom-la-Bretèche (Red Course)
www.saint-nom-la-breteche.org,
10/31
*Sperone, Golf de, Corsica
www.sperone.com, 4/5

GAMBIA
*Fajara Club, The
www.smiles.gm/fajara.htm, 3/19

GERMANY
*Berlin Sporting Club (Nick Faldo
Course)
www.sporting-club-berlin.de, 8/24
**Club zur Vahr
www.club-zur-vahr-bremen.de, 8/27
**Hamburger Golf Club
www.hamburgergolf-club.de, 8/26
*Seddiner See, Golf and Country Club
(South Course)
www.gccseddinersee.de, 8/25

GREECE
*Crete Golf Club
www.crete-golf.com, 11/7

GUATEMALA
*Fuego Maya Golf Course
www.lareunion.com.gt, 2/7

HONG KONG
*Jockey Club Kau Sai Chau Course
www.kscgolf.org.hk, 11/24

HUNGARY
*Pannónia Golf & Country Club
www.golfclub.hu, 8/20

INDIA
*Delhi Golf Club
www.delhigolfclub.org, 11/16

INDONESIA
*Bali Handara Kosaido Country Club,
Bali
www.balihandarakosaido.com,
12/10
**Cengkareng Golf Club
www.cengkarenggolfclub.com, 12/8
*Nirwana Bali Golf Club, Bali
www.nirwanabaligolf.com, 12/9
*Ria Bintan Golf Club, Bintan
www.riabintan.com, 12/5

IRELAND
*Ballybunion Golf Club (Old Course)
www.ballybuniongolfclub.ie, 7/25
*Ballyliffin Golf Club
www.ballyliffingolfclub.com, 7/30
*Carton House Golf Club
www.cartonhousegolf.ie, 7/20
*Carne Golf Links
www.carnegolflinks.com, 7/28
*County Sligo Golf Club
www.countysligogolfclub.ie, 7/29
*Doonbeg Golf Club
www.doonbeggolfclub.com, 7/26

*Dun Laoghaire Golf Club
www.dunlaoghairegolfclub.ie, 7/21
*European Club, The
www.theeuropeanclub.com, 7/22
*Lahinch Golf Club
www.lahinchgolf.com, 7/27
*Old Head Golf Links
www.oldheadgolflinks.com, 7/23
*Portmarnock Golf Club
www.portmarnockgolfclub.ie, 7/19
*Tralee Golf Club
www.traleegolfclub.com, 7/24

ISRAEL
**Caesarea Golf Club
www.golf.caesarea.com, 11/11

ITALY
*Castelconturbia Golf Club
www.castelconturbia.it, 4/8
*Circolo Golf Bogogno
www.circologolfbogogno.com, 4/7
*Pevero Golf Club, Sardinia
www.golfclubpevero.it, 4/6
*Verdura Golf & Spa Resort, Sicily
www.verduraresort.com, 11/6

JAMAICA
*Cinnamon Hill Country Club
www.rosehallresort.com, 2/25

JAPAN
*Bonari Kogen Golf Club
www.bonari.co.jp/golf, 12/27
Hirono Golf Club, 12/30
Kawana Golf Club (Fuji Course)
www.princehotels.co.jp/kawana-e/
fuji.html, 12/28
Kasumigaseki Golf Club (East Course),
12/26
Naruo Golf Club, 12/29
Taiheiyo Club Gotemba Course
www.taiheiyoclub.co.jp/course/go-
tenba, 12/31

KENYA
*Karen Golf Club
www.karencountryclub.org, 3/16

LATVIA
*Ozo Golf Club
www.ozogolf.lv, 8/16

MALAYSIA
*Mines Resort, The
www.mines.com.my, 12/3
*Mount Kinabalu Golf Course, Sabah,
12/6
*Nexus Resort Karambunai, Sabah
www.nexusresort.com/new/golf.
html, 12/7

MAURITIUS
*Le Touessrok Golf Course
www.letouessrokresort.com, 3/12
*Tamarina Golf Club
www.tamarina.mu, 3/13

MEXICO
*Cabo del Sol Golf Club (Ocean Course)
www.cabodelsol.com, 2/1
Diamante Cabo San Lucas
www.diamantelife.com, 2/2
*El Camaleón Golf Course at the Fair-
mont Mayakoba Resort
www.fairmont.com/mayakoba/Rec-
reation/Golf, 2/6
*Four Seasons Resort Punta Mita
www.fourseasons.com/puntamita,
2/5
*Puerto Los Cabos Golf Club
www.puertoloscabos.com/golf.php,
2/3
Querencia Golf Club
www.loscabosquerencia.com, 2/4

MOROCCO
*Royal Dar Es Salam Golf Club (Red
Course)
www.royalgolfdaressalam.com, 3/20

NEPAL
*Gokarna Forest Golf Resort
www.gokarna.com, 11/17

NETHERLANDS, THE
**Royal Hague Golf Club
www.khgcc.nl, 8/28

NEW ZEALAND
*Cape Kidnappers Golf Course
www.capekidnappers.com, 12/20
Gulf Harbour Country Club
www.gulfharbour.com, 12/18
Hills Golf Course, The
www.thehills.co.nz, 12/22
*Kinloch Club, The
www.kinloch-golf.com, 12/19
*Terrace Downs Golf Course
www.terracedowns.co.nz, 12/21

NORTHERN IRELAND
*Castlerock Golf Club
www.castlerockgc.co.uk, 7/31
*Royal County Down Golf Club
www.royalcountydown.org, 8/2
*Royal Portrush Golf Club
www.royalportrushgolfclub.com,
8/1

NORWAY
*Bjaavann Golf Club
www.bjaavanngk.no, 8/13

PHILIPPINES
Mount Malarayat Golf and Country Club
www.malarayat.com/golfclub.htm,
12/23

POLAND
*Krakow Valley Golf Club
www.krakow-valley.com, 8/18

PORTUGAL
*Amendoeira Golf Resort (Faldo Course)
www.oceanicodevelopments.com/
developments/portugal_the_algarve/
amendoeira, 3/26
**Batalha Golf Club, Azores, 3/29
*Monte Rei Golf & Country Club
www.monte-rei.com, 3/27
*Oitavos Dunes Course at Quinta da
Marinha Resort
www.quintadamarinha.com, 3/28
*Praia d'El Rey Golf & Beach Resort
www.praia-del-rey.com, 3/30
*San Lorenzo Golf Club
www.sanlorenzogolfcourse.com, 3/25
*Santo da Serra Golf Club, Madeira
www.santodaserragolf.com, 3/31

PUERTO RICO
*Bahía Beach Resort & Golf Club
www.bahiabeachpuertorico.com,
2/20

RUSSIA
Pestovo Golf & Yacht Club
www.pestovogolf.com, 8/17

ST. KITTS AND NEVIS
*Royal St. Kitts Golf Club
www.royalstkittsgolfclub.com, 2/19

ST. VINCENT AND THE GRENADINES
*Trump International Golf Club at
Canouan
www.canouan.com/golf.asp, 2/18

SCOTLAND
*Askernish Golf Club
www.askernishgolfclub.com, 7/16
*Brora Golf Club
www.broragolf.co.uk, 7/14
*Carnoustie Golf Links
www.carnoustiegolflinks.co.uk, 7/11
*Castle Course at St. Andrews
www.standrews.org.uk, 7/10

*Castle Stuart Golf Club
www.castlestuartgolf.com, 7/13
*Gleneagles Resort
www.gleneagles.com, 7/12
Loch Lomond Golf Club
www.lochlomond.com, 8/8
*Machrihanish Dunes Golf Club
www.machrihanishdunes.com, 8/7
**Muirfield
www.muirfield.org.uk, 7/17
*North Berwick Golf Club
www.northberwickgolfclub.com,
7/18
*Old Course at St. Andrews, The
www.standrews.org.uk, 7/9
*Prestwick Golf Club
www.prestwickgc.co.uk, 8/4
*Royal Dornoch Golf Club
www.royaldornoch.com, 7/15
**Royal Troon Golf Club
www.royaltroon.co.uk, 8/5
*Turnberry Resort (Ailsa Course)
www.turnberry.co.uk, 8/3
*Western Gailes Golf Club
www.westerngailes.com, 8/6

SINGAPORE
**Sentosa Golf Club
www.sentosagolf.com, 12/4

SOUTH AFRICA
Durban Country Club
www.dcclub.co.za, 3/11
**Erinvale Golf Club
www.erinvalegolfclub.com, 3/9
*Fancourt Resort and Hotel
www.fancourt.co.za, 3/8
**Leopard Creek Golf Estate & Country
Club
www.leopardcreek.co.za, 3/15
*Sun City Resort (Lost City Golf Course)
www.suninternational.com, 3/14
*Pinnacle Point Golf Course
www.pinnaclepoint.co.za, 3/10

SOUTH KOREA
Club at Nine Bridges, The
www.ninebridges.co.kr, 12/25
*Pine Beach Golf Links, 12/24

SPAIN
*Abama Golf & Spa Resort, Canary
Islands
www.abamahotelresort.com/golf_en,
3/23
*Costa Teguise Golf Course, Canary
Islands
www.lanzarote-golf.com, 3/24
D'Aro (Mas Nou), Club de Golf
www.golfdaro.com, 4/3
*El Saler, Campo de Golf, 4/1
*La Cala Golf & Spa Resort
www.lacala.com, 3/22
*Platja de Pals Golf Club
www.golfplatjadepals.com, 4/2
**Valderrama, Club de Golf
www.valderrama.com, 3/21

SWEDEN
*Barsebäck Golf and Country Club
(Old Course)
www.barseback-golf.se, 8/12
*Bro Hof Slott Golf Club (Stadium
Course)
www.brohofslott.se, 8/14
*Falsterbo Golf Club
www.falsterbogk.com, 8/11

SWITZERLAND
*Crans-Sur-Sierre, Golf Club
www.golfcrans.ch, 8/23

THAILAND
*Alpine Golf Club
www.alpinegolfclub.com, 11/29
*Blue Canyon Country Club (Canyon
Course)
www.bluecanyonclub.com, 12/2
*Santiburi Country Club

www.santiburi.com, 12/1
*Santiburi Samui Country Club
www.santiburi.com, 11/30

TUNISIA
*Tabarka Golf Club
www.tabarkagolf.com, 3/18

TURKEY
*Montgomerie Course at Papillon Golf
Resort
www.golfturkey.com/montgomerie-
golf-course.htm, 11/10

UNITED ARAB EMIRATES
*Al Badia Golf Club
www.ichotelsgroup.com/intercon-
tinental/en/gb/locations/dubai-
festivalcity, 11/13
Els Club at Dubai Sports City
www.elsclubdubai.com, 11/14
*Emirates Golf Club (Majlis Course)
www.dubaigolf.com/egc, 11/15

VIETNAM
*Montgomerie Links
www.montgomerielinks.com, 11/27

WALES
*Celtic Manor Resort (Twenty Ten
Course)
www.celtic-manor.com, 10/19
*Conwy (Caernarvonshire) Golf Club
www.conwygolfclub.com, 10/16
*Pennard Golf Club
www.pennardgolfclub.com, 10/17
*Royal Porthcawl Golf Club
www.royalporthcawl.com, 10/18

*Open to the public
**Limited access to the public

PHOTOGRAPHY CREDITS

Courtesy of Aphrodite Hills Golf Club: November 8; Phil Arnold/Golfscape: July 2 (right), September 15; Beckenham Golf Library/www.pocket.golf.com: October 20 (below), November 4 (right); Aidan Bradley: front cover, January 3, 6, 13, 22, 27, 31, February 23 (right), 26, March 22, 26, 27, 29, April 2, 3, May 19, 31 (below), July 16, 20, August 7, September 17, November 14; Tom Breazeale: January 20, June 12, August 18, November 15 (below), 18, 20, 21 (right), 27, 28, December 23, 24; courtesy of Bro Hof Slott Golf Club: August 14; Nic Brook/Phil Sheldon Golf Picture Library: March 24; courtesy of Bully Pulpit Golf Club: June 13; Richard Castka/Phil Sheldon Golf Picture Library: November 21 (below), 22 (right), 23, 24, December 3, 6; courtesy of Castle Stuart Golf Club: July 13; courtesy of The Cliffs at Keowee Falls: April 19; Jordan Coonrad/Airborne: January 5 (right), April 15, May 9, 28, June 9, 11, August 3 (right); courtesy of Cougar Canyon Golf Club: May 16; courtesy of Creek Club at Reynolds Plantation: April 12; courtesy of Crete Golf Club: November 7; courtesy of Tom Doak/Renaissance Golf Design: February 21, March 11 (below), August 28, October 11, December 11; Joann Dost: February 28, May 7, June 6, September 11, November 3, December 20; Dick Durrance II: January 1 (below), 5 (below), March 7, May 25 (below); courtesy of Eichenheim Golf Club: August 22; courtesy of Fontana Golf Club: August 21; courtesy of Four Mile Ranch Golf Club: May 17; courtesy of Ronald Fream/GolfPlan: March 18, August 15; December 25 (below), 27; Jorgé Gamboa: February 17; courtesy of Lester George Golf Design: April 25; Getty Images: David Alexander, December 2 (right); Allsport UK/Allsport, August 19; David Cannon, March 12, April 30, June 23 (right), July 18, August 5, 23 (right), 31, September 2, October 22, 24, November 12, 15 (right); Mike Ehrmann, February 6; Stuart Franklin, March 23; Phil Inglis, March 28 (right), August 17 (right), December 8 (right); Alexander Joe/AFP, March 14 (below); Koichi Kamoshida, 1; Ross Kinnaird/Allsport, April 1, August 23 (below); Toshifumi Kitamura/AFP, December 31; Andy Lyons, April 9; Tim Matthews/Allsport, April 8; Ryan Pierse, March 31; Norbert Schmidt/Sports Illustrated, November 1; James Schnepf/Sports Illustrated, June 14; Fred Vuich/Sports Illustrated, July 4; Phil Walter, December 19; 22 (below); Ian Walton, August 17 (below), December 2 (below), 4, 8 (below); Tria Giovan: February 18; courtesy of Gozzer Ranch Golf Club: June 10; John & Jeannine Henebry: January 1 (right), 4, 7, 8, 12, 18, 21, February 5, 8, 23 (below), March 4 (right), 8, 10, 15, April 21, 22 (right), 24 (right), May 1, 20, 21, 24, 25 (right), 26, 31 (right), June 4, 5, August 10, 13, 25, September 19 (right), 22, October 2 (right), 7 (below), November 17, December 9, 10 (right), 12, 21; Eric Hepworth: March 21 (below), July 9 (below), 11 (below), 15, July 27 (right), August 3 (below), 4 (right), 5 (below), 30 (right), October 15, 17, 23, 26, 27, 28; courtesy of The Hills Golf Course: December 22; Paul Hundley: April 18, June 21, 22, 23 (below), 24; Phil Inglis/Phil Sheldon Golf Picture Library: April 6; Taliaferro Jones: February 20, May 14, 27, June 3, September 13, November 13; courtesy of the Kinloch Club: 2; Russell Kirk/GolfLinks: January 16, 19, 23, February 1, 25, 27, March 21 (right), April 10, 11, 16, 26, 27, 29, May 2, 4, 5, June 15, 18, 20 (right), 30, July 5, 6, 7, 10, August 11, 12, 26, 27, 30 (below), September 1, 7 (above), 9, 19 (below), October 2 (below), 4 (below), 9, 10, 12, 13 (right), 18, 25, December 18; courtesy of Bradley Klein: April 28 (below); Mike Klemme/Golfoto: January 10 (below), March 16, 20, April 13 (below), 14, 24 (below), May 3, 8, 10, 11, 23, June 19, 29, July 2 (below), 3, September 18, December 10 (below), 25 (right); L.C. Lambrecht: Introduction, January 2, 9, 10 (right), 11, 14, 15, 17, 25, 26, 28-30, February 2-4, 9-13, 16, 22, 24, March 1-3, 4 (below), 5, 6, 9, 11 (right), April 13 (right), 17, 20, 23, May 12, 15, 18, 22, 29, 30, June 16, 17, 25-28, July 8, 11 (right), 12, 14, 17, 19, 22-26, 27, 28-31, August 1, 2 (below), 6, 8, September 3-6, 7 (right), 8, 10, 14, 20, 23, 30, October 1, 3, 4, 5 (right), 6, 7 (right), 8, December 13, 16, 17; Jean-François Lefèvre: March 14 (right), August 4 (below), October 29, November 4 (below), 5, 16; Patrick Lim: November 19, 25, 26, 30, December 1, 7; Iain Lowe: November 11; Ken E. May/Rolling Greens Photography: February 7, April 28 (right), July 1; Taku Miyamoto/Golflinks: March 25, November 2, December 30; courtesy of Mount Washington Course: September 21; Kevin Murray: February 14, 15, 19, July 21, August 2 (right), 9, October 14, 16, 19, 20 (right), November 9, 10; courtesy of Oitavos Dunes Golf Course: March 28 (below); courtesy of Olympia Fields Country Club: June 20 (below); courtesy of Ozo Golf Club and Armands Puce: August 16; courtesy of Palouse Ridge Golf Club: June 8; courtesy of Pannónia Golf Club: August 20; Rob Perry: May 13; courtesy of the Preserve Golf Club: May 6; courtesy of Royal Golf Club de Belgique: August 29; Wood Sabold: June 7; David Scaletti: March 30, April 4, 5, 7, June 2, September 16, October 30, December 5, 14, 15, 26, 28, 29; courtesy of Seven Canyons Golf Club: January 24; Phil Sheldon/Phil Sheldon Golf Picture Library: October 31, November 22 (below); Stefan V. Stengel/TGPL: August 24; courtesy of Taba Heights Golf Resort/Helen Shippey: March 17; courtesy of Tamarina Golf Club: March 13; courtesy of Tobiano Golf Club/Bob Huxtable: June 1; courtesy of Turning Stone Resort: September 12; courtesy of Verdura Golf Resort: November 6; Allan Watson/Phil Sheldon Golf Picture Library: March 19.

Editor: Margaret Kaplan
Designer: Kris Tobiassen
Production Manager: Jules Thomson

Library of Congress Cataloging-in-Publication Data

Sidorsky, Robert.
 Golf courses of the world : 365 days / Robert Sidorsky.
 — Rev. and updated ed.
 p. cm.
Includes index.
ISBN 978-0-8109-8920-7 (hardcover)
1. Golf courses. I. Title.
GV975.S535 2010
796.352'068—dc22

2009035065

Text © 2010 Robert Sidorsky

Front cover: Chambers Bay Golf Course, Washington,
 U.S.A. © Aidan Bradley (see June 3)
Back cover: Bro Hof Slott Golf Club, Sweden © Bro Hof
 Slott Golf Club (see August 14)
Spine: Le Touessrok Golf Course, Mauritius © David
 Cannon / Getty Images (see March 12)

Printed and bound in China
10 9 8 7 6 5 4 3 2 1

Abrams books are available at special discounts when purchased in quantity for premiums and promotions as well as fundraising or educational use. Special editions can also be created to specification. For details, contact specialmarkets@abramsbooks.com or the address below.

THE ART OF BOOKS SINCE 1949
115 West 18th Street
New York, NY 10011
www.abramsbooks.com